Praise for Anne-Marie O'Connor's

The Lady in Gold

A *LIBRARY JOURNAL* BEST BOOK OF THE YEAR

"Captivating." —*MORE* magazine

"Combines detailed reportage with passionate storytelling. . . . Unraveling the portrait's journey also reveals how global norms of art and war have changed, and the powerful roles that art plays in politics, society, identity and memory." —*The Rumpus*

"A fascinating book." —*The Dallas Morning News*

"A nuanced view of a painting whose story transcends its own time." —*Bookforum*

"Richly drawn. . . . Part history and part mystery, *The Lady in Gold* is a striking tale." —*BookPage*

"The lusciously detailed story of Gustav Klimt's most famous painting, detailing the relationship between the artist, the subject, their heirs and those who coveted the masterpiece. . . . Art history fans will love the deep details of the painting, and history buffs will revel in the facts O'Connor includes as she exposes a deeper picture of World War II." —*Kirkus Reviews*

"Intriguing. . . . Poignant and convincing. . . . Vividly evokes the intellectually precocious and ambitious Adele's rich cultural and social milieu in Vienna, and how she became entwined with the charismatic, sexually charged, and irreverent Klimt." —*Publishers Weekly*

"Writing with a novelist's dynamism, O'Connor resurrects fascinating individuals and tells a many-faceted, intensely affecting, and profoundly revelatory tale of the inciting power of art and the unending need for justice." —*Booklist* (starred review)

Anne-Marie O'Connor

The Lady in Gold

Anne-Marie O'Connor attended Vassar College, studied painting at the San Francisco Art Institute, and graduated from the University of California, Berkeley. She was a foreign correspondent for Reuters and a staff writer for the *Los Angeles Times* for twelve years, and has written extensively on the Klimt painting and the Bloch-Bauer family's efforts to recover its art collection. Her articles have appeared in *Esquire*, *The Nation*, and *The Christian Science Monitor*. She currently contributes to *The Washington Post* from Jerusalem, where her husband, William Booth, is *Post* bureau chief.

The Lady in Gold

The Extraordinary Tale of
Gustav Klimt's Masterpiece,
Portrait of Adele Bloch-Bauer

Anne-Marie O'Connor

VINTAGE BOOKS
A Division of Penguin Random House LLC
New York

To William Booth,
Mary Patricia O'Connor,
and
Carolyn Koppel

FIRST VINTAGE BOOKS EDITION, MARCH 2015

Copyright © 2012 by Anne-Marie O'Connor

All rights reserved. Published in the United States by Vintage Books,
a division of Penguin Random House LLC, New York, and distributed
in Canada by Random House of Canada, a division of Penguin Random
House Ltd., Toronto. Originally published in hardcover in the United
States by Alfred A. Knopf, a division of Penguin Random House LLC,
New York, in 2012.

Vintage and colophon are registered trademarks of
Penguin Random House LLC.

Portions of this book previously appeared in the *Los Angeles Times
Magazine* in 2001 and are reprinted with permission.

Bauer family tree reprinted courtesy of Penn Publishing Ltd.

The Library of Congress has cataloged the Knopf edition as follows:
O'Connor, Anne-Marie.
The lady in gold : the extraordinary tale of Gustav Klimt's masterpiece,
Portrait of Adele Bloch-Bauer / by Anne-Marie O'Connor.—1st ed.
p. cm.
Includes bibliographical references and index.
1. Klimt, Gustav, 1862–1918. Adele Bloch-Bauer I.
2. Bloch-Bauer, Adele, 1881–1925—Portraits. I. Title.
ND511.5K55A618 2012
759.36—dc23 2011033578

Vintage Books Trade Paperback ISBN: 978-1-101-87312-0
eBook ISBN: 978-0-307-95756-6

Book design by M. Kristen Bearse
Author photograph © Phoebe Ling

www.vintagebooks.com

Printed in the United States of America
14 16 18 20 19 17 15

Contents

PART THREE *Atonement*

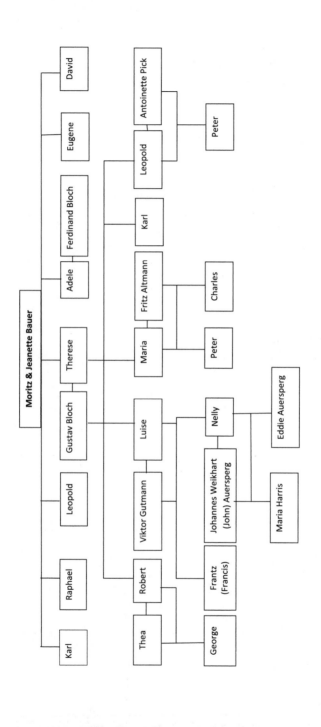

Illustrations

Prologue

The Belvedere Palace of war hero Prince Eugene seemed the setting of a fairy tale on the winter morning in 2006 when a young Los Angeles attorney, wearing a long black coat and an habitual air of impatience, trudged through its snowy gardens to lay claim to a painting he had spent years fighting for.

The lone man strode briskly along the imperial palace's frozen pond. Ice clung to the monumental sphinxes standing sentinel along his path, their hair swirling around fiercely beautiful faces, breasts naked between tassels dangling from armor. Their eyes cast a bold gaze, of sated conquest.

The lawyer was Randol Schoenberg, the grandson of a venerated Viennese composer who had fled the rise of Hitler. The return of this ominous heir was anything but welcome. The painting Schoenberg sought was a shimmering gold masterpiece, painted a century earlier, by the artistic heretic Gustav Klimt. It was a portrait of a Viennese society beauty, Adele Bloch-Bauer.

Both artist and model were long dead, but people still enjoyed speculating they had been lovers. Their artistic collaboration produced one of the greatest portraits of the modern age. Austrians regarded the painting as their *Mona Lisa.*

Schoenberg paused to stamp snow from his boots at the doors of the palace, which now housed the Austrian Gallery, the premier national art museum, though it still bore the name bestowed by Prince Eugene, who called it his Belvedere, or "beautiful view." From this hill the Turks had laid siege to Vienna in the last great showdown between East and West, and the soaring green Belvedere roof emulated their billowing tents.

In the distance, St. Stephen's Cathedral rose toward the heavens, reaching for the love of God. Its majestic blackened spires towered over the site of an ancient moat built by Roman emperors over the remains of a prehistoric Celtic settlement.

Here was the primeval heart of Vienna.

Above Schoenberg, stone gods and goddesses gazed down from the par-

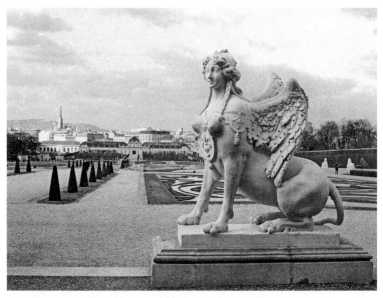

*The Belvedere Palace of Prince Eugene of Savoy, the Baroque
monument to the victory over the Turks.*

apet of the palace. Cherubs cast mischievous glances, as capricious as love
itself. A group of Japanese tourists stood and shivered, waiting for the
museum to open. Schoenberg hurried past them.

A silver-haired patriarch in a gray overcoat stopped his morning walk
and stared: it was that American lawyer from newspapers and television.
"Schoenberg!" the Austrian hissed to his wife. They exchanged stony
glances. *Schoenberg.* The man who wanted to take the gold portrait from
Austria.

Inside, Schoenberg was greeted with cool circumspection by the direc-
tor of the Austrian Gallery, Gerbert Frodl. Frodl was a tall man with watch-
ful eyes and a thin smile. Schoenberg was the last person Frodl, or Austria,
wanted to see. But Frodl was shrewd enough to realize that it would be
best to treat the composer's grandson with courtesy. Ticking him off would
only make things worse.

For years, Austrian officials had stonewalled Schoenberg. Now Frodl
was reduced to showing him the way to precious paintings like a museum
guide. Frodl quickly handed Schoenberg off to a tight-lipped functionary.
She led him to a glass elevator and pushed a button. They rode down in
silence. Deep under the museum, the elevator groaned to a halt. Schoen-

berg followed the administrator down a maze of dark passageways, their footsteps echoing. Schoenberg thought, What is this place?

He knew better than to ask. The answer might not be pretty. Bunkers like this were not built for fairy-tale palaces.

Finally the administrator opened a heavy door to reveal a strange chamber, as immense and fortified as a refuge to wait out the end of the world. The administrator didn't bother to offer an explanation for this place, whose colossal walls, built during World War II, had been strong enough to withstand aerial bombardment.

Like many things and many people in Austria, the bunker beneath the Belvedere possessed a mysterious pedigree. Museum curators whispered, incredibly, that it was built as a last refuge for Hitler. But there was no official explanation.

The bunker now sheltered the artistic treasures of Middle Europe. Some of the art locked away here had been "collected" by the Nazis—meaning that it had been stolen, appropriated as ransom from families of accomplished Jews, who were humiliated, fleeced, and finally hounded out of Vienna. If they stayed, far worse fates befell them.

Older Austrians wished to forget this unpleasantness. Museum officials, in particular, had no incentive to sort through their institution's own musty papers and pull out letters from Nazi functionaries proving that this or that painting did not belong on their walls. They disliked being reminded that fellow art historians and mentors—even relatives—had curated art for Hitler. Now, unbelievably, it had come to this: this Schoenberg was going to paw through national treasures like Napoleon.

The administrator led Schoenberg into the shadowy vault. He blinked to adjust his eyes to the dim light. What he saw astounded him. Rack after rack of paintings lined the walls. Centuries of art that had once hung in monasteries, palaces, grand apartments, and country homes.

The administrator walked silently along the rows of gilded frames, then stopped. Here, she said decisively.

Schoenberg lifted the first painting in the rack, and the light caught a shimmering surface. Here was the masterpiece Schoenberg was fighting for. He stared in wonder at Adele's face, floating in a haze of gold, as pale and sultry as a diva of the silent screen.

For eight years, Schoenberg had argued this painting did not belong to Austria. Most people would have given up long ago. But Schoenberg had a remarkable client, with a stubbornness to match his own. A ninety-year-old retired dress-shop owner, disarmingly charming and as dignified and composed as the carefully cultivated Viennese debutante she had once been.

This onetime Vienna belle, Maria Bloch-Bauer Altmann, was the last living link to her aunt Adele, who was the muse, and perhaps much more, of Gustav Klimt.

Maria Altmann had all the will in the world. But she didn't have much time. Never had a little old Jewish lady in Los Angeles caused Austria so much trouble.

Schoenberg was not the first attorney to hold this contested jewel in his hands. Half a century before, a Nazi lawyer, known for his arrogance and tailored suits, turned the key of the Elisabethstrasse *palais* of Adele Bloch-Bauer.

Vienna was ruled by a native son, Adolf Hitler. The attorney, Erich Führer, was riding the crest of this triumphant wave. Even his name was serendipitous. Führer was proud of his stern hatchet face, and the long scar on his cheek that advertised his membership in an elite anti-Semitic university fencing fraternity.

Führer was from a "good family." But when he opened the massive wooden door of the Bloch-Bauer *palais,* he looked like a thug in a suit. It was a pose he relished, and like Hitler, it was very much in vogue.

The four-story Bloch-Bauer *palais* was just off the Ringstrasse, or "Ring Street," the broad avenue built in a circle around the city after 1857, when Vienna began to tear down the massive walls that had staved off the Turks. Jewish barons like Rothschild and Schey were allowed to build the ceremonial mansions that the Viennese called *palais* on the empty ring of land where the battlements had stood. The Ringstrasse became the home of a newer elite known as the "second society."

Now brilliant Jewish families like the Bloch-Bauers were gone. The salon was silent. Curtains were drawn over the long windows overlooking the Schillerplatz and its statue, draped in a garland of golden roses, of the poet Friedrich Schiller, beloved for the *Ode to Joy* that was his "kiss to the whole world." Angels gazed down demurely from the Vienna Academy of Fine Arts across the square. Once this Elisabethstrasse *palais* had witnessed the academy's humiliating rejection of Hitler, when he was a penniless young art student.

Denying Hitler anything in Vienna was inconceivable now.

Führer strode across jewel-toned Persian rugs, until he reached the bedroom of Adele Bloch-Bauer, the late wife of the man who had been forced to flee this mansion. She had died years ago. But there were flowers in a

vase on a table, so withered and dry they crumbled at the touch, and a framed photograph of a bearlike man, grinning and embracing a black-and-white kitten.

Klimt.

Whatever did women see in him?

Führer walked deeper into the shadowy, cold room. Then he spotted his quarry. For a moment, he stood before it and stared. Here was the portrait that had dazzled turn-of-the-century Vienna. A painting with the flourish of Mozart, yet a product of Freud's emerging age of the psyche. In this painting, Vienna's glittering past met its fratricidal present.

Now it would meet its future.

Führer knew Klimt's work was not entirely in keeping with Nazi tastes. Hitler had an aversion to modernists, and Klimt had been a notorious "philo-Semite," a friend of Jews. Yet his portraits of society ladies were synonymous with Viennese glamour. The fact that the woman in the golden painting was Jewish was inconvenient, but not incurable.

The painting of Adele would be hoisted into a vehicle and driven across town, slowly, to protect the fragile gold leaf. Führer would not deliver the painting to brutal Nazi storm troopers with guns and boots. He would present it to bespectacled curators at the Austrian Gallery, who were advancing their careers under Nazi rule. It was to these tainted aesthetes that Führer would offer the beautiful Adele, like pirates' booty, or a trophy of war, with a letter that bore the salutation "Heil Hitler!"

The placard on the wall at the Belvedere gave no clues as to the identity of the woman in the portrait. Any hint of her Jewish origins would betray the Nazi lie of racial superiority.

So they engaged in one of the greatest identity thefts in the history of artistic provenance, craftily erasing the traces of Adele's life and legacy. The first mention of the "acquisition" of Adele's gold portrait was written in 1942 by an old friend of Klimt. He knew very well who Adele was. Yet in one of the small collaborations that pushed the Nazi machinery forward, he politely called the gold portrait of Adele Bloch-Bauer the *Dame in Gold*.

The Lady in Gold.

Adele would gaze down mutely on well-dressed visitors, like a deposed queen of fin de siècle Vienna, a forgotten fragment of the birth of modernism. Her lips were slightly parted, as if she were about to speak. It might take years for Adele's truth to get out, but her secret would not remain locked up forever.

The woman who held the key to the mystery carefully balanced a tray of aromatic Viennese coffee, brimming with whipped cream, and set it on a table in a sun-dappled living room in Los Angeles at the turn of another century.

Maria Altmann was gracious and warm, the kind of woman referred to in another era as a grande dame. Her face was deeply lined, but her bright brown eyes still held a gaze of wonder.

"It is a very complicated story," Maria began, in an elegant Old World accent that belonged to a vanished world in *Mitteleuropa.* She paused a moment, trying to decide where to start. "People always asked me, did your aunt have a mad affair with Klimt? My sister thought so. My mother—she was very Victorian—said, 'How dare you say that? It was an *intellectual* friendship.' "

Maria looked up at a reproduction of Adele's portrait on the wall, regarding her face thoughtfully.

"My darling," she said finally, "Adele was a modern woman, living in the world of yesterday."

PART ONE

Emancipation

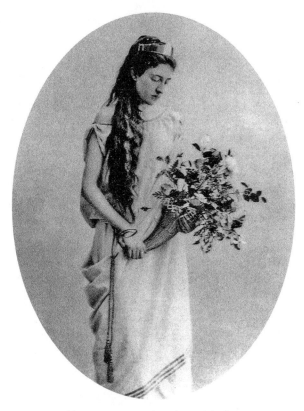

*Adele Bauer at sixteen, dressed as a sylph of spring,
to recite a poem for her sister's wedding, March 1898.*

Adele's Vienna
Poems and Privilege

It was 1898, and the devil himself seemed to dance in Vienna.

The mistress of Emperor Franz Joseph was Vienna's premier actress, Katharina Schratt, and she was threatening to retire from the stage unless the Imperial Burgtheater staged a scandalous Arthur Schnitzler play that glamorized free love. Vienna's most acclaimed star couldn't possibly be allowed to step down in the Jubilee Year, the fiftieth anniversary of the reign of the Austro-Hungarian monarch. So when the curtains opened on Schnitzler's *Veil of Beatrice,* the emperor personally saw to it that his mistress was onstage in a black veil, in the role of the seduced woman.

If it had once been unthinkable for the Austrian emperor to publicly indulge the whims of a common actress, Vienna was now a hothouse where nothing seemed impossible.

For hundreds of years, the great Habsburg dynasty had reigned over this crossroad of East and West. Behind immense battlements, its frilly court united German, Italian, Polish, Czech, Hungarian, and Croatian aristocracies into a single royal house whose multicultural capital was as ornate as a Fabergé egg. Even their German acquired elaborate embellishments and a lilting cadence, softened by Italian and French, and Baroque exhortations to *kuss die hand.* This culture of pleasure was so unabashed that one Habsburg archduke declared wine "the principal nourishment of the city of Vienna."

Now Vienna's ancient ramparts had come tumbling down, and a wave of newcomers was crowding in from Bohemia, Moravia, Galicia, and Transylvania. You could hear a dozen languages in a single street—or a single tavern.

This new Vienna was a city of contradictions. It was one of Europe's richest cities, yet its immigrants were among the poorest. The construction of opulent new palaces did little to hide a severe housing shortage. Vienna doctors were creating modern medicine—pioneering surgeries; discovering germs, the polio virus, and blood types—yet incurable syphilis spread unchecked. Sigmund Freud was illuminating hidden drives of sex

*Franz Joseph, Emperor of Austria,
King of Bohemia, and Apostolic King of
Hungary, ruler of the empire from
1848 until his death in 1916;
shown here in 1897.*

and aggression at a time of xenophobia and anti-Semitism so crude that some believed Jews murdered children to leaven their matzoh with blood. Famed for its gaiety, "the sacred city of musicians" had the highest suicide rate in Europe.

The hallowed house of Habsburg, which produced the kings of the Holy Roman Empire and boasted such ancestors as Julius Caesar and Nero, seemed to be coming apart. Emperor Franz Joseph was carrying on with an actress. His wife, Empress Elisabeth, detested court life and spent her time traveling the continent, earning a reputation as Europe's most famous liberated woman. His brother, Maximilian, playfully donned a sombrero during an ill-fated adventure as emperor of Mexico that ended with his execution by firing squad. His wife, Charlotte, went mad in a Belgian castle.

The dynasty that had united Europe and the Americas had become the empire's premier dysfunctional family.

Arrivistes were upending the social order. Prominent Jewish men like Gustav Mahler—who converted to Catholicism to qualify for an imperial post as director of the Vienna State Opera—were somehow becoming eligible bachelors, chased by wealthy Catholic society girls. The intoxicating waltz was throwing Viennese maidens into the arms of strangers. "African and hot-blooded, crazy with life . . . restless . . . passionate," wrote an appalled director of the Burgtheater. "The devil is loose here . . . in one single night, the Viennese went with him."

Yet even in this "Gay Apocalypse," Vienna maintained a deeply old-fashioned charm, with its snow-covered palaces and strolling parks, its aromatic cafés and seductive pastry carts piled with petit fours and chocolate bonbons filled with sweet liqueur. Possessed of a childlike love of adornment, Vienna was a city where gilded iron roses climbed balconies and stone goddesses framed doorways; where gargoyles glared from cornices and Herculean men bared their immense chests from façades.

Even the empire's military was as festive as a marching band, with

Emperor Franz Joseph in scarlet trousers trimmed
with gold braid, his officers and hussars strutting
through Vienna in uniforms in purple, salmon,
and powder blue, festooned with red lanyards and
long plumes trailing from their helmets.

In 1898, Vienna was a place where illusions could
still be preserved by well-to-do families like the
Bauers, who gathered at their elegant apartment
above the Ringstrasse on a March afternoon when
the musky sweetness of lilacs filled the damp air.

Adele Bauer was standing before the family in a
white Grecian robe, revealing a slender frame as
long and delicate as a vase. Her thick dark hair fell
to her waist. At sixteen, Adele was crossing that
mysterious line between girl and woman. Dressed
as the spirit of Spring, she held a wicker cornuco-
pia filled with spring blossoms and sheaves. With
her poise and regal bearing and her dark, heavily
lidded eyes, Adele might have been an actress, like

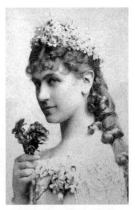

*Katharina Schratt, shown
here ca. 1880, was the greatest
actress in the Germanic world.
Emperor Franz Joseph built
her the Villa Schratt at Ischl
and made her an heir.*

Katharina Schratt, who ruled a few steps down the Ringstrasse, at the
Burgtheater. For now, Bauer family gatherings were the stage for Adele, the
pampered youngest child of Viennese banker Moritz Bauer.

Today Adele would read a poem in honor of a family wedding. In two
days, her sister, Therese Bauer, would solemnize her union with Gustav
Bloch, the jovial son of a prominent Czech sugar baron. So there was a
dynastic air to the proceedings in the Bauer parlor, a great room richly
furnished with gilded mirrors, the framed portraits of family ancestors,
and an ornate clock, adorned with a golden Roman chariot.

Bauer family celebrations always had a touch of theater. Friends played
music while guests waltzed. A special poem elevated the atmosphere from
the realm of the ordinary, inviting guests to share the deeper significance of
the moment.

The room grew still.

"Do you recognize me? Must I introduce myself?" Adele began, in a low,
rich voice, with an air of intrigue. "Do you know who is speaking to you?

"I bring you joy, I bring you lust for life! I chase away your sorrow and
grief. In a word, I am the Good Spirit of the house." This slip of a girl did
look like a spirit; or a long-limbed water sprite, or a lithe Muse from an
Etruscan urn.

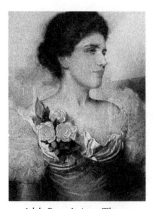

Adele Bauer's sister, Therese, was everything Adele was not: conventionally feminine and a conformist at heart. This pastel sketch dates from ca. 1898.

Gustav Bloch smiled at his bride-to-be, Therese, the very proper sister of Adele. Gustav, a handsome man with a thick mustache, had wooed Therese with the intricate courtesies suitable to the old-fashioned daughter of an established banker.

Gustav's brother, Ferdinand, standing beside him, eyed Adele. Ferdinand was poised to take over his Czech father's sugar beet industry. Sugar barons were the oil sheiks of pastry-mad Vienna, their wealth increasing with every surge in the price of the white gold. Ferdinand was twice Adele's age. He was a kind, homely bachelor who collected fussy eighteenth-century porcelain. Serious and methodical, Ferdinand was as different from his café-loving brother as Therese was from her literary, artistically inclined sister.

The conventional Therese would straighten out Ferdinand's bon vivant of a brother. But her sister! Adele looked like a charming little pagan goddess.

"I am a creature of this house, which I have always loved, always inhabited, and seldom left," Adele was reciting. "My worst enemy is the sadness that drove me away." Ferdinand suffered from periodic melancholy. He listened more closely.

"But you see that I emerged the stronger one!" Adele said, with theatrical triumph. "And how do I return? Whole and strong, with all the Might that I can muster.

"How much do I love to see you here? You can see it in my shining eyes, in my flushed cheeks. My masterpiece is you, gathered here," Adele said with rising emotion, as the guests smiled.

Ferdinand was hooked. How had his distracted brother managed to betroth himself to this charming Viennese family?

"As my little Ghosts foretold," Adele said, "Happiness has moved in with the Bauers."

Ferdinand's eyes wandered to a sepia portrait of Adele's mother in a heavy gilded frame, dressed in the daring pre-Victorian manner, her gown falling far from her thin shoulders, and baring a touch of décolletage. Adele obviously took after her mother.

"Is it not true that little Cupid, with his bow and arrow, has made an

excellent shot?" Adele asked, taking Gustav and Therese by the hand. "I feel it, in the beating of my heart; in the blood that runs through my veins; I feel it in the hot streak of luck that shoots through me!"

The poem was long. Guests shifted on their feet impatiently, thinking of the champagne and roast beef to come. Ferdinand wondered if he could arrange to be seated near Adele.

"Suddenly, I have lost my words!" Adele stalled mischievously. "My desires rise to my lips, inside me my feelings are in turmoil, and every emotion clamors to emerge at once!"

Waiters were bringing fluted glasses.

"But the *hausfrau* is giving me an annoyed look," Adele said, smiling at her mother. "She wants you to sample her culinary skills. The man of the house would like you to judge his vintages of wine. Therefore, I will go now.

"I call out to you, with all the force of my lungs, and even more: Long live the bride and groom!"

Everyone raised a glass. The deserving but dour Ferdinand made a silent toast to the dazzling woman-child in white, the bewitching embodiment of youth and hope.

The King

Not far from Adele's sheltered world, the finest painter in Austria was charting a collision course with the Vienna art establishment.

Gustav Klimt still didn't seem the rebel as he held court at his daily haunt, the Café Tivoli, at the foot of the gardens of the Schönbrunn Castle. Every morning Klimt downed strong coffee and ordered an enormous breakfast. "Whipped cream played a major role," along with *Gugelhopf*, a rich cake of rum, raisins, and cherries in the shape of a Turkish turban, recalled the painter Carl Moll, who sat at the open-air table with Klimt and their fellow artists, plotting the future of Austrian art.

Klimt was becoming a celebrity. When he strode into Vienna's Café Central, heads turned. Women found him alluring. His massive athletic frame, tanned face, and boldly direct glance distinguished him from the

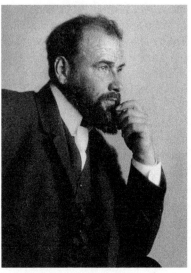

*Gustav Klimt, Austria's finest painter,
whose affairs fueled Vienna gossip,
shown here ca. 1900.*

prissier dandies of upper-class Vienna, who paid careful attention to their dress and the figure they cut. Klimt exuded the natural sexual charisma of a man comfortable in his own skin.

Klimt's friends called him König—the King.

At thirty-five, Klimt *was* a king, of the Vienna art world. By the time he was in his midtwenties, Emperor Franz Joseph had awarded him the golden service cross, and had personally congratulated him for his staircase murals in Vienna's Imperial Burgtheater, or "Castle Theater," the monumental new building for one of the greatest stages in the Germanic world. Klimt's decorative paintings of Greek myths, Norse legends, and heroic women adorned palaces, spas, and theaters throughout the empire.

To outsiders, Klimt seemed to lead a charmed life. People were calling him the heir to Vienna's late "prince of painters," Hans Makart, a romantic painter of scenes of Romeo and Juliet, wood nymphs, knights, and troubadours. Makart had turned his studio into a salon for wealthy women, flattering them with unctuous portraits and romantic attention, until he died, ravaged by syphilis, in 1884.

A comparison to Makart was a heady designation for a man who had

stayed away from grammar school as a boy because his family was too poor to replace his shabby clothes. In the years when Klimt aspired to be no more than an art teacher, such acclaim would have been beyond his wildest ambitions.

Klimt admired Makart, of course, and acknowledged his influence. But he wasn't interested in following in his footsteps as an artistic courtier of official Vienna. He was restless in the gilded cage of a state-sanctioned artist.

The lucrative work had lifted him from desperate poverty. But he bristled at the conventional world he now inhabited. The provincial prejudices of the Viennese aristocrats who courted him only fed his brewing rebellion against his own success.

In the privacy of his lush walled garden studio, Klimt had begun to reach into his own psyche. He was experimenting with Symbolism, a French movement that used mythical figures and psychologically charged symbols. Its proponents had a particular fascination with strong female figures. They rediscovered a neglected portrait, Leonardo da Vinci's *Mona Lisa,* and resurrected it as a masterpiece of the "eternal feminine."

Klimt was gravitating to new patrons, self-made Viennese industrialists, many of them Jewish, who were buying the innovative new art that state museums rejected. To this emerging elite, Klimt was something of a sex symbol. His charisma was enhanced by his devil-may-care impatience with the hypocrisies of Viennese society. In this Janus-faced world, men of distinguished lineage hid their indiscretions with prostitutes, or their "sweet girls" from the lower social orders, while respectable women were expected to pretend not to like sex.

Klimt liked women.

At a time when open female sensuality was disdained as an aberration or a "hysteria" to be treated, Klimt's elegantly erotic line drawings, more whispered about than seen, made it clear he understood the sexual desires of women. "The erotic neurasthenia that vibrates in many of his most deeply felt drawings is filled with his most profound and painful experience," wrote art historian Hans Tietze of this "refined man of nature, a mixture of satyr and ascetic."

Women far above Klimt in social status were disarmed by his direct, irreverent manner, his burning stare and deep baritone. His magnetism was enhanced by the kind of powerful physique more typical of a woodcutter or a sailor. Klimt did nothing to discourage his image of roguish virility.

Yet his work habits were rigidly ascetic. He lived with his mother and sisters. He woke at first light, sometimes at his studio on Josefstädterstrasse, then set out on a brisk walk across Vienna for his hearty breakfast at the Café Tivoli. He returned to his studio for long days of painting, taking breaks to exercise with barbells.

Klimt's influences were Viennese. In an era when gold symbolized imperial power, he let the reflections of the herculean golden globes and statues perched on Vienna buildings bleed into his paintings. In a Vienna in which even psychoanalyst Sigmund Freud sifted through the black market for Egyptian antiquities, Klimt incorporated exotic motifs from North Africa and sketched the ubiquitous sphinxes scattered through imperial palaces.

But it was women who fascinated Klimt, and women who were emerging as his patrons and champions. In a class-stratified, anti-Semitic Vienna crowded with pretentious royalty, Klimt began to accept commissions to paint portraits of women from the new Jewish intellectual families. The women in these families lived in a world of ideas. Some knew Freud personally and weren't shocked by his belief that subconscious sexual desires burned beneath Vienna's embellished façade. These women were not born into their place in society; they were creating it.

Perhaps Klimt saw something of himself in them.

Emancipated Immigrants

Vienna, one of the oldest settlements on the River Danube, has always been a frontier, a walled city of the West on the doorstep of the East, defending itself from outsiders but shaped by immigration since the beginning of time. The Aurignacians left Venus-like fertility figures in Austria before moving on to paint caves in France and Spain. The restless Celts moved up the Danube, building a settlement on a wooded bluff above the waters the Romans would later call Vindobona.

The warrior emperor Marcus Aurelius himself guarded the vineyards of this Roman bulwark from Marcomanni attackers, building the walls higher to fend off the Huns, the Goths, and the Alemanni. Soon it was the eastern bulwark of Christendom, the frontier defender against Slav

invaders and Magyar horsemen who thundered across the Hungarian plain. The garrison became a growing citadel known as Wien.

The discovery of a golden scroll in a child's grave near Vienna with a Jewish prayer—"Hear, O Israel! The Lord is Our God! The Lord is One!"—placed the Jewish presence at least as far back as the third century, suggesting Jews were co-founders of Roman Austria. But as Christianity replaced paganism, the relationship with Jewish citizens became capricious. They were tolerated, then expelled; allowed to return as merchants, but not to own houses. Literacy set Jews apart, and the Jewish tradition of aiding their widowed, orphaned, and handicapped inspired envy.

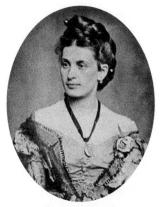

Jeanette Bauer, whose youngest child, Adele, was Klimt's most famous model, ca. 1862.

If Jews became too successful, a misfortune—plague, drought, war, famine—transformed peaceful neighbors into howling mobs. Jews were defamed as usurious moneylenders and killers of Christ, then derided as shiftless wanderers when they fled.

Gradually, Jewish industry—along with bailouts of spendthrift barons, counts, and princes—won respect, even titles, from Germanic aristocracy. By 1814, diplomats at the Congress of Vienna were flocking to the salon of the Jewish aristocrat Fanny von Arnstein, and they whirled to the beat of a salacious mountain courtship dance, imported by Danubian boatmen, that the Viennese called the waltz.

When the earliest reforms of the Jewish emancipation came in 1848, Vienna had only two hundred tolerated Jewish families. Now thousands more packed their bags in Galicia, Czechoslovakia, and Yugoslavia. As restrictions on Jewish residency loosened, Vienna beckoned.

In 1857, Emperor Franz Joseph ordered the dismantling of Vienna's massive stone fortifications. It was a revolutionary decision. The battlements had grown to immense dimensions during the Crusades, financed, according to legend, with ransom for freeing Richard the Lionhearted. The walls had stopped the Turks and sheltered Viennese sensibilities from the crude peasantry. Down came the walls! The imperial city was remaking itself. Johann Strauss II, the merry fiddler, wrote the "Demolition Polka" to celebrate this chaotic reinvention.

The construction din on the Ringstrasse, the cradle of the city's rebirth,

was as ferocious as the monumental new neoclassical Parliament building architects had crowned with chariots of winged goddesses permanently in battle. The emperor's War Ministry was adorned with avenging angels and busts of soldiers that celebrated the empire's ethnic diversity: Serb horsemen with handlebar mustaches, Hungarian Magyars wearing head kerchiefs like Gypsies, Croats with the jaunty cravats that Parisians adopted as the tie, and Bosnians sporting the "blood-red fezzes" that the Austrian novelist Joseph Roth compared to "tiny bonfires lit by Islam in honor of his Apostolic Majesty." "If you want peace, prepare for war" read the ministry's inscription.

The Habsburgs courted wealthy Jewish families to finance railroads and factories, honoring them with aristocratic titles handed out like party favors. Jewish barons—Rothschilds, Gutmanns, and Scheys—could now aspire to marry their daughters to Catholic aristocrats. They could mingle in Vienna's "second society," of freshly minted aristocrats and industrialists.

Between 1860 and 1900, the Jewish population of Vienna exploded, from 6,000 to 147,000, the largest in Western Europe. As the turn of the century neared, nearly one in ten Vienna residents was Jewish. Vienna had gained some of Middle Europe's most talented minds, like Sigmund Freud, whose family had moved from an Edenic town in Moravia; Gustav Mahler, whose family had relocated from Bohemia; and Ludwig Wittgenstein, whose family had converted to Catholicism generations ago.

Affluent Viennese Jewish families were instant lovers of Viennese culture. They filled the empire's new theaters, opera houses, and schools far out of proportion to their share of the population. Less than 10 percent of Viennese children were Jewish, yet Jewish children were 30 percent of high school classes. The Jewish Viennese embraced the newly unrestricted fields of science and medicine. More free to make things up as they went along, they supported new artists, intellectuals, and political trends. They became such crucial patrons of culture that soon, the journalist Stefan Zweig wrote, "whoever wished to put through something in Vienna," or "sought appreciation as well as an audience, was dependent on the Jewish bourgeoisie."

The Jewish elite was, as the Czech writer Milan Kundera put it, the "intellectual cement" of Middle Europe.

Yet most Jewish families crowding into Vienna lived far from the charmed circle on the Ringstrasse. The *Ostjuden*, or Eastern Jews, had fled poverty and pogroms in backward corners of Poland and Russia. They arrived desperate and devout, crowding into decrepit warrens that clung to the banks of the Danube Canal in Leopoldstadt, the old Jewish ghetto,

now referred to as "Matzoh Island." This was turn-of-the-century Vienna: a cosmopolitan, wealthy imperial city, a playground of aristocrats and palaces, a magnet for desperately poor refugees.

Anti-Semitism marched hand in hand with the rising prominence of Jewish families. Georg von Schönerer, an anti-Semitic politician near the German border, was jailed in 1888 for beating Jews. But his sister, the open-minded actress Alexandrine von Schönerer, socialized with Jewish theater patrons, and their father was a friend and business associate of the Rothschilds.

One of Georg von Schönerer's disciples, Karl Lueger, would make Vienna the birthplace of anti-Semitism as a mainstream political force. Lueger, who electrified crowds by blaming Jewish entrepreneurs for Vienna's economic woes, was elected mayor on an anti-Semitic platform and took office in 1897 over the strident opposition of the emperor. "Handsome Karl" introduced electric streetlights, a public marketplace, and municipal gasworks—all the while pleading for assistance from the very Jewish bankers he denounced as an international conspiracy. When it was pointed out that Lueger himself socialized with people of Jewish descent, Lueger snapped: "I decide who is a Jew."

For members of the privileged Jewish elites like Moritz Bauer, the crude anti-Semitism of politicians like Lueger was background noise, the tasteless chatter of déclassé demagogues who were best occupied with fixing the streets.

Moritz and Jeanette Bauer were newcomers to Austria when their Viennese daughter was born, on August 9, 1881, in the heat of the Danubian summer. They named her Adele, Old German for "Noble," suggesting the family's aspirations to live the promise of the emancipation.

The Wounded Creator

The Greeks thought inspiration was a gift of the gods.

Freud believed art arose from attempts to resolve psychological conflict, and that for creators, the pain of childhood trauma was a wellspring of

inspiration. If so, it didn't require Freud to identify the demons that haunted the workaholic artist and serial philanderer who was Gustav Klimt.

Klimt was born the second of seven children on July 14, 1862, in Baumgarten on the outskirts of Vienna, into a Catholic family of the city's large immigrant underclass. His father, Ernst Klimt, from Bohemia, was a gruff uneducated Czech, isolated by his rudimentary German and frustrated by his meager earnings as a gold engraver. Klimt's Viennese mother, Anna, had once nurtured unattainable dreams of being an opera singer. Now she struggled with anxiety and depression that deepened after each child's birth.

Gustav Klimt grew up miserably poor. His father worked brutal hours, lacking the connections to obtain lucrative commissions. At Christmas, "there wasn't even any bread in the house, much less presents," recalled Gustav's sister Hermine. Instability was constant. The family moved five times before Klimt was two, and in one home, they shared a single room. When he was twelve, his winsome five-year-old sister, Anna, died of a childhood illness. His mother collapsed. His beautiful, emotionally brittle older sister, Klara, had an attack of "religious madness" and never really recovered. School was a humiliating daily ordeal. Gustav stayed out one year because he lacked proper pants. Another year a prosperous schoolboy's watch went missing, and Gustav believed his status as the poorest boy in class made him the prime suspect. He often suffered hurt feelings, rejection, and disappointment. But he loved to draw. When he finished his chores, he sketched the neighbor's cat, his younger brother Ernst, and his wan mother, slumped in her chair.

Gustav and Ernst helped their father work with gold. Thanks to the construction boom of the Ringstrasse, gold was a more promising trade. The Midas touch was everywhere on the imperial ministries and monuments going up on the Ringstrasse. All that glittered was gold, or at least gilt. Here, Atlas hoisted his golden globe, the gilt features of Pallas Athena shone in the sun, and gold leaf glowed from ceilings and Corinthian columns.

Gold symbolized everything that was out of reach for Gustav and Ernst Klimt, who seemed born to live at the sidelines of Vienna's pageantry, as skilled tradesmen like their father.

But Gustav had a sense of destiny. At fourteen, he enrolled at the new School of Applied Arts in Vienna. Ernst soon joined him. The talented, good-looking Klimt brothers attracted an important mentor, Professor Ferdinand Laufberger. Impressed by their precocious gifts and relentless

work ethic, Laufberger guided them into mosaic and fresco. He recommended them for their first commissions, and soon the brothers were painting the interiors of the Hermes Palace, an imperial retreat for Empress Elisabeth from the Vienna court she despised. The Klimt brothers teamed up with another promising student, Franz Matsch. In 1880, the trio painted the ceilings of the Palais Sturany in Vienna. They began to call themselves the Künstler-Compagnie, or Artists Company.

Gustav Klimt, then eighteen, was the hope of his desolate family.

"He was not naturally a man of society but more a loner, and it therefore had to be the duty of his brothers and sisters to eliminate all the small things in his daily life that were inconvenient," his sister Hermine recalled.

"Gustl, why don't you know how to play music?" asked his little brother, Georg, as Gustav sketched. "Because I must paint, you monkey you," Gustav answered affectionately.

The Künstler-Compagnie soon had more work than its three young artists had time. They were invited to the Middle European architectural gem of Karlsbad to paint a theater. That led to wall decorations for the silver anniversary of Emperor Franz Joseph and Empress Elisabeth's lifeless marriage. They painted a lion lying languidly at the feet of a lushly nude heroine, in what seemed a risqué allusion to the bohemian empress.

Socially, the Klimt brothers cut striking figures. They were well spoken, with the discerning eye of gifted artists, and the rugged physicality of men destined for the fields. Unknown to their admirers, they were under tremendous financial pressure. Only one of their three surviving sisters, Johanna, would ever marry.

But the Ringstrasse offered opportunity. The Klimts studied ancient vases at the Imperial Museum in search of the Etruscan figures and Egyptian motifs so fashionable for Vienna friezes. They used photographs to achieve a sharply realistic style that was far ahead of its time.

Even in rigidly hierarchical Vienna, the Klimt brothers' talent eclipsed their dubious pedigree. At one reception, a society girl cast sultry glances at Gustav, telling him she was pleasantly surprised to discover he was so young. "What seducers you are!" a sculptor friend remarked, laughing.

Ernst began to court Helene Flöge, the daughter of Hermann August Flöge, a manufacturer and exporter of meerschaum pipes.

The Flöges were as happy as the Klimts were miserable. One uncle, Friedrich Paulick, a decorative artisan for the emperor, built an enormous handmade castle on Lake Attersee in the Austrian Alps, with a labyrinth of

suites for his large extended family. The Villa Paulick was a dreamlike palace that delighted the eye. Sharp-tongued dragons lounged over the massive entryway, and a carved wooden lion reared from a banister. Woven into the ironwork were bare-breasted Valkyries, the mythic winged women who chose which slain warriors rise to Valhalla. Children were captivated by the murals of fairy tales painted above the luminous wood paneling of a small downstairs room. At this idyllic lakeside retreat, built solely for the pleasure of the extended family, the Flöges lived the contented family life denied to the hardscrabble Klimt brothers.

As Ernst courted Helene, the Künstler-Compagnie painted their most important commission, the decoration of the new Burgtheater. On the stairway, Gustav planned to re-create a conventional classical frieze of an idyllic theater of ancient Italy.

At the same time, in a related painting, Klimt was asked to portray real-life spectators of Vienna theater, sitting in their curtained boxes. He painted in cameos of progressive Viennese women he knew and admired, like Serena Pulitzer, one of the witty Pulitzer sisters from Budapest, who would someday be recalled as a relative of the American newspaperman Joseph Pulitzer. He painted cultural heroes, like the composer Johannes Brahms and the opera singer Alexander Girardi. Klimt knew that including Katharina Schratt, the emperor's mistress, was obligatory. But he omitted Vienna's notoriously anti-Semitic politician, Karl Lueger, from the painting. When the omission was noticed, Klimt reluctantly painted Lueger in. But as someone would remark to Klimt, Lueger was far outnumbered in the painting by Viennese Jews. In a city in which theater was staged drama within the great drama of life, inclusion in Klimt's painting of the Burgtheater audience was more than prestige; it was public proof of membership in Vienna society. In Klimt's painting, this society was not a collection of aristocrats, but something approaching a meritocracy.

The young members of the Künstler-Compagnie agonized over the reception of their murals. But when the new Burgtheater was unveiled in October 1888, Vienna gasped with admiration.

In a daze of astonishment and relief, Klimt accepted the emperor's prize, the Golden Service Cross with Crown. Klimt was twenty-six.

"Is it we who are stupid or them?" Klimt growled to his brother and Matsch, who had spent months worrying the mural wasn't good enough.

The Klimt brothers had painted their way out of a precarious childhood and into a warmly approving spotlight. Art was power in Vienna, and the Klimt brothers were now young gods.

———

Armed with this prestige, Ernst asked Helene Flöge's father for her hand. Ernst had tremendous liabilities: a nervous mother and erratic sisters. But he had the makings of a brilliant career—and dark good looks that quickened the pulse.

Helene was very much in love with her handsome artist. In 1890, her father gave his blessing.

It seemed the brothers had finally rescued their fragile family. But in 1892 their father fell ill. He wept on his deathbed, begging his oldest son to swear to take care of his mother and three sisters, and to "put their fate, whatever happens, into my hands and my heart," Gustav recalled. Later that year, in snowy December, Ernst died suddenly, of pericarditis, leaving a widow and a tiny daughter, Helene.

Gustav Klimt promised to look after them all. His responsibilities were not trifling. It was cruel to be poor, especially for women. For impoverished men, the army beckoned, a dangerous life as cannon fodder. The fate of desperate women was visible to all. The streets of Vienna were filled with girls who were forced to become prostitutes. They were exposed to cold, tuberculosis, and the rampant syphilis whose slow death was the fear of all Vienna. Klimt remained with his family. His brother and sisters "had to see to it that everyday annoyances were kept away from him," his sister Hermine recalled. "He came to us every evening, ate without saying much and then went to bed early."

He turned to art for solace. With the death of Ernst, Gustav lost interest in painting architectural decorations to please rich people. Art was his salvation. It was the beautiful mask of a strong but scarred soul. Soon Gustav Klimt's demons would spill from his tumultuous psyche and into his paintings.

Arranged Marriage

Adele was always different.

At the height of the season, Therese was thrilled to lead the waltz at the

opera balls, whirling around a ballroom in a purplish blue watered-silk gown, a matching corsage of lilacs pinned above her ample décolletage. Adele would be contentedly curled up on a divan, reading Goethe, or discussing the new artists' movement with its patrons at the *palais*.

Witty, poised, and intellectually precocious, Adele longed to study. It was an unlikely ambition. A handful of women had finally been allowed to matriculate at the 532-year-old University of Vienna in 1897, but only in philosophy. Young society girls like Adele were expected to pass the time with needlepoint, reading, or private instruction in language or music, as they awaited their destiny in life—marriage.

But Adele was bored out of her mind with the rounds of teas and luncheons that filled the days of society girls, who were expected to blush, abstain from strong opinions, and whisper and giggle "as if they were slightly tipsy," observed Stefan Zweig, a family friend.

Therese had brimmed with excitement at her coming out, as young ladies arrived in evening gowns, and young men in tails and collapsible top hats called *chapeaux claques*. Adele showed little interest in making a debut. She only endured the kind of fashions that had young women "laced into a wasp's shape in a corset of stiff whalebone, blown out like a huge bell from the waist down, the neck closed in up to the chin, legs shrouded to the toes" until women "could no longer move about freely," Zweig wrote.

Adele found Vienna society dull and superficial compared to the artistic world unfolding on the effervescent Ringstrasse, which was literally at her doorstep. The Bauers lived in an apartment in a subdivided *palais* owned by Hermine Wittgenstein, who had persuaded her father, Karl Wittgenstein, to finance a new building for the Secession movement of Gustav Klimt. The Wittgensteins were important patrons, hosting concerts in their mansion by Johannes Brahms, Gustav Mahler, and Pablo Casals. They rented apartments at the Ringstrasse *palais* to other patrons of the arts scene. It was a heady address.

Immigrant parents like Adele's were from less cosmopolitan Bavarian cities. Adele grew up a member of a generation that viewed immersion in art as its birthright, and as an essential prism for understanding the world. "You don't have to become an art expert, but you have to know what is genuine, what style is. You have to learn to see," Adele believed.

"You have to develop a feeling for quality," she would muse. "Once you have learned to enjoy the great works of art, the plastic arts and literature, then you will be able to evaluate people, whether they are valuable

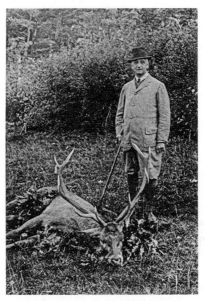

*Ferdinand Bloch, a Czech sugar magnate,
shown here ca. 1920, was captivated by the
seventeen-year-old Adele Bauer
when he was thirty-four.*

or worthless." In the rarefied world of privileged Viennese, a life in the world of art was a noble, near-religious calling, and Adele was already a convert. Her parents, however, had more conventional aspirations for their youngest.

Adele's father was an ambitious man, a modern entrepreneur who was following in the footsteps of the Rothschilds. By the time Adele came of age, Moritz Bauer's bank was the seventh largest in the empire. Bauer was president of the Orientbahn, or Oriental Railway, the Vienna component of a large-scale scheme, financed by German banks, to create a line from Berlin to Baghdad. Negotiated directly with the Turkish grand vizier and built on old caravan trails, the project was closely watched by Austria's Crown Prince Rudolf. Moritz fretted constantly that the ethnic tinderbox of the Balkans would sabotage the expensive project. But by 1888, the railroad had reached Belgrade, Sofia, and Constantinople, and was carrying the glamorous luxury cars of the Orient Express. Moritz relished his reputation as a sophisticated man who embraced technological innovation.

"Today, I tried to reach you by telephone. You were not there, and in view of your general aversion to it, I decided not to try again," Moritz would humorously chide a stodgy colleague at Deutsche Bank, a sponsor of the railway. Jewish modernizers were now rewarded: Moritz Bauer received a knighthood—the Order of the Iron Crown, an ornate golden medal with a double-headed eagle, as well as the Imperial Ottoman Order of Medschidie, and the Royal Serbian order of Takowo.

Moritz had successfully steered his eldest daughter, Therese, into marriage with Gustav Bloch, an attorney for the Orientbahn. He would have less luck with his five sons. Raphael left to become a New York banker, and Karl would die of pneumonia. Leopold would succumb to insanity— a common delicate term for syphilis—and David would die in Italy at the age of thirty-two. Eugene, a successful businessman, would succumb to tuberculosis.

It was difficult for Moritz to imagine a more brilliant match for Adele than Gustav's brother, Ferdinand, captain of an emerging sugar-beet industry that had reduced dependence on sugar imports from the Caribbean. In Vienna, where sugar was not just a condiment but a staple, this was a revolutionary shift.

The Bauers' ambitions for Adele were the product of an era when "in order to protect young girls, they were not left alone for a single moment," noted Zweig, and "a female person could have no physical desires as long as they had not been awakened by man" in the sanctity of marriage. This cloistered social world believed "one could distinguish at a distance a young girl from a woman who had already known a man, simply by the way she walked," Zweig wrote. "In Vienna in particular, the air was full of dangerous erotic infection." A young woman had to be kept "in a completely sterilized atmosphere . . . until the day when she left the altar on her husband's arm." A wealthy girl was like a jewel, to be locked away until her family found a worthy setting.

This was changing. Adele could see it happening, in the lives of the royal family, and even among her own circle. A childhood friend of hers, Alma Schindler, wanted to be a composer. Alma was the daughter of the late Austrian painter Jakob Emil Schindler and the stepdaughter of the artist Carl Moll, a friend of Gustav Klimt. Alma's family took her artistic ambitions seriously. Unmarried Alma would be allowed to enjoy the thrilling kisses of her music teacher, au courant bachelor Alexander von Zem-

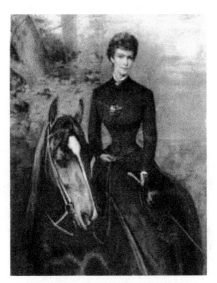

The empress Elisabeth, beloved in Austria
as "Sisi." The empress was an excellent
horsewoman who detested the Vienna court
and found life a challenging search for meaning.

linsky, whose sister Mathilde had married a promising young composer named Arnold Schoenberg. Alma would be left unchaperoned for heated assignations on the sofa of the family parlor with the brilliant conductor Gustav Mahler.

For sheltered Adele to gain this kind of autonomy, she would have to marry.

Arranged marriage was an institution in upscale Vienna. Men sought love or passionate sex with mistresses. Such extramarital liaisons carried shame and stigma for lonely wives. Yet even this was changing, and the gender shift was being led by Empress Elisabeth, the unhappy defector from the best-known arranged marriage in the empire. Everyone in Vienna knew the story of how Elisabeth had traipsed happily through the woods with her brothers, and grown into an excellent horsewoman who loved art, literature, and Gypsy music. How her ambitious mother presented her older sister to Emperor Franz Joseph in the Austrian resort town of Ischl, but he couldn't take his eyes off sixteen-year-old Elisabeth. The teenager married

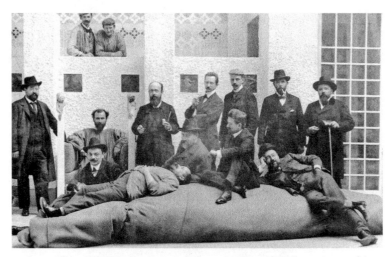

Gustav Klimt, "The King," in tunic, sittling on a throne, and his fellow artists, spoof the Vienna Establishment with a satire of the solemn photographs of important men, 1902.

the emperor with the muttonchop whiskers, and enchanted Vienna with the little diamond stars she wore in her long, dark hair.

She was pronounced the most beautiful woman in Europe.

Elisabeth was also one of the most unhappy. Locked in the gloomy Hofburg Castle with a mother-in-law who controlled access even to her children, Elisabeth spent her empty hours working out on custom-made wooden gym equipment, developing a notorious aversion to the spiteful Viennese court. She wrote wistful poetry, yearning for a life unfettered, "and when it is time for me to die, lay down at the ocean's shore."

Finally she fled the palace to wander Europe, leaving the Vienna aristocracy to speculate and gossip about her amorous adventures. Instead of being buried in scorn and scandal, this desperate royal housewife inspired popular sympathy. Ordinary Viennese adopted her as their own people's princess, affectionately referring to her by her nickname, Sisi.

Adele had just turned seventeen in September 1898, when the empress Elisabeth left a gathering at Mathilde Rothschild's manor at Lake Geneva. Elisabeth was boarding a steamship when a twenty-five-year-old Italian anarchist stabbed her in the chest. "How can you kill a woman who has never hurt anyone," the emperor kept repeating. "You do not know how much I loved this woman," he told their daughter.

Even Elisabeth's messy death failed to turn her into the predictable

warning for wayward women. Instead she was enshrined as a symbol of a lonely woman trapped in a loveless marriage.

Elisabeth could have been a cautionary tale for Adele, who still had not committed herself to Ferdinand when he attended Moritz and Jeanette's anniversary celebration in October.

The occasion required another syrupy poem. "Hand-in-hand to the altar, you stepped through life's spring," Adele read, with comic ceremoniousness. "Now you dwell amidst beloved children in a space full of bliss, like a sweet dream." Ferdinand was charmed. He didn't mind that bad poetry was a cornerstone of the cozy Bauer *Gemütlichkeit*. Ferdinand was living an honorable but dull existence. The Bauers lived in the moment, and Ferdinand yearned to marry Adele and live there with them.

The Secession

In November 1898, Gustav Klimt prepared to step into the spotlight.

Klimt and his fellow maverick artists were unveiling their palace dedicated to Art Nouveau on the Ringstrasse. It was a monastic white building crowned by a dome of golden laurels, designed by architect Joseph Maria Olbrich. All of Vienna paused to stare at this temple for those who believed art had the power to change the world. Here, Klimt and eighteen of Vienna's most talented artists would break away from the Establishment and fight for their "art of the soul."

Vienna artists were frustrated. Aesthetic tastes were dictated by a handful of upper-class patrons who had the money to buy and commission art. They preferred historic art, exemplified by Hans Makart's neo-Renaissance painting of Romeo and Juliet, that endlessly repeated medieval or ancient Greek themes, mirroring the neoclassical architecture on the Ringstrasse. Vienna artists who had defected from the official Kunstlerhaus were electrified by Vincent van Gogh and the French Impressionists. They wanted the freedom of Pablo Picasso and Henri Matisse. In Paris and Munich, the work of new artists hung alongside the old. But the staid Vienna establishment refused to display experimental work in major museums. In Klimt's view, state sponsors created a "dictatorship of exhibitions" that showed

only "weak" and "false" art, and grasped "every opportunity for attacking genuine art and genuine artists."

Even worse, the incestuous relationship between art dealers and some artists fostered a stale culture of art-for-hire that stifled innovation and had people buying "paintings that go with the furniture," as the critic Hermann Bahr complained.

The fight was on.

"Business or art, that is the question of our Secession," Bahr said. "Shall the Viennese painters be damned to remain petty businessmen, or should they attempt to become artists?" Those artists "who are of the opinion that paintings are goods, like trousers or stockings, to be manufactured according to the client's wishes," should stay in the state-sponsored Kunstlerhaus, he said. "Those who want to reveal—in painting or drawing—the secrets of their soul, are already in the society."

At the opening, the patrons walked under a credo, by Ludwig Hevesi, painted over the door: TO EVERY AGE ITS ART; TO ART ITS FREEDOM. Throughout the building, the Secessionists repeated their vow to create art that reflected their moment in history. "Let the artist show his world, the beauty that was born with him, that never was before and never will be again," Bahr urged on a script wall. Mark Twain was a surprise guest.

As the notoriety grew, Emperor Franz Joseph himself strode in with his entourage for an official appearance. Everyone turned to stare.

The city had provided the land for the building, and the imperial state would pay subsidies. The state wanted to be in on the ground floor, even if this art rebellion was aimed at them.

But the artists had the upper hand.

The emperor and his entourage had to come to them, to the debut exhibit of this Secession, to see what all the fuss was about.

Even the emperor couldn't upstage the charismatic Klimt.

"How surprised the general public was," wrote Emil Pirchan, a young designer, "when it actually saw the artist himself: an energetic, large and powerful body with a head like that of an apostle on a strong bull neck— a head reminiscent of Dürer's *Peter* . . .

"The eyes, melancholy and unworldly, gazed out from a hard, tanned face, framed by a dark, severe beard. That, and the unruly coronet of hair, sometimes gave him a faun-like appearance," Pirchan wrote, alluding to the mythic Bacchus, the wine-loving, hedonistic satyr beloved in Vienna.

The empowered artists would later commemorate their triumph with a telling photograph. Carl Moll, Alma's stepfather, lay on the floor of the

Secession great hall, on top of a rolled-up carpet. Gustav Klimt, their president, sat smugly in a thronelike chair wearing a long black artist's smock, handsome as a king. Koloman Moser sat at his feet, his eyebrows raised and mustache curled, with a picaresque, mocking smile. One artist is smoking. Two ordinary workmen in coveralls appear to be laughing. The photo was a mockery, a send-up of the self-important formal photographs of the bespectacled, graying members of the academy.

It was a provocation. The artists were thumbing their nose at the Establishment.

These artists named their Secession after the Parisian *Salon des refusés*—"exhibition of rejects"—reflecting their marginalization by pompous art officials. Now the Viennese Expressionist movement would have a home, along with the mad lucidity of the work of Vincent van Gogh and Edvard Munch, whose *Shrik,* or Scream, would express the anxiety of his age. "If you cannot please all through your art, please a few," Klimt wrote. "To please many is immoral."

Official guardians of propriety did not surrender so easily. In his poster announcing the opening of the Secession, Klimt portrayed Theseus, the warrior, in the nude, slaying the mythic Minotaur, a monster with a man's body and bull's head. Theseus represented the innovator, vanquishing the stale Old Guard of the official art world. But when the poster was printed, a Vienna official insisted Theseus's genitals be covered. Klimt was furious. Censorship already? Ridiculous! There was already a painting of Theseus by Antonio Canova on prominent display, genitals and all, at the staid Kunsthistorisches Museum.

The prudishness seemed absurd in a Vienna in which sexual tensions seemed everywhere, from the notorious affairs of the Habsburgs to the army of prostitutes walking the cobblestones of the Graben. At a time when Freud was exploring repressed sexual urges embedded in the psyche, Klimt was embarking on his own exploration, with erotic drawings of his models, sexually aroused, or even pleasuring themselves. What did women want? Klimt seemed to know.

As Freud penned his *Interpretation of Dreams,* Klimt was launched on his own psychic interior voyage that would imbue his canvases with desire, childbirth, aging, and death. Both men were finding support among a small coterie of forward-minded Viennese, many of them Jewish.

For Klimt and his confederates, the Secession was more than a place for new artists. It represented a break with an outmoded past, and the creation of a more honest way of experiencing life. It meant opening minds and

society. As Klimt made drawings of a nude young woman for his painting of *Nuda Veritas,* or Naked Truth—a visual manifesto of the Secession—he idly wrote on one sketch: "Truth is fire, and to tell the truth means to glow and burn."

Klimt the Seducer

By the summer of 1899, Adele was betrothed to Ferdinand. Among those not impressed by Adele's "hideous fiancé" was her friend Alma Schindler. Like Adele, Alma was still in her teens, and in no mood to be generous.

Alma was struggling with the desire aroused by the kisses and caresses of Gustav Klimt. She had been fantasizing about Klimt for months that spring when her mother mentioned that the sultry genius would be joining the family on a trip to Italy. Her mother pointedly warned that Klimt had "at least three affairs running simultaneously" and was not to be viewed as a prospective suitor.

But when Klimt dined with her family on his first night in Italy, "we devoured each other with our glances," Alma wrote in her diary. Alone with Klimt in a covered horse-drawn carriage on a rainy afternoon in Florence, Alma let Klimt caress her under a blanket, and couldn't sleep that night for "sheer physical excitement." At their hotel, Klimt ran his hands through her waist-length hair, abruptly stopping because "he would have lost control of himself and done something foolish." At the Bridge of Sighs in Venice, "my heart missed a beat. He wanted to feel my breasts!"

Klimt slipped into Alma's hotel room in Genoa, "and before I realized it, he'd taken me in his arms and kissed me." It was "indescribable." In Verona, Alma volunteered to take Klimt's ironed shirts to his room, and they kissed until "we were both terribly agitated." Later, on a stairway, "he stood behind me and said: 'There's only one thing for it: complete physical union.'" Overwhelmed by desire, Alma "staggered and had to steady myself on the banister." Klimt insisted: Surely God wouldn't mind if they physically consummated a union inspired by love.

The heated glances became obvious. Carl Moll ordered Klimt to stop. Klimt got Alma alone for a feverish last kiss, "with such force, such frisson," that it "fulfilled a physical instinct." Now, Alma wrote, "I know what a kiss is."

Then Klimt was gone. Soon Alma was smitten with her new composition teacher, Alexander von Zemlinsky, who "pressed my right hand between his legs" and "placed his whole body between my legs *and pressed hard*" as they kissed.

But she still burned for Klimt. "I desire him with every fibre of my body," she wrote in her diary, and "even if I marry ten times, I shall always love him." She fantasized about going to Klimt's studio and "living life to the full, just once."

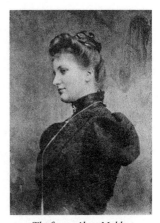

The future Alma Mahler, the daughter of Vienna painter Jakob Emil Schindler, ca. 1898. She was tempted to surrender to Klimt at the start of her famous love life with brilliant men.

As Alma pined, Klimt's personal life erupted in crisis. Klimt was entering his most creative period, and the intensity coincided with an increasingly complicated love life. When Klimt returned from Italy, he wrote a long emotional letter to one of his young models, Maria Zimmermann, known as Mizzi. Mizzi's parents lived far from the magnetic world on the Ringstrasse. Her stepfather was a stern, low-paid officer in the royal guard of Emperor Franz Joseph. Her family was poor and Catholic, with many children. Her mother had high hopes for Mizzi, who spent hours in museums and dreamed of being an artist. Her mother mistakenly saw Klimt as a conspicuously eligible bachelor. She encouraged Mizzi to stroll the leafy street in the Josefstadt district where Klimt had his studio.

Klimt opened the garden door one day and noticed the teenager with golden braids lingering under the chestnut blooms. He invited Mizzi in.

As Mizzi told her mother breathlessly, Klimt delicately arranged her heavy red-gold hair, gently turning head and shoulders with his large hands as he sketched her. Klimt told Mizzi he would like her to be in a painting of Franz Schubert playing piano by candlelight. A wealthy Klimt patron, Serena Lederer, lent Mizzi a whispery silk gown to model for the painting, and Mizzi eagerly shed her unfashionable street clothes.

Mizzi felt honored to be taken seriously by a great man. Klimt asked her to model nude for the *Naked Truth* of the Secession. Mizzi introduced Klimt to her mother, raising expectations. Klimt wangled Mizzi a role on a holiday parade float representing Vienna, and her family cheered with the crowd.

Teenager Mizzi Zimmermann, at left, 1899. She became pregnant with Klimt's son while she modeled for his painting of Schubert playing the piano.

Klimt unveiled his painting of Schubert, playing one of his sensual piano compositions. But he didn't invite Mizzi to the Dumba Palace on the Ringstrasse to join the guests admiring his rendering of her as a delicately lit, mysterious beauty by the piano, her hair a russet halo. The critic Hermann Bahr called it "the most beautiful painting that was ever painted by an Austrian," saying that "this tranquility, this placidness, this radiance on the civic modesty—this is our Austrian character."

But Mizzi was desperate. Mizzi was pregnant. "Is it possible that your dear good mother doesn't have a clue?" Klimt wrote, when he returned from his steamy encounter with Alma.

I'm falling apart from within, in a chaos of contradictions. How destiny has tortured me, hunted me. I feel more guilty than you can ever imagine. How was I ever happy? How was I looking forward to Italy? How much did I hope, full of longing, to be relieved of this sadness? But it was not meant to be. Everything beautiful was destroyed by torturous thoughts! My heart wanted to burst from pain.

From the time you came, I felt you were a kind of Fate. I felt it would be better if you didn't come, but I couldn't do without you. But at the same time, the beast within the man was aroused. I held it down, and we resisted for a time. I had a holy reverence for the Virgin. You were saved. Then you came again, you came again, transformed! And the disastrous mischief began.

How deeply it cut into my heart when I was asked, at the unveiling of my last painting, this painting of misfortune, so many times: "Who is She?" Always "She," the very image of you. I should have told them, "That is a blessed and beautiful child, that I have brought misfortune and misery." And if I rake my feverish mind, from the depths of my idiotic skull, I can't change what has happened.

Dear Mizzi, maybe you can find the courage to tell [your mother] everything. Is it really so unnatural, so incomprehensible, Mizzi? Is it the most disgusting thing that can happen to two human beings? Must I wander the earth a haunted man? Bring me a bit of comfort by telling me that you forgive me. I need strength. It is imperative. I am bound to do major state commissions until the Paris World Exhibition. I have to sustain my poor and defenseless sisters.

You shall be cared for as if you were my wife. I want to shelter you from sorrow, and look after your future, as a small penitence, for the misery I have brought upon us. For that, however, I need the strength to awaken from this despair.

You are going to bring it to me when you say that you don't blame me, and your dear mother does not condemn me. I ask you for this comfort. With it, I will return to work, with redoubled strength. Will there be a reprieve? Your deeply unhappy friend, Gustav Klimt

He didn't tell Mizzi he was expecting another child in two months, with a poor Czech washerwoman named Maria Ucicka.

The odds were against Mizzi from the start. Klimt was deeply attached to his unmarried sister-in-law, Emilie Flöge, and her family. He would never give up this relationship, or the summer idylls at mountain lakes with the warm, close-knit family that his late brother Ernst had had the good fortune to marry into. They were the only real family Klimt had ever had.

Mizzi took Klimt's advice. She told her family. Her stepfather threw her out, enraged she would jeopardize her sisters' slim marriage prospects. Mizzi moved into a small hotel and begged Klimt for financial support. Marriage was not just a convention for most women in those days; it was

the arbitrator of their destiny. It could determine comfort or poverty, companionship or abject loneliness. For a girl like Mizzi, an affair with Klimt was a high-stakes endeavor.

"Love moves in rapture," Klimt espoused. But free love was easier for men to advocate.

An Innocent Abroad

Like the Bauers, many members of the Jewish elite considered themselves quintessentially Viennese. Freud donned lederhosen to stroll in the Vienna Woods with his daughter Anna. The Bauers celebrated Christmas and Easter as they did the balls of the opera season. In the eyes of Vienna wit Alfred Polgar, even the classic Viennese *feuilleton,* or short funny sketch, blended "the melancholy of the synagogue and the alcoholic mood of Grinzing," the medieval winery district in the Vienna Woods. The Viennese *Fiakerlied,* or "Coachman's Song," a favorite of the crown prince, was composed by a Hungarian Jewish immigrant. Jewish bon vivants like Budapest-born Felix Salten seemed *über Wiener,* more Viennese than the Viennese.

Yet a wall of social prejudice stubbornly defined them as Jews. One of the more unusual Vienna residents to point out the virulence of this tenacious anti-Semitism was Samuel Clemens, the American writer known by his pen name, Mark Twain.

Twain moved his family to Vienna in September 1897. He was depressed. The previous year, his family had lost their beloved daughter Susy to spinal meningitis, at twenty-four. Twain desperately needed a change of scene. He was suffering from paralyzing writer's block when he checked in to the Hotel Metropol, on the Morzinplatz overlooking the Danube Canal. He brought his God-fearing wife, Olivia, and his daughter Clara, the belle of the family.

Twain was already something of a philo-Semite. "The difference between the brain of the average Christian and that of the average Jew—certainly in Europe—is about the difference between a tadpole's and the Archbishop's," Twain wrote a few weeks after arriving in Vienna, to the Reverend Joseph Twichell, an old friend. "It's a marvelous race—by long odds the most marvelous the world has ever produced, I suppose."

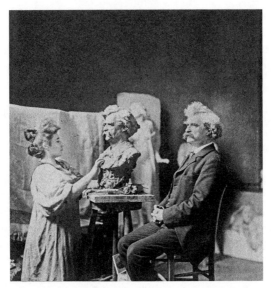

*Mark Twain, sitting for a sculpture by Theresa Federowna Ries
in Vienna. Twain had so many Jewish friends
in Adele's milieu that he was called "the Jew Mark Twain"
in the anti-Semitic press of 1897.*

The Vienna literati invited Twain to address the Concordia club in October. He found himself face-to-face with the crème de la crème of Jewish society. Nearly half the Concordia's 348 members were Jews. The audience included nearly every prominent member of Adele Bauer's Jewish milieu, from Gustav Mahler, Alma's future husband, to the handsome and picaresque Felix Salten, a journalist who was writing a sexually explicit fictional memoir of a teenage Vienna prostitute, but would someday be better known as the author of *Bambi,* the children's classic. Viktor Leon was the librettist of *The Merry Widow.* The great Vienna newspaper editor Moritz Szeps found a seat at the august all-male club; and his daughter, the pioneer female journalist Berta Zuckerkandl, likely watched from a special balcony for women. Vienna journalist Julius Bauer, a close friend of Adele's family who penned a libretto for Johann Strauss the Younger, wrote a picaresque song about Twain's exploits that was sung, opera-style, by Alexander Girardi, the star of the wildly popular Strauss opera *Die Fledermaus.*

Then Twain stood up before these Vienna wits and confided that he had always wanted to deliver a speech in German, but people "thwarted my

desire, sometimes violently. Those people have always said to me: 'Be still sir! For God's sake, be quiet! Find another way to make yourself tiresome.' "

His listeners were astonished, and delighted—Twain spoke and read what he had famously termed "the awful German language." They leaned forward to listen, as Twain threatened to reform German "so that when you need it for prayer it can be understood Up Yonder."

Among the guests laughing at Twain's send-up was the journalist Theodor Herzl, the founder of modern political Zionism and a friend of Twain. They had covered the Dreyfus affair together in Paris, in which a Jewish officer, Alfred Dreyfus, had been unfairly accused by the French of spying for the Germans—a case that was a cause célèbre of anti-Semitic scapegoating. Twain began his Vienna sojourn by openly defending Dreyfus at the salon of ardent pacifist Bertha von Suttner, who would be the first woman to win the Nobel Peace Prize. This prompted the anti-Semitic *Reichspost* newspaper to sniff at "the unavoidable Mark Twain, who seems to have no idea of how he is being mishandled by the Jews in Vienna."

Vienna would watch every move of the man the press called "Our Famous Guest." The city of 1.7 million had forty-five newspapers, a score of cultural journals, and a dozen humor magazines. Twain's appearances would be covered by Stefan Zweig.

As Twain socialized with the high society, he puzzled over the anti-Semitism of Vienna. "The Jew is not a burden upon the Charities of the State, nor of the city. When he is well enough to work, he works; when he is incapacitated his own people take care of him," Twain wrote a friend in Vienna. "His race is entitled to be called the most benevolent of all the races of men."

Twain and his family made a highly watched outing at his friend Theodor Herzl's play, *The New Ghetto,* which predicted that invisible social walls would prevent Jewish assimilation as durably as the old walled ghettos of days past.

It could even be said that Twain influenced early psychoanalysis. Sigmund Freud was a regular at lectures of "our old friend Mark Twain," though there is no evidence that they ever met. The therapist took notes that would turn up in his *Jokes and Their Relation to the Unconscious.* Freud confessed to skipping the lecture of a prince's doctor to see Twain brag about teaching six members of the imperial family watermelon-stealing techniques—an anecdote Freud used in *Civilization and Its Discontents.* Freud would quote Twain in *Jokes and Their Relation to the Unconscious, The Psychopathology of Everyday Life,* and *Interpretation of Dreams.*

Historians believe Freud was also influenced by Mark Twain's Septem-

ber 1899 *Harper's* essay, "Concerning the Jews," which Twain wrote in Vienna. Why is it, Twain asked, that "the Jews have thus ever been, and are even now, in these days of intelligence, the butt of baseless, vicious animosities? I dare say that for centuries there has been no more quiet, undisturbing, and well-behaving citizen, as a class, than that same Jew.

"Will it ever come to an end?" Twain wrote. "Will a Jew be permitted to live honestly, decently and peaceably like the rest of mankind?"

Twain delighted his new Viennese friends by becoming mixed up in open ridicule of Vienna's anti-Semitic mayor, Karl Lueger, through a mysterious mock letter, published in the *Neue Freie Presse,* and bearing the signature "Mark Twain." The letter described a heated city meeting on the "Jewifying" of judgeships—the anti-Semitic term for allowing Jews into the judiciary. The letter reported that Mayor Lueger recommended tolerance of Jewish judgeships, which made the writer so happy he jumped to his feet and waved his hat in the air, yelling, "Long live Lueger! Long live the Jews!" until someone punched him, knocking him out cold. According to the letter, he awoke at the Hotel Metropol with broken bones and missing teeth. "I won't very soon forget the session of your city council," "Twain" concluded brightly in the letter—which was edited by the newspaper's *feuilleton* editor, the Zionist Theodor Herzl, Twain's friend.

Twain protested he had been the victim of a hoax. But the letter's trademark humor suggested he had been in on the joke. Twain did in fact report on government, and he embellished his notes with satire. At one long-winded government meeting, Twain wrote in his notebook that a "tallow-chandler" had wandered in and accused Vienna's leading anti-Semites, Lueger and Schönerer, of having Jewish great-grandmothers—plunging the chamber into an uproar. "Invented a new name tonight for [Schönerer's] party: 'The Louseboy's Party,' " Twain scribbled to himself.

Twain's daughter Clara was studying piano with the young Russian Jewish composer Ossip Gabrilowitsch, whose seductive manner and kisses would so beguile Adele Bauer's friend Alma that she found herself falling in love with him, though she said a friend told her he was "ugly as a Russian Jew after a pogrom." Ossip began an attentive courtship of Clara that made it clear Twain would gain a Jewish son-in-law.

Twain and his family of "innocent wild Americans" rubbed shoulders with everyone from Johann Strauss to Emperor Franz Joseph. But anti-Semites focused their suspicions on his many social ties to Jews. Old Testament names like Samuel were customarily Jewish in Vienna, and anti-Semites began insisting "Mark Twain" was an attempt by Clemens to

disguise his Jewish roots. The anti-Semitic press began to taunt him as "the Jew Mark Twain." One cartoon showed Twain surrounded by greedy Jewish merchants caricatured as hook-nosed Shylocks.

Twain was unfazed. His depression had lifted. He was writing a play with the Vienna playwright Sigmund Schlesinger, and the two men joked about a role for Katharina Schratt. Like the rest of Vienna, Twain was quoting *Fledermaus:* "Happy he who forgets what cannot be changed."

At his desk overlooking the Danube Canal, Twain finally began to write again. His new story, "The Mysterious Stranger," was reminiscent of the Goethe Faust tale, beloved by the Viennese, of a man's deal with the devil. "It was past midnight," Twain wrote, when down on the Morzinplatz, he saw "a tall, handsome stranger, dressed in black." With a "rush of wind, a crash of thunder, and a glare of lightning," the Prince of Darkness appeared. He had "an intellectual face, and that subtle air of distinction which goes with ancient blood and high lineage." Vienna "is my favorite city," Satan told Twain. "I was its patron saint in the early times. I still have much influence here, and am greatly respected."

In less than two years, Twain had become intimately acquainted with Vienna's most virulent demon.

When Twain moved his closely watched spectacle from Austria in the fall of 1899, Adele had chosen her wedding date.

Vienna, too, was at a threshold. In November 1899, Freud published *The Interpretation of Dreams,* his anatomy of the unconscious impulses driving individuals and society. It took six weeks for the first review to appear, a snide dismissal that epitomized the isolation suffered by emerging modernists who tried to express ideas that did not conform to hostile convention.

On the brink of the twentieth century, Vienna was, in the words of one new writer, Karl Kraus, an "isolation cell in which one was allowed to scream." But this isolation of genius was ending. The salons of the emerging "second society," run by the small coterie of Jewish intellectual women, would open a forum for new ideas and art. In the process, the women who hosted them would gain influence they could never have aspired to in Vienna's hostile tradition-bound institutions.

Adele was one step closer to joining this world on December 19, 1899, when she emerged a bride from Vienna's grand Stadt Temple and stepped carefully onto the cobblestones of Seitenstettengasse.

"I Want to Get Out"

Klimt is often described as a recluse. But at the turn of the century, he was a doting intimate to the host of loyal patrons who supported his search for a new language of art. Klimt's most important private patron that year was Serena Lederer, the wife of spirits manufacturer August Lederer, who belonged to the same circle of prominent Jewish businessmen as Moritz Bauer and Ferdinand Bloch.

Serena, high-spirited, outgoing, and extroverted, had appeared in Klimt's Burgtheater painting. Klimt had painted an 1899 portrait of Serena in a flowing white dress, and stayed on to give Serena drawing lessons.

Klimt was a regular at the Lederer dinner table, and his complaints about "petit-bourgeois" narrow-mindedness were familiar to the family. "If only people would analyze less and create more," Klimt lamented.

Klimt was nervous, and rightly so. He was working on the most important, high-profile commission in the empire. He was to create a series of immense ceiling murals for the University of Vienna, to immortalize the quest for knowledge of one of the oldest universities in the Germanic world, which had opened its doors in 1365. Klimt was to illustrate the themes of Philosophy, Medicine, and Jurisprudence.

Klimt was now working on *Philosophy*, using the passages of life, from conception to death, as a visual representation of the drama of human existence. He was apprehensive about the reaction. The various officials were probably expecting a neoclassical tableau of great philosophers in Greek togas. They might not appreciate Klimt's attempts to visually grapple with mortality and a search for meaning in which God played no evident role.

At Klimt's studio, Serena's daughter Elisabeth, age six, found his work-in-progress difficult to comprehend. Klimt told her gently that he "liked it this way, and I could only understand this when I was older."

Klimt unveiled *Philosophy* at the Secession in March 1900, revealing a world in which men and women floated in frightening uncertainty. The figures were naked, realistic, with wrinkles and bony hips. A vulnerable old man with shriveled genitals bowed his head in despair. A woman clutched her breasts in anguish. A man and a woman embraced, as an almighty being in the guise of a woman surveyed a dystopian abyss of existential angst.

The painting was subtitled *Victory of Light over Darkness*. But this shapeless void didn't reassure anyone that darkness had been vanquished.

This vision of an uncertain future could not have been comforting to an imperial family shaken to the core by the suicide, in January 1889, of Crown Prince Rudolf, after apparently shooting his nubile mistress, Marie Vetsera, a month after she turned seventeen. The shocking deaths at the royal estate at Mayerling robbed the emperor of his son—and the empire of an heir to the throne.

To the correspondent of a Munich art magazine, Klimt's *Philosophy* showed mankind as "a dull, spineless mass" that "struggles in its battle for happiness and knowledge and remains a mere pawn in the hands of nature."

Once they recovered from their shock, nearly a hundred university professors protested. The university rector, Wilhelm Neumann, said Klimt's mural was too vague. Philosophy should not be "portrayed in a puzzling painting; as a puzzling sphinx," he said, "at a time when it sought to find its source in the exact sciences." The Vienna writer Karl Kraus found the mural solipsistic: "Who is really interested in how Herr Klimt imagines Philosophy?" he asked.

"He must allegorize her as the philosophical minds of the times see her," jibed Kraus, who was gaining increasing influence with his critical essays in his magazine, *Die Fackel*—The Torch—and was a member, with Felix Salten and the Vienna playwright Arthur Schnitzler, of an intellectual salon at Café Griensteidl that had earned the writers' hangout its nickname, Café Megalomania.

Philosophy "not only provoked a fierce debate in the world of journalists but among all circles that thought of themselves as intellectual," Serena's daughter Elisabeth recalled. "They gave their pros and cons, but spent most of their time with ugly irrational yelling. The government was on the same side as the howling mob." Klimt was angry. "You must not become a creature like them, like those who creep and slither around," he told Elisabeth.

Vienna officials hoped Klimt would turn in more acceptable illustrations of the second and third murals, *Medicine* and *Jurisprudence*. But "while the war of the pens was raging," Elisabeth recalled, Klimt told his friends he would paint the next two murals exactly as he had planned. "Klimt didn't think of delivering them. Klimt said he would keep his paintings 'even if I have to throw out this mob with my own hands,'" Elisabeth wrote. "Whoever saw the gestures he made, and the glowing of his eyes, which usually were so gentle, had to find him fearsome. Since, by the way,

there was probably no professional boxer at that time who would have wished to take him on."

Serena and August Lederer offered to buy the ridiculed murals, if necessary, to free Klimt from the financial obligation of the commission. The close relationship between Klimt and the house of Lederer did not go unnoticed. "Herr Klimt initiates Frau Lederer into the art of Secessionist painting," wrote Karl Kraus in November 1900. "Just as every aristocrat used to keep his Jew-in-residence, so today every stockbroker has a Secessionist in the house.

"This rapport between modern art and idle-rich Jewry, this rise in the art of design, capable of transforming ghettos into mansions, occasions the fondest of hopes," wrote Kraus, who had renounced Judaism in 1899 and now treated his readers to anti-Semitic barbs, like a derisive new expression for the work of Klimt and the Secession: "*le goût juif*"—Jewish taste.

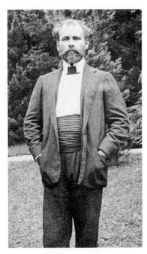

Gustav Klimt, tired of painting state commissions, shocked his state patrons with art some found pornographic.

Yet Kraus was perceptive in his observation that Jewish families were assimilating in Vienna through art and culture. Perhaps these families dreamed of leaving behind a history of ghettos, physical or social. Or perhaps their history as outsiders made them unfettered visionaries who were more willing to embrace the avant-garde. Whatever the reason, forward-minded Jewish patrons like the Lederers were now liberating Klimt, and helping him build a path to his future—as he was burning all bridges to his past.

Klimt unveiled his next Faculty mural, *Medicine,* at the Secession in March 1901. It sealed his exile. In the foreground stood an exotic Hygeia, uncoiling the golden snake of medicine. Another nude swayed supine over the crowd as naked figures, representing the infinite chain of mortality, trudged toward a grinning skeleton dressed in a robe. Death.

Officials were irate. The Ministry of Culture rejected Klimt for a professorship at the Academy of Fine Arts, and a displeased Emperor Franz Joseph was said to be behind the decision. Austria canceled plans to make Klimt works the centerpiece of a Secession pavilion at the 1904 World's Fair in St. Louis.

The modern art Klimt hoped to be remembered for was being openly

ridiculed as self-indulgent by the Establishment. "I would prefer to bypass Klimt's personality, if only because I feel sympathy for his quiet, suffering nature, and because I consider him to be deluded rather than guilty," jeered the humorist Eduard Potz.

The scorn did not abate.

In 1902, Klimt prepared to exhibit his next modernist mural, the *Beethoven Frieze,* at the Secession. A few days before the opening, Felix Salten was watching Klimt finish the fresco when a prominent count strode in and glared at the *Frieze.* "Hideous!" the count shrieked, and stormed out. To Salten, the irreverent look on Klimt's face was "marvelous."

"His eyes were shining," Salten wrote, "a flush had darkened his brown cheeks, his hair and beard were a little ruffled and untidy. His gaze followed his laconic critic as if he were ashamed of him and at the same time made fun of him."

Klimt cast a bemused glance at everyone there, and resumed his painting.

The opening of the frieze at the Secession building was a *Gesamtkunstwerk,* or "total artwork," combining music, art, and architecture—a fin de siècle Vienna equivalent of a 1960s "happening." Secessionist architect Josef Hoffmann designed the exhibition to create the "feeling of a temple for one who has become God." As guests entered, Gustav Mahler directed musicians playing the final movement of Beethoven's Ninth Symphony.

This was art as a religious conversion experience.

Guests strolled under the first panel, a painting of soulful, yearning women, *Longing for Happiness.* Next was *Hostile Powers,* a giant ape representing the menace Typhoeus, and the three Gorgons: Sickness, Insanity, and Death. A crowd of gaunt figures seemed to beg for salvation, and a knight in armor was on the way, as *Longing for Happiness Finds Repose in Poetry.* Finally, a man as muscular as Klimt himself wrapped a woman in his nude embrace: Klimt's *Kiss to the Whole World,* inspired by Schiller's *Ode to Joy.*

This was art as deliverance, leading humanity from mortal terror and uncertainty "into the ideal realm, where we find only pure happiness, pure joy, and pure love," the catalogue said.

The journalist Berta Zuckerkandl would bring the French sculptor Auguste Rodin to see the frieze on a summery day, when "slim and lovely vamps came buzzing around Klimt and Rodin, those two fiery lovers."

"I have never before experienced such an atmosphere—your tragic and magnificent Beethoven fresco; your unforgettable, temple-like exhibition,"

Rodin marveled. "What is the reason for it all? And Klimt slowly nodded his beautiful head and answered only one word: 'Austria.'"

The press was less appreciative. Klimt's friend Emil Pirchan recoiled at their slights: "orgies of the nude," "obscene art," "painted pornography," "pathological fantasies." Robert Hirschfield called it "among the most extreme examples in the realm of obscene art." To another it was "revolting and obnoxious to all conventional notions of beauty." The outraged count demanded "all possible measures to inhibit this tendency."

Klimt unveiled *Jurisprudence* in 1903. By then he was prepared for rejection. Klimt had painted an octopus whose tentacles were threatening to engulf humanity. Some Austrians took this as a criticism of the police, which were nicknamed "polyps." A battered naked man bent his head, as if he were about to receive an unjust sentence. Was this an assault on the empire itself? "Those of us who are modern will react in different ways: according to character and mood some will mock, others will be moved to pity at the sight of this man, drunk with color, reeling through our modern lives," wrote Karl Kraus. "The despicable ones are those who have curried favor with him as companions and supporters."

Now even Klimt's patrons were being attacked! Why such "hatred"? the art critic Hermann Bahr asked in his diary. Because Klimt refused to create more "kitsch"?

Bahr tried to cheer Klimt up by collecting the negative press in a little book he titled *Against Klimt.*

"One can tell Klimt is a Viennese from the fact that he is honored around the world and attacked only in Vienna," Felix Salten observed wryly.

"Forget the censorship," Klimt told Berta Zuckerkandl defiantly. "I want to liberate myself. I want to break away from all these unpleasant, ridiculous aspects that restrict my work. I want to get out. I want my freedom. I refuse all official support. I will do without everything."

Without the financial support of "princely households," Klimt faced a difficult future, his little brother Georg feared. "Gustav is following the arduous, uncomfortable path of one who is looking for his own way," Georg said. "Destiny has forced him to take up the fight of his life."

Klimt retreated to the seclusion of his studio and his walled garden. He

sported a simple Arab burnous, or long caftan, as he strolled through his leafy urban retreat, posing for mystical photographs that portrayed him as a prophet. People said that underneath his burnous he wore nothing at all.

But it hardly mattered what people said now. Klimt had made himself the bête noire of the Austrian culture establishment. He had bitten the hand that fed him. He had answered Austria's most prestigious state art commission with imagery so erotic and deviant that it would startle people even years later.

Yet his courage had endeared him to Vienna's emerging intellectual class. Klimt's livelihood now depended on his private patrons, and his patrons thought him a genius. August Lederer paid to release Klimt from his Faculty Paintings commission. He took home *Philosophy,* even though he considered it too controversial to hang in his own parlor.

Klimt had found a refuge.

At peace in his studio, Klimt explored erotic themes. He drew a couple making love, women masturbating and reveling in sexual arousal. He made a self-mocking drawing of himself as a penis, making light of his rash libido. His critics called these drawings pornography. Censors wanted to confiscate and destroy a published edition of his sketches for *Medicine.* But the Crown Prosecution Service scrutinized his drawings and concluded that they were "undoubtedly only of aesthetic interest for the viewer and the scholar" and "cannot be called improper and prohibited."

Klimt cast sensual desire as a universal life force, behind love and creativity itself. Paintings might last forever. In Klimt's work, the power of sex, though as fleeting as a pirouette, a promise, or a poem, was no less transcendent. His paintings portrayed sexual passion as an ascension to immortality as glorious as the angels rushing to the ceilings of Habsburg palaces. Klimt began to burnish his sensual paintings with the gold used in religious art to signal the divine.

Some critics would later suggest that Klimt exploited women, casting them as femme fatales, sirens, or passive dolls, but always as objects of male sexual fantasies. At the time, however, women were his biggest defenders. In an age hostile to female sexuality, Klimt's erotic drawings were a rare acknowledgment of female sexual desire. His drawings made it clear that Klimt would never be a subscriber to Freud's theory of vaginal orgasm. Klimt's erotic art added to his roguish reputation, as people gossiped about the models lounging around his studio in various states of undress.

Klimt would not become rich with his new work. He called the accumulation of wealth "a nasty thing," and said if people spent their money freely, there would be "an absolute end to all the economic misery on earth."

He needed support, and he remained in the orbit of the patrons who made his artistic freedom possible. In the summer of 1903, Klimt dropped in on the Lederers' country home in the mountain lake district known as the Salzkammergut for its ancient salt mines. He wore an elegant tuxedo with a cummerbund, telling his hosts' wealthy guests that in this getup, "a guy can hide a belly like a market woman." As the evening wore on, the adults at dinner bored him, and he wandered into the children's room. Using his hands and a sheet, he acted out shadow caricatures of the adults in the dining room, mocking their affectations and pretensions—triggering gales of laughter from Elisabeth Lederer and the other children. Serena peeked in and was amused by his satire, but worried that her guests would discover they had been the butt of Klimt's incorrigible irreverence.

Adele's "Bohemian Home"

On August 22, 1903, Adele wrote her friend and confidant Julius Bauer, the librettist of the song welcoming Mark Twain, to tell him Klimt had agreed to paint her portrait. Her teasing letter suggested Adele already knew Klimt. Adele wanted Julius to compose a poem for her parents' wedding anniversary.

Julius was notorious: a "dreaded dramatic critic, witty librettist, and jovial fighting cock," a music reviewer wrote, "whose every jest pleased Brahms, with several of his victims spared for the future." One victim was fellow writer-librettist Theodor Herzl. Julius lampooned Herzl's Zionism—the proposal of a Jewish homeland—in a poem, and Herzl was furious. He retaliated by fictionalizing Julius as a frivolous society gadfly. He told Stefan Zweig he might never have developed Zionism if he hadn't been living in Paris, away from the withering mockery of Vienna.

In Vienna café society, verbal swordplay only elevated the prominence of the combatants. Julius himself was a regular target, drawing the caustic

disdain of Karl Kraus, now Vienna's leading commentator. "As truly as an itching of the head is not an activity of the brain, I have never considered Mr. Julius Bauer a poet," Kraus wrote.

But Julius *was* the poet of the Bauer family. He wrote the "bachelor jokes" for the wedding of Adele's cousin August von Wassermann, whose research would lead to the Wassermann test for the early detection of syphilis, and composed the purple prose Adele read at celebrations.

Adele wrote Julius:

> I am sure you thought that at least in Ischl you would be left alone. But nuisance that I am, I even persecute you into your countryside idyll. Please forgive my intrusiveness. But it is a little bit your fault, too. In Vienna you allowed me to appeal to your kindness and poetic talents, and as compensation I can only offer you my wonderful voice and my talent for acting.
>
> It is not the intention of my parents to celebrate their wedding anniversary ostentatiously. But you will understand that we, the children, do not want to let this day pass without ado.
>
> I, too, am against any exaggerated festivity but on the other hand I do want to benefit from your great kindness. Originally, we children wanted to give them a joint present, but we have abandoned this idea completely. My husband has then decided to have me portrayed by Klimt who, however, is not able to start to work before winter. So my parents will have to have patience.
>
> I would be incredibly grateful to you, dear Herr Bauer, if you told me your intentions . . . Should you call upon my weak forces, I would be more than happy to be at your disposal.
>
> My husband sends you a thousand regards, and would be very happy to greet you at our bohemian home.

A portrait by Gustav Klimt was no small gift. Klimt was the painter of the moment. A Klimt commission at the time cost 4,000 crowns, a quarter of the price of a well-appointed country villa.

Commissioned portraits of women were often unctuous affairs, reflecting the wealth and stature of their men. Klimt portrayed women as individuals, without the presence of a husband, father, or children to suggest their domestic role. Yet a portrait by Klimt was acquiring an air of the risqué. As Bahr the critic observed, "It was sometimes not 'safe' for society women, and their good name, to have their portrait painted by Klimt.

They soon gained the reputation of having an affair with the master who was so infamous with his amours."

Yet Klimt had painted some Vienna maidens. His latest was the ethereal painting of Gertrud Loew, the daughter of Dr. Anton Loew, the owner of the famous Sanatorium Loew, a baptized Jew who socialized with Klimt. Gertrud had been raised Catholic. Klimt painted Gertrud in whispery whites, blue washes, and translucent flesh tones so pale they appeared to be watercolors. He softened the tilt of Gertrud's almond eyes and her thick, curly hair, which her family attributed to her mother's indiscretion with a handsome Hungarian general. Ludwig Hevesi called this picture of virginal youth "the most sweet-scented poetry the palette is able to create." When it was exhibited at the Secession in November 1903, *Neue Freie Presse* critic Franz Servaes pronounced it "the still half-closed bud of a girl's chaste soul."

If the reputation of a woman in Vienna was not entirely untouched by her sitting for a portrait with the controversial Gustav Klimt, the Jewish elite seemed less inclined to care. To Felix Salten, the quintessential Klimt subject was a "beautiful Jewish *Jourdame.*"

When Adele Bloch-Bauer finally swept downstairs from her elegantly appointed apartment to board the horse-drawn fiacre waiting to take her to Klimt's studio, her reputation was the last thing on her mind.

Adele had waited months. As she stepped out into the crisp weather in December 1903, she had the breathless anticipation of a bride. Her husband didn't care if some men didn't allow their unmarried daughters to model for Klimt, or that Klimt reputedly tried to seduce his models. He wanted his wife immortalized. Adele was a married woman now, and a commitment from Klimt was a rare prize.

As the driver flicked the reins and the horse drew forward, Adele looked eagerly onto the Schwarzenbergplatz, the home to the palace of a dynasty of Czech princes who were friends of Ferdinand. Nearby, the gilded dome of the Secession shone in the sun. When the horse drew up to Klimt's studio, Adele stepped out of the closed carriage. Her warm white breath hung in the cold air. She wore a high-necked dress and overcoat, and she pulled off her gloves as Klimt opened the door. We do not know if he greeted her formally, as a new patron, or if he was welcoming a woman he already knew, perhaps quite well. Whatever their previous acquaintance, Adele would now enter into one of the most intimate relationships Klimt was capable of. While he was working on the portrait, they would spend long periods of time completely alone together. This was not entirely

proper, even with a man with a different kind of reputation. But times were changing.

Soon Klimt was silently sketching Adele, his dark eyes caressing her form as his pencil traced the lines of her hair, her face, her lips, the curves of her body. When he looked up, his bold stare met her eyes. Adele was a sensitive young woman, being drawn by one of Vienna's most famous men. She would now be in regular contact with one of Vienna's most famous seducers, a celebrity even seasoned society women found difficult to resist.

The Adele sketched by Klimt in 1903 was a much-changed woman from the teenage bride of Ferdinand. Adele and her husband divided their time between a smart *palais* off the elegant Schwarzenbergplatz and a parklike summer castle Ferdinand bought that year in Brezany, outside Prague, where he hunted deer. They socialized with interesting men, like Prince Adolph Schwarzenberg, the composer Richard Strauss, and Czech intellectual Tomas Masaryk, who would someday be president of a republic of Czechoslovakia.

But the comfortable façade of Adele's marriage concealed a growing vulnerability. Adele's sister, Therese, had already given birth to a robust little bruiser, Karl. Adele was plagued by miscarriages. One child was stillborn. Finally, a baby boy, Fritzl, was born alive, to the relief of all. But little Fritzl lived just a few days, then weakly sighed his last breaths.

The possibility of childlessness was a crushing setback for Ferdinand and Adele. Children were the foundation of family life. For women, they were the path into the human tribe. They meant membership in a world where families gathered at country homes, surrounded by generations, and young mothers chatted while their children played. Childlessness meant a quiet, lonely apartment where the gilt clock ticked loudly while Ferdinand worked at the sugar factory. It meant being less womanly, less than a full participant in the human race—even an object of pity. Ferdinand would have to give up the dream of being a paterfamilias. He faced an empty house, the absence of heirs. It was a great loss. But he still had his work.

For a married woman, childlessness was a catastrophe, the loss of the prime anchor of personal and social identity.

So when Adele went to Klimt's studio that winter, she faced the possibility of failure as a woman. No one ever believed Adele was in love with Ferdinand. But she was expected to feel lucky, or at least content. Instead, she struggled with sobering disappointment.

At that moment, a door opened to one of the most exciting experiences any woman in Vienna could desire.

Klimt made endless sketches of Adele. They were simple pencil drawings on thin manila paper, of Adele seated, her hair piled on her head. Or Adele smiling, laughing, her movements like the frames of a film. Work on the painting went slowly under Klimt's dark, determined gaze. He would make more than a hundred studies of Adele. Only a handful of women would ever receive this much of his time and attention.

In this portrait, Adele and Klimt began the next chapter of their lives.

The Empress

Klimt had a well-known aversion to scripture. But he loved religious symbolism, and considered art the source of an almost religious truth. So that December of 1903 he made an aesthetic pilgrimage to Ravenna, an ancient Roman capital and Adriatic port, to study the sixth-century mosaics, the greatest legacies of Byzantine art outside Constantinople.

Klimt's footsteps echoed on stone floors as he walked through the octagonal San Vitale Basilica, and gazed up at the gleaming murals. The golden tiles of Byzantium had dazzled Europe. Gold symbolized the primeval power of the sun, and in the Christian world it represented the divine. Gold tile was reserved for potentates and early Christian saints.

Klimt beheld the age-old stories of Cain and Abel, of Moses and the Burning Bush, of the sacrifice of Isaac and of the Twelve Tribes of Israel. The Lamb of God was flanked by a kaleidoscope of peacocks, flowers, and fruit. Jesus Christ, in a rich purple robe, offered his martyr's crown to Saint Vitale.

As Klimt drank in the explosion of color, his eyes wandered to Empress Theodora, glowing against golden tiles that shimmered like a halo above her head. Remarkable Theodora, portrayed by disapproving sixth-century historians as a stage actress, a courtesan, an infamous woman. Whatever her common origins, one civil servant praised her as "surpassing in intelligence all men who ever lived." Theodora had already been another man's mistress when she met Justinian, the son of the emperor. Justinian defied royal opposition and married her anyway. Theodora was unable to bear him children. But she was a skillful military strategist with a canny ability to foil intrigues and plots. When Justinian became emperor in the year

527, he made Theodora an unusually powerful empress. "Neither did anything without the consent of the other," grumbled the historian Procopius, who defamed Theodora as a power-hungry concubine. Theodora began to push for laws that eroded the chattel status of women. She fought the widespread kidnapping of women into prostitution. She pushed for laws against rape, for women's rights to hold property and to inherit. Theodora was credited with helping to elevate the legal status of women to unprecedented levels. She herself became one of the most powerful women in the Byzantine Age.

The Eastern Orthodox Church made unlikely saints of this powerful couple, granting Theodora the immortality beheld by Klimt as he stood before her. These "mosaics of unbelievable splendor" were nothing short of a "revelation," Klimt wrote.

This was the image that scholars suspect was the inspiration for Klimt as he began to plot his golden portrait of Adele as a painted mosaic, and his subject as a fallen icon.

"Degenerate Women"

The ongoing portrait made Adele and Ferdinand full partners in the Secession. It put Adele in the company of some of the most remarkable women of her time: art patronesses, journalists, and intellectuals. Adele had a haven from the confines of her sheltered family life, in a milieu in which she could freely exchange ideas about such things as Freud's theories that human consciousness could be broadened by examining unconscious dreams and fantasies.

Adele was immersed in a serious program of study, reading philosophy and political texts. Every morning after Ferdinand headed to the sugar factory at the castle town of Bruck an der Leitha, Adele sat down to devour classic works of French, German, and English literature. She studied art, medicine, and science. Removed from the enforced conformity of university classrooms in which women were still unwelcome, Adele began to develop a highly individual point of view. She came to believe that insight could not be taught, but had to be discovered through a personal quest similar to Klimt's artistic "*voyage intérieur.*"

"You cannot receive knowledge or high literacy from a High School education, nor from University professors," Adele would write years later. "You have to proceed with open eyes and an iron will to become thoroughly educated.

"Only the person who places the highest demands on himself can progress one step further," she believed. "Self-satisfied individuals are incapable of development."

Adele's association with Klimt propelled this intellectual journey by making Adele a member of an elite sorority.

One of Klimt's allies was Berta Zuckerkandl, a young journalist whose salon of artists and intellectuals hosted the first conversations "by a small group of moderns" that led to the creation of the Secession. Berta considered Klimt a "great man" who lived by "the truth of his own soul."

Berta was a woman with unusual clout. She was the daughter of Moritz Szeps, the Viennese newspaper editor who had been a confidant of the ill-starred crown prince. As a teenager, Berta had traveled with her father, meeting Disraeli and future French prime minister Georges Clemenceau, whose brother Paul would marry her sister Sophie. Berta, a keen observer of political and cultural currents, was becoming known as the "Viennese Cassandra."

Berta was married to Emil Zuckerkandl, a pioneering anatomist at the University of Vienna Medical School. Emil was then arguing for the admittance of women to the school of medicine. The school dean, however, had a different view. He said that Emil, "as an anatomist, should know perfectly well that women's brains were less developed than those of men."

Berta and Emil privately rolled their eyes and snickered. But the school administrators were deadly serious.

Emil cleverly pronounced that female doctors had become a matter of imperial urgency. They were needed to treat Muslim women in the former Ottoman-ruled regions of Bosnia and Serbia.

Emperor Franz Joseph agreed.

Emil quickly called in a protégée, bright young Gertrud Bien. She passed the entrance exam, and under the reluctant gaze of the university administration, Emil escorted Fräulein Bien into anatomy class. She was ordered to sit in the last row, ask no questions, and wear men's clothing so she would blend in. Shock settled over the room, then murmurs, as the young men realized that "Herr Bien" was a Fräulein. Emil had to call security to escort hecklers from the hall.

Emil made Fräulein Bien his assistant. In a few years, young Dr. Bien was Vienna's first female pediatrician, and a member of Adele's growing circle.

Berta's salon was a magnet for Viennese who were fascinated by the latest trends in psychology, politics, and art. Visitors like Auguste Rodin dropped in, and playwright Arthur Schnitzler watched Klimt pursuing women like a "faun" there. Adele's friend Alma got to know her future husband, Gustav Mahler, at Berta's salon. Johann Strauss, a regular, had fallen to his knees and gratefully proclaimed her "the most marvelous and witty woman in Vienna."

If art was a way to liberate minds, salons gave unusual women the social support to exercise aspirations that would not have been welcomed by Vienna institutions. They offered an alternative to stuffy circles closed to Jewish women by anti-Semitism and sexism. But what gave salons gravitas was the fact that in the days before mass media, salons were indispensable to the spread of ideas.

The fashion sense of the women in Adele's circle was set by Klimt's sister-in-law and companion, Emilie Flöge, a dress designer and early Vienna career woman. Flöge's fashion house freed women from the confines of corseted Victorian dresses. She replaced them with loose, caftan-style dresses that allowed women to move comfortably, and were something of a feminine counterpart to the tunic worn by Klimt. Klimt and Flöge sometimes collaborated on the design of women's dresses, giving the clothes added cachet. For women in Adele's circle, the unfettered style of Flöge's designs was a symbol of their liberated lifestyle.

Other constraints were more difficult to elude.

Adele's friend Alma had made an enviable marriage with the composer Gustav Mahler, and had not waited for the wedding to consummate the union. But Mahler had demanded before they wed that his fiancée abandon her ambitions to be a composer. During their courtship Mahler wrote:

A husband and wife who are both composers: How do you envisage that? Such a strange relationship between rivals: Do you have any idea how ridiculous that would appear, can you imagine the loss of self-respect it would later cause us both? If, at a time when you should be attending to household duties or fetching me something I urgently needed, or if, as you wrote, you wish to relieve me of life's trivia—if at such a moment you were befallen by "inspiration": what then?

From now on you have only one vocation: to make me happy. You must give yourself up to me unconditionally, make the shaping of your future life, in all its facets, dependent on my inner needs, and wish nothing more in return than my love.

Ambitious women were policed by stigma. They were brazen, unnatural, mad, or, in Freudian terms, hysterical. Or simply irrelevant. Fellow intellectual Karl Kraus derided Berta Zuckerkandl as a "cultural chatterbox."

In more conservative circles, women whose behavior violated feminine "nature" were labeled with a fashionable new term: "degenerate." Women who pushed for higher education were "degenerate." Women who agitated for the right to vote were having a "degenerate women's emancipation fit."

A best-selling book of the era, Otto Weininger's *Sex and Character,* spelled out the social punishments for female individualism. "The sexual impulse destroys the body and mind of the woman," Weininger wrote. Women lacked the capacity "not only of the logical rules, but of the functions of making concepts and judgements," he believed; "a real woman never becomes conscious of destiny, of her own destiny." Passivity was not just a virtue for women, it was a "natural" state, and "waiting for a man is simply waiting for the moment when she can be completely passive."

"There is no female genius, and there never has been," said Weininger. Normal women, in his view, "have no desire for immortality."

In a hypocritical society hostile to women in general, and fearful of female sexuality in particular, Klimt's studio was a haven of sensuality for women whose most elemental feelings and aspirations were pathologized as "degenerate."

The "degenerate" label was soon applied to the artists and composers whom Klimt's female patrons supported. "The degenerates babble and stammer instead of talking," sneered Max Nordau, of the *Neue Freie Presse.* "They draw and paint like children who with useless hands dirty tables and walls. They make music like the yellow people in Asia. They mix together all artistic genres."

The racially loaded culture wars of turn-of-the-century Vienna were on. It was only a matter of time before "degenerate" would be aimed at Jews. Turn-of-the-century Vienna was governed by opposing forces. As artists and intellectuals pushed ahead with new ways of seeing, giving birth to Austrian modernism, the old Vienna, conservative and hidebound, pushed back. Innovation from Klimt was met with hostility. The rise of Jewish patrons was heckled by persistent anti-Semitism. In

another generation, these reactionary forces would prevail, absolutely, in a crushing triumph.

Eyes Wide Shut

Adele, too, adopted the chic flowing dresses favored by emancipated women and immersed herself in Klimt's artistic world.

Even music was dangerous now. The disturbing atonal concerts of Arnold Schoenberg moved men to fistfights. Art forced people to see differently, listen differently, and feel differently. Adele was no longer an aspirant, but a member.

For her growing library, she commissioned a bookplate, or ex libris, by a well-known Secession artist, Koloman Moser, a close friend of Klimt's. Moser drew a lithe, naked princess with long, black hair and a golden crown, holding her gown over her nude body as she emerges from a lily pond and encounters a frog croaking on a rock. The image seemed to sum up the prevailing view of Adele as the princess who had kissed the frog. Poor Ferdinand.

Klimt and Adele were now involved in a close relationship that would last the rest of their lives, much of it conducted in a hushed studio that was a haven for artistic creation and heated trysts. Neither of them left a written record of what occurred.

The indiscretions of the Vienna intelligentsia were open secrets, though in public, decorum was as rigid as the crust of Klimt's golden mosaics. The Viennese playwright Arthur Schnitzler, who knew Freud, mapped out the tensions of this social schizophrenia in an erotic thriller, *Dream Story*, where masked Viennese indulge their sexual fantasies at a costume ball. In this confusing milieu, Sigmund Freud became the confidant for the sexual anxieties of a generation of Viennese women, and Klimt's studio became a refuge for Adele and her friends.

Those who wondered whether Adele and Klimt were lovers looked for clues in his paintings.

Some art historians suggest that Klimt had met Adele years before, perhaps in the company of Alma, when she was a theatrical unmarried teen-

ager, eager to throw herself into Vienna's cultural whirl. If so, it would mean Adele met Klimt at his most amorous moment, a time he was unapologetically passionate, not for one, but for many. Alma may have told Adele of her struggle with her desire to surrender to Klimt.

One thing is strikingly clear: Klimt's first portrait of Judith bears an almost photographic resemblance to Adele. Klimt envisioned Judith as a bare-breasted sexual provocateuse, a mysterious, dark-haired Salome with a golden choker and a triumphant smile playing on her lips. She was not so much a temptress but an aroused conqueror, holding the severed head of Holofernes with the self-satisfied look of a femme fatale who has won the upper hand. Art historians were not the only ones left to sort out the waltz of intimacies. When Klimt unveiled his sexually charged *Judith* at the Secession in 1901, it was not just the heated eroticism that raised eyebrows. This Judith seemed familiar.

As Adele rose from the bed she shared with Ferdinand and sipped her

Klimt's portrait of the newly married Adele Bauer,
ca. 1907, brought them together on a regular basis
for more than three years.

coffee from their fine porcelain, she would have had to take interest in Felix Salten's suggestion that this Judith was walking among the Viennese, in the form of a smoldering society belle.

"In his Judith," Salten wrote in a review, Klimt

takes a present-day figure, a lively, vivid person the warmth of whose blood can intoxicate him, and transposes her into the magical shadows of distant centuries, so that she seems enhanced and transfigured in all her realness.

One sees this Judith dressed in a sequined robe in a studio on Vienna's Ringstrasse; she is the kind of beautiful hostess one meets everywhere, whom men's eyes follow at every premiere as she rustles by in her silk petticoats. A slim, supple, pliant female, with sultry fire in her dark glances, cruelty in the lines of her mouth, and nostrils trembling with passion. Mysterious forces seem to be slumbering within this enticing female, energies and ferocities that would be unquenchable if what is stifled by bourgeois life were ever to burst into flame. An artist strips the fashionable dress from their bodies, and takes one of them and places her before us, decked in her timeless nudity.

Salten was adding fuel to a popular Vienna guessing game: Who was the model for this achingly sensual Klimt painting? Salten seemed to hint that he knew.

Years later, some art historians would argue that Klimt's 1901 *Judith* was the young Adele.

As Klimt slowly developed her portrait, Adele was settling into a marriage in which something was clearly missing. She was possessed by the same desires as Alma. But she had failed to hold out for a grand passion. Now she found herself in the embrace of a homely man twice her age who had never been confident with women. And she was spending vast amounts of unstructured time with Klimt, whom Alma, and many other women, found arousing.

This would go on for three years.

What occurred between Adele and Klimt as he worked on the portrait is left to the imagination. Klimt revealed little of his complicated personal life in his limited correspondence, and only a few of Adele's papers have ever been recovered.

What might have happened was written by Arthur Schnitzler, a member of Adele's circle who used the thinly disguised personal lives of people he knew as the fodder for his plays. Schnitzler knew Klimt, had watched

him flirt with women at Berta's salons, and had bought two drawings from him. Schnitzler had dreams in which Klimt appeared.

Schnitzler wrote *The Comedy of Seduction,* a play about a fictionalized Klimt and a beautiful society woman whom he calls Aurelie—from the Latin word for "golden." His Klimt character implores Aurelie to allow him to paint her portrait, promising to immortalize her like the empress in the mosaics at Ravenna. Aurelie coyly resists, but she is intrigued.

At society parties, the artist dances too close to Aurelie under the gaze of her fiancé. He whispers that she must surrender to his "artistic" urgency. Only by painting remarkable women, he insists, can "I become the person I am."

"Did I ever have to beg?" the artist implores.

He talks her into posing at her elegant home, then pushes her to come to his studio, where "my house stands alone, and there are high walls around the garden," much like Klimt's isolated studio.

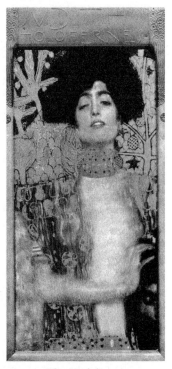

Klimt's Judith, *1901.*

She is reluctant. She has heard about models lounging there undressed. "The police will come before long and raid that nest," a matron warns. "There are women running around there the way God created them."

Another woman whispers that he paints his mistresses "just as Corregio painted Io, when the cloud descended on her. And he is always the cloud."

The artist implores: If she comes to his studio, she will live forever, like the empress in Ravenna. "Don't refuse me any longer," he pleads. "I want to paint you in the sunshine. Heaven's light over your hair, over your forehead, your throat, your neck, your hips. We'll be like an island on the ocean. Come."

Aurelie finally goes to his studio. The artist is not there. She finds her finished portrait and stands before it, stunned. Here, beneath the façade her society spent a lifetime creating, is her true face. The artist has lifted her mask to reveal who she really is.

Later that night, she sits alone at home, amazed, infuriated. Aroused.

Felix Salten, the sultry Vienna journalist who wrote about Klimt, ca. 1910. He went on to write the children's classic Bambi.

Calling her carriage, she hurries across Vienna. "To embrace him or kill him?" she asks herself. "I don't know."

A crowded costume party fills the artist's garden. Couples move through a dark, fragrant night, "alive with the lamentation and singing of violins and flutes." Aurelie wanders under the stars, through torchlight and darkness, as "all around me gliding and sliding, shouts of joy, a sinking down."

Suddenly she is face-to-face with the painter.

She sinks down, "smothered in flowers, darkly glowing eyes above me," overwhelmed by desire. "Did it last for minutes or hours? Was it a dream or was I awake?"

"And then I experienced it—all of a sudden I was not myself anymore. I was the picture he painted. I felt myself, in the limbs I'd surrendered, my quivering breasts . . . all as I'd seen them in the painting—and knew then: this painting did not lie; this painting expressed a truth of which I'd had no idea . . ."

The artist had descended on her like a cloud. Her passion was not a source of shame, but a transformative moment. The painting was the catalyst for her sexual awakening.

Whatever occurred between Klimt and Adele, Schnitzler's play captured the sexual fantasy the Vienna elite had of Klimt in his prime.

Did Klimt unmask his subjects, in the same way Freud sought to lift the veil on the human psyche? Did Klimt celebrate his female subjects, allowing them complex emotions and sexuality, or did he exploit women? Given all that we know, probably both.

Years later, Dallas psychiatrist and art historian Salomon Grimberg, determined to unravel this mystery, would unearth an erotic Klimt drawing of a woman that was indistinguishable from his sketches of Adele. Except this woman was nude and aroused. Did Adele strike this pose? Or did Klimt fantasize about it?

Whatever occurred between Adele and Klimt as he painted her portrait, his own family would assume he tried to seduce her.

The Outsider

Lurking at the fringes of Adele's world was a penniless, shabbily dressed young man from the provinces who came to Vienna with dreams of becoming an artist. This man's troubled parents, like Klimt's, had been unable to meet his basic emotional needs, much less provide entrée into the cultural milieu he longed to join. He was shy, unconfident, awkward with women.

His name, Adolf, was from an old German name meaning "noble wolf." His surname was chosen by his father, Alois Schicklgruber, who was born out of wedlock and as an adult adopted a variation of the name of the man his mother had later married, Hiedler, spelling it "Hitler."

Hitler was Austrian, though the world forgets this. He grew up near the German border, in the stronghold of Austria's ferocious promoter of anti-Semitism, the politician Georg von Schönerer; a region where the German nationalist salutation "Heil!" was already popular.

In Linz, Hitler studied at the same school as Ludwig Wittgenstein, the son of the Secession patron. Though they were the same age, Wittgenstein was two grades ahead. Wittgenstein became one of the century's most influential philosophers, mapping the way in which "the limits of my language mean the limits of my world"—the manner in which language shapes thoughts and perceptions.

Young Adolf had a different destiny. He got poor grades and was asked to leave school, at seventeen, in 1906. He headed to Vienna, to study art at the Court Museum. But he found himself irresistibly drawn to the Ringstrasse. "For hours and hours I could stand in wonderment before the Opera and the Parliament. The whole Ringstrasse had a magic effect upon me, as if it were a scene from *The Thousand-and-One Nights*," he recalled.

Hitler moved to Vienna in 1907, renting a tiny bedroom in a crowded district. His room was a few doors from the *Alldeutsches Tagblatt*, or Pan-German Daily, which endorsed the anti-Semitic Schönerer and advocated Anschluss, the linking of Austria and Germany into a single German Reich. In September, Hitler walked to the Academy of Fine Arts to take the admissions test, expecting it to be "child's play." But he failed the drawing exam. "I was so convinced of my success that when the news that I had failed to pass was brought to me it struck me like a bolt from the skies," Hitler remembered.

Crushed, he walked out of the majestic academy on the Schillerplatz, "for the first time in my young life at odds with myself," Hitler recalled. "My dream of following an artistic calling seemed beyond the limits of possibility." Some would blame Hitler's rejection by Jewish professors for his subsequent anti-Semitism. But none of Hitler's jurors were Jewish.

In fact, Hitler was the beneficiary of kindness from Jewish Viennese. As he became an increasingly down-and-out artist, he moved into a six-story men's shelter in a crowded workers' district on the outskirts of Vienna, a hostel financed with large donations from Baron Nathaniel Rothschild and the Gutmanns.

The Jewish owner of a frame and window store, Samuel Morgenstern, became the buyer of Hitler's drawings and watercolors. Morgenstern, a kind, entirely self-made man, felt sorry for Hitler and managed to interest his customers in Hitler's mediocre architectural scenes: the Auersperg Palace, the Parliament, the Burgtheater.

Rejection from the academy was hardly fatal. Another man excluded in 1907 would become its director years later. But Hitler was immersed in a Vienna that offered him a scapegoat for his woes. He initially disapproved of the anti-Semitic rhetoric of Karl Lueger. But he soon became fascinated by "beautiful Karl," a fiery, charismatic orator who was able to focus popular discontent on the liberal Jewish intelligentsia. Lueger railed against the "press Jews," the "ink Jews," the "money and stock market Jews." He promised to liberate the Viennese from the "shameful shackles of servitude to the Jews," once suggesting that Viennese Jews be marched onto a boat and sunk on the high seas. Soon Hitler would confess "open admiration" for Lueger, "the greatest German mayor of all time."

Living at the fringes of society, Hitler began to transform his frustrations into resentment against Jews who enjoyed privileges denied to him. "Jewish youth is represented everywhere in the educational institutions . . . while there were hardly any Aryan youth," he would write in *Mein Kampf* (My Struggle), the best seller he wrote from prison after his failed uprising in 1923.

Like Klimt, Hitler saw salvation and dignity in art. He was dazzled by the 1907 production of the Richard Strauss opera *Salome.* But perhaps reacting to the chaos of his childhood, Hitler sought an orderly, tidy art. He avoided the bright colors that arouse emotions. He shied away from portraying people, creating instead tourist scenes that were linear and unimaginative, devoid of innovation or originality.

Hitler was an admirer of Makart. He blamed Jewish tastes for promot-

ing Vienna modernism, which he would dismiss as "nothing but crippled daubing." Anything "wholesome was called kitsch by the filthy Jews," he complained.

But some modernists were embraced by critics and patrons. As Salieri once asked of Mozart, how could God love them more?

For this, Hitler blamed the Jewish press. At a time when Felix Salten and Berta Zuckerkandl were prominent arts writers, Hitler disdained the "art reviews in which one Jew scribbled about another."

"This race simply has a tendency toward ridiculing everything that is beautiful, and it frequently does so by way of masterful satire," Hitler wrote. "Behind that there is more: there is a tendency toward undermining and toward ridiculing authority."

He began to loathe Eastern Jews in their black caftans, and the "odour of those people" which "often used to make me feel ill." He began to see Vienna Jews as "germ-carriers" of a "moral pestilence" that was "worse than the Black Plague." Hitler asked, "Was there any shady undertaking, any form of foulness, especially in cultural life, in which at least one Jew did participate? On putting the probing knife carefully to that kind of abscess one immediately discovered, like a maggot in a putrescent body, a little Jew."

At his hostel, Hitler regaled other penniless men with his belief in the creation of a single country with a united Germanic nationality. He derided Vienna's "linguistic Babel" and longed for "the hour of freedom for my German-Austrian people. Only in this way could the Anschluss with the old mother country be restored."

Years later, Hitler would recall how his Vienna ordeal had "turned into the greatest blessing for the German nation." Being "deprived of the right to belong to his cherished fatherland" would give Hitler the impetus to bring Austrians together with "their mother country."

When Hitler left Vienna in 1913, his obsession with German hegemony was inseparable from his belief in a "Germanic" art reflecting the *völkisch* values of his fatherland.

If Adele had passed Hitler on the street in Vienna in those days, carrying his paints and pastels, she would have seen only an unfortunate young man, lacking in confidence. She probably would have felt sorry for him.

The Painted Mosaic

Klimt unveiled his first portrait of Adele in Vienna in June 1908. It made Adele, at twenty-six, an instant celebrity. The *Wiener Allgemeine Zeitung* described the portrait as "an idol in a golden shrine." Another critic complained it was "more Blech than Bloch"—*Blech* is the German word for "brass."

Everyone had something to say about it.

Adele had arrived.

Adele's portrait hung at the Kunstschau, a downtown garden exhibition space designed by Vienna artists and architects led by painters, like Klimt, who were now moving beyond the Secession. The Kunstschau galleries were installed in a strolling park, with courtyards and a café, and Adele and Ferdinand could wander in with friends and contemplate the portrait. Architect Josef Hoffmann himself had made the simple golden frame, heightening the gravity of the painting.

The visceral impact was complex. Adele's lips were red and full. Her eyes stared out from a light-filled gold leaf that seemed to create a transcendent plane of its own. Adele's pale face floated against this mosaic like that of a silent film siren. "The expression 'vamp' had not yet enriched our vocabularies, but it was Klimt who first invented or discovered the ideal Garbo or Dietrich, long before Hollywood," Adele's friend Berta Zuckerkandl noted.

Like the *Mona Lisa*, this painting seemed to embody femininity. But it was a restless, sensual femininity, devoid of matronly resignation.

Perhaps it was Klimt's mischievous nature that made him imagine dressing Adele in a heavy bejeweled choker, as he did with his provocative Judith. Adele's hand was bent, hiding a crooked finger that seemed a touching mortal imperfection when set against so much grandeur.

The painting seemed alive with meaning. The Egyptian eyes of Horus floated on a tapestry with stylized vulvular symbols. Ludwig Hevesi thought it had "a rapturous feeling of the most majestic colorfulness. Colorful, sensual pleasure, a dream of bejeweled lust" that gave viewers the feeling "of being able to rummage through gems." It was "a bodiless, pure feast for the eyes, conjuring up, once again, the soul which lived in the physical art of former times of magnificence."

Klimt embedded Adele in a luminous field of real gold leaf, giving her the appearance of a religious icon, which art historians would compare to the mosaic portrait of Empress Theodora in Ravenna.

Hevesi coined an expression for this new style: Klimt's "painted mosaic."

The Kunstschau show was the first major exhibition of new Klimt works since he walked away from the state art world in disgust. The show also exhibited his portraits of Margarethe Stonborough-Wittgenstein, the intellectual daughter of the Secession patron and sister of Ludwig, the future famous philosopher, and Frieda Riedler, another progressive Viennese woman.

Klimt had ennobled these women from Vienna's "second society," elevating this emerging meritocracy to an aesthetic aristocracy. "They have a great longing to rise above the ordinary, everyday world, like princesses and madonnas, in a beauty that can never be ravaged and devastated by the

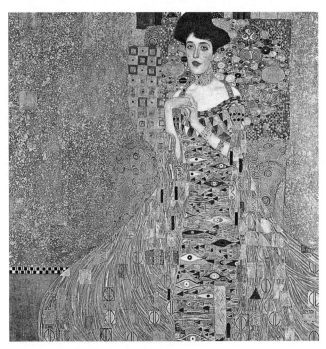

Klimt's Adele Bloch-Bauer I.

clutching hands of life," wrote Joseph A. Lux, a critic. With Klimt, these women found "the nobility which they are longing for."

The fact that these woman were of Jewish ancestry was not lost on critics. "Whether her name is Hygieia or Judith, Madame X or Madame Y, all of his figures have the pallor of the professionally misunderstood woman," sniped Karl Kraus, adding that the models also shared the same dark rings under their eyes, or *Schottenringe*—a play on words alluding to the Klimt models who were from wealthy Jewish families that lived near Vienna's Schottenring.

But some Viennese coined an expression to describe the exotic, dark-haired allure of Klimt's models: "*la belle Juive*," or "Jewish beauty." They too were promoting a stereotype, but this time it was appreciative.

With the gold portrait, Adele was frozen as a symbol of the enlightened turn-of-the-century Viennese woman, imbued with the opulence Klimt disdained and thrived on. The Habsburgs would borrow Adele's gold portrait for exhibitions, to present the regal face of an empire that was modern, sophisticated, and decidedly urbane. "The new Viennese woman—a very

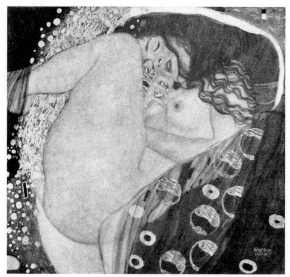

Danae, *painted 1907–8, at the same time as Adele's portrait.*

specific type of new Viennese woman, whose ancestors are Judith and Salome—was discovered or invented by Klimt," a reviewer would write. "She is delightfully dissolute, attractively sinful, deliciously perverse."

As Klimt rubbed gold leaf on Adele's portrait in 1907, he was finishing his painting of long-limbed Danae, the mythic symbol of divine love. Locked in a tower of bronze by her father, the King of Argos, Danae is receiving a celestial visitation from Zeus. There is a look of rapture on Danae's face as his immortal gold falls between her thighs, conceiving the son, Perseus, who will slay the Medusa.

As was done in religious art, Klimt used gold to convey the reach for the divine. The next gold painting Klimt would show at the Kunstschau was *The Kiss;* a delicate woman wrapped in the bear hug of a naked man, in a field of gold that shimmered with transcendence. Years later, scholars would remark upon Adele's resemblance to the woman in *The Kiss,* and how Adele's crooked finger matched the hand of the woman who kneeled before Klimt's mortal embrace.

Klimt's Women

By 1909, Klimt was at a crossroads.

Pablo Picasso and Cubism were creating a new way to see. Vassily Kandinsky was mapping abstract modernism. Claude Monet was pushing the limits of artistic expression with his water lilies, without even leaving his garden.

Klimt had failed to win recognition for his experimental work in Vienna. He was back to decorative work, finishing a commission of a golden tree of life, for a Brussels villa designed by Josef Hoffmann for Belgian engineer Adolph Stoclet.

He had not triumphed, like Picasso, over his detractors. He sometimes worried he was becoming passé. "The young no longer understand me. I don't even know whether they appreciate my work anymore," Klimt told Berta Zuckerkandl.

"It happens to every artist," he mused. "The young will always want to take everything that's already there by storm, and pull it down."

Klimt was encouraging a younger friend, Oskar Kokoschka, who would soon unleash his own wild Expressionism on *Bride of the Wind,* a painting of himself in passionate embrace with a widowed Alma Mahler. When a seventeen-year-old Egon Schiele unfurled his drawings and asked if he had talent, Klimt looked at his angular nudes and replied: "Much too much." Soon Schiele sat at the Café Tivoli with Klimt, a vital young prince to the aging king.

The exuberance that fueled his gold paintings was weakening. Klimt had always had a terrible fear of syphilis, and now the aging Pan was suffering signs of its dreaded advance. Klimt's letters complained of the skin eruptions that mark the advanced stages of the illness. "Results good. Boil seems to be closing," he wrote Emilie Flöge.

Klimt took healing trips to Lake Attersee with his beloved sister-in-law, Emilie Flöge. There he spent hours gazing, his paintbrush in hand, at the small villages that spilled down the mountains on the shores of the Attersee. He painted Schloss Kammer, a castle near the Villa Paulick. He painted the Persian carpet of wildflowers on the mountains. Flöge had become his home in this world. He had painted her portrait, but it failed to capture her confidence and enigmatic smile, and she was frank: she didn't like it. This was a partnership of equals; Klimt finally settled into something approaching emotional intimacy.

In this physical and moral retreat, Klimt was painting the portraits of women that people would be forced to remember—the women who had kept his career alive. The fact that he was deeply enmeshed in his patrons' emotional lives lent psychological depth to his portraits.

Serena Lederer's niece Ria Munk had shot herself in the chest in 1911 over a failed love affair with a promising young writer. Her mother, Aranka, pleaded with Klimt to paint Ria posthumously.

Klimt was also working on a second commissioned portrait of Adele, and visiting the Czech castle she shared with Ferdinand at Brezany. "Beautiful," Klimt wrote Flöge after arriving at Brezany on September 27, 1911. "A very beautiful existence. I am for the time being the only guest of this couple," though more were to arrive for quail hunting. "A mixture of rain and sun," Klimt wrote the next day. "The hunt may be spoiled by the rain. I'm doing fine." Adele may have known of Klimt's illness. In February 1912, after a visit to a spa at Semmering, Klimt wrote from Brezany that "Mrs. Bloch tells me that I look very good, that this trip did me good. She thought I went to Attersee." In mid-November, Klimt "arrived well" at Brezany. "The whole way it was already like winter. I ate the swill in the train dining car. But the exhaustion is quite strong."

In 1912 Klimt unveiled his second portrait of Adele. It was a very different work. Her expression was mature, direct, and anything but seductive. This was an older Adele, with world-weary eyes and cigarette-stained teeth, a painting some would call evidence of the end of the affair. This Adele was no Salome. She was beyond flirtation and the mundane. Here was a serious Adele, one who had left behind her golden youth and grown into a formidable woman who demanded respect. In this painting, Klimt's admiration had deepened into empathy. This Adele mirrored his preoccupation with mortality.

Klimt in a photograph that stood on the night table of Adele's bedroom, 1912.

As the years passed, Klimt was more inscrutable than ever, outside of his supportive coterie of loyal patrons. He began to acquire "an almost pathological sensitivity of avoiding the public," a newspaper article contended. "I am less interested in myself as a subject for a picture than in other people, above all women," Klimt stated cryptically. "I am convinced that I am not particularly interesting as a person. I am a painter who paints day after day from morning until night. Whoever wants to know something about me—as an artist, the only important thing—ought to look carefully at my pictures and try to see in them what I am and what I want."

The Empire was shrouded in uncertainty, as if the dark prophecies of Klimt's murals were coming to life. In June 1914, Archduke Franz Ferdinand left his Vienna residence at the Belvedere Palace for a trip to imperial Sarajevo, where an anarchist stepped out of the crowd and shot him, precipitating the outbreak of World War I. The ethnic tensions that Adele's father feared would sabotage his railroad line through the Balkans were breaking apart the empire's cosmopolitan mosaic.

Klimt often seemed depressed. "Little pleasure for work," he wrote Emilie Flöge that year. "I get up without much joy." Later, he confided, "I didn't want to write on the first day—I was too down. Worn down, washed out, crushed."

Klimt spent the first two years of the Great War painting Serena Lederer's daughter Elisabeth. The Lederers had remained loyal. August bought

Klimt's *Beethoven Frieze* from a collector in 1915. There was no better Klimt collection in Vienna.

Little Elisabeth had grown into a high-minded young beauty. Klimt captured her doe-eyed vulnerability, flanking her with protective Chinese warriors. He found it impossible to finish. "I'll paint my girl as I like!" he would bark, cursing floridly. Finally, Serena drove to his studio and impatiently loaded the portrait into her car. When Klimt saw the painting on their wall, he shook his head. "It's still not her," he said.

Klimt spent the last two years of the war painting his third portrait of Ria Munk. This time he resurrected the ill-starred teenage lover in a resplendent dress, surrounded by flowers. Klimt was having difficulty— "slaving away with the dead girl"—and sometimes he felt that "I just can't do it." But Aranka found solace in his artistic re-creation of her daughter. Klimt was feeling the strain. "Work proceeding slowly, like the War, but it has to go on," Klimt wrote Emilie in 1916. "It all sounds so sad."

By August 1917, Klimt was feeling "artistically super rotten." His latest independent painting, *The Bride,* was "really getting on my nerves." A newspaper detected "weariness and suffering on the high, furrowed brow of the aging master." His health was in free fall. Klimt was vacationing with the Primavesi family when a boil suddenly opened on his skin, so he headed to Bad Gastein for a spa treatment. By 1917, he was struggling to complete his portrait of Berta Zuckerkandl's sister-in-law, Amalie, in a ballroom gown that left her delicate white shoulders bare.

At some point, Alma Mahler noted in her diary that when she had longed for Klimt, "I did not know that he was syphilitic."

Perhaps Alma resented never being immortalized by Klimt. Or perhaps she was indulging her habitual anti-Semitism when in December 1917 she asked a salon of wealthy women, "Why is Klimt, the poor, radiant, great artist, only permitted to paint parvenues, and nobody well-bred and beautiful?

"Take advantage of the time this genius is among us," she urged them.

Around that time, Klimt picked up his sketchbook and jotted down the name of one of his "parvenues": "A. Bauer." Adele Bauer. It was a final clue to Klimt's mysterious tie to the woman he had painted into history.

A few weeks later, in the wintry dregs of World War I, Klimt had a stroke. He was rushed to the Sanatorium Loew. When he stabilized, he was transferred to the Vienna hospital. There Spanish influenza swept through his ward. Klimt was quickly overcome. Gustav Klimt died on February 6, 1918. He was fifty-five. His last words were "Send for Emilie." His life partner, Emilie Flöge.

Egon Schiele sat at his bedside and silently made three sketches of the lifeless Klimt. The Austrian Artists' Society announced, "Art has lost something enormous; mankind, much more."

"He died of syphilis," Alma Mahler wrote in her diary.

Adele recorded Klimt's death with a cross in the black leather-bound agenda she used to track the final days of the empire, tracing the march of Austrian troops across Europe, each battle won and lost, each ship sunk—the unraveling of her world—like the jottings of a war correspondent in the battlefield. Among Adele's handful of personal notations was Klimt's birthday, and the day and time of his funeral, on a page with a printed quote by William Shakespeare: "To thine own self be true, and it must follow, as the night the day, Thou canst not then be false to any man."

All of progressive Vienna crowded into the Hietzing Cemetery, near Schönbrunn Castle, to pay their respects to Klimt. Josef Hoffmann designed Klimt's simple tomb. Arnold Schoenberg, whose music had caused fistfights, walked in the crowd with Berta Zuckerkandl. Serena and August Lederer came with Elisabeth. "I was paralyzed, and only the singing of the choir of a Beethoven piece during his funeral unleashed the tears and all the pain, the first tremendous one I had lived," Elisabeth Lederer wrote.

Klimt had come into the world at the dawn of the Austro-Hungarian Empire. By the time of his death, the turn-of-the-century rebel had visually defined an empire that was now in its twilight.

"He has entered into the centre of the earth in the Orient, this man with the high forehead of Rodin's Man with Broken Nose and the mysterious features of Pan under the beard and hair of the ageing Saint Peter," wrote artist Albert Paris Gütersloh.

In the final days of World War I, Vienna's shimmering era of brilliance was drawing to a close. By fall, the empire of 60 million people was defeated, and reduced to an Austrian backwater of 6 million. The Habsburgs and their titles were royal no more. Spanish flu claimed Schiele, his pregnant wife, and millions of others.

Klimt and his golden moment were gone.

"Hugs from Your Buddha"

Klimt's muse lived on. Still beautiful, Adele wore the formless dresses of the Wiener Werkstatte, an alliance of innovative designers and artists, and chain-smoked cigarettes from a long gold holder. Adele had grown into a serious woman. She told people she was a socialist.

Adele had moved with Ferdinand in 1920 to a decidedly nonproletarian *palais* at Elisabethstrasse 18. The four-story town house was a rarefied address. Katharina Schratt had once lived there. Karl Kraus had lived in a building next door, where Ferdinand rented offices.

Adele's friend Alma Mahler lived a few doors down. Gustav Mahler had died in 1911. Alma had divorced her latest husband, Walter Gropius, the founder of the Bauhaus, and was living with a Czech-born writer, Franz Werfel, near the offices of an obscure group of men who called themselves National Socialists.

Adele proclaimed herself an atheist. She contemplated alternative spirituality, signing a letter "Hugs from your Buddha."

Richard Strauss frequently came to dine, though Alma dismissed him as "a speculator, an exploiter of opera, a materialist par excellence."

Adele's family now used the kind of hyphenated surname, Bloch-Bauer, that was most common among the Viennese aristocracy, though it was ostensibly designed to carry on the family name after the death of Adele's brothers.

Adele considered herself equal to her remarkable friends. "If fate has given me friends who may be counted on intellectually and ethically as extraordinary, then I owe these friendships to one of my main qualities: the strongest self-criticism," Adele would write. "I have always been, and still am, my strictest judge. Through the years I have become better and more mature, and have earned the right for myself to exercise criticism and place the highest demands on my friends."

Adele still saw her immortality in art. She was working with the new director of the Belvedere museum, Franz Martin Haberditzl, to make the family's Klimt collection their legacy. "I think that in memory of my dear friend Klimt, I owe it to him to make a work by his hands accessible to the public," she wrote Haberditzl. *My dear friend Klimt.*

Haberditzl was a visionary. Confined to a wheelchair by what was diagnosed as rheumatoid arthritis but some historians suspect was multiple

sclerosis, he was leading an ambitious plan to make the Belvedere a showcase of new Austrian art. Haberditzl embraced the avant-garde. He was among the first important believers in Egon Schiele, buying his drawings and a portrait of Schiele's wife, Edith. The grateful Schiele called Haberditzl his "soul mate," and painted a thoughtful portrait of his warm, kindhearted patron. Haberditzl was recruiting the patrons who had helped to create the Secession to assist him in transforming the Austrian Gallery into a showcase for the art they had nurtured. He would bring to the Belvedere more than five hundred new works by 250 new artists. Aided by patrons like Adele and Ferdinand, Haberditzl would pull these artists into the august Vienna institutions that had once shunned them. Ferdinand helped pay for the acquisi-

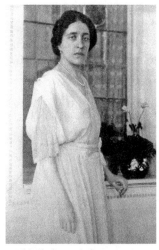

Adele, by her early forties, ca. 1920, was a socialist, an atheist, and a proponent of women's rights.

tion of one of Klimt's scandalous Faculty Paintings, *Medicine,* from Koloman Moser's widow, Ditha, along with an old Klimt admirer, Sonja Knips. Klimt was gone. But the patrons he left behind still believed art had the power to open minds and change the world.

The transformation of the Belvedere was formidable. Like many venerable Viennese institutions, the Belvedere had a complicated past, even by the standards of Habsburgs, who buried their entrails among the "bone rooms" in the catacombs of St. Stephen's and their hearts in the Augustinerkirche.

The Belvedere's creator, Prince Eugene of Savoy, was an aspiring soldier whose scandal-tainted mother had left him with dim career prospects in France. So in 1683 Prince Eugene headed to Vienna, where the Turks had laid siege outside the city walls, and helped rout them.

The prince spent the rest of his life erecting a fantastically ornate Baroque palace that was a monument to his life as a warrior. He had a lusty eye for the male physique. On one ceiling, Prince Eugene had himself painted as Apollo, master of the Muses, rolling around the heavens with Eros, the Greek god of desire. His palace's copper-green roof was made to resemble the tent camps of his Turkish adversaries, who left behind Vienna's most important fuel, after wine and sex: coffee. Decorative arrows and shields symbolized the booty of war. Fantastic lion-women, his sphinxes,

kept the palace secrets. He died in his sleep at the Belvedere in 1736, still a bachelor.

It was the transformation of this campy palace of war, suffused, like so much of Vienna, with the weight of history, that childless Adele wished to leave behind.

On January 19, 1923, Adele chose a piece of fine Elisabethstrasse stationery, dipped pen in ink, and wrote a short will. She asked Ferdinand to leave money to a home for poor children she sponsored, the Kinderfreunde. She left money to the Vienna Workers' Association Friends of the Children and another charity. She left her jewelry to Gustav Bloch-Bauer's daughters, Luise and Maria, and her other nieces and nephews. Her immense library of books would go to the People's and Workers' Library of Vienna. "I ask my husband after his death, to leave my two portraits and the four landscapes by Gustav Klimt to the Austrian Gallery in Vienna," Adele wrote.

Art was no longer Adele's only existential concern. Women got the vote in late 1918, and a few months after elected a solidly Social Democratic city government that promised to help Vienna's poor. Adele was immersed in the ideals of this "Red Vienna," and the battle for social justice. The socialists were determined to turn the capital into a liberal island. They were fighting for health care, decent housing, workers' rights, and secular education. The luxury taxes used to finance reform bred resentment, and church authorities preached against the atheists.

The architects of this movement gathered at Adele's house every week for a salon her family called her Red Saturday.

Adele now held court at Elisabethstrasse with Karl Renner, the former chancellor of the first republic of Austria. Renner, a Social Democrat, had spent his youth at the birth of modern socialism with Leon Trotsky, at Vienna's Café Central. Renner spoke of a revolutionary transformation of Vienna, an end to its teeming poverty. Their family friend Dr. Gertrud Bien, now a successful pediatrician, discussed the delivery of health care to the poor. Adele had never been afraid to wade into Vienna's culture wars. This time it was not for an art-loving elite, but for the populist masses. "Goethe writes in *Torquato Tasso:* A talent is formed in stillness, a character in the mainstream of the world," Adele wrote.

In her private life, Adele was a bit of a mystery. She was always tired, not feeling well, and suffering from headaches and vague ailments. No record

of a diagnosis exists. Adele refused to go to the doctor. If poor women in Vienna didn't have access to doctors, she told her family, why should she?

Adele seemed disillusioned with her marriage. By the end of World War I, arranged marriages were giving way to love matches with an expectation of sexual passion, what Freud called a union of the "tender" and the "sensual." The kind of intense union that Alma had insisted on, over and over. Her friend Alma had begun her affair with Walter Gropius before Gustav Mahler died; stormed through Kokoschka, married Gropius, then fallen in love with Franz Werfel. Alma had always attained the fascinating men who aroused her passion. Except for Klimt.

Adele often seemed merely impatient with Ferdinand, with an air of resigned disappointment. When Ferdinand presented Adele with a luxurious diamond bracelet, Adele showed little pleasure. With socialism in the air, she rarely wore it.

To her family, Adele seemed moody and self-involved. She barely looked up when Therese's eight-year-old daughter, Maria, peered silently through the velvet curtains of Adele's crowded salon. Maria was intimidated by her formidable, remote aunt Adele, with her long gold cigarette holder and her sober, unsmiling stare. Adele did not warm to children. Maria watched as Adele blossomed in the company of her distinguished, learned friends.

The Good Spirit

Ferdinand never lost the awe he had felt when he first set eyes on Adele, arrogant and self-assured, sweeping into the room in a long white dress, as slim as a vase. Ferdinand still felt privileged to be married to this proud beauty who answered her distinguished guests and their strong opinions with raised eyebrows and her own strong convictions.

Women from good families rarely smoked openly, but Adele did so unrepentantly. Ferdinand watched silently as a plume rose in a delicate spiral from Adele's cigarette holder, while she and Alma Mahler listened to the dashing young Renner discuss the latest improvements in Vienna social services with Berta Zuckerkandl.

Not all of Adele's family approved of her flirtation with socialism, and she knew it. But she was adamant about the importance of keeping an

open mind. "Beware of criticizing things and conditions that you have no idea about or are unfamiliar to you. Beware of being disrespectful! You have to be thorough in everything!" Adele admonished.

"With regards to others, you have to approach them with the greatest respect (also from within)," Adele wrote in a letter to her nephew Robert, Therese's deeply conservative youngest son.

Ferdinand was powerless to deny his wife what pleased her. He shrugged when she openly told people she did not believe in a Supreme Being. There was no point in trying to tone down her frankness. Ferdinand was a forward-minded industrialist, but he was as impeccably conventional as his porcelain collection. Without Adele, the *palais* on Elisabethstrasse would have been a silent museum.

Klimt's painting of Adele captured Ferdinand's own feelings with such clarity, it was as if Klimt knew Ferdinand's heart better than he knew it himself. As encrusted with golden mystery as a Byzantine mosaic, Klimt revealed Adele as a proud, regal empress, with her chin held high and her eyes shining with the aspirations Ferdinand saw when he first laid eyes on her. Anything was worth the treasure of that glance. Ferdinand did not possess a photograph that captured it. It had proved fleeting, like the empire, and so much else in life.

Adele's eyes gave away little now.

As Ferdinand watched his wife across the room in a silk brocade chair, tossing off bons mots his slower wit left him powerless to attempt, Adele wore her usual expression of opaque sophistication: self-possessed, subtle, inscrutable. She had grown into the very incarnation of the elegant, elusive Viennese woman he had seen in the street but never dreamed he would marry.

The childless Adele had failed as a conventional woman. She would be written out of the family tree, a dead-end branch that failed to bear fruit. Adele had not distinguished herself in world affairs, like Berta Zucker-kandl. She was not brave enough to face hostile resistance to women entering a profession, like Gertrud Bien. Unlike Alma, she wasn't courageous enough to roll the dice for love. Adele remained an unfinished woman. But like Serena Lederer and Klimt's other patrons, Adele had succeeded in being a woman of her times. She was a freethinker, a muse, a self-invented founder of the Vienna Bloch-Bauers, the handmaidens of artists, progressive thinkers, and cultural creation. In her own way, Adele had pushed history forward, as one who helped give birth to modernism in Vienna. Yet her air of self-importance suggested she longed to be more.

Perhaps Adele was most fully realized in Klimt's majestic gold portrait.

Adele set a new course now, but she did not complete the journey. At her Saturday salon, she spoke excitedly with public health pioneer Julius Tandler about the creation of a new society in the Soviet Union. Renner knew some of the Russian revolutionaries personally. Adele spoke of traveling with Renner, to witness the Soviet experiment.

This was the dream that illuminated Adele when Alma dropped by with Werfel one wintry day in February 1925. Alma and Werfel were headed to Jerusalem. Adele was excited about their trip. She pulled books off her library shelves and gave them to the couple to read on the journey. A few days later, Adele felt feverish, went to lie down, and slipped into a coma. Early the next morning Adele was dead, at the age of forty-three. Doctors debated the cause: Was it a tumor? Or "brain flu"? They settled on meningitis. Adele's maid quietly removed a packet of love letters from Renner to Adele from her nightstand.

"I'm still dazed by Adele Bloch's death, which I learned of here yesterday," Alma wrote the composer Anton von Webern from Cairo.

> In the last days of my Viennese sojourn she couldn't show me enough love! As if she had known!
>
> She gave us books, offered me hundreds of things, so that I was reminded of her during the whole trip. I have not yet used the sleeping bag for fear of spoiling it. Poor creature! She fainted and didn't wake up. Lucky, terrible death!
>
> I would prefer to leave this world in a properly organized way.
>
> Her death completely unsettled me yesterday.
>
> Today the world is brighter again.

Ferdinand was devastated. As sleet fell outside, he turned his wife's room into a shrine. He hung their Klimt paintings on the wall, and set a photograph of Klimt, cuddling a black and white kitten, on her bed table. He asked servants to ensure there were always fresh flowers in the room. He called it his Gedenkzimmer, his Room of Remembrance. Here he retreated into mute mourning, gazing at the portrait of Adele, the teenage bride he had outlived, frozen in the golden instant when Vienna rivaled Paris.

The little poetess who won Ferdinand's heart before she knew her own.

The Good Spirit of his life was now a ghost.

PART TWO

Love and Betrayal

Degenerate Art

By the summer of 1937, Ferdinand's brother, Gustav, presided over a big, happy family. When they strolled over to Elisabethstrasse to dine with Ferdinand, they visited his bedroom shrine to Adele and exchanged glances. Ferdinand still kept fresh flowers at Adele's bedside in his Room of Remembrance.

His family worried that he was lonely, but Ferdinand was too preoccupied to notice their concern. He was deeply distracted, as his chauffeur drove him to his sugar factory in a late-model limousine built by Graf & Stift, the carmaker whose elegant convertible had carried the archduke on the day of his 1914 assassination in Sarajevo.

The factory was in Bruck an der Leitha, a peaceful twelfth-century castle town near the Hungarian border. As the villages and farmland rolled by, Ferdinand brooded over the troubling political developments in Germany. He was increasingly convinced that the ugly movement led by Hitler was not just an outrage, but a serious threat.

In the years since Adele's death, Ferdinand had attained stature in Vienna. The Vienna Handbook of Culture and Economy described him as one of the last gentleman industrialists of the monarchy, "cultured and educated," who lived "not for his work, but for the nurturing of his spirit and his noble heart." By then he had served as president of the sugar industry and so many other business associations he was often addressed simply as "Herr President," or with the "von" prefix of the titled aristocracy, though there was no record of his ennoblement to a "von Bloch-Bauer."

Ferdinand was a serious patron—not just a collector of beautiful objects, but someone who cared deeply about artists and the future of art. This had led him far from his conventional tastes. After years of porcelain and Waldmüller pastorals, Ferdinand was gravitating to the modernism Adele had loved. He was sponsoring a fifty-year retrospective of Kokoschka, Austria's greatest living painter, an Expressionist who embraced political engagement with the same reckless passion that roiled his love life.

Ferdinand had been introduced to Kokoschka by Klimt's old friend Carl Moll, whose stepdaughter, Alma Mahler, had been a great love of the artist, his "Bride of the Wind," the subject of his painting of a couple entwined.

Kokoschka was a different man than his gruff mentor. Kokoschka was intellectual and articulate.

Like Klimt, he gravitated to the Jewish intelligentsia because, unlike the entrenched Viennese elite, they "welcomed anything new." He told a friend that Ferdinand reminded him of "the old Moses of Rembrandt." Their friendship deepened when Ferdinand asked Kokoschka to paint a portrait of him, wearing a hunting rifle and Alpine lederhosen.

The result, *Portrait of Ferdinand Bloch-Bauer as a Hunter,* turned out "very differently from how you imagined it," Kokoschka wrote Carl Moll. "He is sitting with his little hat, reflective, and yet curious. He is old, and not as sympathetic as my feeling for him."

Yet Ferdinand was "very happy" with the portrait, Kokoschka reported to Moll. "He found it very true to him, and he made an allusion to Rembrandt. I told him, of course, that in these times, one shouldn't speak of the Gods. Such comparisons are not allowed."

Moll told Kokoschka he would ask "our Uncle Ferdinand" to sponsor the Kokoschka retrospective. Everyone knew Ferdinand was a soft touch.

But Ferdinand probably never planned to be a hero.

The Kokoschka show opened in Vienna in early May 1937, and quickly became a place to see and be seen among the avant-garde.

The show's notoriety soared on June 30, when Joseph Goebbels, the minister of propaganda of the German Reich, gave subordinates free rein to ransack museums and "cleanse" Germany of more than five thousand artworks deemed symptomatic of the "perverse Jewish spirit" infecting German culture. Museum directors were forced to pull down these works of "degenerate art," created by the most distinguished artists of their time, from Pablo Picasso to Vincent van Gogh.

Kokoschka was one of them. He was outraged. How could these beer-hall thugs judge art? He defiantly titled one of his works *Self-Portrait of a Degenerate Artist.*

Ferdinand was disturbed by this news from Germany. Kokoschka was already threatening not to appear at the retrospective at all, as a protest against the authoritarian Austrian state, known as Austro-fascism.

One of the organizers of the show, Richard Ernst, had written a monograph on Ferdinand's porcelain collection in 1925, and he was well aware of Ferdinand's reputation for generosity. Ernst asked Ferdinand to pay to extend the show. Ferdinand agreed. He felt they couldn't appear to back down. But he wondered: Where will it end?

The attack on "degenerate art" was a manifestation of Hitler's long ob-

session with dictating artistic tastes, rooted in his youthful experience as a failed artist in Vienna. Now Hitler had the power to control art, and even artists, in the Reich.

The rest of the Bloch-Bauers did not share the depth of Ferdinand's anxiety about the rising political din in Germany. The bustling family had far less time to worry than the introspective Ferdinand. To them, the antics of Hitler were a more distant problem, an unfortunate turn of events that nevertheless would blow over, as had so much other political turmoil. Like many happy people, Ferdinand's brother, Gustav, and his wife, Therese, were deeply involved in the daily dramas of their own lives. They had lived through World War I; they had lived through the assassination of the architect of Austro-fascism, Chancellor Engelbert Dollfuss, in a failed Nazi coup in 1934. They would weather this too.

Ferdinand was not so certain.

"You Are Peace"

In early 1937, when Vienna still wavered between winter and spring, Ferdinand's unmarried young niece, Maria Bloch-Bauer, stood with guests of the family around the grand piano at their Stubenbastei apartment. A family friend, Paul Ulanowsky, was going to play for them. Ulanowsky was one of Vienna's most popular pianists.

Life in the Bloch-Bauer household revolved around music. Music quickened the pulse and stirred the heart. It lured the young Viennese out for feverish nights of tango. Music was dangerous.

Ulanowsky, the son of a Ukrainian singer for the Prague opera, was a favored accompanist for singers in Vienna. In addition to being a fine musician, Ulanowsky was sensitive and kind. As Ulanowsky sat down at the piano, a young man stepped out of the crowd and boldly asked if the pianist could play Schubert. What a ridiculous question! Maria thought impatiently. Of course Ulanowsky could play Schubert. Ulanowsky was one of the best interpreters of Schubert in Europe! Who would dare ask such an impertinent question?

Fritz Altmann stepped forward.

Adele's niece Maria Bloch-Bauer, ca. 1936, at the Opera Ball, the glamorous stage for all to see and be seen in Vienna.

Ah, Fritz. Maria had nursed a crush on Fritz for months. Fritz, a lover of music, played saxophone in a jazz band and haunted the opera. She wondered what Ulanowsky would make of his cocky audacity. But the distinguished Ulanowsky merely smiled affectionately, and introduced "the opera singer, Fritz Altmann." Ulanowsky began to languidly play the first notes of the sensual Schubert ode to love, *Du bist die Ruh*—"You Are Peace."

Fritz began to sing, slowly and ardently.

You are peace,
The gentle peace,
You are longing.
And what stills it.

Fritz turned his gaze to his audience imploringly, as if he himself were overcome with yearning.

Maria was startled. This was a stirringly romantic song, of desire and fulfillment. It hinted at the private world behind bedroom doors, inside closed carriages, on picnic blankets in hidden glens in the Vienna Woods. A world Maria had yet to enter, though she had heard plenty about it from her best friend, Christl. The breathless world of her favorite poet, Goethe. Now Fritz conjured up this unknown realm of seduction. Maria felt chills run down her spine.

I consecrate to you
With all my joy and pain,
A home
In my eyes and my heart,
Enter into me
And close softly behind you the gates of your gentle embrace . . .

As Maria listened to Fritz sing, an unnamed feeling came into focus. Fritz sang on, drawing out the last word seductively:

Drive the pain from my breast
May my heart be filled with your desire.

Perhaps Fritz noticed the effect he was having. Because now this Orpheus turned to Maria and looked her in the eyes, as if he were singing to her alone.

> *The tabernacle of my eyes is illumined by your radiance. O fill it completely!*

As Ulanowsky played the closing notes, Maria felt the kind of dizzying, weak-kneed thrill that electrified her when she rode the Ghost Train at the Prater, below the giant Ferris wheel that spun over Vienna. The Ghost Train ran through dark tunnels where unchaperoned couples stole private moments to kiss and caress.

"I'd like to go on the Ghost Train with him," Maria whispered to Christl.

Fritz stood for a moment, as Ulanowsky artfully interpreted the final stanzas, and looked boldly at Maria. Maria looked up shyly, overwhelmed by an impulse that none

Fritz Altmann, a Vienna sophisticate from a Polish immigrant family. He dreamed of being an opera singer and toyed with the affections of Maria Bloch-Bauer.

of her suitors had ever awakened. The music stopped. Fritz turned away and walked across the room to sit down with a crowd of men. One of them pulled out a silver cigarette case and offered Fritz a cigarette. Maria was crestfallen. Her poised older sister, Luise, would have walked over to Fritz and made a provocative joke. Maria was not that confident.

As Fritz said his goodbyes, he treated Maria affectionately, like someone's little sister. Maria hardly listened to what he said, and though she was a lively wit, she struggled to find clever words. Infatuation had made a fool of her. For the next few weeks, Maria made it a point to run into Fritz, at a lunch or recital. Fritz clearly enjoyed the attention of this shapely young beauty, but though he flirted with her, he was casual and aloof.

At a party at the apartment of mutual friends, Maria told Fritz how she admired the Ractor Raoul Aslan, Austria's leading man. Aslan had just starred in a stirring theater production of *Faust,* about the man who sells his soul to the devil in exchange for the granting of all his earthly wishes. The Goethe classic had been given a jolt of relevance by the incendiary new Klaus Mann novel, *Mephisto,* about a young German actor who

*Maria, middle left, at a ladies' lunch with her fashionably thin sister,
Luise, middle right, suffering the misery of her first love, ca. 1937.*

advances his career with the help of Nazi Party patrons—betraying his
lover, his friends, and his integrity. *Mephisto* was based on a real-life Ger-
man actor whose career had been boosted by Emmy Göring, the actress
wife of Hermann Göring, commander in chief of the German Luftwaffe.

Maria confessed she had always had a crush on the handsome Aslan.
Fritz raised his eyebrows and looked at Maria with amusement. "I wouldn't
get my hopes up," Fritz said. "He prefers men."

Maria stared at Fritz blankly.

"He's a homosexual," Fritz said. He laughed at her surprise. "He's a
friend of mine. It's quite all right." He bent over and kissed Maria softly,
on both cheeks, French-style, and left the party.

Maria's face burned. He had treated her like a child! It wasn't as if she
didn't know about homosexuality. A childhood friend of hers was already
involved with men, and it amused Maria greatly that her mother insisted
on pushing him as an eligible suitor. Of course she had heard rumors.
Maria was simply disappointed that Raoul Aslan, the great sex symbol, was
not interested in women.

Weeks went by. Finally Maria boldly called Fritz on the telephone. He
was friendly, amusing, but cool. He never called to arrange a date. Her
sister, Luise, who had always been coy and self-possessed, was dismayed by
Maria's lack of artifice. Men liked elusive girls! Maria should never call

Fritz! Maria's brothers rolled their eyes and told Maria she was crazy. Fritz Altmann was in love with another woman. He would be living with this woman except for one complication: she had a husband. Maria digested the news of this arrangement. She might even have met this woman, at the same parties where she saw Fritz. Yet if the woman was married, there was hope. Each time the butler, Georg, told Maria a young man had called, she was disappointed anew.

It was never Fritz.

Unrequited Love

Maria Bloch-Bauer was a sheltered young debutante the summer of 1937, when her mother, Therese, concerned she was falling for the wrong man, packed her off to the resort town of Bad Ischl in the Austrian Alps. Ischl was hardly painful exile. Cradled between snowcapped mountains and blue lakes dotted with castles, Ischl had been a haunt of the exuberant young Mozart. Now it was a favorite of Viennese high society. It was the summer home of Katharina Schratt, the mistress of the late emperor. It was a stone's throw from Mozart's birthplace, Salzburg, a grand musical city where Arturo Toscanini conducted like a man possessed. Ischl was tiny, but it had theater, cafés, pastry shops, and a promenade where young people strolled and socialized. In short, it was the perfect place to get Maria away from her ill-conceived longing for Fritz.

Maria, twenty-one, was deeply lovesick. She had been mooning around the Bloch-Bauer apartment on Vienna's Stubenbastei for weeks. Ordinarily, Maria was a merry young woman, with an impish smile and enormous upturned eyes that delighted her aging father, Gustav. But now Maria wore a perpetual look of melancholy as she crossed the Ringstrasse and wandered under the golden statue of the notoriously amorous Waltz King, Johann Strauss, watching young lovers stroll beneath the chestnut blossoms.

Maria had no shortage of admirers. The problem was Maria's stubborn admiration for a man whom her mother did not find suitable.

Therese Bloch-Bauer was a stolidly conventional Vienna society matron.

Her conservative inclinations had always contrasted with those of her unorthodox sister, Adele, God rest her soul. It was easy for Adele to smoke, tell people she was an atheist, and cultivate socialists. It was easy for Adele to spend inordinate amounts of time with Gustav Klimt, whose explicitly erotic drawings seemed to Therese a rather unfortunate use of his talents. And all his illegitimate children! But Adele, whatever her bohemian inclinations, had submitted to the first advantageous marriage that presented itself. Adele could do as she pleased.

Maria was not a steely, strong-willed aesthete like her late aunt Adele. Maria was a dreamer who quoted the love poetry of Goethe but showed no serious interest in the presentable young men introduced to her. When Therese was young, her dance card was full, her suitors so attentive that they presented her with corsages that matched the color of her gowns. Maria didn't even seem interested in this year's formal dance season, though she had made a gorgeous impression at the Opera Ball, in her white satin dress.

Now Maria was pining for Fritz Altmann. The only thing worse, to Therese, would be if Fritz actually decided to reciprocate Maria's unschooled infatuation.

Adele might not have set the best example for Maria's chic older sister, Luise. Luise had greatly admired her aunt Adele, with her gold cigarette holder, her opinions, and her many interesting male friends. Luise had been sixteen when Adele died. Even at that age Luise was a cool customer, playing her admirers off against one another with the skill of a poker shark, and holding her own with her older brothers' sophisticated crowd of actors and singers. Therese had guided Luise to the altar at nineteen, three years after Adele's death, with an excellent match to Viktor Gutmann, a Jewish baron whose family had been ennobled by the Emperor Franz Joseph.

Never mind that in her official wedding photo, Luise posed like a 1930s movie siren, staring into the camera under heavily lidded eyes so seductively people would later wonder whether she had made it to the altar a maiden. Now Luise was the Baroness Gutmann de Gelse.

Therese's son Leopold had married equally well. His wife, the former Antoinette Pick, was the daughter of Otto Pick, a prominent art collector and industrialist; she was also the niece of a distinguished physician who knew Sigmund Freud personally.

In Maria's eyes, it was the social origins of the Altmann family that were most to blame for Therese's lack of enthusiasm for Fritz. The Altmanns

were *Ostjuden* from Galicia, Poland's poorest region. They were members of the Eastern Jewish immigrant wave that had flooded into Vienna, bringing poverty and Orthodox customs that were out of step with wealthy, assimilated Bavarians like the Bloch-Bauers. The *Ostjuden* had borne the brunt of the cruel pogroms that swept through Russia and Poland, and many had arrived with little more than the clothes they wore.

Fritz had grown up in the former Jewish ghetto of Leopoldstadt, Vienna's "Matzoh Island." His mother, Karoline, started the family textile business and insisted on running it herself for years, working such long hours that Fritz joked he had been born under a knitting machine. His father, Karl Chaskel Altmann, was a devoutly religious Galician who spoke Yiddish, spent hours studying the Talmud, and went to synagogue daily in an eastern caftan. The Bloch-Bauers had not converted to Catholicism, but they celebrated Christmas and Easter. Aside from weddings and funerals, the Bloch-Bauers attended the elegant Stadt Temple only on Yom Kippur, the Day of Atonement, sitting alongside the Rothschilds in smoking jackets and top hats.

If Fritz was a playboy, he owed this entitlement to his brother, Bernhard. A casual passerby would never have taken Fritz and Bernhard for brothers if they saw them strolling under the arches of the Imperial Hofburg in front of the Spanish Riding School, where the white Lipizzaner stallions pranced to waltz music.

Bernhard, twenty years older than Fritz, toiled like the devil in the family knitting business. Bernhard lived like a devil, too, keeping his Jewish family in a villa in the fashionable suburb of Hietzing and a Catholic mistress with three children across town. As everyone knew but his wife.

Fritz had little real understanding of the prejudice his family had fled in Galicia. But as a child in Poland, Bernhard had experienced the raw anti-Semitism that turned ignorant mobs against Jewish families. Bernhard was less complaisant, and far less trusting, than his assimilated Vienna Jewish friends. At fifty, Bernhard was a hard-knuckled, self-made businessman with an intimidating stare. Bernhard had many friends in Vienna—and many enemies.

Therese raised her eyebrows at the mere mention of Bernhard's name.

But her husband, Gustav, admired and respected him. The steely-eyed Bernhard had turned his mother's cottage industry into an international wool manufacturer, with plants from the Soviet Union to England. By some accounts, he was the largest knitwear producer in Austria. Gustav told Maria that Bernhard was like the folk hero Rumpelstiltskin—he could spin straw into gold. Bernhard had acquired cultural inclinations along the

way. He was helping to finance restoration of the Roman ruins of Tiberius's old winter camp at Carnuntum, not far from Ferdinand's sugar factory. He had amassed an art collection of more than a hundred artworks, by Degas and Canaletto. He even had a small Klimt—not one of the grand paintings of society women, but an unknown young woman with plaintive eyes.

Maria was in no rush to be steered into a marriage arranged by her mother. After all, Hedy Kiesler, the Jewish protégée of theater impresario Max Reinhardt, had caused such a stir at the Opera Ball in her sapphire-blue sequined dress, and made a supposedly brilliant match with Friedrich Mandl, the arms dealer. But Mandl turned out to be a cruel tyrant. He locked Hedy in his castle and obsessively tried to buy every copy of a titillating Czech film, *Ecstasy,* in which Hedy swam naked and gave herself to a muscular Adonis in the woods. Mandl forced Hedy to socialize with Mussolini and Hitler.

At the end of the summer she would disguise herself as a servant to flee her husband, then make her way to Hollywood to star in a thriller, *Algiers,* as Hedy Lamarr.

Maria would wait. Maria would marry for love.

Marie Viktoria

Maria was born Marie Viktoria Bloch-Bauer on February 18, 1916. Her middle name represented her parents' hopes that the Austro-Hungarian Empire would survive World War I. The family followed the news of every battle, hoping for the triumph of the Habsburgs, who had ushered in an era of tolerance for the Jews. Their dreams would be dashed. The Habsburgs lost. Overnight, it seemed, Austria went from a great nation to a defeated backwater. The royalty was finished. The immense Austro-Hungarian Empire was now the small Österreich, or Eastern Reich.

Therese, forty-two, initially misinterpreted her last pregnancy as "the change of life." Therese thought she was done with the endless needs of small children. She had raised three sons to adolescence and had an adorable eight-year-old daughter, Luise, who was vivacious and quick-witted.

Therese enjoyed having Gustav to herself. She was a fixture of Vienna society, a regular at the ladies' teas and lunches Adele had disdained.

Therese never developed a taste for the new art. She and Gustav collected "fantasy watches," tiny monuments to the ability to know the precise hour, created when many Austrians still relied on church clocks and sundials. Vienna was in thrall to this "scientific jewelry," pocket watches that dated back to the 1400s, coinciding with the revolutionary appearance of a mass-produced Gutenberg Bible. Each was as intricate as a Fabergé egg. A one-inch tulip watch created by Jean Rousseau in 1625 celebrated the arrival of the first tulip from Constantinople to Vienna, setting off Europe's tulip mania. There was a little telescope, jewel-encrusted lutes, a tiny gold gun. Art historians were particularly taken by a white enamel skull with glittering diamond eyes and gold teeth, made in the 1600s by a Prague goldsmith. Its cranium opened to reveal a watch that seemed to tick out the precious moments of life itself, before Death reclaimed its mortal bearer.

Society columns extolled Therese and Gustav's watch collection. The Viennese had "a craze for totally meaningless articles of decoration," and many parlors "were not living rooms, but pawnshops and curiosity shops," observed the cultural critic Egon Friedell. When a museum director hustled over to Stubenbastei to write a monograph about the Bloch-Bauer watches, Therese was thrilled.

To Therese, a new baby meant the end of idyllic collecting trips with Gustav to Venice and Trieste. To Gustav, his unexpected daughter was an unadulterated delight. From the time she was a tiny girl, his "Mariechen" adopted her father's conspiratorial smile. Gustav loved to bundle Maria up in her fluffy white winter coat and hussar hat and parade her down the Stubenbastei.

When Maria was not with her father, she was often handed off to her nanny, Fräulein Emma Raschke, a petite blonde Lutheran from a poor Germanic region of Poland. Next to her father, Fräulein Emma was the person Maria most adored. It was Fräulein Emma who dressed Maria in her embroidered flannel nightgown and tucked her into bed. Fräulein Emma told Maria bedtime stories, introducing her to the lurid world of the Brothers Grimm. There was "Little Red Riding Hood and the Big Bad Wolf," "Hansel and Gretel," "Rapunzel," and "The Pied Piper," whose magic flute led the children away when city fathers refused to pay him for

Little Maria at her family's Alpine vacation chalet at Ischl, ca. 1924.
Maria loved animals, and cried when she read the children's classic Bambi.

driving out the rats. The fairy tales were collections of the myths, folklore, and magical tales the Brothers Grimm had collected all over Middle and Eastern Europe. In the early 1800s, during his quest for stories, Jacob Grimm had lived a short walk from the Bloch-Bauer apartment on Stubenbastei. Therese viewed their stories as backward peasant tales: *tasteless.* Maria craved their frightening thrill. At night, when Fräulein Emma tucked her in, it was easy to persuade her to tell just one more. All right, Emma would tell Maria, I'll tell you the story of "The Wolf and the Seven Little Kids." Maria nestled under her blankets delightedly.

This was her favorite.

"There once was a mother goat who had seven little kids," Emma told Maria. "One day, as the mother goat went into the forest to find food, she told the little goats, 'You must not open the door, because the Big Bad Wolf is out there, and he will devour you.' Soon the little goats heard a gruff voice, saying, 'Children, open the door and I will feed you.' They could tell it was the wolf. So the wolf ate chalk to soften his voice, but the little goats saw his black feet under the door. The wolf asked the miller to spread flour on his feet. The miller knew what the wolf was up to, and refused. But the wolf threatened to eat the miller, so he did as he was told," Fräulein Emma told Maria.

"Deceived, the little goats opened the door, and it was the wolf. The little goats ran and hid, but the wolf found them and ate them up. When

Maria and Luise Bloch-Bauer summer at the Czech castle of their uncle, Ferdinand Bloch-Bauer, who was still mourning his late wife, Adele, ca. 1925.

the mother came home, she called for her children. Finally, the youngest kid jumped out from the clock case and led the mother to the wolf.

"The mother goat found the wolf sleeping. She cut open the wolf's belly, and her kids jumped out, unhurt. The goats found some river stones, stuffed them in the wolf's belly, and sewed him up. The wolf woke up, leaned over the well for a drink, and fell in and drowned." Maria would drift off to sleep, imagining herself as the little goat who rescues her family.

Years later, Bruno Bettelheim, then a Vienna student, would write his classic book, *The Uses of Enchantment,* about how fairy tales help children cope with their fears. Freud believed fairy tales were a window into the unconscious. He thought that "The Wolf and the Seven Little Kids" had inspired a patient's dream in which the wolf represented the patient's anxiety over his father.

But when Maria blithely repeated this story, Therese raised her eyebrows at Fräulein Emma. Did Maria really need to hear these *Greuelmärchen,* gory fairy tales? Couldn't Fräulein Emma read her the new children's book by Felix Salten, *Bambi?*

"Finally, he's written something we can *all* read," Therese added archly,

in a disapproving allusion to the scandalously explicit best seller Salten had reportedly authored anonymously in 1906, with the indelicate title *Josephine Mutzenbacher: A Viennese Whore's Life Story, as Told by Herself.*

In the eyes of her indulgent father, Maria could do no wrong. When she began school, she confessed she had been reprimanded for giggling or whispering in class. "The old swine do you injustice again!" Gustav would thunder, with mock outrage. One day Maria came home and innocently repeated a new word some older schoolboys taught her. It was the name of a popular condom brand. Her father burst out laughing.

Therese was horrified. She enrolled Maria at the Schwarzwaldschule, or Black Forest School, founded by Adele's socialist friends, a private girls' school so highbrow that Schoenberg and Kokoschka had taught there.

Maria and Luise

If Ferdinand and Adele had raised girls, they might have encouraged them to take up a career.

Adele's best friends were career women in an age when women did not take up professions. Berta Zuckerkandl was now a prominent journalist and cultural critic. Dr. Gertrud Bien was a respected physician.

Therese, however, brought up her girls in a sheltered manner, designed to lead to marriage within their cultured circle. Their aunt Adele had spent her life trying to be remarkable. Maria and Luise were encouraged to be ordinary, unusual only within their carefully circumscribed conventions.

Maria was a child of eight when her glamorous older sister turned sixteen. Luise was an unusually poised teenager, with a willowy figure and a biting wit. An insomniac, Luise stayed up into the wee hours and woke Maria to tell her thrilling details of the love affairs of actors and aristocrats. Maria was in awe of stylish Luise, whose first evening gowns were made by the fashion house of Klimt's old companion, Emilie Flöge. Luise was mature enough to disarm guests with her bons mots at the salons of her aunt Adele and uncle Ferdinand.

Maria was too shy to do much more than stand by the curtains watching Adele hold forth in a long gown, her cigarette holder draped from her long, elegant fingers.

At Ferdinand's Brezany Castle, outside of Prague, Maria was the youngest guest. She would wander through the drafty rooms filled with Baroque antiques of dark woods, heavily carved with swans and lions, and the formal and uncomfortable furniture of the Biedermeier period. Meals were served at precise hours, and servants helped everyone dress for dinner. Luise and her brothers went off to hunt with Ferdinand. Maria loved *Bambi*, and she had cried when she read the passage where the fawn's mother was shot by hunters. When she saw the group return jubilantly one day with a dead stag, targeted for his magnificent rack of antlers, Maria burst into tears.

Ferdinand's gardens were a well-tended park, with statues and topiaries. The girls begged Ferdinand to dig a pool at Brezany, but it was futile. It didn't appeal to his classical tastes, and Ferdinand had no interest in donning a swimming costume.

Though the girls were discouraged from any real vocation, they were expected to be conversant in the world of culture. Luise read widely, devouring Goethe and Schiller. She had a genius for languages, and dreamed of writing plays. She was studying to be a teacher, but Therese viewed finding a good husband to be Luise's primary vocation.

This posed little challenge. By eighteen, Luise was a scene stealer. She spun around the dance floor at Vienna balls, dressed with style and ease, and was a skillful flirt. By day, she flitted around the house, singing her favorite opera, *Die Fledermaus:* "Happy he who forgets what cannot be changed." By night, Luise accompanied lonely "Uncle Ferry" to the theater or opera, and the socially prominent widower loved to make an entrance with his stunning niece on his arm.

Therese was the anchor of Bloch-Bauer gatherings, invitations to which were coveted in Vienna. Unlike Adele's, these gatherings were designed less for the exchange of ideas than for the family's social advancement.

Guests ate at a long, deeply carved formal dining table. A Dutch tapestry covered one wall, and guests dined under the gaze of the tapestry harlequin, who watched with vicarious pleasure as a busty maiden tried to squirm out of the embrace of a rogue nobleman. Some of Adele's old friends still came to dine, like Alma Mahler and Amalie Zuckerkandl, whose father, Sigmund Schlesinger, had written an unfinished play with Mark Twain. At one Bloch-Bauer lunch, Luise caught the eye of a

Maria Bloch-Bauer, "the Duckling," carries the wedding train of her sister, Luise, nineteen, a celebrated belle of prewar Vienna. The witty and intelligent Luise married Viktor Gutmann in 1927.

Maria, still a schoolgirl, with her widowed uncle, Ferdinand Bloch-Bauer, at his Czech castle, ca. 1933.

*Christl, left, and Maria, right, ca.
1934, best friends from childhood until
they left Austria.*

*Maria is presented to Vienna society at her debutante ball, ca. 1934,
attended by Alma Mahler and Manon, Alma's daughter with the
Bauhaus founder Walter Gropius.*

handsome blond aristocrat and moved her seating card next to his. Therese had other plans. She seated the blond next to Luise's best friend, Renee Rein, a socially connected young woman who was a confidante of the aging Katharina Schratt. Therese put Luise's card back in its place, next to that of one of Vienna's most eligible bachelors: Baron Viktor Gutmann, heir to a vast timber operation in Yugoslavia. The Gutmann barons were philanthropic: one had paid for the studies of the Hungarian carpenter's son who fathered Vienna playwright Arthur Schnitzler.

Viktor Gutmann was a dashing young man who had returned from the eastern front of World War I in a braid-trimmed officer's uniform festooned with medals. It was Viktor whom Therese had in mind when she began to plan the brilliant illusion that would be Luise's debutante ball, an affair she plotted like a general deploying an army. Therese decided on a "flower cotillion."

On the morning of the ball, Maria opened the door at the Stubenbastei, and florists marched in with armloads of orchids, lilies, hyacinths, and tiny white lilies of the valley. They wove the flowers into wicker archways, transforming them into bloom-laden arbors. Wreaths of blossoms hung over the doorways.

Maria was still a gangly girl of ten, with a swaying walk that earned her the nickname "Duckling." She was disappointed to learn her role: Therese wanted Maria to pull a toy donkey cart filled with bouquets, and "whinny like a horse." When the guests arrived, servants passed them little flutes of champagne. Maria obediently neighed and trotted by the elegantly attired guests. The glamorous Baron Gutmann smiled indulgently, and Maria felt the first stirrings of self-consciousness and humiliation. She was not a little girl anymore! But she dutifully pulled the cart, handing out bouquets.

Suddenly Luise appeared in the doorway, in a sleek gown.

Even the chamber musicians stopped to stare at her. Then they struck up the first notes of a waltz. Baron Gutmann put down his champagne glass and took Luise by the hand to lead her through the first dance. Maria set down her cart and watched as Viktor and Luise glided away, her slender arm on his shoulder, his hand barely touching the small of her back. Baron Gutmann casually put his lips to Luise's ear to tell her something that made her throw her head back with laughter as they whirled around the room.

It was no surprise when Luise and Viktor announced their engagement. In contrast to his nineteen-year-old fiancée, Viktor was a well-traveled

man of thirty-four who had known many women. Viktor had a roving eye, something that Luise, accustomed to being the center of attention, found maddening. Her first taste of jealousy was a disconcerting surprise. Their engagement was stormy, passionate, and brief. A few months after her debutante ball, Luise stepped into the ornate, gilded Stadt Temple in an ivory silk wedding gown. She wore simple white pearls and an intricate handmade lace veil that fell rakishly over her eyes.

Therese ordered Maria, now eleven, to carry the long train of Luise's gown. Maria was to pull carefully, so Luise would sally forth regally. "Hold back, so she strides like a queen," Therese whispered to Maria, just before her "Duckling" walked into the synagogue behind Luise. Maria tugged on Luise's dress as hard as she could, while Luise beamed radiantly at the upturned, admiring faces. Maria must have pulled too tightly, because as Luise strode down the aisle, smiling blandly, she hissed irritatedly to her sister: "*Trottel*—Idiot! Walk faster!" Maria's face burned with shame.

Luise's wedding banquet featured a printed menu with course after course of French dishes, each with its own wine. There was *potage à la crème d'orange* with Château 1916 Coutet. *Truites au bleu sauce mayonnaise* with Niersteiner Kranzberg 1917. *Selle de chevreuil rôtie à la Cumberland* and *fonds d'artichauds aux pointes d'asperges*, with Pommery Sec. Dessert was *crème aux fraises de la saison*, with Château Grand la Cagune 1914 and French cheese, Viennese pastry, and fresh fruit.

For her wedding photo, Luise stared up seductively, like the floating faces of Klimt's sirens.

As Maria grew toward adolescence, she was the mirthful, loyal sister; Luise was the poised beauty of society pages. Even as a married woman, Luise mingled with a cosmopolitan crowd, peopled by actors, singers, and aristocrats.

Luise told Maria titillating stories. Like the time a married friend left her husband in the opera box for a breathtaking sexual tryst with her lover in a dark, velvet-curtained niche of the Vienna State Opera, while Luise made excuses until her friend returned.

To sheltered Maria, it was a thrill when, at sixteen, a boy she had a tremendous crush on pulled her into his arms for her first real kiss, on a boat on Lake Attersee. He pressed his body against hers, and Maria was so surprised she almost tipped the boat over. She told her best friend, Christl, believing the kiss a prelude to a courtship. But when Maria saw the boy at

a party, he greeted her casually and moved on to speak to another teenage girl. Maria was crushed.

Not all her contemporaries were so naïve. Christl was already having a very adult affair with Anton Felsovanyi, a scion of the prominent, titled family that owned the distinguished Loew Sanatorium, where Gustav Mahler had died. Felsovanyi, like other young men of the upper class, attended Vienna's Theresianum, a castlelike military school that took up an entire block near the Belvedere Palace. The Theresianum's love affair with the past was nearly necrophiliac: in the library, two crumbling mummies—the gift of an Egyptian prince whose sons had studied there—lay in a glass case, along with a crocodile that appeared to be rotting.

Christl and Anton took Maria to a basement wine bar near Vienna's old city hall, where Anton invited his rakish school friends to flirt with Maria.

Anton's grandfather, Dr. Anton Loew, had been a friend of Adele. But his less approving mother, Gertrud Felsovanyi, characterized Adele as a "flaming socialist." At Anton's elegant family mansion on Pelikangasse, he showed Maria the Klimt portrait of his mother in a white gown, an ethereally untouched maiden—so unlike the sultry gold portrait of Adele that Ferdinand kept in his shrine. To Maria, Anton was a bit of a philistine. His mother bought him orchestra seats for Richard Wagner's masterpiece, *Die Walküre,* and he described it as "Torture. Hours and hours of those women, shrieking."

Maria and Christl had played together since they were children, in the little plaza off the Ringstrasse that honored Karl Lueger, the former Viennese mayor who famously pronounced that "I decide who is a Jew."

Settling this question was more difficult than ever after generations of intermarriage in Vienna. Christl's father, a good-looking, dull blond bureaucrat, was Catholic; her mother a baptized Jew. Families like Christl's had become common. Christl grew into a spirited young woman, whose self-confidence was the envy of Maria. Anton Felsovanyi conquered Christl with all the weapons in his privileged arsenal. He took her to dine at absurdly extravagant restaurants. He arranged private carriage rides in the Vienna Woods. Soon, Christl was telling Maria how Anton kissed and caressed her until she was incapable of resisting him. He gave her an expensive gold necklace and a puppy to walk. He told her he wanted to marry her.

Anton did want to marry Christl. He went to her house regularly to chat with her father, who told Anton of his admiration for Adolf Hitler. Christl rolled her eyes and complained that her father was "a big Nazi," a

member of Vienna's secret illegal fraternity. Hans, the fiancé of Christl's sister, was also a Nazi Party member. Over beers, Hans told Anton his dream of the unification of all German peoples, of the National Socialism that would provide jobs and restore Austria to greatness. Anton had been an activist in a competing Austrian fascist group, the Heimwehr, or Home Defence. Anton loved its parties, hosted by the Heimwehr leader Prince Starhemberg, and he had vied to dance with leggy young Hedy Kiesler, who would soon be better known as Hedy Lamarr.

Christl was hardly Anton's first affair. Wealthy young men like Anton did as they pleased. Felsovanyi's mother was said to be the child of her own mother's affair with a Hungarian general. Anton's mother usually ignored her son's indiscretions. But with Christl she intervened. She didn't raise her son to marry the daughter of a petty civil servant. Gertrud paid a discreet visit to Christl's father. She quietly explained that Christl's relationship with Anton was growing far too *serious* for his daughter's own good. The conservative patriarch immediately understood. Christl wept. Anton consoled himself by quickly overwhelming the innocence of an adoring aristocratic girl whose pedigree impressed his mother. Maria was offended. How could Gertrud Felsovanyi reject Christl when her son wasted his time at nightclubs and parties?

Stubenbastei

The Bloch-Bauer residence on the Stubenbastei embodied the glamour of Old Vienna for Gustav Rinesch, a tall, handsome rake who, as one of Vienna's most eligible bachelors, was certain he could win the heart of Maria Bloch-Bauer.

His spirits never failed to rise when he turned down the lovely walking street that marked the onetime Stuben Bastion of walled Vienna. Rinesch found Maria's world on Stubenbastei, with its inside jokes, cultured visitors, and endless family intrigues, a seductive place indeed.

Rinesch was one of a growing number of Catholic attorneys in Vienna who worked for a Jewish law firm. Jewish firms offered some of the best opportunities. Jews, just 2.8 percent of the population of Austria, made up

more than half of Austria's lawyers, doctors, and dentists, and their firms and factories now employed many non-Jewish Austrians in top positions. Rinesch relished the entrée his job gave him into Vienna high society.

The Jewish intelligentsia was for Rinesch "the spirit of the town." He considered the Jewish elite "very humanistic" and admired "Jewish humor," the way "they can laugh at themselves very easily." In fact, the laughter and conversation at Stubenbastei was robbing his bachelor freedom of its appeal.

Rinesch was a regular at the Friday-night gatherings at Stubenbastei, where Gustav Bloch-Bauer played cello with his quartet. Here Rinesch rubbed shoulders with dapper composer Erich Wolfgang Korngold, with the librettist Franz Lehar, with Alma Mahler.

Maria was pining for Fritz Altmann, "an aspiring opera singer with a mediocre baritone." But Rinesch knew her infatuation with this glib ladies' man would run its course. For now, he bided his time, carousing around Vienna with Maria's brother Robert, "a real womanizer" who spent his time cultivating good-looking women, "mostly from non-Jewish society, who always fell immediately into the bed of his rented pied-à-terre."

Therese approved of Rinesch, who had a saucy grin but a proper air of respect. Therese hoped Maria would take Rinesch more seriously when they returned from their summer at Ischl.

But as the family prepared to leave Vienna that summer of 1937, Gustav received an unexpected caller. Bernhard Altmann swept into the house, sporting a well-cut suit and a hearty, affectionate air. Bernhard greeted Maria with fatherly warmth, as she smiled up at him with the amusement that melted his tough reserve. Bernhard liked strong women, from his mother and sister to his wife and mistress. But he was disarmed by Maria's sweetness. Gustav made no secret of his admiration for Bernhard. He invited him to sit down in one of the leather chairs of his book-lined study and closed the doors. The only thing to emerge was the scent of fine cigars, the murmur of men's voices, and deep laughter.

Maria soon learned the reason for the visit: Bernhard wanted to know if the Bloch-Bauers would accept an Altmann into the family. Bernhard was impatient with Fritz's affair with the married woman. He was a close friend of the woman's husband, and felt it was time to put a stop to it. Gustav didn't know Fritz well, though he knew Fritz shared his love for music. But Maria's indulgent father was inclined to give his blessing to a match with

Fritz, if that was his daughter's wish. The Altmanns were *nouveau* and only Bernhard was *riche*. But they had come a long way from hardscrabble Galicia and the cramped Leopoldstadt apartment of their Yiddish-speaking parents.

When Fritz found out about Bernhard's visit, he was furious. Yes, he found Maria very charming. You'd have to be blind not to see she was beautiful. But Fritz was deeply smitten with his mistress. Fritz appealed directly to Maria. He sent Maria a fine porcelain bowl, hand-painted with tiny flowers, that cradled a blooming orchid.

Maria eagerly opened the ivory envelope, anticipating her long-awaited romantic letter from Fritz. Finally.

Bernhard Altmann, the tough Galician who turned a family cottage industry into an international textile brand, ca. 1937.

"If I were a prince and you were a princess, and a fairy godmother could put you to sleep for a year, it would work," Fritz wrote. "But this is real life. So I must say goodbye. It will be a year before you hear from me."

Maria was crushed.

Soon Maria and her parents were on the train to Bad Ischl in Austria's Salzkammergut, the old Celtic salt-mining region that was once the exclusive retreat of emperors. A place where snowcapped mountains cupped deep blue lakes, and freezing streams rushed madly into valleys and villages where salt miners still turned up Celtic spears and knives. Summer stretched before Maria, with rides down country roads in horse-drawn fiacres and walks in high mountain meadows filled with edelweiss. But Maria couldn't have been more miserable.

Maria summers at Ischl with her friends, ca. 1934.

*Maria in the Austrian Alps, in traditional
Tyrolean dress, ca. 1936.*

The Housepainter from Austria

Ferdinand would have been with the Bloch-Bauers at Ischl that summer. But his Vienna Kokoschka show was under siege. Organizers were worried that the uproar in Germany was smothering the exhibit in controversy.

On July 19, 1937, the German government opened its *Degenerate Art* exhibition in Munich. The paintings were hung in a deliberately disturbing jumble. "Revelation of the Jewish racial soul," read one slogan on the wall. "An insult to German womanhood," read another. "The Jewish longing for wildness reveals itself—in Germany the Negro becomes the racial ideal of a degenerate art," one scrawl said. "Nature as seen by sick minds," read another. Phrases of speeches by Nazi leaders mingled with the manifestos of "degenerate" art movements: Impressionism, Cubism, Surrealism.

Nine of the works in the Munich show were by Oskar Kokoschka, as if Hitler and Joseph Goebbels were nursing a personal grudge against Kokoschka for flourishing as an art student in Vienna the same year Hitler was turned down.

"As for the degenerate artists, I forbid them to force their 'experiences' on the people," Hitler announced at the House of German Art, where he was presiding over a kind of countershow of officially approved art. "If they do see fields blue, they are deranged, and should go to an asylum. If they only pretend to see them blue, they are criminals, and should go to prison. I will purge the nation of them, and let no one take part in their corruption. The day of punishment will come."

In an angry July 30 letter to Alma Mahler, his onetime lover, Kokoschka angrily disdained Hitler as a "housepainter from Austria who intends to use the power apparatus he has seized from the Germans to have his supposed rivals, real artists, castrated.

"The courage must be found to put him into a lunatic asylum," wrote Kokoschka, who still had not shown up in Vienna.

Hitler knew very well what he was doing. He viewed art as political propaganda. "We call upon our artists to wield the noblest weapon in the defense of the German people: German art!" he had shouted at his first Nuremberg rally in 1933.

Some artists could be subtly recruited. Hitler knew he was wielding a potent force when an old friend of Ferdinand, Richard Strauss, was per-

suaded to serve as president of the Reich Music Chamber and compose the hymn for the 1936 Summer Olympics in Berlin, prompting conductor Arturo Toscanini to remark: "To Strauss the composer I take off my hat, to Strauss the man I put it back on again."

Jewish artists would not be wooed. They would be crushed. The Nazis banned Felix Salten's 1923 *Bambi,* which now invited interpretation as a powerful political allegory on the mistreatment of Jews. The Gestapo ordered *Bambi* seized, along with thousands of "un-German" books burned in Germany.

Hitler had once been a penniless artist. Now he had the power to unleash his toxic view of German culture. By August 1937, more than sixteen thousand "degenerate" artworks would be seized in Germany. Some would be sold at auction for a fraction of their value, "to make some money from this garbage," Goebbels said.

Ferdinand paid to extend the Kokoschka show a second time, as if the power of art itself could temper this assault. In Germany, a petty Nazi bureaucrat denounced the "exhibition of Jewish Communist art" in Vienna, calling it "a protest against National Socialism and a protest against Hitler."

Ferdinand watched the escalation of the campaign against "degenerate" artists with alarm. It was also an escalation of the repression of Jews in Germany. Why so much hatred? Jews were only one percent of the population in Germany.

Many of the people persuaded to hate Jews didn't actually know any, particularly the provincial German nationalists who derided cosmopolitanism as "asphalt culture," the culture of the streets or the gutter, of capitalism and free markets. Their antidote to Jewish urbanism was "Germanic" *völkisch* folk culture, represented by their lederhosen and dirndls.

With or Without You

Fritz Altmann kept his word. He made no attempt to contact Maria that summer. After Maria left for the countryside, Fritz and his family were shaken by the death in Leopoldstadt of Fritz's father, severing a tie to the

Altmann family roots. Maria had no idea of this when she walked into the family apartment in September and dialed Fritz's number, before even removing her straw country hat. A woman answered and said Fritz could not come to the phone because he was with a professor from the history museum. He was going over his collection of ex libris, the elaborate book-plates made for wealthy Viennese by artists. Maria's father had an ex libris of a blindfolded woman holding the scales of justice over a harp encircled by musical notes. Fritz's collection included a woodblock of Rumpel-stiltskin, the Middle European trickster, by the artist Oskar Leuschner; an Art Deco bookplate of a jazz piano created for a Vienna musician; and an ex libris of a castle perched on a mountain of books made for Vienna writer Wilhelm Swoboda, who once reviewed Mark Twain's *Tramps Abroad.* Adele's ex libris, of the princess and the frog, was in all the books at Ferdinand's house.

To Maria, this sounded absurd. She had no interest in bookplates. My brothers are right, she thought. He's nuts. But Fritz called back. His voice was languid and inviting. His artist had made him a new ex libris, of an open window framing a starry night, with a pointed inscription: "You are always standing in the way of your luck and happiness." Maria was discon-certed. "I still haven't seen your ex libris," she stammered. "We haven't done that, or a lot of other things," Fritz said softly.

A few days later, Fritz arranged their first date. Maria panicked.

Her siblings had told her that Fritz's affair—if it was even over, they said skeptically—was very passionate. The married woman was older, fascinat-ing, experienced. Surely Fritz would find Maria naïve and unschooled.

Then there was the matter of her unfashionably ample bust. The eve of their date was a hot September night, and Maria's fox terrier, Jahen, watched drowsily from the floor as Maria threw dresses around her bed-room, trying to find one that concealed her generous décolletage. As her lamp burned, she sewed a brassiere into a tight double corset to minimize her breasts. "How come you're still awake?" her brother Karl called down from his bedroom. "It's so hot, I can't sleep," Maria lied, as she tried on her flattening bra.

The next night, Fritz pulled up to the Luegerplatz, where Maria sat waiting on a bench in front of the red roses ringing the statue of Karl Lueger. As Fritz drove her to the Kahlenberg, an elegant restaurant on a peak with a panoramic view of the Vienna Woods, it wasn't just infatua-

tion that left her short of breath. Her brassiere was so tight! At the restau-
rant, Fritz poured her red wine as the waiter served *tafelspitz,* seasoned beef
boiled with root vegetables. Fritz told her of his dream of singing opera
professionally, touching her hand from time to time with thrilling famil-
iarity. Maria was a bit tipsy when, on the way home, Fritz parked at a
popular lookout over Vienna. They chatted about the latest Shakespeare
play staged at the Burgtheater. Finally Fritz leaned over and pulled Maria
toward him. His skilled kisses and caresses were overwhelming. Having
heard so much about Fritz's affair, Maria made a fumbling attempt to
appear more experienced than she actually was. Fritz wasn't fooled. He
discouraged her pretensions.

Fritz was finally ready for an old-fashioned courtship.

A few weeks later Maria's father turned seventy-five, and Fritz formally
asked Gustav for her hand. Maria's wedding was set for December, barely
two months away.

Maria's older brother, Leopold, rolled his eyes. "If you marry him, you're
crazy," he said breezily. But Maria would have married Fritz the next day.

She ran into Gustav Rinesch at a restaurant in the Vienna Woods, and
breathlessly told him the news. Rinesch's face fell. He opened his wallet to
reveal a photograph of Maria in her white gown at the Opera Ball. He
kissed her hand with dignity and wished her luck.

Maria's mother made the best of it. At dinner, Bernhard lit a cigar, and
Therese hopefully asked if his family was Russian. "No. We are Galician,"
Bernhard said firmly, voluntarily placing himself in Vienna's lowest social
caste.

When Maria's father pulled Bernhard aside to discuss Maria's dowry,
Bernhard turned his proud, bold gaze on Gustav. "We don't believe in
dowries," he said curtly.

Gustav was impressed.

Maria and Fritz wed on December 9, 1937. Maria was twenty-one.

Luise cried when she saw Maria walk into the synagogue on Turnergasse
in her simple white satin gown, radiant with hope. Luise's own marriage
was in trouble. Viktor had always enjoyed women, and marriage hadn't
changed him. He flippantly told his wife he was "polygamous." Luise, still
so young and admired, often found herself alone, and humiliated, because
of course people knew. It was painful to see Maria so convinced of her love.

At the reception, Maria took Fritz's hand and stood with the guests to

listen to her wedding poem by Julius Bauer, the lifelong friend of her parents who had once welcomed Mark Twain to Vienna. The poet, now eighty-four, put on his spectacles and peered at his papers. His hands were shaky and wrinkled.

"Back in the day, before my head turned gray, I wrote a poem for the grandparents of this bride," Julius began.

"After a long pause, Thedy gave birth to a fifth child," he read. "Maria saw the light of this world, an unwelcome belated addition to the house."

Maria was stung. Therese's chagrin was an open secret, but why dredge it up on her wedding day? "But when the latecomer opened her shining eyes, the whole family was dazzled," Julius said, winking. "As you can see, she grew into a vision of beauty."

The old wit careened on heedlessly. He called one of Fritz's philandering brothers a "seducer of women" and described Bernhard as an object of spiteful envy. Julius spared deep-pocketed Ferdinand, calling him a "great industrialist" and a "friend of art and man on whom the golden sun shines." Mercifully, the poem sputtered to an end.

Maria sat down with Fritz for a lunch of *filet de sole Metternich.* Luise sat silently at her end of the table, strangely sullen, though she looked beautiful in her chic Emilie Flöge gown. She put down her napkin and rose from the table. Like many family milestones, this one was bittersweet. She wandered into her father's dark study. There, sunk in a leather club chair, was Gustav. Her father had been ill lately, perhaps suffering from indigestion. Or maybe it was nerves.

Tonight his eyes were filled with tears. Luise reached for her father's hand. "My sun has set," Gustav said.

Maria was leaving home.

Not long after the last waltz, Maria got her own taste of the complexity of the human heart. She and Fritz drove to an elegant hotel near the Danube, on the outskirts of Vienna. Her wedding night had come at last.

Maria's inexperienced imagination was fueled by Goethe's arousing vision of *The Wedding Night.*

> *The silence of the bridal bed,*
> *His torch's pale flame serves to gild*
> *The scene with mystic sacred glow;*
> *The room with incense clouds is filled,*

That ye may perfect rapture know.

. .

How heaves her bosom, and how burns,
Her face at every fervent kiss!
 Her coldness now to trembling turns;
Thy daring now a duty is,
Love helps thee to undress her fast,
But thou art twice as fast as he.

Maria was terribly disappointed. Her long-awaited first embrace was awkward and embarrassing. Maria cursed herself as a "stupid iron virgin," a fumbling child, a pitiful disappointment.

Maria on her wedding day, December 1937.
Vienna portrait photographers were famous
for radiantly lit photographs that were
as theatrically staged as movie stills.

Maria on her honeymoon on the Paris Métro, 1938.

Then, in a moment of passion, Fritz cried out: "Lene!"

Lene? Maria paused to digest this. Fritz froze with embarrassment.

But Maria was flooded with a strange relief. It wasn't as if she didn't know about his married girlfriend, though she prayed it was finally over. Now it was out in the open. Fritz's glaring faux-pas finally gave her the upper hand, at least for a moment. Maria began to shake with irrepressible amusement. Fritz stared at her with astonishment. "Well, at least now I know her name," Maria managed to say, wiping tears of laughter from her eyes.

Maria's first real love affair had finally begun.

Newlyweds Maria and Fritz Altmann honeymoon
at St. Moritz, early 1938.

The Return of the Native

Maria was oblivious to the tension building in Vienna on the February day she and Fritz returned from their European honeymoon and glimpsed the Gothic spires of St. Stephen's. Fresh snow framed the cobblestones of old Vienna as they walked to the Café Central.

Their honeymoon was transformed by the magic wand of Bernhard. Bernhard had filled his Paris apartment with early-blooming lilacs from southern Europe, so the newlyweds were overwhelmed by the heavy, sweetly musky scent when they opened the door. Servants had put champagne and caviar on ice and filled the pantry with French cheeses, fresh bread, and Swiss chocolates. In St. Moritz, Bernhard booked them into a romantic little hotel where the staff had been so well briefed on the honeymoon they exchanged winks as they waited on Fritz and Maria.

When they returned, Bernhard handed them the keys to an apartment at the Altmann compound on Siebenbrungasse. Maria gasped with delight when Bernhard opened the door. Shimmering gray-green silk drapes lined the windows of the sun-filled sitting room. The kitchen was spacious, with iridescent green ceramic tiles and modern features unusual in old-fashioned Vienna. The master bathroom was a vision compared to the cramped family bathroom at Stubenbastei. There were plump Turkish towels and French lavender soaps. The apartment was fully furnished, with a lovely Art Deco walnut bedroom set and simple stylish silverware. Bernhard took them down to the garage to show them a new Steyr sedan with red roses on the front seat. He waved away Maria's insistence that this was really too much. Maria had cracked the tough exterior of this tough Galician, and inspired his love of extravagance. Bernhard openly adored his new sister-in-law, and like her father, Maria admired scrappy, generous Bernhard.

Maria's German-born mother was harder to win over. At one large family lunch, Bernhard put his arm around Therese's shoulder, and said, "Well, we Eastern Jews—" Therese shook his hand from her shoulder. "The Bloch-Bauers are not *Ostjuden*," she said coldly. "We are German." Maria was mortified. Bernhard turned away abruptly. Maria went to apologize. But Bernhard was shaking with laughter.

Not long after, Therese tripped and fractured her arm at the State Opera. The cast was awkward, and it was difficult to find a coat whose sleeve could be pulled over it. Therese threatened not to go out at all until her arm healed. A few days later, a messenger arrived at the door with a gift-wrapped box carrying a note of condolence from Bernhard. Nestled in the rustling tissue paper was a pale lavender cashmere sweater, with only one full sleeve, and a cunning little shawl cape on the other side to cover the cast. It was beautiful, and fit Therese perfectly. Bernhard also sent an orchid, in a pale purple that matched the sweater. Even Therese admitted the sweater was in very good taste.

To Maria's father, the Altmanns were a great gift. His opera-singing son-in-law, with his bohemian musician friends, fit in perfectly at the Stubenbastei. Gustav was ebullient as he played his cello in the twilight one unseasonably mild Friday evening in March. Hans Mühlbacher, a childhood friend of Maria, fiddled away on his violin.

Maria stood under an open window that let in the first soft breezes of spring. Gustav watched his "Duckling," still a girl really, trying to act the part of the poised married lady she would become. At seventy-five, all seemed right in the world, as Gustav caught Maria's eye and smiled, playing his "fourth son," the Rothschild Stradivarius.

Outside, shouts rose from the esplanade. A loud speech echoed from the apartments of their neighbors. What a racket! Gustav gestured to Maria to close the window. Instead, someone turned on the radio. Their chancellor was speaking. Gustav and Hans resignedly put down their bows. Chancellor Kurt Schuschnigg was saying Austria would allow Hitler's forces to enter Austria. He said he would capitulate, to avoid shedding "German blood." "God protect Austria," he said soberly. Gustav looked around the room. His guests were alarmed. What did this mean? Would Hitler really rule Austria? Guests pulled on their coats, called home. What was happening?

Maria and Fritz sat down with Gustav and Therese. Austria had weathered many storms over the years, with riots, shooting in the streets. The telephone rang. Some of their friends talked of leaving Austria immediately.

To Therese, this sounded extreme. She couldn't just pack overnight bags and get on a train. Gustav was not in the best of health. Fritz said the thing to do was remain calm. What Fritz really wanted was to talk to Bernhard.

But no one had seen Bernhard since he went to work that morning. Maria's old suitor, Gustav Rinesch, was going to take Leopold's wife, Antoinette, to the Czech border at once, with their son, Peter, and he would try to take others. But Robert wouldn't hear of leaving. Robert's wife, Thea, was about to have a baby. Leopold needed to stay and look after the family businesses.

No one agreed on the right thing to do.

Hans bid the disconcerted guests farewell and picked up his violin case. A convoy of trucks came down the Ringstrasse, filled with pink-cheeked adolescents in the brown-shirted uniform of Nazi enthusiasts. They raised their arms at Hans, crying, "Heil Hitler!" and "Jews, kick the bucket!" A group of men in lederhosen marched up the Ringstrasse in formation, smiling exuberantly, singing about breaking Jewish bones in "the coming big war." Men with torches mingled in the crowd, chanting, "Down with the Jews!"

Idiots, Hans mused. It's like carnival for the Nazi Party. At his student hostel, Hans sat down and wrote a letter to the chancellor, assuring him that most Austrians supported him, and "Austria will live again." Hans walked through the jubilant crowds to the chancellery and slipped the letter under the door.

Hans prayed this would blow over. Some of his old high school friends, even a few Catholic cousins, had joined the illegal Nazi Party in his hometown of St. Wolfgang. They weren't bad people. They called themselves "idealists," and were openly enthusiastic about Hitler and his promises in *Mein Kampf.* They dismissed anti-Semitic violence as "excesses" committed by fringe "underminers," whom the Führer couldn't control. When Hans returned to his hostel, a friend of his ran out, gleeful. Hitler was coming! He laughed off the violent Nazi chants. Don't worry about the songs of the "trembling of the broken bones"! he told Hans. "It's just nonsense. Hansl, we will be united to Germany, and Austria will be great once again, like before the world war," his friend said euphorically, as he and a group of students spilled into the street to join the celebration in the Stephensplatz.

A few mornings later, Maria awoke to loud noises in the garage. She dressed and went down the stairs. There were strange men there. They seemed to have pried open the garage door, and they were trying to roll her new car into the street. The men had swastikas on their sleeves. The officer in

charge of the men smiled when he saw Maria and introduced himself as Gestapo agent Felix Landau. They were "confiscating" the car, Landau explained. He was polite, obsequious, almost apologetic, as he asked Maria to show him into the apartment. Landau was not particularly intimidating. He was badly dressed and spoke uncultivated German. He seemed a little sheepish about barging in.

Was she alone? Landau asked, standing close to Maria, and smiling in a manner she found overly familiar. Maria felt a stab of fear. No, she said, my husband is with me, and suddenly the word "husband" seemed like an amulet of protection.

In the foyer of the Altmanns' apartment, Landau introduced himself to Fritz in the cordial tone of a social call. As if it were the most natural thing in the world, he asked Maria to show him her valuables. Fritz held Maria's gaze for a moment, as if to say: just do what he says.

Fritz offered Landau a cigarette. They made small talk while Maria fetched her jewels. When she returned, Fritz was chatting nonchalantly with Landau at the kitchen table. Maria spread her earrings, brooches, and even her engagement ring on the table. Landau sorted through them. They were fine pieces, antique jewelry of Adele's from the Wiener Werkstatte. But Landau seemed unimpressed.

Then Maria recalled Adele's diamond necklace. Ferdinand had given it to her as a wedding present. If she didn't report it, they might be arrested. So she told Landau. His face lit up. She told Landau she would call her jeweler. As she went to the phone, she heard Fritz and Landau talking about what a rainy spring it had been.

"Are you sure?" Maria's jeweler, an older, decent Catholic man, asked Maria with disconcerting concern in his voice. Maria had no choice! The jeweler sent the necklace over in a blue velvet box.

Landau eagerly pulled out Adele's diamond necklace, fingering it with satisfaction, then slipped it into his pocket like a handful of marbles. Maria was going to tell him that such a fine piece of jewelry could get scratched rolling around with pocket change and car keys. Adele had hardly worn the necklace after she decided she was a socialist. It was in perfect condition. But Maria remained silent.

Landau walked through the apartment, appraising the modern kitchen and bathroom. He ran his hand over Bernhard's luxurious brocade drapes, lingering in the bedroom and rubbing the fine sheets between his fingers, until Maria nervously led him back to the kitchen. Landau told Maria and Fritz they had to move out of the apartment. As she and Fritz packed, Lan-

dau stopped them, demanding a satin dress, some fine silk stockings, an elegant black smoking suit. He spotted a silk dress hanging over a chair; Maria had set it aside to remove a red wine spot. He wanted that too. Did she have to give him anything he demanded? What difference did it make, really, Maria thought. A lot of these things were wedding gifts. She hadn't had them long enough to be attached to them. Landau's men, meanwhile, brought a suitcase and some small bags up the stairs. The Gestapo was taking the apartment Bernhard had created for them, after just ten days of married life there.

As Maria and Fritz headed downstairs to another Altmann family apartment in the building, the guards brought Landau's things in. Was Landau going to sleep in their bed? That would put Maria and Fritz under house arrest. The agents stationed at the door seemed to leave no question. They were Landau's prisoners.

Or were they? Landau smiled as Maria left for the streetcar, and said goodbye, in his working-class Viennese accent. At least Landau didn't try to greet her the way he did his fellow agents and her neighbors, who gleefully replied in kind: "Heil Hitler!"

The streets were erupting with joy. The newspaper said Hitler was on his way. People poured out of their homes and ran past her, waving Nazi flags, on their way to the Heldenplatz, Heroes Square, as the news spread. At the Stubenbastei, her father was sitting in his study, pale and silent. Gustav greeted Maria with a wan smile, as Fräulein Emma quietly prepared lunch. Outside, people began to cheer wildly. Therese walked briskly through the apartment, shutting windows and drawing drapes. "Peps," Maria said to her father, "come have something to eat." It was impossible to ignore Hitler's arrival. A far-off roar grew as the motorcade neared Heroes Square. Maria wished there was a way to nail the windows shut, as the family sat quietly and listened to the crowd chant "Heil Hitler." Gustav stared into his plate silently.

As Maria made her way home to Fritz, the path of Hitler's motorcade was strewn with roses. Eager Viennese waved the flags of Nazi Germany.

If only we could find Bernhard, Maria thought. Bernhard was so fearless. Bernhard would make her father strong. But Bernhard, Maria and Fritz discovered, had fled. He was driving across Vienna as news of the Anschluss came on the radio. Turn the car around, Bernhard ordered the chauffeur: Get us to the Hungarian border. Bernhard, with his sprawling textile empire and foreign bank accounts, knew he would be a prime target. Bernhard had been keeping an eye on Hitler since he began to threaten

Austria in February. The memory of anti-Jewish mobs in Poland was etched in his psyche. Bernhard's driver pulled up to a quiet rural border crossing. A guard stopped him. Bernhard insisted. The guard, perhaps persuaded by some of Bernhard's cash, told him to wait for darkness. At nightfall the guard turned his back. Bernhard slipped out of his elegant sedan and ran into the woods of Hungary.

In Vienna, the Gestapo was furious. Bernhard's wife, Nelly, tearfully protested that she had no idea where he was. "Do you know your husband has another family?" they taunted her, confirming a terrible suspicion she had long harbored. "Did you know your husband has a mistress and three children?"

Maria's father was more withdrawn every day, and he complained of vague abdominal pains, perhaps from nerves. When a Gestapo agent banged on the door, Gustav didn't even come out of his study. His stern wife had long intimidated him, but now he relied on her strength. Therese showed the Gestapo agent to the parlor. "Would you mind removing your hat for a lady?" she said witheringly. The pink-cheeked young man quickly put his hat on the settee.

The next morning, Therese insisted that Gustav accompany her on a stroll in the composer's park. He trudged by the golden statue of Johann Strauss like a sleepwalker. When they returned, Fräulein Emma opened the door with a look of alarm. The Gestapo had come! The officers had asked to see the Rothschilds' Stradivarius cello. Georg, the butler, had opened the glass music cabinet and handed over the valuable instrument. The Gestapo carried it away. Gustav was visibly shaken.

Did they have to take his cello? Maria thought, as she walked from Stubenbastei to see Christl. How did the Gestapo know he had it? They knew everything.

Christl's father must be happy, Maria thought. His beloved Hitler was in Vienna. Christl opened the door with red-rimmed eyes, wearing a simple black dress, her wheat-blonde hair in a French twist. "Maria, my God! Something awful has happened," Christl whispered, pulling Maria into the apartment so neighbors wouldn't hear. Christl poured them each a glass of wine. Christl couldn't talk long. Of course, father was delighted when Hitler came. Then he discovered he was violating the race laws. Christl's mother, a baptized Catholic, had Jewish parents. That meant Christl and her sister were half Jewish. This was news to her father! His euphoria faded to reveal an impossible future. He found his old World War I pistol, raised it to his temple, and pulled the trigger.

"He was so happy Hitler was coming," Christl said, shaking her head. "He found out all his dreams were false."

Maria gasped. She had never liked Christl's father. But this was shocking.

There was more. The Nazi fiancé of Christl's sister had broken off the engagement, though perhaps he could help them escape. Anton Felsovanyi had gone to see Hitler speak, out of curiosity. All of Vienna was at the Heldenplatz, waving and cheering. When Felsovanyi got home, his mother, Gertrud, told him she had Jewish parents. They had to leave their elegant palace on Pelikangasse to avoid being arrested. After a lifetime as a Catholic, on the day of Hitler's triumph Felsovanyi had discovered he was Jewish. Felsovanyi's sister, Maria Aline, a comely sloe-eyed girl with a sleek bob, was jilted by her Catholic fiancé.

Felsovanyi might be Christl's husband, Maria thought, if Gertrud weren't such a snob. Not that it would help now. Christl went to the parlor mirror and began to pin up loose strands of her long blonde hair. With her blue eyes and hourglass figure, Christl was the living image of a good German girl. It all seemed so bizarre. "You'd better go," Christl said. "My mother and sister will be back. They're trying to organize a memorial. There are problems with my father's family, though they all seemed to like us. Before." Christl looked at Maria. What a mess!

"So now we're all going to leave, just like that?" Christl said, looking around the comfortable apartment with its plush rugs, her father's family portraits, the ticking antique clock decorated with a pastoral maiden and her suitor. Leave everything?

That night, Maria went home to Fritz. Bernhard had sent word: You must leave the country. All of you. I'll arrange it. Don't do anything to provoke the Gestapo.

The mobs in the streets seemed to be growing more violent. Terrible stories were coming out of the poor neighborhood of Leopoldstadt. Elderly Jews were being ordered to get down on their hands and knees to scrub the streets. Sometimes the water was mixed with acid, so it burned their hands. In the posh Währing district, Nazis urinated on the heads of Jewish women as they knelt down to scrub. Brownshirts were forcing merchants to paint "Juden," in big letters, on their shops. They grabbed a woman who ventured into a Jewish store and hung a sign around her neck, THIS ARYAN SWINE BUYS FROM JEWS, forcing her to sit in the store

window for hours, weeping, while crowds yelled insults and spit at her. Jeering crowds were plundering stores, and even barging into the homes of Jewish families.

Wealthy families like the Bloch-Bauers had factories, valuables, and bank accounts that could be used to bolster the coffers of the Third Reich. But how long could that shield them? Dapper Louis Rothschild was locked up at Gestapo headquarters at the old Hotel Metropol, where Mark Twain had imagined he saw Satan from his window. The Gestapo agents who "searched" the home of the aging industrialist Isidor Pollack beat him so badly that he died. Franz Rottenberg, the chairman of the Creditanstalt, was picked up by SS agents and pushed to his death from a speeding car.

Uncle Ferdinand had briefly attempted to organize a monarchist rebellion against the Anschluss, at his age! Thank God he had given up and fled to his Czech castle.

What a relief, Maria thought, that Ferdinand didn't have to listen to the news that Adele's old friend Karl Renner, the dashing hero of Red Vienna and former chancellor, endorsed the takeover as a way to heal the wounds of World War I.

In a statement covered by national radio, Renner confessed some distaste for the "methods" of the Anschluss. "But the Anschluss has nonetheless been achieved; it is a historical fact," Renner said. "I regard this as satisfaction indeed for the humiliations of Saint-Germain and Versailles. The twenty years of stray wandering of the Austrian people is now ended."

Maria and Therese listened in disbelief.

How could a onetime hero of Red Vienna place a seal of approval on a movement that had persecuted Jews for years in Germany? What about the Jewish friends who had helped Renner become chancellor, build schools and hospitals, implement social reforms? Were they now so expendable? Maria flicked the radio off.

What if her father heard?

But Gustav was sitting silently, staring blankly at the curtains drawn over the closed windows. The Ringstrasse, the source of so much joy and pleasure to Gustav, with its promenades, moonlit strolls, and cafés, was now a source of dread. He didn't dare to walk around the corner. Gustav sat like a ghost in his chair. When Maria kissed him, he managed a wry smile.

Now the family concealed many things from Maria's father.

They kept the radio off in the apartment a few days later, when the Nazi propaganda minister, Joseph Goebbels, staged an hours-long rally in

Vienna for an appallingly vast sea of admirers. Goebbels dismissed foreign press reports of attacks on Jews as just *Greuelmärchen*—gruesome fables.

"I have been informed that many Jews in Vienna are committing suicide," he told the crowd with faux sadness, alluding to reports that hundreds of Viennese Jews had taken their lives since the Anschluss.

"In the past, Germans committed suicide. Now Jews are committing suicide, and there is nothing I can do about it, since I cannot put a policeman behind every Jew," Goebbels said in a coldly mocking tone.

The crowd roared with laughter and applause.

The world had gone mad. What were they going to do?

Maria and Fritz still found refuge in new love, even under the watchful eye of Felix Landau. Maria was concerned, but not frightened, when in late April, as the chestnut trees bloomed along the Ringstrasse, the Gestapo came to pick up Fritz for questioning. We'll bring him back this afternoon, Landau assured Maria.

Night fell. Then dawn. Fritz had not returned.

Landau sounded a little tougher now as he told Maria that Fritz was at Rossauer Lande, a police jail where political prisoners were held for questioning by the Gestapo at the Hotel Metropol.

Fritz would be released, Landau said, when Bernhard turned over the foreign accounts of his textile factory, and everything else.

Love Letters from a Bride

Just weeks after their honeymoon in Paris, Maria had lost Fritz. As their world crumbled, on April 29, Maria sat down to write him a love letter.

My beloved Fritzl,

I hope you are well and you write to me soon. What should I get you? Do you have a blanket and pillow? I will bring you a comb, a brush, the toothbrush holder, new laundry and warm pants on Monday. Today I am sending you five reichsmarks. I will send you some

more money in two or three days. Your family is well. We are together, speak only of you, and love you boundlessly, above all your wife Maria, embracing you from deep in my heart.

With love from your family embracing you, Maria.

Fritz replied in the same spirit.

My beloved Duckling!

I arrived here in a good mood, and am here with some acquaintances. I got your delivery this morning at the police station, and was allowed to take it with me, to our great joy. I thank you for it, with all my heart. In the future, there will be a laundry package brought to me every week, Tuesday between 4 and 5:30 p.m., and my dirty laundry will be collected at the same time. I really don't want you to run these errands. And of course, visiting is not allowed. So please send me: one laundry bag, slippers, another pair of pajamas, two day shirts, two pairs of underpants, handkerchiefs, two towels, a rubber bag for the washing things, a little comb, Brilliantine, a small toothbrush, toothpaste, plus, via postal order, 6.50 marks. You're allowed to write me daily (everybody's allowed to write to me). I, however, am only allowed to write one card every 8 to 14 days, and of course, I will write it to you. I send greetings to all the others—yes please, one sports training suit. Only send older clothes. Please don't be afraid for me. I'm really excellent, and the treatment is flawless. I also have a lot of patience and love for you. Please send greetings to all of our loved ones. I embrace you.

Your Fritz.

Maria was startled. The treatment was "flawless"? Well of course, his mail was read by the police. What could he say?

There was no point in upsetting him with the stories she heard of the Vienna unraveling at their doorstep. Teenagers were painting "Juden" on Jewish stores up and down the posh Karntnerstrasse. A feeble old Jewish man had been kicked to death in front of a jeering mob. Thousands of Jewish professionals were being arrested. Her father's best friend, a Catholic pediatrician, had committed suicide with an overdose of morphine. In his formal old script, he wrote a farewell apology: "From an old Austrian who can no longer live in the world of today."

How could Maria convey all this, in letters she was sure were read by authorities, written in tiny letters on pieces of paper as small as an index

card? Yet her and Fritz's attempts to bridge this gap in correspondence provide a remarkable document of two young Viennese trying to cope together with the deterioration of their safe, predictable world.

A few days later Maria wrote:

> My beloved Fritzl,
> Today I received your lovely card, and it made me so happy. In my thoughts I am living only with you. My parents are well. Our families are often together and every word is devoted to you. Be patient. Everything will be fine. Soon you will come back to your wife who loves you above all else . . .

"Be embraced by your Maria," she wrote, signing her letter with a drawing of a little duckling.

Next Maria wrote "my beloved husband" that she had tried to bring him sports clothes, but the police had turned her away. "I'm with you every minute of the day, and walk around as if in a dream," Maria wrote. "Have patience, love. Our parents are fine. They send you a thousand greetings. I really am bearing up with courage, a real 'lion-woman.' Keep my loving memory. I love you more every day. Your Maria."

Fritz's sister Klara wrote Fritz that Maria's little fox terrier, Jahen, was "taking good care of his mistress," barking at anyone who came near her. "Your wife is the most enchanting creature on earth!" his niece, Lisl, added.

"My beloved Fritzl," Maria wrote on May 5. "It has been a week since I last saw you. For me, it has been an eternity." Gustav, she wrote, "has problems with his nerves." This was a massive understatement.

"Last night I had a wonderful dream, that we would see each other soon," Maria wrote. "Do love me. Thinking always of you, your wife."

On May 6, Thea, the chic and very pregnant young wife of Maria's brother Robert, wrote Fritz that "the Duckling ruffles her feathers sadly every day, and kisses you, deeply in love."

"I have to tell you again how incredibly much I love you," Maria wrote next. "Peps is doing much better with his nerves . . . I'm trying to be brave and patient."

In reality, Maria's father was having anxiety attacks and chest pains. Seven close family friends had taken their lives.

Fritz focused on minutiae in his letter, sending Maria elaborate laundry lists. He had four daytime shirts but needed two more. He needed two pairs of pajamas, twelve handkerchiefs, two napkins, leather gloves, terry-

cloth towels, a white pullover with sleeves, a gray pullover without sleeves, a cravat.

"My beloved Fritz," Therese wrote from the Stubenbastei. "We're thinking of you with much love. Your good, lovely wife is with us often, and is our whole joy. Be embraced with much love, from your Mama who loves you." Maria's father added: "How much I'm hoping that you will soon, with the help of God, be home with our beloved Baby (Bützel)." On the same card, Maria wrote, "You see, the parents are fine, my love!"

Maria didn't dare tell Fritz that no one was fine. Everyone they knew regretted not trying to escape immediately. Austria's deposed chancellor, Kurt Schuschnigg, locked in the Belvedere Palace and a nervous wreck, had married a Czernin countess by proxy. On April 27, the Nazis had filed trumped-up charges of tax evasion against Ferdinand. His sugar factory was being run by one of his employees, a cashier who happened to belong to the Nazi Party. Jews had been ordered to register their assets.

"My dearest Fritzl," Maria wrote on May 11, "I received your truly precious letter. You write so enchantingly. Your lines keep me going for the whole week, and I live for the next letter. As you know, I can wait, and love you more every day. When someone is loved by you, they are so strong."

Maria gently noted that Elsa Kuranda and her journalist son, Peter, "died suddenly." "You see, I tell you everything," she wrote. "As an improvement on your food rations, I send you a big pot full of love. Your life, Maria."

"Died suddenly" was, of course, code for "committed suicide." Elsa Kuranda had been Therese's best friend. The charmed world the Kurandas shared with the Bloch-Bauers had become incomprehensible, a place where once-pleasant neighbors turned on them, and their beloved city unleashed goons whose hatred they had no means of comprehending. Mother and son decided they could not go on.

Bernhard had tramped through the Hungarian woods and boarded a train to Yugoslavia, paid a seaplane pilot to fly him to Lake Trasimeno in Umbria, and made his way to unoccupied Paris. Now he was bivouacked in the apartment where Maria and Fritz spent their honeymoon just weeks earlier, plotting his family's escape. Ever the tough dealmaker, Bernhard didn't care if he had to beg, borrow, or lie his family's way out of this maelstrom.

Maria could have left on her own. She had a passport in good order, money, the help of Rinesch. But she rebuffed any suggestion that she leave without Fritz. On May 13, Maria wrote to Fritz that she went to the Hotel Metropol to beg the Gestapo for permission to see him.

A contemptuous desk clerk waved her away dismissively. In his eyes, Maria was no longer a well-to-do lady, or even a fellow Viennese. She was just a Jew. Maria wrote:

> I went away quite depressed. If God is willing, it won't be long before we are together again. I'm with you completely, and the fact that we love each other so much, and have a long life ahead of us, gives us strength, turning weeks into days.
>
> I read your little letter every hour, over and over. It makes me incredibly happy. Peps said yesterday, "When will our adorable Fritz return?" Think of them, all the people who love you, and of a happy future with your wife, who loves you above all. The little Duckling is greeting the hero.
>
> Kissing you with my whole heart, Maria

On May 15, Fritz wrote back:

> My beloved wife,
>
> With incredible joy I received your cards, as well as the razor. The four elements that determine my life are, the walk in the courtyard, the extra food from the four reichsmarks a week, a few rays of sunshine that at noon come through an angle of the cell—and the mail . . . My prayer book contains, besides your cards . . . the soulful words of our beloved Peps.

Maria and her father "find words that go through the most forbidding walls, straight to the heart." Fritz wrote. "Your lines are a revelation, a poetic reprieve from daily life." He asked Maria to send his red cotton scarf and leather gloves, his lederhosen for the high summer, and photos of her. "Lover!" Fritz wrote:

> In my thoughts I send you hundreds of letters, and now that finally Sunday has arrived, it is again a very dull and ordinary one. I lay awake half the night thinking about how I could write you even more tenderly than ever.
>
> If you really live through the bad times, the future will pay us back a thousandfold. These days are forging the pitcher from which happiness will be poured. Please be strong. My beloved Maria, I am always with you.

And for God's sake, please don't go on the diet that Luise was on! I wrap you in a long embrace, holding you so tightly in my arms to renew your force so you will be a strong woman for the weeks to come, even without me.

Your husband in love

Maria laughed at this. How could Fritz think she would start dieting at a time like this! "We both have to be patient," Maria wrote on May 16. "But these weeks are bringing us so much closer. It won't be much longer before you'll come back to me. Last year, I was much more unhappy, as I waited for an uncertain goal, and this year I know you will come to me. I only live for you . . . A thousand kisses from your Maria."

On May 18, Maria wrote, "My love, today your letter arrived. Your beloved, long-awaited letter . . . My Fritzl, what an immense love I have for you . . . I just have one thought, and that is you, again and again you. My whole life long, I will only love you."

Maria didn't mind that Fritz was seldom allowed to reply. Writing him allowed her to retreat into the romantic dream that shut out the menace closing in around her family.

If there was one thing Maria underestimated during these tender exchanges, it was her resident Gestapo agent, Felix Landau. Landau still treated Maria with courtly deference. Maria saw him as an errand boy for more powerful evil men. She never imagined she was getting a daily, firsthand look at one of history's monsters.

Landau's origins were pitiful. He was born in 1910 to a poor young Viennese Catholic woman. Around the time of his first birthday, his mother married a Jewish gentleman who gave the boy his name and raised him as his son, then died suddenly when Landau was nine. His mother sent him to a harsh Catholic boarding school and, when he was fifteen, to a trade school to learn furniture making. There he finally found dignity and belonging—as a member of the National Socialist Working Youth. This led Landau to Austria's Nazi Party.

When Hitler rose to power in Germany, Landau became a member of the Schutzstaffel, the SS, a fascist militia that surfaced publicly in 1934 when Landau and other Nazis-in-waiting mounted a coup against Austrian chancellor Engelbert Dollfuss. The coup failed, but Dollfuss was killed. Landau and other plotters were imprisoned, along with the Vien-

nese attorney who defended them, Erich Führer. Released in 1937, Landau headed to Germany for a medal and a Gestapo post.

Like Hitler, Landau returned to his Austrian homeland, no longer a loser, but a victor. Now he ruled the fates of the people into whose parlors he once would have entered only as a workman.

Maria had no way to know Landau had been handpicked for a systematic campaign to rob wealthy Jews.

Landau was playing a stealthy game of cat and mouse with Maria and Fritz. He probably read their love letters. Maria knew nothing of this the day she went to the police to bring fresh shirts to Fritz.

Fritz was no longer there. Landau feigned ignorance.

Of course, he knew Fritz had been transferred to another prison, the Landesgericht Wien, near City Hall. There the Nazis had put a guillotine in an execution room where hundreds would be murdered.

Maria found Fritz by doggedly combing the detention centers of Vienna. She was certain of only one thing: She was first in Fritz's heart. But that meant so much.

"My love!" Fritz wrote Maria on May 22, from his new prison. "From the post I get I'm the Croesus of the prison! You cannot imagine how my time seems shorter by receiving this precious mail.

"The daily gigantic letters are wonderful," but if the entire family was going to write, "then I really need to be locked up," Fritz joked. "The big event of the week is the photograph of the little wife. I laugh with joy just looking at it. The little frau, pensive." Fritz wrote that his spirits were lifted by the camaraderie of his fellow prisoners, and "sometimes we have great laughs together. I don't sleep on the floor anymore, so I'm really doing well," he quipped.

He peppered Maria with questions. Could she get his shirt collar repaired? "When is Thea supposed to give birth? I will keep my fingers crossed for her. When will her parents go to Ischl? What about you?"

Go to Ischl for a holiday? Was he mad? Maria thought. They're hunting Jews. One overzealous teenager in uniform on the road could doom their entire family. Her father was afraid to leave the house.

"Please send an honest report," Fritz concluded.

An honest report? The Nuremberg laws "for the Protection of German Blood" were extended to Austria on May 20, forbidding marriage between Jews and "Aryans," and prohibiting Jews from employing women "of Ger-

man blood" under the age of forty-five as domestic workers. There were 170,000 Jews in Vienna, and it was now clear none were welcome. The Gestapo fired 153 of the 197 professors at the University of Vienna Medical School. One Jewish Nobel laureate, Otto Loewi, was jailed and forced to transfer his prize money to a Nazi-controlled bank before authorities would let him out of the country. Sigmund Freud was freed from Gestapo headquarters only through the intervention of an American millionaire who was also a former patient, after being forced to sign a paper testifying to good treatment. "I can heartily recommend the Gestapo to anyone," Freud wrote drily, with an irony that would have made Mark Twain proud.

An honest report would have landed them all in jail.

"Dearest wife, I'm so happy to be your husband," Fritz continued.

If you feel this much love, it's easy to be in prison, even for a long time, with joy. I feel sorry for all the people who are free, but don't have a wife like you.

I live on the thoughts of you and our future, and I'm incredibly happy dreaming about it. I'm also happy about the loved ones of both our families, who I know care for me. I'm deeply grateful to everybody, and for the love you give me, my beloved Duckling.

Please keep sending me all your love. Please be healthy. Treat yourself well. And be deeply joyful and merry. I am too. I cuddle up to you and kiss your beloved mouth deep and long.

Your husband, Z207

He was now a number.

Then, suddenly, silence. The letters stopped. Maria went to the Landesgericht Wien prison and Fritz wasn't there. The guard shrugged. A train had left for Dachau. Maybe Fritz was on it. Dachau! Maria hastily scrawled a panicked note to the Dachau command. "Desperately begging for information about the well-being of Friedrich Altmann, admitted May 24. Wife and family entirely without notice."

Work Makes Freedom

Fritz was resting in his prison cell on an unbearably hot night in late May when SS officers strode in and ordered him and two hundred other men to get in line. "They're taking us to Dachau," some of the men whispered.

Dachau.

The SS recruits who pushed them onto the train with their rifle butts were boys. They looked sixteen or seventeen. Their soft faces contorted with hate as they yelled: "Get down!" The teenagers pushed a slow old man onto the floor and kicked him until he curled up in pain. They ordered the men to sit motionless and stare at the light in the ceiling. As the train bumped along into the countryside, older men strained to hold their necks rigid.

As the hours went by, the guards forced elderly passengers to stand. Many were not physically capable of it. A former managing director of the Austrian railways stumbled, and they beat the old man over the head with their rifle butts until blood streamed down his face. He cringed on the floor, clutching his broken spectacles, his eyes bright with bewildered tears.

This train was not filled with huddled masses of poor Viennese from Leopoldstadt. The passengers were clergymen, entertainers, decorated World War I veterans, hostages from wealthy families. This train carried celebrities like Fritz Grünbaum, the Groucho Marx of Vienna. This Dachau would house child psychiatrist Bruno Bettelheim.

Some gentlemen eyed the windows. Men had come into their homes, stolen their silverware, and dragged them off. What had become of their wives and daughters? But the guards watched them closely. People had already tried to jump from the train.

Outside, the train rolled through a spring landscape Fritz knew by heart, a riot of Austrian wildflowers that Klimt had immortalized in his paint-ings. In the humid air, red poppies rested alongside lacy spikes of bouquets in every shade of purple and lavender. The grass was the pale green Klimt had captured so vividly, and the rich soil was fecund with beets, wheat, and barley. It was an unseen paradise, and Fritz, who had been in jail since the first chestnut trees bloomed, could tell when they passed through farm-land by the smell of moist earth.

Dawn broke. The train slowed to a stop. Fritz was shoved off the train, as cramped and stiff as a crab. Guards met them with angry faces, barking orders: "Line up! Get your head shaved there!" Fritz stood exhaustedly in line.

The Fritz who had once risen at dawn to secure good standing room for *La Bohème* at Vienna's elaborate, angel-bedecked State Opera now looked around, amazed, at a very different architectural tableau. Dachau, Germany's original concentration camp, was outfitted for another kind of theater. The camp was surrounded by a deep trench and a high fence of barbed wire. Its stark yard was designed to make prisoners feel as insignificant as insects. This was the stage of deliberate cruelty. The SS held absolute power over the prisoners, who were humiliated, degraded, and crushed. Dachau would be the model for the camps of the Reich. As Fritz passed through the black iron gates, he saw the words spelled out, in twisted metal: WORK MAKES FREEDOM.

Was there anyone less suited to withstand the rigors of life at Dachau than the golf-playing, waltzing former playboy Fritz Altmann? His brother Bernhard fought the family battles. His mother, Karoline, had founded the business. If Fritz worried about clean handkerchiefs and pressed shirts in jail in Vienna, such niceties were now left behind.

The Nazis had already seized Bernhard's Vienna factory and arrested its two dozen managers. Bernhard still held cash from the factory's earnings in foreign bank accounts. To force Bernhard to transfer the accounts to them, authorities had adopted "the gangster's method, and took a hostage," Fritz realized. "I was taken for the hostage, and was imprisoned. Nobody told me why, for how long, or to what purpose."

The Nazis were in a stalemate, chasing their infuriating prey. They set up a meeting in Paris. Bernhard arrived in an impeccable suit. Outwardly, it was like a business meeting, albeit a rather coercive one. The emissaries told Bernhard that if he wanted to see his brother alive, he should sign his client payment accounts over to them.

The Reich also demanded his Paris assets, with an arrogance that the canny Bernhard noted with great interest. The Germans were not yet in France, yet they already felt entitled to Jewish businesses in Paris. Interesting.

They ordered Bernhard to promise never to produce his well-known brand, Bernhard Altmann, anywhere else, to avoid competition with the

factory they had confiscated. Bernhard wanted to laugh out loud—who the hell did they think they were? But he maintained his stern poker face, puffing on his cigar. "I'll do as you wish," Bernhard lied. "But first you must release my brother."

Since Fritz's last name began with an A, he was among the first to have his head shaved. As the afternoon wore on, the prisoners were registered, shaved, and insulted, until they stood exhausted before the camp commander in their baggy tunics with Stars of David fashioned with red and yellow triangles.

The men had not slept in thirty hours. Fritz stumbled to the barracks where he would sleep. Sunburned, dazed, and numb, he lay down on his wooden plank and passed out. At 3:30 a.m., the men stood before the guards as they took roll call, punctuated with "Jewish swine!"

"Everything in Dachau is prohibited," a commander told new prisoners. "Even life itself. If it happens, it happens by accident."

Fritz and the other men dug ditches and carted cement. The day went on endlessly into the evening. Those who fell down were flogged. Finally, at 9 p.m., they were relieved. They staggered to dinner. Men in their sixties and seventies—as old as his father-in-law, Gustav, Fritz shuddered—appeared near collapse. Fritz wondered how long they could make it. A few days after they arrived, they were forced to stand at attendance for hours while guards searched the camp and its surroundings for a missing prisoner. They finally found him. He was an old man, dead in his bed.

Work makes freedom!

What a lie, thought Fritz, who had never in his life performed arduous labor.

In Fritz's experience, the people who extolled the virtues of work were people who wanted other people to toil for them.

They're going to work us to death, the "Jewish swine," Fritz thought.

But the prisoners were not all Jewish. Some of the five hundred men at the camp were gay, with pink triangles, Communists and socialists with red triangles, while black triangles were used for "anti-social elements."

The deposed mayor of Vienna, Richard Schmitz, a Catholic, was in the camp for refusing to hand over City Hall. Also in Dachau, unbelievably, were Ernst and Maximilian Hohenberg, the sons of the last heir to the Habsburg throne, Archduke Franz Ferdinand, whose assassination in 1914 had set off World War I. The other prisoners, startled to be mingling

with Habsburgs, addressed them as "Your Royal Highness." The men bore their ordeal stoically, their stony faces doing little to disguise their disdain.

Fritz was delighted when Grünbaum, the social satirist, was assigned to his barracks. Grünbaum was well-known in the cabarets of Berlin and Vienna. One of the letters asking for Grünbaum's release was written from the Chateau Marmont hotel in Hollywood. Like those of the Marx Brothers, the targets of Grünbaum's humor ran the gamut, from politics— meaning, of course, the Nazis—to himself. Grünbaum was irreverent, wicked, and an astute mimic. He reduced the guards who terrorized them by day into buffoonish, goose-stepping cartoons by night.

But as the days passed, he did it more discreetly.

The camp guards had it in for Grünbaum.

They weren't ashamed to imprison talented people. A Nazi propaganda pamphlet circulating in Vienna had photos of "Jews and Jew Lackeys at the Dachau Resort"—celebrities in uniform. Poor Grünbaum was featured prominently, his famous beloved face squinting into the Dachau sun in a white camp tunic. The Viennese were accustomed to seeing posters of Grünbaum in a dapper smoking jacket, smiling under his mustache and comically raised eyebrows, with his glamorous blonde wife, Lily Herzl, at his side. This new vision was bizarre, another sign of their upside-down world.

Another camp luminary was Herbert Zipper, a former student of Richard Strauss. At the time of his arrest, Zipper had been conductor of the Vienna Madrigal Chorus and the Dusseldorf Symphony.

Now these men, accustomed to applause and autograph seekers, were themselves the audience, for sadistic political theater.

One morning, at roll call, a guard called out a prisoner's number, and added: "Your mother croaked."

Now it was Fritz's turn to soft-pedal reality. He wrote Maria on June 1:

My beloved good wife,

Today I got your precious letter of May 27th, for which I thank you with all my heart. I'm really doing fine here. My body, which has endured mountain hikes, doesn't abandon me here, nor do my good spirits. I'm fresh and healthy. Your baldie has already a nice tanned color and red cheeks. Please send me 15 marks a week . . . Visiting, etc. is not

permitted, my love. Your thoughts watch over me, like a guardian angel.
I can really feel them.

I kiss you, your husband.

Ridiculous, Maria thought. He makes it sound like he's on holiday.

In Vienna they were unfurling banners of Jewish Shylocks with hooked
noses on public buildings. She tried not to imagine what might really be
happening in Dachau.

"I'm fit as a fiddle," Fritz wrote on June 6. "Knowing that my delightful
Marienkinderl and family are doing well gives me strength, courage and
balance," he wrote. "Maria, we have been married for half a year. I am so
happy to have you! I can feel your love so strongly, and it keeps my spirits
up." He asked Maria not to worry about him, and "don't think about com-
ing here, or trying in Vienna." Fritz joked that Therese was "very unlucky
with sons-in-law . . . I will always be totally yours, beloved wife."

The camp guards deliberately set out to dehumanize and disorient the
privileged prisoners. Well-to-do scions like Fritz dug trenches, and com-
posers cleaned latrines. On this level playing field, comedians cheered up
depressed prisoners, and a kindly grocer with a fourth-grade education
became the de facto camp therapist for those who were suicidal. Soccer
games matched gays against Gypsies, or Jews against Communists. Fritz
found himself befriended by burglars who bragged in meticulous detail of
their heists at factories, banks, and jewelry stores. One night, smiling
meaningfully at Fritz, one of the thieves described Bernhard Altmann's
textile factory: where the cash was hidden, when workers were paid, even
the watchman's dog. The burglar was one of the thieves who had broken
into the factory a decade before. They had stolen so much from its safe
that his accomplice had moved to America.

Fritz, sitting on the dirt floor of the barracks, felt a strange lack of out-
rage. These criminals practiced their vocation—stealing—without disguis-
ing their crime with "legal" Aryanization or self-righteous rhetoric about a
German "homeland." Fritz felt only envy, "that I was the person from
whom he had stolen, and not the one safe in the States." In a netherworld
in which social roles had been stripped off like carnival masks, Fritz and
the burglar became fast friends.

Maria's letters filled Fritz with tenderness. "My beloved husband," Maria
wrote on June 17, "Yesterday evening Thea gave birth to a healthy boy.

She and Robert are overjoyed! From Landau and his friends we were told that [you] will soon be on [your] way home. I'm with you every hour, and I dream about our reunion when I'm awake and when I'm sleeping." At the grave of Fritz's father, Carl, "I prayed for you," Maria wrote. "In spite of everything, I'm so incredibly blessed to have you. Your Maria."

Your Maria. Fritz knew things were not fine. He knew he and Maria might never see each other again.

But he clung to her gentle fictions as he drifted off to sleep, exhausted, listening to his bunkmates murmur about a rumor they would be sent to a place called Buchenwald.

Instead, the guards sent Grünbaum.

Maria's letters began to worry Fritz. She must stop going to the Gestapo headquarters at the Metropol to ask for permission to visit him. What if some bored bureaucrat decided to arrest her?

"After your last letter you must have been especially impatient," Fritz wrote on July 3. "Don't let Landau get to you! We didn't mind the time before our engagement, and now we know how much we love each other, even if it takes three times longer" to be reunited, he wrote. "Shame on you, Duckling!"

He reminded Maria that they had been married six months, and joked that if they were lucky, they'd be together again by their first wedding anniversary. "I want you to drive immediately to join your parents in Ischl, you hear me? I will address the next letter to Ischl!"

"I have only one worry: If Peps is going to be well soon. Maybe he can write a few lines?"

A few days later, Fritz's burglar friend asked him if he wasn't married to one of the Vienna Bloch-Bauers. He held up a newspaper obituary for Gustav Bloch-Bauer. He had died on July 2. Peps! His merry father-in-law, who had cried when Maria married but had opened his big heart to his Galician in-laws.

Why hadn't Maria told him?

It was terrible to be unable to speak with her. Fritz was marooned, in an endless limbo. Day after day, he woke to dig ditches in the hot summer sun and then fell into bed for another day of toil. As he worked, he began to sing, over and over, a poem by Wilhelm Muller that Schubert had set to music. It was called "Courage." "When your heart within you

breaks, sing serenely and brightly," he sang to himself. "If no God is here on earth, let's all be gods together!"

Thunder at Twilight

There were many things Maria had not told Fritz.

At the Stubenbastei, Gustav had declined precipitously after the Gestapo stole his Stradivarius and suicide took his best friend. It was as if all the losses of old age had happened overnight. One day, Therese asked Georg, the butler, to go to the butcher. Georg gave her a hard look. "Things will be different now," Georg said, and walked off the job. Emma was ill. So Therese ventured out, looking away from the swastikas hanging from stores. One day she asked the baker for Gustav's favorite pumpkin-seed rolls, but the shopkeeper only glared.

The Gestapo had arrested Maria's brother, Leopold, as a hostage for the assets of his father-in-law. Leopold had managed to flee abroad with a promise of shares of the sugar factory, which Ferdinand had protected in a Swiss bank trust. The "sudden deaths" continued. An entire family committed suicide with weapons the sons had once proudly displayed with their World War I medals.

Gustav begged Therese not to go out again, even for a walk. He was afraid his indomitable wife would never come back.

"Where is Fritzl?" Gustav kept asking. Maria told her father Fritz was still in prison. She didn't dare tell him Fritz was in Dachau.

Gustav now had severe gastrointestinal pain, which couldn't be blamed on nerves. He had suddenly worsened. Therese told Maria her father had cancer and that it had metastasized. They searched for a specialist willing to treat him. Gentile doctors were reluctant or unwilling to treat Jews, and Jewish doctors were on the run or in hiding. The Felsovanyis' Sanatorium Loew, the top private medical center, had been Aryanized. Therese heard it was to be the Vienna headquarters for the German Luftwaffe.

On July 2, Therese looked in on Gustav and realized with a shock that he was gone.

It was inconceivable to hold a service at the Stadt Temple, two blocks

from Gestapo headquarters at the Hotel Metropol. Instead, they quietly placed Gustav's ashes in an urn at the family mausoleum in Central Cemetery, under the gold-lettered plaque of Adele Bloch-Bauer. Hans Mühlbacher played for the funeral service with the two other members of Gustav's quartet. They played Mozart, whose joyous spirit seemed to conjure up the merry Gustav of the old days.

Gustav Rinesch dropped in to check on Maria.

Rinesch was pulling any strings he could on Fritz's behalf, and now his drinking buddies came in handy. One of the Richthofen barons, a nephew of World War I flying ace Manfred von Richthofen, the "Red Baron," was overseeing Aryanized Jewish banks. Rinesch told Richthofen's staff that getting Fritz out of Dachau, alive, would persuade Bernhard to hand over all his foreign accounts.

Rinesch poured Maria some whiskey, but he did most of the drinking. He told Maria he was worried about her. "I don't think you ever knew how much in love with you I was," Rinesch began, after a couple of drinks, his eyes bleary, as if he hadn't been sleeping well.

There was a long, awkward silence.

Maria dreamed of Fritz, dreams where he kissed her again and again, as he had in Paris. Or dreams where Fritz was again the aloof stranger who loved someone else, and Maria would awake feeling haunted and unloved, relieved to remember that Fritz hadn't abandoned her. They had taken him away.

A few weeks after her father died, Maria awoke to loud knocking. It was early. Maria pulled on a dress and drowsily opened the door to stony-faced Gestapo officers. Maria froze. Arrest was commonplace now.

The men parted to reveal a gaunt, sunburnt man, his head fuzzy with short stubble. Fritz! A fragile-looking Fritz, who bore no resemblance to the suave dandy who had won her heart with a romantic ode. But he was alive. Fritz smiled wanly as the Gestapo officers took their leave. Inside the door, he clung to her.

Now Fritz and Maria enjoyed a second honeymoon, conducted in hushed whispers. Fritz was frightened, worried by the guards and the openly hostile world outside. He became feverish, and for days he slept. He awoke ravenously hungry, and asked for Viennese pastries with whipped

cream. "I'm in love with my husband," Maria typed on a sheet of paper one hot afternoon in September, as Fritz slept. "Night and day you are the one, only you beneath the moon and under the sun. In the roaring traffic in the loneliness of my lonely room I think of you."

Rinesch joked that Dachau had turned his rival, Fritz, into "a crew-cut skull, which didn't improve his looks." In the heat of late August, Rinesch spent his days in line at the Palais Albert Rothschild. It was now the new Central Office for Jewish Emigration, presided over by Adolf Eichmann. Rinesch said the mansion had been picked clean of art, furniture, fixtures, everything. The Nazis told Rinesch they wanted Maria's mother, Therese, to sign over any remaining family valuables too. One day, as Rinesch stood in line to get Maria's brother Robert a passport, Gestapo agents came by to kick, insult, and spit on Jews in line. "You don't look like a Jew," a young Gestapo agent remarked to Rinesch. "I'm here for a friend who's sick in bed," Rinesch replied. Robert was sick—with fear. "You Jew lackey," the agent said derisively, laughing at Rinesch. After a lifetime in a Vienna known for its social delicacy, Rinesch was appalled.

Fritz's family was observant. They had welcomed the Sabbath together every Friday evening, with silver candlesticks that were such treasured keepsakes that their father had buried them when the emperor called for donations of metal in World War I. As roving gangs beat Jews on the streets in Vienna, Maria decided to please Fritz with a special celebration of the Jewish holiday Yom Kippur, or the Day of Atonement. Maria was a novice cook. Her dish, Fräulein Emma's Hungarian-style peppers stuffed with spicy meats, was not entirely appropriate. Maria nervously pulled the hot dish from the oven. The peppers spilled all over the floor. She looked up with chagrin. But for the first time since his return, Fritz met her eyes and smiled with conspiratorial amusement, like the old Fritz. After helping her pick the peppers off the floor, he sat down with her and ate them, proclaiming the dish a delectable triumph.

Bernhard finally got them a message: "I have found a way for you to leave. You must do exactly what I say, and tell no one. Wait until you hear from me."

All Saints' Day was approaching. Roving mobs of brownshirts were erupting into spontaneous riots, randomly arresting Jews in the street.

Why are we still here? Maria thought desperately one day, as she walked past Adele and Ferdinand's house on Elisabethstrasse, now dark and shuttered, on her way to the Stubenbastei.

Jahen answered the door at her house, wagging his tail and spinning happily. Silly Jahen! What would become of him? Maria had heard the Nazis shot the dogs of Jewish families right in front of them.

It was very quiet. Emma was sleeping, though it was early afternoon. Emma was very ill. As Therese set the table for lunch, Maria tiptoed into Emma's room and sat on her bed. Emma, her dear nanny, finally opened her eyes. "Emma," Maria whispered. "Fritz and I are going to escape. We'll take you with us." The gray-haired Emma was no longer a young fräulein. Maria was like a daughter to her. Emma smiled, imagining an adventure, a life together, far away. "I love you more than my life," Emma said. "I can't come. I'm too sick." Doctors suspected she had ovarian cancer. Soon Emma would go back to her village. Maria asked Emma to give Jahen to Georg. Georg loved Jahen. Maria hugged Emma. As she left, Emma called out that the jeweler needed to see her.

The jeweler greeted Maria gravely and locked the door. His face was old and lined. He was sober and unsmiling. By now they must have picked his safe clean. Turning in Jewish jewelry was mandatory.

The jeweler opened a small purple flannel bag and revealed two diamond earrings that matched Adele's necklace. He pressed the bag into Maria's hand. "I saved these for you, Maria. They could help you." Meaning, Maria supposed, that they could be used as a bribe. The jeweler attempted a strained smile. "Go with God, Maria."

Maria asked Landau for permission to leave the house with Fritz for a doctor's appointment. They took a city train, getting off at different stations to see if anyone was following. No one seemed to be. Another day, Maria told the guard they were going to the dentist. Listening to the radio, the guard disinterestedly told them to return by five that evening. It was a cloudy fall morning. Maria and Fritz pulled on their raincoats and set off. They walked a few blocks, hailed a cab, and asked to go to the airport. Maria had Adele's diamond earrings in her brassiere. At the airport, a bespectacled man with a cold expression inspected their tickets carefully. A Catholic woman Maria knew had purchased tickets for a small commercial flight to the German city of Cologne.

Since Austria was now Germany, they didn't need passports. Fritz had

no papers. The man waved them to the gate, and Maria breathed a sigh of relief.

When they boarded the plane, a pretty blonde attendant looked Maria over carefully. Maria and Fritz went to the back of the plane and took the last seats. There were only ten other passengers. The plane's propellers whirred, and Maria and Fritz relaxed. Then the propellers spun to a stop. The stairs returned to the plane, and the door of the plane opened. The captain came out of the cockpit, and he looked back at Maria and Fritz. Maria squeezed Fritz's hand. She was terrified. The Gestapo must have learned of Fritz's absence. They would be arrested! Some officials boarded and spoke with the flight crew, who nodded gravely. The pretty attendant asked for their attention. Bad weather at their destination had caused a delay. She thanked the passengers for their patience. Then she approached Maria and Fritz. They froze.

"I was admiring your raincoat," the attendant said to Maria, in a German accent, smiling. "Did you get it in Vienna?"

Forty minutes later the plane took off for Cologne. When they landed, they went to the Gothic cathedral of Cologne to meet the contact who would take them to the Dutch border. They waited nervously for the rest of the afternoon. The man didn't come. "Let's not waste any more time," Fritz said. They boarded a train to the German city of Aachen. There they gave a cabdriver an address in Kohlscheid, a small German town on the border. The driver couldn't find the house. Finally he turned down a one-way street that led to the border post where Germans stood guard. "Let's ask them," the cabdriver said. Oh God no, Maria thought.

Maria asked the cabdriver to drop them off. She and Fritz walked briskly, unsure of where they were going, when Maria suddenly saw a strikingly handsome young priest. "Ah yes, a lot of my people go to him," the priest said, when they showed him the address. "I'll take you."

The priest stopped at the house of a farmer, Jan Servatius Honnef. Honnef was a tall, long-limbed man with high cheekbones, clear blue eyes, and a kind, reassuring smile. He was Dutch and the father of six children. His farmland ran along the German side of the border. The border had always been friendly and porous, until the Nazi takeover.

Jan's son, Josef, worked in a mine a few miles away in Holland, so the family often crossed back and forth every day. Jan had expected Maria and Fritz to arrive the next day, but he welcomed them into his home.

They sat down to a farmer's dinner of chicken and bread with thick slabs of white cheese, washed down with lager. They waited for the change in shifts at the border post they had passed, which would allow a several-minute lull in vigilance. Josef was to be their guide. He was in his early twenties and recently married, with a little girl, Elfriede, who doted on her father. But Josef had expected them to come the following day, and he wasn't there.

So Jan walked them into the crisp fall night. The sky was dark, with stars and a sliver of a moon. Maria had her diamond earrings in her bra. She and Fritz followed Jan through his pasture and over the stepping-stones of a little brook. Jan stopped for a moment and looked at the guards. Then he gingerly held down the barbed wire and whispered "Hop!" to Maria. Maria didn't see the wire in the dark, and she thought he said "Run!" So she charged blindly ahead, falling face forward over the barbed wire into the mud, shredding her silk stockings. She lay there, certain she had given them all away.

Fritz stepped carefully over the wire and helped Maria up.

Jan waved goodbye and melted into the night.

A Dutch man and woman stepped from the shadows, putting their fingers to their lips. "We'll do the talking," the woman whispered.

But they met no Dutch border patrol on their walk to the little hotel in Maastricht. Bernhard had made arrangements with a son-in-law of the chief of police, and the hotel barred the doors behind them.

At dawn, Maria and Fritz ran to catch the train to Amsterdam. In the Dutch capital, Bernhard had a private plane waiting, with champagne and caviar. At Liverpool, Bernhard's contact in Immigration welcomed them warmly, though Fritz had no papers. Bernhard already had a factory in Liverpool. Maria and Fritz stared at each other. It was unreal. They had made it.

Back in Vienna, the Gestapo banged on Therese's door. "Where are your children?" they demanded. Therese had no idea what they were talking about.

The Gestapo returned the next day. "We know your children are in Yugoslavia, and we can find them there," they said.

Luise! But Yugoslavia was unoccupied. Were the Nazis already coveting the Gutmann timber empire? "My children are in England," Therese said evenly. The Gestapo was furious. Bernhard Altmann had managed to get their prime hostage to his fortune out of the country. Bernhard's wife, mistress, his children, and even many of his friends and factory workers had

quietly escaped abroad, with the help of his cash and connections. The Nazis had his Vienna factory, his homes, his furniture and art. But Bernhard had outmaneuvered them. He already had a competing factory in Liverpool.

Maria and Fritz were among the last to make it out on this lifeline. The operation was an open secret, and the Germans soon learned who was running it. They arrested Jan Honnef and deported him to Poland, to a concentration camp outside of Lodz. Jan's six children fled to unoccupied Holland. But when the Nazis invaded Holland in May 1940, Jan's son Josef was packed off to Auschwitz.

Jan survived the war. Josef didn't make it through the first winter. He died in February 1941 at Auschwitz, "where the people he and his father led to freedom were supposed to die," a friend of his wrote to Maria. Josef's daughter, Elfriede, never recovered from the loss of her father. Years later, she cried when survivors wrote to thank the Honnef family for saving their lives.

Decent Honorable People

Now Gustav Rinesch tried to engineer the escape of Maria's brother Robert, Ferdinand Bloch-Bauer's onetime personal secretary.

It wasn't easy. Robert and his wife, Thea, had a newborn, Georg. Thea had a widowed mother, Ada Stern, and a mentally handicapped sister, Susi, who lived on a farm in the Alps. Thea, twenty, had wanted to leave the moment the Anschluss was declared. No one listened to her. Rinesch understood why: the Bloch-Bauers lived in a cozy world, where friendships lasted a lifetime. Even Rinesch couldn't imagine a Vienna in which people he knew joined the SS.

Thea could. Thea had been a baby when her father died in World War I. She went to public schools rife with anti-Semitism, where on field trips, non-Jewish children soaked the bedsheets of Jewish students so they shivered all night. Teachers announced after exams that "all the Jew-

ish students got it wrong," making the boys in the illegal Nazi groups smile. In Thea's neighborhood, people spat at "Jewish swine" like her. For Thea, anti-Semitism meant having a thick skin, and expecting less of people.

This had all changed when she married Robert Bloch-Bauer in 1937. Her pretty sisters-in-law, Maria and Luise, had never been called "Jewish swine." Maria had gone to a private school where most teachers were Jewish. She moved in a cultured, exclusive circle where Jews and Gentiles mingled and married. Maria's brother Leopold was socially prominent and flew his own private plane. Their house was filled with Leopold's hunting trophies. At Ferdinand's Czech castle, there were butlers, cooks, liverymen, chauffeurs, and laundresses. On her first visit, Thea's little Czech maid dissolved in tears. "You don't like me," the maid sobbed. "You never call me to help you dress." Thea was astonished: No one here dressed themselves?

Thea viewed Hitler not as a distant aberration but as an immediate menace. To Thea, the Bloch-Bauers were living in a dream world. But it was a pleasant dream. Thea and Robert had beautifully furnished rooms within walking distance of the Belvedere, with a ruby-colored velvet settee and Biedermeier side chairs with petit-point seats. On their mantel was a magnificent marble clock, with a golden Roman legionnaire on a chariot with two steeds, a wedding present from the Bloch-Bauers.

One day, as Thea and Robert left a movie theater, they spotted vendors selling afternoon newspapers headlined with the Austrian chancellor's summons to meet Hitler at his Eagle's Nest in the Alps. Thea froze. "We have to get out," she said. Robert rolled his eyes. Thea was six months pregnant. Leave?

The day Hitler arrived, Thea watched from her window as the German army marched down the boulevard. Tank after tank rolled by. German bombers roared overhead. "Today Germany belongs to us, tomorrow the world," the soldiers sang. Harassment began immediately. Teenage boys pulled Jews from streetcars and beat them up. Thea, a petite blonde, didn't "look Jewish" to these boys, and she hurried by, hiding her fear. Yet even Therese dismissed the notion of leaving. "We're not going anywhere," her mother-in-law said. "We've always been decent, honorable people." Of course, Thea thought. But that's beside the point.

One day there was a knock at the door. Thea, exhausted from the heat, got up from a nap and peered out warily. It was the janitor, a harmless man. He smiled and made aimless comments about the humidity. Then he

told her that every Sunday, he expected cash. Or else he would report them to the Gestapo as Jews with subversive literature.

Thea stared at him, stunned. She gave him money and he slunk away.

By June 1938, Thea was due to give birth any day. Their car had been confiscated, but Thea knew better than to stop making the payments. She had heard that someone was killed for that. Fritz was in Dachau. Robert was terrified. Gustav Rinesch had warned the family that there would be *razzias,* or house-to-house sweeps, that week to arrest Jews and deport them to concentration camps. Rinesch thought it would be safest for them to move into the hospital.

But was it safer there? Jewish doctors had been turned out of non-Jewish hospitals like the Rudolfinerhaus, a private hospital near the Vienna Woods where Thea was to give birth. Jewish patients were forbidden. The staff had been replaced with Germans. Thea's obstetrician was well-known. He had delivered Thea. Now he was a Jew whom Nazi authorities had ordered to stop practicing medicine.

They could all be arrested.

But the new German head nurse assured the doctor they would not turn him in. When they arrived, the new German hospital staff tucked Robert and another Jewish father into hospital beds, as Aryan "patients."

It was with great fear that the obstetrician nervously brought little Georg into this terrifying world.

The obstetrician carefully examined the wailing Georg and handed him to Thea. Then he hurried down the hall, pulling off his gloves, gown, and cap. At the back door, he broke into a run. He vaulted over the garden wall and fled down the dark street. The doctor had brought new life into the world for the last time in Vienna. Now he had to save his own.

A week later, Thea's father-in-law, Gustav, died. At least poor Gustl is at peace, she thought. Now, with a newborn, how would they get out?

Gay Marriage

Thea's mother, Ada Stern, found her own way to escape from Nazi Vienna. Vienna was becoming a mecca for a small underground of presentable "Aryan" bachelors. Except that these men were gay. Gay culture had flourished in Vienna artistic circles. Now some of its members would be lifesavers.

Some gay men married Jewish women and asked for nothing. Many wanted something in return: money, or a temporary cover of respectability, before the inevitable divorce. Ada found a Dutch "fiancé," Jongman van Genderingen, a distinguished-looking sixty-year-old. His boyfriend offered to marry Ada's cousin. "Naturally," Gustav Rinesch observed, "these gay men had their price. Since they were Dutch they understood diamonds, and the dowry was a diamond ring." Ada bought a solitaire, but Jongman said the diamond wasn't good enough. "At the town hall, they had a heated discussion, back and forth, about the value of this solitaire, and Ada had to exchange it for another." It was a double wedding, witnessed by Rinesch, with "not a word about sentiment, compatibility, or consummating the marriage. The two men spent their wedding night together, at their hotel, and the two women returned to their widow's beds."

Thea found her new stepfather "very decent." Jongman was gravely ill with cancer. He wanted Thea to pay for surgery in Vienna, and his return to Holland.

Thea prayed he would keep his promise to protect her mother and get her out of Austria.

The Orient Express

Rinesch helped Thea and Robert get a twenty-four-hour transit visa to Yugoslavia. At the last minute, Robert hastily stuffed some of Ferdinand's

family papers into a small suitcase, and they took the train to the city of Osijek. Luise took them to a private Gutmann train station above a stone quarry in timberland nearby. There was a cow for fresh milk, and running water to wash Georg's diapers. Luise sent servants with meat, bread, cheese, and vegetables. Luise rarely visited, to avoid drawing attention. There they waited for six weeks.

One day Luise brought them visas for Canada. But they had long over-stayed their twenty-four-hour Yugoslav visas. Rinesch feared they would be arrested boarding the train. Resourceful Luise had an idea. With help from Rinesch, she paid a conductor of the Orient Express to make an unscheduled midnight stop near the little station. Thea packed up their things one night and hiked to the train tracks with Robert. She held little Georg close and prayed he wouldn't cry. The tracks began to sing, and they saw the light of the approaching train. But the cars rumbled by, one by one, until the last cars approached. Thea's heart sank. The train was leaving them behind.

Then the train slowed and groaned to a halt. Robert and Thea stumbled up the embankment in the dark. Without a station platform, the train steps loomed impossibly high. Robert pulled himself up and held out his arms. Thea passed Robert the baby and their suitcases.

Tiny Thea strained to reach the train steps. Robert grabbed her arms and pulled. Thea struggled up to the platform, and the train began to move.

In the little compartment, Thea fell into a fitful sleep. She awoke to find a nervous young Austrian woman with a man who looked at least eighty. Thea thought he was obviously a fake husband. Yugoslav authorities drew the same conclusion. They led the terrified young woman off the train. Thea feigned sleep.

Italian immigration officials weighed Thea and Robert's expired Yugo-slav transit passes against their Canadian visas. The officials finally let them go, assigning a young carabiniere to guard them. Soon the carabiniere was gallantly fetching pretty Thea refreshments, lighting her cigarettes, and shaking his keys for little Georg, as they chugged toward Trieste.

Now Therese, alone at the Stubenbastei, was the focus of the Bloch-Bauer shakedown. The Nazis insisted on their usual legal charade. They wanted Therese to pay an exit tax and to sign a paper leaving the family posses-sions to the state. Therese walked through the empty, beautiful rooms,

with their carved antique furniture, their heavy gold mirrors, the tapestry of the lusty nobleman squeezing the bodacious maiden as the harlequin grinned knowingly.

Stubenbastei, the lonely stage set of the warm family life Therese had built with Gustav. Must she leave all this to *them*?

The days grew cold, short, and gray. One afternoon in November, as twilight fell, a roar rose from the street. Therese peered out the window. Truckloads of uniformed men crowded the Ringstrasse. A mob gathered. A friend called: SS officers were taking axes and crowbars to Jewish businesses, attacking Jews they found in the street!

Men rounded up Jews at a school, and some people were so frightened they jumped out of the windows to their deaths. They were destroying the synagogues. There were fires all over the city.

It was Kristallnacht—the "Night of the Broken Glass"—a dress rehearsal for the unimaginable destruction to come.

Therese's precious Vienna was a bloodthirsty mob. She was cornered. Three days before Christmas, Therese began to sign over her assets.

She had to get out.

The Autograph Hunter

Like the Bloch-Bauers, many of Adele's old friends stayed too long.

"We're going to have to leave," Berta Zuckerkandl told her teenage grandson, Emile, one afternoon in February 1938 as she prepared for a salon in her apartment across from the Burgtheater. "You're exaggerating, Grandmother," good-looking Emile replied, smiling, lying cozily on her sofa as freezing sleet fell outside. "Everything will blow over."

Emile lived part-time with Berta on Oppelgasse, above the Café Landtmann, where Freud once took his morning coffee. It was a five-minute walk to Elisabethstrasse, and Berta's friend Ferdinand Bloch-Bauer. Ferdinand provided financial help to Berta's sister-in-law, Amalie Zuckerkandl, who had been on her own nearby since her husband divorced her for an actress. Amalie's arresting but unfinished Klimt portrait, with bare shoulders and upturned face, hung in Ferdinand's bedroom.

Emile, sixteen, spent the rest of his time at the Zuckerkandls' enormous Purkersdorf Sanatorium on the outskirts of Vienna. Josef Hoffmann had designed the main building for Emile's late uncle, Viktor Zuckerkandl, an industrialist. Emile's family lived in a splendid villa with a foyer dominated by an enormous Klimt painting, *Mohnwiese,* of a lush poppy field with the bright red blooms of an Austrian summer. Close by was the *schloss* of Serena and August Lederer, where Emile admired their statue of a Chinese dragon in the foyer, and their delicately pretty daughter, Elisabeth, the wife of the beer baron Wolfgang Bachofen-Echt.

Berta's salons were still filled with intellectuals. Alma Mahler had come with Gustav Mahler and Walter Gropius, and now she brought Franz Werfel. Felix Salten came, and Bertolt Brecht.

Albert Einstein dropped by Berta's salon after he fled the rise of Hitler in Germany. "Any nonsense can attain importance by virtue of being believed by millions of people," Einstein wrote ruefully in Emile's autograph book.

The writer and cultural critic Egon Friedell thoughtfully wrote Emile a critique of materialism. "If humans, now that at long last it has become obvious that money is dirt, do not understand that money is dirt, they do not deserve for money to be dirt," Friedell wrote.

"For Emile Zuckerkandl, the magnificent grandson of a magnificent grandmother," wrote Fritz Grünbaum, Vienna's Groucho Marx.

"So, you are an autograph hunter," wrote Carl Moll, Alma Mahler's stepfather. "So young and already so corrupted. Do you know where this could lead? To become a cutthroat vandal is no doubt the least! And I am supposed to share that responsibility? Well [Berta] already has more than that on her conscience. Reform yourself!"

Julius Bauer, the portly poet of Bloch-Bauer weddings, wrote that Emile was "a descendant of a noble lineage. Your grandfather was a great man . . . The question of race never blocked his genius. Today that sounds like a fairy tale. You, too, even in the folly of today, will get over that dam."

French celebrity explorer Lucien Audouin-Dubreuil urged Emile to "take notes every day." "One will always forget the days passing, in the midst of the effort and the beauty of the present day, and the hope of the unforeseen in the days to come."

Emile started a diary.

Adele's old friend Stefan Zweig had a few glasses of wine one night and scribbled: "Has not everything that we give already lost its way when it is not transformed into help or love?"

How could they possibly give up this lovely existence? Emile asked Berta

that day in February 1938. Berta smiled at her tall grandson, named for her husband, the late anatomist. She had high hopes for Emile.

At her salon that night, everyone talked about Hitler's latest hateful rally. "For kind remembrance of the speech of Hitler," a writer, Walter Mayering, wrote sarcastically in Emile's book.

Now Hitler was coming.

The sky was blue and cloudless. Emile walked down to the highway. Who were all these people? They pushed up to the roadside, cheering, throwing roses at German troops, weeping with joy. Finally a roar went through the crowd. High above the multitude, Hitler stood in his car, with his hand outstretched. "Heil!" the crowd chanted. Hitler passed very close to Emile, his car moving slowly. If I had a gun, I could kill him, Emile thought.

A few days later, armed men pulled up to the Purkersdorf Sanatorium. Emile's mother was in bed, recovering from a hysterectomy. Emile went upstairs to tell her the men were searching the house. She closed her eyes and sighed. She asked Emile to bring her a robe.

"Burn your diary," she whispered weakly. *"Burn it!"* Emile locked the bathroom door and regretfully held a match to his journal of the year leading up to the Anschluss, fanning the smoke out the window. The men came into the bedroom, and his mother pointed to the drawer where she hid her jewelry.

One man paused before Klimt's poppy field, hanging over the Steinway piano, and studied the exuberant blooms. He pulled it off the wall.

Many of Berta's friends, like Felix Salten, had already fled. Salten knew that men who would burn *Bambi* were capable of far worse. Berta showed up to take refuge in the sanatorium, joined by her friend, Egon Friedell. Friedell was distraught, and he walked the grounds with Berta, berating himself.

Friedell had once suggested that benevolent dictatorship, as in ancient Greece, could defuse modern tensions. Berta had argued that "a dictatorship without a gospel of hatred is impossible." Friedell had insisted that the enlightened dictator should be a man who had never known hatred, "and so he was doubly unhappy when history made him realize his error—when Hitler became dictator of Germany."

Now Austria was in the grip of this destructive man, whose gospel of hatred demanded scapegoats.

Friedell felt guilty. Even anti-Nazi intellectuals like himself had frittered away precious time in the world of culture, disdainfully leaving the sordid business of government to the hack politicians who had ushered in this fratricidal present. "One has to pay for one's sins," Friedell kept repeating to Berta.

A few days later, at his apartment, Friedell heard a loud knocking in the hall. It was the Gestapo. Friedell thought they were coming for him. He walked to his open window and dove out to his death.

Stealing Beauty

Klimt's mosaic of Jewish patrons and friends would be pried apart, piece by piece, by men incapable of creating beauty but determined to steal it. The plunder of the families who gave Vienna its luster would not be engineered by mobs. It would be carried out by well-dressed gentlemen with pretensions to genteel respectability.

On the cold morning of January 28, 1939, an eminent group of Austrian art curators gathered at Ferdinand's elegant Elisabethstrasse palace to divide up Ferdinand and Adele's art.

Like many Aryanizations, this one had a flimsy legal pretext: a trumped-up tax charge against Ferdinand's sugar factory. But it hardly mattered. The Bloch-Bauers were now exiles. They were free to scatter Ferdinand's collection like a smashed piñata.

It might appear unseemly for academic art lovers to lend their expertise to the bizarre mix of "law," eugenics, and thievery called "Aryanization." Yet these learned men eagerly fought for the chance to come to Elisabethstrasse to choose art for Hitler's monument to Germanic culture, the "Führermuseum" in Linz, Austria, that would be the jewel in the crown of the thousand-year Reich. Art was not just an interest for Hitler, it was an obsession, and these men wished to ingratiate themselves with his new regime.

Art curators had always had a symbiotic relationship with monied elites. The new elites just happened to be Nazis. These men didn't think of themselves as thieves. They thought of themselves as a distinguished gathering,

though their discriminating aesthetic sensibilities would be used to bolster Nazi conceits.

They were men with precisely the kind of imperious self-regard that Klimt had detested. Not only were they accommodating Hitler, they were endorsing the Führer's rejection of the world's brilliant modern art— a betrayal of their profession. Worse, some of the treasures they pulled out of Viennese collections would be sold for a more nefarious aim: to finance Hitler's assault on Europe.

Since the day of the Anschluss, the confiscation of Vienna's vast Jewish art collections had become an irresistible opportunity for career advancement and financial gain.

"Thousands of Jews were fleeing the city voluntarily or by force," wrote a young art historian, Walter Frodl, who had joined the Nazi Party as a student in 1933. "Before finishing the necessary paperwork they had to apply for an export permit for their artworks. The few functionaries at the office had to work day and night." Frodl "spent weeks that summer and fall in Vienna, driving through the boroughs by cab. I found this whole job rather disgusting. It was not just about visiting big houses and collections, but every apartment had to be inspected, even if the 'artwork' was just a cheap carpet, a piece of embroidery or a photograph of the grandparents."

Now a meticulous team of art appraisers would sift through the collections of Ferdinand and Adele. The man sent to evaluate Ferdinand's porcelain was one of his old "friends," Richard Ernst, who had helped persuade Ferdinand to pay the bills for the Kokoschka exhibition in 1937.

Ernst had insinuated himself into the Elisabethstrasse mansion in 1925 to write an admiring illustrated monograph about Ferdinand's porcelain. Now he could get his hands on the porcelain itself.

Leopold Rupprecht represented the Vienna Art History Museum, the Kunsthistorisches, at the meeting, though he would soon start working for Hitler's Führermuseum. The federal monument office, which oversaw art confiscations, sent Josef Zykan and Waltraud Oberwalder, who would list works they coveted as Austrian "patrimony," to be banned for export so their owners could not take them out of the country.

Vienna art institutions had turned out to be more corrupt than Klimt had ever imagined.

The dream of a new Austrian Gallery at the Belvedere was extinguished.

Adele's old friend, Belvedere director Franz Martin Haberditzl, was tainted by his association with "degenerate artists" and his Jewish ties. His

wife's Jewish heritage meant his daughter was also in danger. Haberditzl was abruptly dismissed and banned from contact with museum staff. His Jewish deputy, Heinrich Schwarz, "relieved of his duties for racial reasons," fled the country.

In this fearful climate, Haberditzl's second deputy, Bruno Grimschitz, won a promotion to a post he might never have attained on merit. Grimschitz, who now flaunted the fact that he had been a Nazi Party member even when it was illegal, was named the new director of the Austrian Gallery.

Grimschitz stood in the Belvedere gardens wearing a black suit with a bow tie, a white pocket handkerchief, and a very pleased smile. He closed the Moderne Galerie, which had been re-created by Haberditzl and his visionary patrons. Later, he would claim he had wanted to protect the art from being seized as degenerate and auctioned off. For now, Grimschitz would display art that was in keeping with Hitler's definition of Germanic *völkisch* identity.

The Austrian Gallery's new mission was quite different from the original one.

Kajetan Mühlmann, a Nazi aesthete who inspected Aryanized property to "collect" art for Hitler, had been given an apartment at the Belvedere. "He has no conscience; he does not care about art, he is a liar and a vile person," an Allied interrogator would one day say of Mühlmann.

For now, one of his first tasks was to pick through Bernhard Altmann's art collection, more than a hundred works by Klimt, Degas, Canaletto, and Waldmüller that had been turned over by Maria's minder, Felix Landau.

The fact that Jews were publicly deemed antithetical to the new Germanic cultural identity undermined any personal qualms about stealing their art. Museum officials came back to Ferdinand's *palais* on February 22, and the Gestapo's Herr Maloch stood by as officials began what Karl Wagner, the director of the Stadtische Sammlungen, called a "negotiation between agencies."

Museum officials tried to identify paintings that they could use to jockey for position with Hitler. As the men walked through Ferdinand's drafty mansion, they spotted paintings that would be perfect for the "Führer's reserve," or *Führervorbehalt:* Hitler's personal art stash—a collection of all the beautiful things Hitler coveted but had been denied as a poor artist in Vienna.

Hitler's conservative taste in art was well-known. Two Rudolf von Alt

paintings were selected from Ferdinand's collection for Hitler's ongoing "Alt Aktion"—a Nazi grab of von Alt's work. Next came Ferdinand's dynastic Waldmüller of Count Esterhazy as a boy. Rodin's bronze *Allegory of Liberty* was picked for the Führermuseum. A tapestry was chosen, and two more Waldmüllers.

Elisabethstrasse was a gold mine.

Some of the best paintings in Ferdinand's collection would be given away to cement relationships. Hermann Göring, whose wife supposedly wore Adele's diamond necklace, would be flattered with four Bloch-Bauer Waldmüllers for Christmas: *Children with a Vat of Grapes, Young Girl with a Dog, Old Woman with Children,* and *After the Fire.*

Ferdinand's porcelain would be passed out to museums like party favors, and the remaining pieces would go to public auction.

The men mostly ignored the Klimts. They eyed Klimt's 1903 *Birch Trees* indifferently. They barely glanced at the portrait of the older Adele with stained teeth, and didn't even jump at the golden portrait of Adele.

The Führer wanted paintings that celebrated German values, not portraits of decadent Jewish society women—who were now officially referred to by the ugly term *Judensau,* or Jewish sow.

Klimt was not even on the list of artists whose work was too important to leave the country. Excited by their loot, the curators left the mansion without the Bloch-Bauer Klimt collection.

Hitler, once excluded from the Vienna art world, now controlled it absolutely, and everyone felt his influence, from dispossessed collectors to the most prominent Vienna artists. As Vienna's Jewish collections were plundered, plans were made to dispose of the degenerate art seized from museums with a public auction.

Oskar Kokoschka had four hundred of his works confiscated. From exile in England, he railed to Alma Mahler about Hitler, "momentarily Lord of the World, who has begun, out of resentment, to hunt artists, because he himself failed to make it."

Carl Moll, Alma Mahler's stepfather, the Secessionist painter whom Kokoschka had once called "my best friend in Austria," now embraced Nazism. He chastised Kokoschka for his intransigence. "I would like to do something to help you, but your politics make it impossible," Moll wrote from Vienna. "America is the only place for you now.

"There are 75 million people," Moll wrote, referring to the population of the Third Reich, "and the fact that some people get trampled, what does it mean? Has this not always happened?"

And by the way, Moll added, "Uncle Ferdinand has left Vienna without saying goodbye."

The Last of the Bloch-Bauers

In August 1939, Hitler was massing troops on the Polish border.

Thea's mother, Ada, had put the Dutch flag of her gay husband on her door. He and his boyfriend had smuggled out as much of her money and jewelry as they could. Now Ada was nervously awaiting her exit papers, as people like her were being arrested all over Vienna.

She couldn't take money or jewelry, so she went on a frenzied clothes-shopping spree, buying up silk dresses, fine lingerie, smart new shoes. The more nervous she became, the more she shopped. In the midst of it, she got an urgent call from Holland: Don't wait any longer, her husband said. Meet me at the Swiss border. War is imminent, and you will be trapped.

Ada and Gustav Rinesch rented two Packard sedans for Ada's trunks of clothes. They stopped in the Alps, at Alt Aussee, to see Ada's mentally handicapped daughter, Susi. Ada gave money to the farmer who cared for Susi and promised to send more, though soon the farmer would write to tell her there was no need. Doctors had "euthanized" Susi, a "useless feeder," in the Nazi program of "mercy killings" of disabled children.

They reached the Swiss border at midnight. Ada's faithful Dutch husband stood there in the rain. German border guards pulled open Ada's trunks. They threw her silk dresses and lingerie on the ground and walked on them with muddy boots. Ada sat on a trunk and sobbed. The German guards laughed. They let Ada cross.

Hitler declared war on Poland the next day.

Rinesch had packed off the last straggler of the Bloch-Bauers, the glamorous family he had once hoped to marry into. "So the whole Bloch-Bauer family—respected old Austrian and Viennese citizens, connoisseurs and art collectors—had been turned into 'Jewish swine,' and kicked out of the German Reich," Rinesch wrote. "People hated them because they were educated, rich, and supported culture, art, history and science," Rinesch

wrote. "The lovely Bloch-Bauers, whose destinies, tragedies and travails touched me and moved me, and could fill several romance novels."

With that, Rinesch reported to the German army. He was assigned to be a translator at Stalag 17, the notorious prison camp that would be immortalized in a Hollywood film by Billy Wilder.

Homecoming

Gustav Ucicky was a prominent Nazi propaganda filmmaker, who dined out on his status as an illegitimate son of Gustav Klimt. Now he was scouring Vienna for paintings by his father that were being stolen from Viennese Jews.

Ucicky bought the ethereal portrait of Anton Felsovanyi's beautiful mother. Gertrud had left it with a baroness friend when she fled. The baroness was now the mistress of an SS leader and Gertrud Felsovanyi's art and jewelry was trickling into the black market. Ucicky bought the sensual, undulating women of *Water Snakes,* stolen from Jenny Steiner, a sister of Serena Lederer who had fled Vienna.

Not all Klimt's children could afford art. The Gustav born to Mizzi Zimmermann was a World War I veteran who now enlisted in the German army for a second round as cannon fodder. Mizzi sold all her Klimt drawings to support her son, whom she was unable to launch out of working-class obscurity.

But Ucicky was an established film director. He had money and access. He was obsessed with the art of a father he had seldom seen. He was vain about his looks. He dressed theatrically in black, letting tendrils of his wavy hair fall over his large, wide-set eyes. He was friendly, curious, intelligent, and deeply insecure about his childhood of squalor with his mother, Maria Ucicka, a poor Czech laundress.

Ucicky might have followed the path of his Viennese colleague Billy Wilder and become a world-class director. He began brilliantly enough. At seventeen, in 1916, Ucicky wandered into Vienna's first major film studio, Sascha Films, owned by the notoriously corpulent Count Alexander Joseph "Sascha" Kolowrat-Krakowsky. Ucicky was hired as a camera assis-

tant. Soon he was working with a promising young director, Michael Curtiz.

In 1927, Ucicky was asked to direct *Café Electric,* starring Willi Forst, a famous stage actor then appearing in Vienna in a musical, *Broadway. Café Electric* followed a young dance-hall girl, Erni, from her initiation into bohemian café society to her descent into a demimonde of seduction and heartbreak. Forst suggested his *Broadway* co-star, a sultry young German named Marlene Dietrich, for the part.

Dietrich had her own ideas about the role, and she was anything but compliant. Perhaps Ucicky was unnerved by the raw sexuality with which Dietrich infused Erni. He didn't want her for the role. But Forst threatened to quit if Dietrich wasn't in the picture. Ucicky was stuck with Dietrich.

Ucicky's boss, Count Sascha, became obsessed with Dietrich, and wanted her for his next films. But the count's health was poor. He was forced to watch *Café Electric* from his hospital bed. Dietrich was critically praised for her portrayal of a sloe-eyed masochistic femme fatale, a blue angel sinking into hedonism.

National Socialism was opening a lot of doors to opportunistic young men like Ucicky. He began to drift into Nazi circles. Marlene Dietrich, by then renowned for *The Blue Angel,* snubbed him. She began to polish her English, seeing hatred where her countrymen saw pride and the promise of jobs. By 1930 Dietrich had gone to America.

In 1933, Hitler was appointed chancellor, and Ucicky became a "sponsoring member of the SS." Perhaps he had found the family and fellowship he craved. More likely it was a career move. Young Ucicky was made a director at the national film institute, which was now controlled by Joseph Goebbels. He began to sport a swastika on his lapel.

Wilder was Jewish. He began packing his bags.

Where his peers saw darkness, Ucicky saw opportunity. He directed a mendacious little Nazi propaganda film, *Refugees,* about a German village imperiled by menacing dark-skinned Slavs eager to ravish blonde German women. A German officer modeled on Adolf Hitler comes to the rescue.

Nazi films about rapacious Slavs or malignant Jews were a deadly serious effort to motivate German soldiers who would be ordered to kill ethnic "enemies." One typical propaganda film of the time portrayed Germans locked in concentration camps and brutalized by murderous Poles.

In 1934, Ucicky's *Refugees* was awarded the first State Film prize, created by Goebbels for films that glorified National Socialism. His next film,

Morgenrot (Dawn), about a German submarine commander, was screened by Hitler three days after he took office as chancellor.

Ucicky had made his choice.

One night in 1935, Ucicky was sipping wine at the apartment of a screenwriter when Billy Wilder sauntered in. Eying Ucicky, Wilder remarked, "For me, the air stinks with a Nazi in the room." Wilder walked out, went into exile, and fulfilled his promise as a cinematic genius.

Ucicky returned to Hitler's Vienna as a key player at the quirky old film studio of Count Sascha—now an efficient Nazi outfit renamed Vienna Film. Ucicky was a darling of the Führer. In 1939, Ucicky mingled with Hitler and Goebbels at festivities for Richard Strauss's opera *Friedenstag,* which were also a celebration of the composer's seventy-fifth birthday.

Strauss was an uneasy camp follower. His daughter-in-law, Alice, was Jewish, and her family was in danger. In 1935, Strauss had refused to remove the name of librettist Stefan Zweig from the German playbill of one of his operas. "Do you suppose Mozart was consciously 'Aryan' when he composed?" Strauss grumbled in a letter to Zweig that was intercepted by the Gestapo.

Ucicky had no pesky qualms. He waved over opera singer Hans Hotter to offer him a film role, and invited him to meet Hitler. Ucicky recruited one of Vienna's greatest actresses, Paula Wessely, who had once brought Maria Altmann to tears as a victim of unrequited love in Schnitzler's *Liebelei.* He persuaded Wessely to star in *Homecoming,* a propaganda film about "a handful of German people whose forefathers emigrated East," to Poland.

Wessely played Marie, the schoolteacher jeopardized by the brutal Polish police who torch her German school. The Poles herd German men, women, and children into prison cells. As they prepare to shoot them, "German tanks arrive, proving that the Führer always acts in time," the Nazi playbill for the film said.

Ucicky's film presciently foreshadowed tactics the Germans would use in Poland. As Ucicky built his luxury villa, his films paved the way for the murderous German offensive on the East. Austrian Nobel laureate Elfriede Jelinek would someday call Ucicky's *Homecoming* "the worst propaganda feature of the Nazis."

Newly rich with Nazi wealth, Ucicky began to hunt for his father's stolen paintings, with the help of Vienna's top Nazi, Baldur von Schirach, the Gauleiter, or Reich governor, of Vienna.

Ucicky got one Klimt from the Dorotheum auction house, then a clear-

inghouse for Aryanized valuables stolen from Jewish families. This paint-
ing had belonged to Bernhard Altmann. It was a small portrait of a young
woman, her face fraught with vulnerability. Ucicky apparently suspected
that the beleaguered woman in the painting was his poor laundress mother.

Now Ucicky wanted to see the rest of the Bloch-Bauer Klimt collection.

Führer

The fate of the Bloch-Bauer Klimts was left to Erich Führer, a hatchet-faced,
arrogant hack of a lawyer with a pedigree to match his serendipitous name.
Führer, an early illegal Nazi Party member, had helped defend the plotters
of the failed 1934 Nazi coup that fatally wounded the Austrian chancellor,
Engelbert Dollfuss. Führer ended up in jail with the plotters—one of
whom was Felix Landau—for six months. Führer's reward was a post as
vice president of the Austrian bar association, now gutted of its Jewish
lawyers.

Since the Anschluss, Führer had become a legal double agent, a vulture
lawyer, awarded the lucrative concession for managing the state theft of
property of Jewish families whom Führer quietly plotted to fleece person-
ally. Führer would compile a distinguished roster of desperate clients,
including Richard Strauss's poor Jewish daughter-in-law, Alice; Serena
Lederer and her daughter, Elisabeth Bachofen-Echt; Louis Rothschild;
Freud's four sisters—and now poor Ferdinand. They may not have been
aware that Führer had been promoted to the rank of SS Hauptsturm-
führer.

Führer sent Ferdinand obsequious birthday cards. Behind his back, Füh-
rer called Ferdinand an "ugly Jew," and secretly disregarded his wishes.
Führer was going to cash in on the Klimts.

Klimt's son, Gustav Ucicky, soon learned who controlled the Bloch-
Bauer Klimts. He tracked down Erich Führer. Ucicky coveted *Schloss Kam-
mer am Attersee,* which was hanging in the Belvedere. *Schloss Kammer am
Attersee* was a lovely painting of the beautiful golden yellow Habsburg
castle at Seewalchen, down the road from the Villa Paulick, where Klimt
vacationed with Emilie Flöge. Ferdinand had donated the painting to the
museum in 1936, deferring to Adele's wishes.

Führer had a solution. On September 30, 1941, he met with Grimschitz, the new Belvedere director, to cut a deal. He proposed to buy *Schloss Kammer am Attersee* from the Belvedere. In return the Belvedere would get two paintings that Erich Führer controlled as the Nazi-appointed "representative" of Ferdinand Bloch-Bauer. One was Klimt's botanical explosion, *Apple Tree*. The other was the spectacular gold portrait of Ferdinand's long-dead wife, Adele Bloch-Bauer.

The German art collectors for Hitler's Führermuseum weren't interested in Adele's gold portrait. But the painting was a familiar icon to Austrians at the Belvedere. Thanks to Ferdinand's generosity in lending it to shows abroad, it had become a visual talisman of the country of Strauss and Mozart at a time when Austria was struggling to forge a new identity.

Erich Führer, the Nazi lawyer who helped the Reich fleece Ferdinand, 1965.

The deal was struck.

Führer sent the gold portrait of Adele to the Belvedere with an obsequious letter signed "Heil Hitler!" The Belvedere art historians knew, of course, that Adele Bloch-Bauer was Jewish, the wife of the man whom government Aryanization files called "the Jew Ferdinand Israel Bloch-Bauer." But the painting could be reinvented, just as Ferdinand and Adele's Elisabethstrasse mansion was being refitted with offices for the German Railways.

Adele's identity disappeared with a simple stroke of the pen.

Her gold portrait turned up in a book that announced the Belvedere's acquisition, in the winter of 1941, of an "awe-inspiring portrait of a woman covered with a shimmering crust of gold. Perhaps the most significant of [Klimt's] works, the dark head emerges, as if drowning in gold, the golden ornaments transporting her from the realm of the ordinary. We are beheld by a goddess, but not from afar, like the solemn, sainted gold mosaics of Ravenna." This was an earthly goddess, a Judith "with an unrestrained sensuality, like a wild Salome in flames," wrote the author of the 1942 book *Gustav Klimt: An Artist from Vienna*. Strangely, he did not identify this illustrious painting, perhaps to avoid drawing attention to a backroom deal involving people he knew personally, or to the origins of a woman who was now a racial enemy.

An illustration in the book gave the gold portrait of Adele Bloch-Bauer a new German title: *Dame in Gold*.

The author of this cover-up was Klimt's old friend, the writer and set designer Emil Pirchan, who had once praised the artist's virile physique, and had likely known Adele personally. It was a sad end to Pirchan's long and rich career. "*Heil* Klimt the Hero!" Pirchan wrote.

Adele, the long-haired sylph with the Grecian gown and tedious wedding poem, was no more. The wealthy muse of Klimt, his patron, his friend, and perhaps much more, was wiped away. Adele Bloch-Bauer was now simply the "Lady in Gold."

Nazis in the Family

For most Klimt patrons, erasing the Jewish stain wasn't quite so easy.

Jewish society families who had supported the Secession with Adele and Ferdinand Bloch-Bauer were now intermarried with Gentile aristocratic families. The Nuremberg laws banned marriage between Germans and Jews, putting these families in a precarious position.

The daughter of August and Serena Lederer had married into a Gentile brewing dynasty and was now Baroness Elisabeth Bachofen-Echt. Elisabeth and her mother, Serena, had been painted by Klimt, as had Serena's mother, Charlotte Pulitzer.

They had imagined themselves members of Austrian society. Now, with the Nazi takeover, they were simply unwanted Jews. Serena had been slapped with the usual trumped-up tax charge against Jews, and she was fighting it, unaware that this would be futile.

Elisabeth was in despair. Her four-year-old son had died after the Anschluss. Her "Aryan" husband, Baron Wolfgang Bachofen-Echt, demanded a divorce from Elisabeth in August 1938, and her property was being transferred to him.

How this sinister predicament had befallen the delicate Elisabeth, raised under the careful tutelage of Gustav Klimt himself, was difficult to com-

prehend. As Klimt had once admonished, Elisabeth had not grown into a silly "petit-bourgeois." Elisabeth, a sculptor, was shy and gentle, with deep convictions. In Klimt's portrait, she was ethereal, fragile, with enormous dark eyes, and surrounded by powerful Chinese dragons that resembled the statue in the foyer of her parents' country home. In life, the girl whom Gustav Rinesch nicknamed "Beautiful Lisl" was a soft-spoken hothouse flower, determined to live her ideals.

When Hitler arrived, Elisabeth, refined and trusting, remained in Vienna to care for her dying child.

The Lederer name might never have been joined with the Bachofen-Echt barons if August Lederer had not been so successful. When Elisabeth met Baron Wolfgang Bachofen-Echt, he was an heir to one of Austria's biggest beer breweries, the Nusdorf. The Bachofens had only become barons in 1906, and their title was abolished after World War I. But they still used it.

The Bachofen-Echt brothers were drinking buddies of Elisabeth's brother, Erich, and Gustav Rinesch, Maria Bloch-Bauer's old admirer. Handsome Wolfgang was in no rush to marry. He and his brothers were playboys. Even in a beer-loving country, the family had managed to drain the finances of the family brewery.

Elisabeth Lederer was conspicuously eligible. She was from a wealthy family with a stately town home and a lovely *schloss,* or great house, on the outskirts of Vienna. She was also beautiful.

Elisabeth had a Jewish surname. But that could be remedied by marriage. By then intermarriage between Jews and Gentiles was hardly rare among the urban elite. There were advantages to marrying Jewish girls. In a patriarchal Austria in which the eldest son, or even a nephew, was still often given control of the inheritance, Jewish fathers willed substantial sums to their daughters.

The high-minded Klimt protégée was no match for the well-practiced charms of rugged Wolfgang. Elisabeth left the Israelite community to convert to Wolfgang's Protestant Helvetian Church and marry him on July 17, 1921.

"Wolfgang did not marry the beautiful Lisl for the Lederer money," his friend Gustav Rinesch wrote, adding, "Of course, the money was no hindrance."

August dutifully bailed out the brewery and installed the couple in a well-appointed building on lovely Jacquingasse, facing the Belvedere gardens.

They finally had a child in 1934. But little August Anton had serious health problems from birth. When Hitler marched into Vienna, the child was very ill.

From the moment they arrived, Elisabeth had an "insane fear" of the Nazis, Rinesch wrote. Her husband found himself saddled with a prominent Jewish wife.

It could hardly have been reassuring that Wolfgang's brother Eberhard immediately applied to become an SS officer. To prove his loyalty, Eberhard noted on his application that he had joined the Austrian Nazi Party in 1933, when it was illegal, and that he had become a brownshirt in 1934.

As Elisabeth struggled with these chilling realities, her crippled little boy died on July 5, a few days before the seventeenth anniversary of her ill-conceived marriage to Wolfgang. Elisabeth collapsed. At the cemetery, "the stricken mother refused any attempts to console her, and didn't want to leave the grave of her child," Rinesch recalled. Wolfgang was more decisive. On August 17, he unilaterally divorced Elisabeth in a Nazi court.

Wolfgang may have kept a secret from Elisabeth: he too had joined the Austrian Nazi Party in 1933. Rinesch said Wolfgang was terribly anguished by Elisabeth's plight.

If so, it was too late for regrets.

Wolfgang now received the title to his wife's shares in the beer brewery and the building on Jacquingasse, though Elisabeth was allowed to remain there, at least for now. Elisabeth had lost everything.

For a time, Elisabeth was simply in shock. She sat behind the long silk drapes at her elegant home at Jacquingasse, looking over the Belvedere gardens and pondering her fate as a racial outcast in a country that no longer existed, the sensitive, doe-eyed girl in her Klimt portrait a fragile relic of a gentler era.

"Above the Mob"

As the purple lilacs bloomed in the terrifying Vienna spring of April 1939, Elisabeth sat down and began a memoir of her idyllic, privileged childhood with Gustav Klimt. The personal reflection must have provided an island of peace, but that may not have been her main motive. Elisabeth was desperately afraid.

Now Klimt's roguish reputation would come in handy.

"My memories of Gustav Klimt go back to my earliest childhood, at the time when the consciousness of the ego and thoughts were being formed," Elisabeth began, in the Freudian lexicon of her childhood.

When she was just learning to speak, she wrote, she would crow with delight when she heard the deep baritone that announced Klimt's arrival. The bearlike Klimt lifted her to his shoulders and spun her around until she was dizzy with joy.

When Elisabeth was older, she wandered through Klimt's studio, playing with his cats, Peter and Murl, while Klimt painted a portrait of her mother. Klimt let Elisabeth play with one of his little kittens. How she cried when Klimt found the kitten a home!

She called him "Uncle."

At elementary school, Elisabeth's teacher was impressed when she told him that Gustav Klimt had already taught her to read. Klimt told her stories by Confucius and Lao-tzu, and introduced her to Japanese and Chinese art.

Klimt defended Elisabeth when she wrote her own fantasy stories instead of class assignments. "I won't let her become a little monkey, she should keep her creativity!" Klimt declared in an argument with Serena, before storming out of the house.

"I was certainly not to become a little bourgeois. He saw to that," Elisabeth wrote.

One day Klimt took her to the Gauguin exhibition at the old Miethke Gallery, where Klimt had exhibited his erotic drawings that were denounced as pornography. Gauguin's Tahiti paintings were "a whole new world," Elisabeth wrote. "And while the people around us criticized the Impressionists, even as a very young girl, I had the feeling I 'stood above the mob,'

as [Klimt] himself put it, and a conscious identification with him was developing inside of me."

Klimt took her to an exhibition of Cézanne, one of his great influences. An art historian told Klimt that "the little one should maybe wait outside, for she would be bored." "You! She knows more about Cézanne than you do!" Klimt retorted dismissively.

When Elisabeth showed Klimt a tiny ceramic dancer she made from a piece of clay, "he decided immediately that I should take up sculpting." She gave her parents the ceramic dancer for Christmas.

Her father's brother smirked maliciously: "Well, well, bohemian." The uncle turned to Elisabeth's father. "I would really suppress these inclinations," he said. "I think we have demonstrated quite enough patience." Serena rushed out of the room, furious. Elisabeth asked her mother to explain these tensions, but "I was rebuffed," Elisabeth wrote. "She said I was too young to understand."

The sculptor Heinrich Zita was Elisabeth's art instructor. When she unveiled her first relief in 1908, sculptor Rudolf Weyr came to look at it with Klimt. Weyr "shook Klimt's hand, grabbed his shoulders, seemed very moved and said passionately, his words still ringing in my ears, 'You can really see the family resemblance.'"

Soon, "Papa categorically told Mama that he forbade her to go to Uncle's studio, and that within the family there was already too much talk about me," Elisabeth wrote.

They went anyway. One day Elisabeth fell asleep there on a divan, and "when I woke up, [Klimt] was there, with a married lady that was part of the circle of the friends of my parents. His behavior didn't leave any doubt of his feelings for this known beautiful woman." Elisabeth burst into tears.

Klimt took her in his arms. "Who do you really love?" Elisabeth asked Klimt. "Your mother, you silly girl," Klimt replied.

At school Elisabeth defended Klimt against a "malicious remark" by a daughter of the Baron Gutmann de Gelse, who "told me openly that the whole world knew whose daughter I was. Her parents were convinced of it, she said."

This suspicion caused tension even in her own family, Elisabeth wrote. When she got older, her paternal grandmother died, leaving Elisabeth a substantial sum. But her father renounced the inheritance. "That's how my suspicion gradually became a legitimate conviction"—that Klimt was in fact her father, she wrote.

When she was fifteen, Klimt convinced her mother to allow her to

draw from nude models at the Kunstgewerbeschule, just off the Stuben-
bastei. Professors objected to exposing a girl to nude models, but they
deferred to Klimt. Her professors watched her work, and one day one
remarked to the others, "completely openly, 'You can see the influence of
the father.' "

Here her association with Klimt was not a scandal but a status symbol.
"Some scholars asked timidly, and with true admiration, about Klimt. And
sometimes I had to tell about his opinions on other artists. When Uncle
came to visit me there one day, there was a real commotion, as if God him-
self had fallen down from heaven."

When Klimt finally painted Elisabeth's portrait, she was treated to
"months of yelling and cursing."

"It was a joy to listen to him. He threw down his pencil many times and
said, 'You should never paint people who are too close to you.' " Klimt
argued with Serena, "and he yelled in his deep beautiful baritone, 'I draw
my girl as I like, and that's final!' "

Klimt painted Elisabeth for three years, "the most beautiful and instruc-
tive hours of my life." Finally, her mother took the painting and loaded it
in her car. Klimt came to see the painting hanging in the Lederer home.
"It's still not her," he mused.

"When I look back now, every word seems meaningful to me," Elisa-
beth wrote.

> Not only has he awakened the love of arts in me, but also the ability to
> understand people. Today, I look at the relationship between him and
> my mother with innermost understanding, and I'm proud that my
> mother was able to captivate him.
>
> His death, for me, was such a terrible blow that I can't even describe
> it. I was paralyzed, and only the singing of the choir of a Beethoven
> piece during his funeral unleashed the tears and all the pain, the first
> tremendous loss I had lived.
>
> His friends were extending condolences, so our relationship didn't
> seem at all a secret anymore. For me, however, it was the end of youth.
> I had only one mission left, to help the world understand Art and its
> meaning.

Elisabeth handed over this deeply personal affidavit, the most detailed
existing account of Klimt's private life, to the Reich authorities on racial
genealogy. It would have gone far to unravel the mystery of the artist's

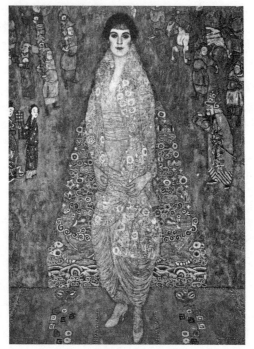

The portrait of Elisabeth Bachofen-Echt
by Gustav Klimt, 1914–16.

psyche—had it not been delivered under duress, to Nazi authorities, in an attempt to protect her from deportation to a concentration camp.

She included photographs given to her by Gustav Ucicky, an acknowledged son of Klimt, to establish a sibling resemblance. She was aided by the fact that Ucicky, too, was seeking legal recognition as Klimt's son.

Elisabeth's mother, Serena, signed a sworn affidavit testifying that Klimt, not her husband August, was the true father of her daughter.

The next step was examination, not by a physician, but by architect Paul Schultze-Naumburg. He was a proponent of eugenics, the pseudoscience that purported to study the genetic basis of race, and had given the world the expression "lowbrow," for the supposedly lower foreheads of southern Europeans and Slavs that were said to denote lesser intelligence.

Elisabeth's handwriting was examined. Her sculptures were scrutinized. According to a perhaps apocryphal account by Gustav Rinesch, the final

proof of paternity rested on a physical anomaly of Klimt, who he said was born missing a rib, a condition purportedly shared by Ucicky and Elisabeth. In March 1940, Schultze-Naumburg announced that Elisabeth's art evinced no "Jewish characteristics."

"If the fully Jewish Lederer was the father it would be absolutely incomprehensible how it was possible that, in her artistic works, there is no expression of a purely Jewish nature," he pronounced. The only explanation was "non-Jewish descent," he wrote, signing his name above a stamp of a swastika.

The utopian generation of turn-of-the-century Vienna was being reclassified by the bureaucrats of the new dystopia.

Elisabeth had been fleeced.

Her jewelry was taken and sold in 1940 at the Dorotheum, the grand European auction house, which was now little more than a Nazi pawnshop. Her former husband now owned her home.

Her mother had fled to Budapest after authorities seized her passport. Serena had failed to get back her precious Klimts. "Why must it be the paintings?" Serena wrote, in a January 1940 appeal from the Schwarzenberg Sanatorium in Budapest, where she lay ill.

Eberhard Bachofen-Echt, one of Elisabeth's former brothers-in-law, had been accepted into the SS in February 1939, and he proudly donned his crisply tailored uniform with its tall leather boots and military cap. He volunteered for the German invasion of Poland.

In March 1940, Elisabeth finally obtained her "certificate of origin." Based on the evidence, it said, "the examinee's descent from Gustav Klimt is not improbable." Elisabeth was declared a *Mischling,* a mongrel, of the first degree.

Elisabeth was saved from outright murder—at least for the moment.

The Viennese Cassandra

In June 1940, as the German army approached Paris, Adele's friend Berta Zuckerkandl fled. The highways were crowded with family cars stuffed with birdcages, candelabras, and dishes. Cars ran out of gas on the road, and families got out and walked. Berta's son, Fritz, persuaded a bus driver to make Berta the last passenger on a bus headed south.

Fritz ran alongside the overcrowded bus, waving. Then he joined thousands of people walking south.

Berta reached Moulins as the Germans overtook the town. A French family waved Berta and another woman into their apartment and hid them. Berta shredded her identity papers. The local pharmacist was a friend of her hosts, and Berta confided in him. He listened thoughtfully and told her he would smuggle her to unoccupied France.

He told Berta to lie on the floor of the backseat of his car, and threw a blanket and clutter over her. The pharmacist reassured her: he often traveled about, helping the ill. When the pharmacist neared the checkpoint, the bored young German guard waved him on.

In Vichy, an old friend got Berta new identity papers. She headed to Montpellier to join her grandson Emile.

But the Germans were closing in on Montpellier, and Emile had already fled, hitchhiking, as his mother, exhausted from surgery and wilting in the heat, sat on their suitcase by the side of the road.

A train packed with refugees took them south. Emile found a man who drove them to Bayonne with his family in exchange for gas money. He dropped them at the harbor.

It was a sweltering day. Bayonne was crowded with refugees. Parents walked forlornly from boat to boat, holding exhausted, uncomprehending children and whatever possessions they could carry.

Emile found a place where his pale mother could sit. Then he walked down the docks, begging crews to take them—anywhere. Captain after captain told Emile no, we're not allowed to take refugees.

Emile headed to the town square. A maelstrom of sweating people with nowhere to go sat in café chairs or on the sidewalk, fanning themselves.

Two familiar faces stepped out of the crowd: Alma Mahler and Franz

Werfel! Emile was as shocked as they were, and they embraced warmly. Werfel was Jewish, and he and Alma were escaping too. Emile told them he had lost Berta. Werfel listened, gazing at the thousands of other people in the same predicament. Tears filled his eyes. Alma, hot, tired, and irritable, snapped: "Why don't you give up on your Jewish love of the neighbor?"

Emile felt as if he had been slapped across the face, though Alma's anti-Semitic cracks were well-known to all of her friends.

Werfel glared at Alma, and Emile fled.

Back at the harbor, a crowd of people milled around a merchant marine ship. The captain was a lean, good-looking man in his forties, with arresting blue eyes. He listened, stony-faced, as refugees begged him to take them. Behind him was the *Kilissi,* a freighter filled with green bananas packed in crates. The captain glanced away impassively. He was under strict orders not to leave the harbor. A German U-boat had just sunk a cargo ship. It wasn't safe.

Perhaps the refugees sensed hesitation in his refusals. Please, they begged. The Germans are drawing near.

The captain sighed wearily. He looked up at the ship, and at the faces of his crewmen who were standing against the guardrails, watching him expectantly.

"D'accord," the captain said finally. "I'll take you."

A roar went through the crowd. The crew jubilantly began to throw the bananas overboard. The refugees pitched in, and a cascade of green bananas splashed into the water. Hundreds of people poured into the boat, with no questions about identity papers or money. Finally the crew raised their hands, shouting, "No more!"

There was a small cannon on deck, and the men strained to push it into the harbor, to avoid giving German vessels any pretext to attack. It tumbled into the water with a mighty splash, and the crew took their positions.

The captain headed out of the harbor, going toward the Bay of Biscay. The passengers had no idea where they were going. The deck was covered with people. When Emile told the captain his mother was recovering from an operation, the captain invited her into his cabin, where she lay on the floor, exhausted.

The freighter hugged the shore to avoid German U-boats. There was a storm that night, and waves washed across the front deck. The captain ordered the people to crowd inside, where there was barely room to stand.

He steered through the pitching sea, his handsome face grave and focused, looking up only to tell Emile where he could find his mother an extra blanket. He let other women join her, until the floor of his cabin was covered. Emile found the captain very *chevaleresque*—gentlemanly.

By dawn the storm had abated. A few days later the captain steered into Lisbon. The *Kilissi* anchored offshore. No one was permitted on land, except the tired, sunburnt captain, who walked off the boat stoically with stern-looking local authorities. The refugees remained onboard, hungry and exhausted. After a few more days, they were ordered to board a much larger French ship that was to take them to Casablanca.

The refugees filed up to the deck in their filthy, wrinkled clothes, under the gaze of the *Kilissi*'s crew, now in freshly starched uniforms. As Emile walked off the *Kilissi,* the crew stood at attention and gave a formal respectful salute to them—the weary, tattered rejects of Europe. Tears sprung to Emile's eyes at this small show of gallantry. The refugees began to sing the "Marseillaise," and Emile jubilantly added his voice: "The day of glory has arrived!"

But glory seemed distant. Their ship finally pulled into Casablanca. Emile reveled in his elegant white Moorish rooms and his hot showers. His mother convalesced on a soft bed with clean sheets. They exchanged gossip in cafés and nightclubs, and found that Emile's father and Berta had made it out of France. They were in Algiers, which was occupied by France's Vichy government.

In Algiers, Emile and his parents moved with Berta into a small white villa with a sunny courtyard. It was a peaceful haven where Berta could grieve the collapse of her treasured Vienna.

But sadness didn't paralyze her. Berta was concerned about her grandson Emile, and she had an idea that she thought might save his life. She asked her old French playwright friend Paul Géraldy to visit.

The elegant French writer arrived with presents and his usual bonhomie. A few days later, Géraldy donned a smart linen suit and walked down to the dilapidated but architecturally splendid building of the Gouvernement Général, the local seat of the new French Vichy government that had surrendered to Germany in June and allied itself with the Axis powers. Géraldy was a French celebrity. He didn't wait long. Upstairs, in a cool office shaded from the heat by wooden blinds, a petty French official greeted him warmly: To what did he owe this great honor? Géraldy explained, sotto voce, that a young man in town was actually the illegitimate son he had fathered with a married woman who was now in Algiers.

Géraldy wished to register his paternity. Géraldy spoke in a low, meaningful tone of how the knowledge of this indiscretion might of course be traumatic for a young man like Emile. He lied well.

The French official nodded with understanding, or at least compliance, taking careful notes on this delicate situation with an air of sophistication. A philandering French playwright—but of course!

The official pulled out some papers, placed them on the desk, and filled them out. Géraldy signed, and the French official wrote his own signature and affixed an endless series of colonial stamps and seals.

The papers denied Emile's connection to one of the most distinguished families in Vienna. Under German racial laws, being half "Aryan" meant a chance to escape death. Should the worst come to pass, Emile could apply for survival as a *Mischling.*

Ferdinand in Exile

In early 1941, German-language radio propaganda in heavily Germanic areas of Yugoslavia began to sound a familiar propaganda alarm: defenseless Germans were threatened by predatory Slavs. Ferdinand monitored this with agony from Switzerland. Why hadn't Baron Gutmann and Luise brought the children to Switzerland? Ferdinand's world was darkening.

On April 2, 1941, Ferdinand picked up his pen and wrote in despair to his old friend Oskar Kokoschka.

Dear friend and professor,

It pleased me very much to hear from you after such a long time, especially that you are doing well and that you are still the brave fighter! In your position I would have gone to America and if it is still possible go immediately! Europe will be a heap of ruins, perhaps the whole world; for art there will be no place here for decades! My people are in Canada in Vancouver, [and] would like me to come, but I am already too old! I think about it, although I believe that I have missed the "ferry" [alluding to his nickname, Uncle Ferry]. For months there is no seat on a ship, not a clipper available! Your friend Dr. Ehrenstein was here with

me yesterday. He obtained a visa for America, but how can he get over there?

In Vienna and Bohemia they took *everything* away from me. Not even a souvenir was left for me. *Perhaps* I will get the 2 [Klimt] portraits of my poor wife, and my portrait. I should find out about that this week! Otherwise I am totally impoverished, and probably will have to live very modestly for a few years, if you can call this vegetation living. At my age, alone, without any of my old attendants, it is often terrible. Luckily, I have a few good friends here in Geneva and Lausanne.

Now that I am already "amortized," I will wait and find out whether justice will still come, then I will gladly lay down my hammer! What one hears from Vienna and Prague is terrible! Now I wish you, from my heart, all the best and remain with heartfelt greetings,

Your old dear true Ferdi.

P.S. [Franz] Werfel is in Hollywood

P.P.S. Carl Moll is an "über-Nazi!"

Kokoschka shared Ferdinand's outrage. He was painting a protest work, *Anschluss—Alice in Wonderland.* The painting showed the Ringstrasse in flames, as Austrians hold their hands over their eyes and ears, and soldiers prowl Vienna.

Four days after Ferdinand wrote Kokoschka, his worst fears came true. On April 6 the Luftwaffe bombed Belgrade, and German troops invaded. Yugoslavia surrendered eleven days later. Ferdinand's niece, Luise, was now living in the "Independent State of Croatia," a Nazi puppet regime run by a fascist movement called the Ustasha.

The Gutmanns

It was never clear why Luise and Viktor ignored the clouds on the horizon in early 1941.

A British intelligence officer warned the family of the impending German invasion. But Viktor was adamant. He would not consider abandoning everything the Gutmanns had built in Yugoslavia.

It was a beautiful spring. Generous rain had yielded a glorious carpet of wildflowers in full bloom across the meadows. Luise and Viktor's daughter, Nelly, took walks through the Gypsy village at the edge of Belisce and rode her "black beauty," a filly named Baba, through the sunflower fields. Trained by a hussar who had fled the Russian Revolution, Nelly was an expert rider.

Nelly's father was often deeply preoccupied that spring, and there was much he didn't tell her. Authorities had confiscated the property of twelve thousand Jews in Zagreb and ordered their possessions handed out to non-Jewish Croats. Jewish students were banned from universities. Jewish government employees were fired, and Jewish lawyers and physicians were forbidden to practice. Synagogues were closed.

Nelly, twelve, had no idea of this. Viktor and Luise tried to shield their children from these realities. The family had converted to Roman Catholicism and thought this might protect them. They were already very secular, and celebrated Christmas and Easter. Now Nelly couldn't go to school. Jews couldn't go to movies, either, lest they "contaminate the environment with their presence." Life became more incomprehensible.

It was difficult for Nelly to imagine that her distant, glamorous parents were anything but infallible.

Outwardly, Nelly's life was very privileged. Her father was a wealthy baron from a celebrated family that had married into nobility for hundreds of years. Her mother was a great beauty from a clan that traced its lineage to fifteenth-century Portugal. Her pediatrician was Dr. Gertrud Bien, one of Vienna's finest doctors. But her parents often seemed preoccupied with their own lives, and Nelly grew into a reserved, serious child. Luise's nickname for Nelly, Trottel, meaning "idiot," was ostensibly affectionate but seemed indicative of the gap between magnetic Luise and her small, shy daughter.

Nelly spent part of every year in the backwater of Belisce, far from the balls and opera her mother thrived on. Belisce was a few miles south of the Hungarian border, not far from the Danube port of Vukovar.

Just down the road was Osijek, with its ancient fort and Secessionist and Art Deco architecture. The breakup of the Empire had

Baroness Luise Gutmann, here with her daughter, Nelly, and son, Franz, ca. 1940, underestimated the danger Hitler posed to her family in Yugoslavia.

long ago dulled its luster. Farther south was the picturesque mountain city of Sarajevo, with its minarets, onion domes, and veiled Muslim women.

Belisce owed its existence to Viktor's grandfather, Aladar, who had founded a timber company and built a railroad line through the forest between Hungary and Yugoslavia. This earned him a title, a visit from Emperor Franz Joseph, and an imperial gold watch.

Here Serbs and Croats intermarried. Gypsies lived peacefully on the outskirts of the village. When dusk fell, they lifted their violins and cimbalos and played the hauntingly seductive music that a Czernin count had likened to "making love standing up." Nelly volunteered to deliver the charity food and clothes to elderly Gypsy widows so she could listen to their sad, strange songs. Her mother hired the Gypsies to play at parties.

The three branches of the extended Gutmann family lived together in a great house, each branch with its own apartment, with common rooms for eating and entertaining. Viktor's brother Erno—an affectionate uncle to the children, and a doting father to his daughter, Elinor—amused everyone by doing their astrological charts.

Here, one day had passed into the next like the pages of Nelly's schoolbooks.

Until now.

Viktor and Luise were under strong family pressure to leave Yugoslavia. To Viktor, this was unthinkable.

Erno was less certain. One night, at dinner, he unveiled his latest astrological chart, that of Adolf Hitler. It predicted a terrible future.

The family shrugged this off. They had rolled their eyes and smiled at Erno's astrology for years. His Hitler chart seemed a reflection of his own fears.

Still, Erno thought his wife should take their daughter to Switzerland. Little Elinor wept forlornly at the idea of being separated from her father. If Belisce was not safe enough for them, why was it safe for her father? As their suitcases were loaded into the train, Erno helped his distraught little girl up the ramp, waving as Elinor pressed her tear-stained face against the window.

To Viktor and Erno, defending their family's business empire seemed more urgent after the sacking of family properties in Vienna. But the dangers of staying were evident.

The Swiss government, citing the threat of war, had already recalled its citizens, including Nelly's Swiss governess. Nelly couldn't have been more delighted. The governess had been cruel, pulling Nelly's long braids to punish her.

When the Germans marched into Yugoslavia, the Gutmanns were still there.

For a while, life for Nelly went on as usual. Her father was so calm in the early days that when a delegation of officials from the Nazi puppet government came by, they were asked to wait while Viktor finished playing a piece on the piano.

Then, in May, an Ustasha government official drove up to the administration offices of the timber factory. He was furious that most of its shareholders had already fled and registered their shares in banks abroad. He wanted to take control of the factory.

Baron Viktor Gutmann, Luise's husband, stayed in Yugoslavia to protect the timber empire his family had spent generations building; shown here ca. 1935.

A few days later, Viktor drove off with some officials and didn't return. The men sent Luise a flippant message, that they were thinking of shooting Viktor "to settle the matter of the shares quickly." But it was a bluff. Viktor was worth more to them alive than dead. He promised to try to obtain signatures for the shares. They released him. For now.

In October, the authorities grew impatient. They summoned Viktor and Erno, and ordered them to speed up the delivery of the shares. Erno, dressed for the meeting in one of his best suits, politely objected. He said he spoke for the entire family when he asked why they should hand over the country's biggest timber concern after the family had spent generations building it and were running it so well.

Why indeed? Authorities said they'd like to talk things over with Erno in Zagreb and would come and pick him up. Erno asked the housekeeper to pack his dress shirts and enough insulin to treat his diabetes for several days. But as they neared Zagreb, the men turned down an unfamiliar road. They drove into a barbed-wire enclosure, where there were crowds of forlorn people with terror on their faces.

Erno stared in disbelief. He was at a secret concentration camp called Jasenovac, a ghastly place where Serbs and Jews were killed by hand, to spare the cost of gas or bullets. A few hours later, Erno was standing in line, and a guard casually slit his throat.

"Where is my father?" Nelly's cousin Elinor wrote from Geneva, after her father's letters abruptly stopped.

The Gutmanns had no idea. All they knew was that Erno had never come home.

The "Blonde Beast"

It was a warm fall day in Prague in October 1941, and the lyrical Charles bridge was bathed in the golden light of autumn when a motorcade pulled up to inspect the Brezany estate of Ferdinand Bloch-Bauer, just outside Prague. Reinhard Tristan Eugen Heydrich, the new Nazi imperial protector of Bohemia and Moravia, got out of a sedan.

Heydrich knew little about Ferdinand. He took in the crystal chandeliers, the long baronial dining room table, and the tapestries, and found the castle an excellent residence for the prestigious position he had long coveted. He liked the classic mounted antlers and the stuffed stag in the entryway.

He was bringing his much-admired wife, Lina, to live here with his two sons and little daughter. Like many Nazis, his career had given him access to the spoils of stolen property, and he had used it to build his power base.

This particular expropriated Jewish estate suited his personal vanities. Heydrich fancied himself a discriminating aesthete and defender of German culture, the kind of man who had always deserved an estate like this.

He acquired these conceits during a childhood as the son of a minor German composer, Richard Bruno Heydrich, and a violinist mother. His parents named him after a passage in *Reinhard's Crime,* an opera that his father had written. Richard Wagner's *Tristan und Isolde* inspired Heydrich's second name. His third name, Eugen, referred to Prince Eugene of Savoy, the war hero of Vienna's Belvedere Palace.

Heydrich married Lina von Osten in 1931, after verifying that she possessed the racial pedigree required of the wives of SS officers—though he himself hid probable Jewish ancestry on his father's side. Lina was the daughter of a school headmaster from a small island in the Baltic Sea. Lina and her brother had been early Nazi Party members, and her family was impeccably anti-Semitic. Heydrich met Lina in Kiel, where he was a naval officer and Lina was studying to be a schoolteacher.

Heydrich, a carousing philanderer, had gotten a well-connected girl pregnant, but he proposed to Lina instead. He was expelled by the navy for conduct unbecoming an officer. Lina's Nazi connections salvaged his career. In June 1931, Heydrich found himself interviewing with Heinrich Himmler, the national commander of Germany's SS, an increasingly powerful paramilitary organization of the Nazi Party.

Lina would discover she had married a dangerous man with a well-deserved reputation for treachery. The foulmouthed Heydrich made many enemies, even among Nazis. His rivals believed he was plotting to kill them. Their fears were not unfounded. In 1934, Heydrich sent men to kidnap a Nazi rival. They badly botched the job, killing their target and panicking, abandoning their car and leaving other glaring clues.

Reinhard Heydrich, the "Butcher of Prague," in his SS uniform, ca. 1940. Heydrich chaired the Wannsee Conference on the Final Solution to exterminate European Jews.

Heydrich had created a group of mobile commandos to secure government offices and documents when the Germans arrived in Austria in 1938. The force evolved into the notorious Einsatzgruppen, or mobile killing teams, whose members had carte blanche to commit butchery.

By the time they arrived at Ferdinand's house, even Heydrich's wife feared him. People whispered about Lina's close friendship with a good-looking Heydrich protégé, Walter Schellenberg. Lina had long resented her husband's dalliances with young women drawn to powerful Nazis, and his enjoyment of the notorious bacchanalias of drinking and sex that were a male bonding ritual. Even Heydrich's fellow officers dreaded his calls to join late-night binges in Berlin nightclubs and brothels. Heydrich was a mean drunk. Some saw Lina as a long-suffering captive of her husband. Unlike her husband, Lina was disgusted by the stuffed stag Ferdinand had placed in the front hall, and consigned it to the rubbish heap.

Heydrich was often out of town. In January 1942, he chaired a conference in the Berlin suburb of Wannsee on the "Final Solution to the Jewish Question." The conferees decided on extermination. The Nazis wished to accomplish this quickly and efficiently, using modern assembly-line methods inspired by an early admirer of Hitler, Henry Ford.

Lina busied herself redecorating. She insisted on a swimming pool for

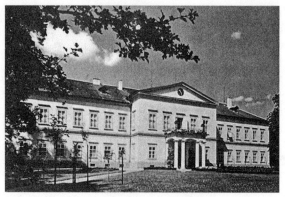

*Heydrich ruled as Nazi governor of Czechoslovakia from
Ferdinand's Czech castle.*

their two sons, Klaus and Heider, and their little daughter, Silke. Ferdi-
nand's castle finally got a pool. By the spring of 1942, the renovations were
finished. Ferdinand's topiaries were clipped, his flowers bloomed, and all
the castle's musty old "Jewish" family papers, letters, and photographs were
burned.

On May 27, Heydrich opened the newspaper expectantly. He and Lina
had gone to a classical music concert in Prague the evening before. The
newspaper published a photo of him leaving the theater, fit and trim in his
dress uniform. Lina, in a tailored dress and wide coat, seemed to have
stepped out of a Hollywood film. Heydrich was pleased.

Lina was in the garden that morning, her hair in blonde plaits wrapped
around her pretty head in the new Germanic style. Her sons were dressed
in Hitler Youth shirts and Silke in an equestrian habit. Lina was visibly
pregnant. Their fourth child was due in July. Heydrich's driver brought his
sleek black Mercedes convertible to the door of Ferdinand's castle. The
"Butcher of Prague" finished his breakfast and wandered out to the garden
for a leisurely goodbye. Brezany was a beautiful place to live.

It was a lovely drive into Prague in the open air, bathed in soft spring
morning sun, to Heydrich's stately offices at the Baroque seventeenth-
century Czernin Palace, the third-largest in Prague.

As the car rounded a bend, a man ran into the street, opened his rain-
coat, and raised a gun. He pulled the trigger but the gun failed to fire.
Heydrich was stunned. Outrageous! He shouted to his driver to stop, and
stood and shot at the buffoon. Heydrich missed. Another man stepped

from the bushes and hurled a bomb, shattering the windows of a streetcar. Passengers screamed. Heydrich's driver leapt out and ran after their attackers. Heydrich, wounded by shrapnel, staggered after him, shouting, "Get that bastard!"

The would-be assassins took refuge in Karel Boromejsky church, in the catacombs.

Heydrich died of infection from his wounds. Hitler was furious. "That a man as irreplaceable as Heydrich should expose himself to unnecessary danger, I can only condemn as stupid and idiotic," he said on June 4.

Revenge was swift. On June 9, a train with a thousand Jewish Czechs was sent from Prague to Poland. Two thousand people were ordered out of the Theresienstadt concentration camp and sent east to be killed.

Finally, under interrogation, someone told the Nazis to look for the assassins in the church. The SS men were greeted there with gunfire, and two officers were wounded. Shouts came from the crypt: We will never surrender!" The officers brought fire hoses to pump water into the catacombs, and tossed in tear-gas canisters. They decided to blow open the crypt.

Gunshots crackled from the church bowels. The surviving would-be assassins had made sure they would not be taken alive.

The Nazis wanted to make an example. They chose Lidice, a quaint, cobblestoned village well-established by the fourteenth century. The fiercely independent villagers disdained occupation. The Nazis rounded up 192 men and boys over sixteen in Lidice and executed them. The women and children were sent to concentration camps, where most of the children died. Lidice was torched and razed. More than 1,300 other people were executed for their purported involvement in the resistance.

In Switzerland, Ferdinand was appalled. The human cost was a terrible price to pay for the assassination of his mad houseguest. Ferdinand worried about his blind sister, Agnes, whom he had moved from Vienna during the Anschluss, and who was now in a Prague sanatorium. Ferdinand contacted an old friend, Prince Schwarzenberg, who had fled the Nazis, and asked him to send someone to check on her. Ferdinand soon got news: During the crackdown following the assassination, Gestapo agents had hustled off the terrified eighty-nine-year-old Agnes Meyer in a roundup of Prague Jews. She was deported to Theresienstadt. Poor gentle Agnes, who asked little more than to live in peace and die in her sleep, had survived less than three days.

After his assassination, Heydrich was made a Nazi martyr, and the plan to exterminate Jews was named "Operation Heydrich" in his honor. Hitler

bestowed Ferdinand's house on Lina and her children in perpetuity. The deal soured somewhat as Lina argued with the SS over the employment terms of the concentration camp slave laborers ordered to remodel the estate, which was now envisioned as a hub of Aryan resettlement.

Love Letters from a Murderer

By 1942, Maria's former minder, Felix Landau, had reached a position of relative power. After helping the Gestapo rob wealthy Viennese Jews, Landau went to Galicia, in the culturally rich eastern borderlands. Landau moved with German soldiers through scores of little castle towns, each a prism illuminating a mosaic of language, food, and ethnicity, where Jews, Gypsies, Ruthenians, and Saxons mingled. Along the way, embroidered women's head scarves became elaborate shawls with dangling ornaments, and even men wore embroidered jackets. Dark-eyed Gypsies gazed up at the soldiers from horse-drawn wagons.

In 1940, men like Landau were sent to conquer this magical East of balalaikas, Jewish mystics, and violent pogroms. Landau volunteered for duty in Drohobycz, a Polish city that had once been part of the Habsburg empire but was under Soviet control when the Nazis arrived. In Drohobycz, Landau was assigned to be director of Jewish slave labor. In this capacity, he found himself face-to-face with Bruno Schulz, one of Poland's most distinguished writers.

Schulz, the 1938 winner of the Golden Laurel of Poland's Academy of Literature, was working on a novel, *The Messiah,* when the Nazis invaded. The son of a textile merchant, Schulz had been a quiet, artistic boy who grew into a gentle dreamer. He became a schoolteacher, distracting disruptive boys with fairy tales he drew on the chalkboard. One day, a friend showed Schulz's letters to a Polish writer, who was bewitched by the magic Schulz found in ordinary daily life. His short-story collection, *The Cinnamon Shops,* was published in English as *The Street of the Crocodiles.* He illustrated the book himself, along with his next book, *Sanatorium Under the Sign of the Hourglass.* Schulz could not be cajoled to leave his beloved backwater, even as German troops drew near.

The Germans ordered Schulz to report for slave labor, and he soon found himself standing before Landau's desk. Schulz was able to converse with Landau in fluent German. The two men soon found their fates intertwined.

One thing Landau shared with his previous detainee, Maria Altmann, was a fascination with Grimm's fairy tales, the Germanic folk legends that permeated Wagner, Goethe, and popular culture—stories with a dark underside and an amoral code that did not always reward the good and punish the bad. The Big Bad Wolf often ate the defenseless woodland creature; the charming Pied Piper led children to senseless deaths. The stories were more warnings than morality plays, and it was often resourcefulness, not justice, that saved would-be victims. Landau's obsession with these grisly stories would earn him a place in history.

Polish writer Bruno Schulz, a talented artist, shown here in 1934, was forced to paint fairy tales for the nursery of his Nazi protector. The murals he painted, lost for years, were rediscovered in 2001, sixty years after they were created.

When Landau learned Schulz had artistic talent, he recruited him to paint nursery murals of fairy tales for Landau's young son. Schulz had no choice but to accept. Landau left Schulz at his villa to sketch out his fairy-tale panorama of kings with golden crowns and sable furs, squires, and knights in armor. Schulz became known as Landau's "protected Jew."

The emotionally unstable Landau was no protector. In June 1941, Landau suspected his mistress was cheating on him. "After a sleepless night," he volunteered for an SS mobile killing squad, or Einsatzkommando, and "suddenly, everything had changed in me."

Along with other SS officers, Landau began to use Jewish strangers on the streets of the Drohobycz ghetto for "shooting exercises." He would idly look out from his apartment at the Jews toiling in the community garden below, then practice his excellent marksmanship by taking aim at the gardeners.

Then came his first massacre. "Fine, so I'll just play executioner and then gravedigger, why not?" he wrote in one of his love letters to Gertrude, his mistress. There were twenty-three victims, and "we had to find a suitable spot to shoot and bury them," Landau wrote. "The death candidates assembled with shovels to dig their own graves. Two of them were weep-

ing. The others certainly had incredible courage." Landau watched the people put money, jewelry, and watches in a little pile. "Strange, I am completely unmoved," Landau wrote. "No pity, nothing."

"As the women walked to the grave they were completely composed. They turned around. Six of us had to shoot them," he wrote.

Later that month, Landau wrote Gertrude that a carefully organized massacre in the city of Lwow had turned into a ghastly public free-for-all at the city's old Citadel, where soldiers "were holding clubs as thick as a man's wrist and were lashing out and hitting anyone who crossed their path." Landau wrote, "There were rows of Jews lying, one on top of the other, like pigs, whimpering horribly. There were "hundreds of Jews walking along the street with blood pouring down their faces . . . Some were carrying others who had collapsed."

As Landau directed these nightmares, Schulz painted his fairy tales, retreating into his rich inner life. "The thought of you is a true bright spot for me," he wrote his dear friend Anna Plockier in September 1941. "You are the partner of my interior dialogues about things that matter to me." Schulz wrote that "intuition tells me that we will meet again soon."

But Anna and her husband were seized by the Nazis in a surprise massacre and buried in the woods. Schulz was moved into the Jewish ghetto. His health deteriorated. He began to take notes, interviewing a fellow prisoner who had been shot. He told an acquaintance that he had written a hundred pages of documentation for a work based on the historic crime going on around him.

But the final insights of this subtle, delicate genius would remain a mystery. In November 1942, as his literary friends outside the ghetto planned his escape, Schulz's "protector," Landau, casually picked off a Jewish dentist who happened to be the "protected Jew" of SS officer Karl Günther.

The infuriated Günther came across Schulz chatting with a friend at a ghetto street corner, a loaf of bread in his hand. Günther shot Schulz point-blank, snuffing out one of Poland's brightest lights. "You killed my Jew—I killed yours," Günther reportedly sneered to Landau.

The nursery frescoes Schulz left behind were embedded with artistic resistance. Though his kings and queens were cloaked in the royal splendor of an imagined past glory, they had the faces of the hungry Jewish captives in the ghetto. Schulz had painted in his father and even himself in royal garb, driving a carriage, one of the many things now forbidden to men like him.

Ferdinand's Legacy

On August 6, 1942, Hermann Göring stood before the Nazi occupation ministers and reported on the treasures the Nazi looters had so far seized. "It used to be called plundering. It was up to the party in question to carry off what had been conquered," he told the conference. "But today things have become more humane. In spite of that, I intend to plunder, and to do it thoroughly."

In a fit of disgust, Ferdinand began to rewrite his will. It read like a protest. Ferdinand noted how "in an illegal manner, a tax penalty of one million reichsmarks was imposed, and my entire estate in Vienna was confiscated and sold."

His family in Europe wasn't safe.

He was still trying to get the Klimt portraits of Adele.

His house was a Vienna headquarters for the German railway that was deporting Jews to camps.

A Swiss bank had illegally handed over the shares of his sugar factory for Aryanization. "The situation has changed," a bank officer wrote coldly. Ferdinand was living at the exclusive Hotel Bellerive au Lac, on the shores of Lake Zurich, but he probably didn't choose to live there. The Swiss, deprived of tourism revenue, often assigned luxury housing to the stateless.

Everything had been stolen, sold, Aryanized.

The world he had shared with Adele was slipping away. His old friend Stefan Zweig—Adele's friend, really—had found refuge in Brazil, where he had finished writing a memoir about Vienna, their Vienna. Zweig had gathered all his memories—memories that Ferdinand shared—of Vienna's turn-of-the-century glamour, the graceful life that had ended, perhaps forever. Zweig called it *The World of Yesterday.*

In February, Zweig had left the manuscript, neatly typed by his wife, Elisabeth Charlotte Zweig, on his desk at their home in Petrópolis, Brazil. He wrote a message thanking Brazil for giving them shelter, "the world of my own language having disappeared for me and my spiritual home, Europe, having destroyed itself." Zweig wrote that at his age, "unusual powers are needed in order to make another wholly new beginning. Those that I possess have been exhausted by long years of homeless wandering."

He hoped his friends would "see the dawn after the long night!" while "I, all too impatient, go on before."

Then Zweig and his wife took their own lives. They died holding hands.

Such news made Ferdinand deeply weary. He was now just an old man in a suit, alone in a hotel in Switzerland.

He wondered how he would go on.

The Uses of Art

In February 1943, as Ferdinand battled depression, Nazi authorities in Vienna proudly prepared to display the gold portrait of his wife, Adele. The exhibit was held at the Secession building, which had been renamed the Exhibition Hall Friedrichstrasse.

The show's patron, Baldur von Schirach, the top Nazi leader, sipped wine and mingled with the guests, taking a break from duties that included overseeing the deportation of Vienna Jews.

Schirach was hungrier than ever for prestige. Until recently, the blandly handsome, boyish Schirach had basked in the glow of Hitler's approval. He had joined the Nazi Party at eighteen in 1925, and begun to compose fanciful poetry to his Führer, "this genius grazing the stars." At twenty-nine, he was named head of Hitler Youth, a paramilitary organization for future "Aryan supermen" that would indoctrinate 5 million German boys and girls in anti-Semitism. In 1940 he became the Gauleiter, or governor, of the Vienna Reichsgau, where he was involved in the creation of a labyrinth of secret underground fortifications, including one in the Vienna Woods that would be known as the "Schirach-bunker."

But in Vienna, things had gone terribly wrong. Schirach had sponsored an exhibition, *Young Art in the German Reich,* with the kind of abstract art that had disturbed Hitler in his youth. Hitler himself had ordered the show closed.

It was an enormous blow to Schirach's career. Now he was struggling to make a comeback. This show had to be a success.

Schirach had no idea of the true significance of the Klimt show. He was presiding over the largest retrospective ever of Klimt's works. Some of these

Baldur von Schirach, the Nazi governor of Vienna,
an aesthete who wrote poetry to "my Führer"
and posed for photos that resembled Hollywood
glamour shots, ca. 1934.

Klimt masterpieces would be exhibited here for the last time. This show would be the last glimpse ever of the full sweep of Klimt's work.

For Schirach, the show would be an impressive display of Germanic culture that could compete with anything in Berlin, justifying the enormous expense in a time of wartime scarcity, when even the paper used to print the catalogue required special permission to obtain.

The philo-Semitic leanings of Klimt were, for the moment, forgotten. For the purposes of this show, Klimt was an *Übermensch,* a "master man," compatible with Nazi ideals of Germanic masculinity.

Schirach had never taken Nazi art dictates too literally. Like other top Nazis, he had snapped up for a song art purged as too modern, amassing a sizable collection. Schirach bought works directly from the Belvedere-based art procurer Kajetan Mühlmann. Some offices at the Belvedere answered directly to Schirach.

As the show opened, Carl Moll, Alma's stepfather, strode in and greeted the Nazi governor. Moll owed his career to the patronage of Jewish fami-

lies, but now he was sipping wine in a roomful of paintings stolen from them. Moll entertained Nazi officials, flaunting his close friendship with Klimt and telling anecdotes about his exploits with the famous artist.

Fritz Novotny, a promising young curator at the Austrian Gallery and organizer of the show, was on hand to provide a whiff of academic respectability. Novotny could not have said he was unaware of what was happening to the Jews. The elderly Jewish parents of one of his closest friends, the exiled painter Gerhart Frankl, had written a poignant letter to Novotny, to say they were "very sad, that you stayed to face such unpleasant things" just before their deportation in 1942.

Novotny would later say he feared that leaving the Reich would endanger his infirm mother and sister. Whatever his rationale, Novotny thanked the "owners of the Klimt works for making this exhibition—and others as well—possible."

The owners of the paintings were in no position to give permission. They were on the run or dead. Schirach had sent an official telegram to notify Hitler: "My Führer, I report to you that Vienna has been cleansed of Jews."

So there was no need to ask the Lederers. The Lederers did not consent to exhibit *Philosophy* and *Jurisprudence,* acquired to free Klimt from officialdom in his journey to modernism. Erich Lederer would have treated any pretense to "borrow" the *Beethoven Frieze* to a salty-tongued diatribe. The panel of the *Frieze*'s muscular nude man and woman embracing—Klimt's *Kiss to the Whole World*—bore its alternate, biblical title, *My Kingdom Is Not of This World,* which now found a serendipitous use for *Reich,* the German word for "kingdom."

Ferdinand was trying to recover his *Apple Tree.* Yet it too was in the show. It hung near *Schloss Kammer am Attersee,* having been donated by Ferdinand to the Belvedere in perpetuity—yet sold by the museum to Gustav Ucicky.

Now, as Vienna was disavowing, even murdering, the Jewish agents of its cultural brilliance, Nazi art historians omitted their names in order to use their paintings as symbols. Their creations were reduced to stolen baubles, as anonymously valuable as Adele's diamond necklace. Klimt's brilliant portraits of Jewish women were each given a generic title: *Portrait of a Lady.*

The shimmering gold portrait of Adele Bloch-Bauer was a centerpiece of the show.

The Nazis had smashed Adele's world like a mirror. But Vienna still saw

itself reflected in its shards. Even the Nazis were forced to locate the Viennese essence of femininity in the face of a Jewish woman. To admit this would undermine the greater deceit of Aryan racial superiority. So the gold portrait of Adele became *Portrait of a Lady with Gold Background.*

A counterfeit of this magnitude was an odd act for a profession said to be motivated by a love of art. They really had no choice. How could they invoke a respected family that had so recently flourished a short walk down the Ringstrasse? How could a symbol of Vienna's belle époque, however iconic, be revealed as a Jewish woman?

Any clue to Adele's identity would unmask their terrible lie. They needed this icon. A month after the show, Belvedere director Bruno Grimschitz bought the second Klimt portrait of Adele, from Erich Führer, for 7,500 reichsmarks, and this too was hung as an anonymous portrait of a lady.

Nelly

As the Nazi elite admired Adele's portrait, her family in Yugoslavia was in grave danger. Their only bargaining chip was the shares of the timber company, held in banks abroad.

In May 1942, Croatian Jews had been declared stateless. Among the few exceptions were those designated "honorary Aryans," most of them wealthy Jews who had contributed to the "Croat cause" by handing over valuable property. Some were forced to pledge their loyalty to the Ustasha regime.

Authorities were growing impatient with their attempts to gain control over the Gutmann family lumber fortune, and its assets held in banks abroad. They ordered Viktor to travel to Switzerland and to transfer the assets there to Croatian control. Viktor would later say he foiled the plan. But soon they ordered him abroad again. They knew he would come back. They were watching his wife and children in Yugoslavia.

The anti-Nazi guerrilla partisans, commanded by Josip Broz Tito, sent an emissary to meet with Viktor. The partisan emissary urged Viktor to join them. He considered it seriously. But what would become of his family?

Nelly, a highly intelligent child surrounded by danger, was too young to fully understand the ordeals of her mother and father; shown here ca. 1940.

By July, thousands of Jews in the Osijek area had been ordered to a makeshift village in nearby Tenje. The Gutmanns were arrested and threatened with deportation. Viktor promised to hand over some company shares, and they were freed, at least for the moment, though Viktor would say he eventually foiled the share transfer. In late August, the makeshift village at Tenje was suddenly deserted. The people had been sent to Jasenovac and Auschwitz.

Now Luise and Viktor woke up every morning to a macabre world in which anything seemed possible. They heard terrible stories. The Ustasha announced that Serbs could save their lives by reporting to a regional church to convert to Roman Catholicism. Families crowded in. Ustasha officers barred the doors and set the church on fire. Luise tried to keep these stories from her children. But it was becoming more difficult. The world was closing in on them.

One sunny morning, as poppies carpeted the meadows and sunflowers raised their enormous yellow heads, Nelly heard a troop truck roar into Belisce. At the Gypsy village, it screeched to a halt. Gypsy men were saddling their horses and chopping wood. Women were cooking and hanging laundry in the sun.

Soldiers shouted at the Gypsies to move to the common. The soldiers moved from house to house, yanking the arms of mothers who were still holding babies and dish towels. They pushed out grandfathers, trailed by small frightened grandchildren, shoving stragglers with rifle butts. Finally the Gypsies stood together apprehensively, blinking in the bright sun.

Then the shooting began. Nelly could hear the crackle of automatic weapon fire, and the screams. Oh my God, she thought, her heart pounding.

It seemed to last an eternity, though it couldn't have been more than a few minutes. Then the truck roared away, toward Osijek.

There was a terrible silence. Then the town came alive. Crowds of men and woman swarmed into the Gypsy village. They helped themselves to clothes, silverware, jewelry, tables, and chairs. They haggled over goats, sheep, cows, and the Gypsies' beautiful horses.

A couple of days later, Nelly wandered into the settlement. She ventured between the houses, eerily abandoned, their doors ajar. There was a trench of fresh earth, and village children pointed to it. That was where the

Gypsies were buried. The other children skipped away. Nelly stood alone in the stillness.

Then Nelly heard a plaintive cheeping. She followed the noise to a passageway between two houses. There she spotted a speck of fluff, no bigger than a cotton boll. It was a tiny chick. The chick huddled against the house. Nelly cupped it in her hands and walked home carefully, whispering to the little orphan not to be afraid.

She called her chick Myra, and made her a nest in a small bucket so she wouldn't get stepped on. She fed Myra by hand, petting her gently, hoping she would grow up and lay lots of eggs. But Myra grew into a cocky rooster, with a luminescent, silky tail. He came when Nelly called. This pleased her, because Nelly now had little to do.

Her world was growing smaller.

Nelly only knew bits and pieces of her parents' desperate struggle to survive. Soldiers would show up at the house, and her parents would quietly tell her and her brother to go upstairs. Once the soldiers casually strafed a cabinet filled with antique porcelain. After they had gone, her mother knelt down and picked up all the shards of early European porcelain and stored them as carefully as if they were delicate crystal goblets.

One night in early May 1943, just before midnight, Nelly was awoken by a truck full of soldiers who arrived at the Gutmann manor. Nelly heard Luise speaking to them outside, in her pleasant melodic Viennese German. Luise called Nelly and Franz to come at once, and they all boarded the truck. They wouldn't let Nelly take Myra. They led away her beautiful filly Baba.

Nelly and her family spent the night in a municipal office. The next morning they were taken to a police headquarters at Osijek. There they were herded, with dozens of other people, into a local school gymnasium. Mothers and fathers were huddled on the floor, with frail grandparents, children, and wide-eyed babies.

The Gutmanns were ordered to crouch down with them. They were told to keep their eyes on the floor. For what seemed like hours, Nelly stared at shoes: the lace-up boots of little children, the heels of women, the heavy men's boots. Her muscles ached. When people involuntarily moved, or fell over, the guards shouted or kicked them.

From her parents' whispered conversations with adults near them, Nelly learned the Ustasha was going to hand them over to the Germans. The Germans would take them to Auschwitz. People who went to Auschwitz never returned.

A friend of Luise's ran to plead with the local Gestapo chief, who had seen the vivacious young baroness around town. Just a few years ago, a man of his background would never have stood a chance with a beautiful, stylish aristocrat like Luise. Things were different now. "I will help your friend," the Gestapo officer told Luise's friend. "But will she be nice to me afterward?"

In the gymnasium, the guards ordered the prisoners to line up to buy their train tickets to Auschwitz. Just then a door opened, and an Ustasha officer ordered the Gutmanns to get up. Nelly silently filed out of the gymnasium with her family. The other prisoners followed them with their eyes, not knowing if the Gutmanns were fortunate or doomed.

Nelly believed the friend of her mother saved their lives.

But Luise told another story. She was escorted to a majestic old place in Osijek that had once been a convent. There she was shown into an apartment with elegant furnishings and liquor. Here Luise was expected to wait for the Gestapo officer.

There were other things Luise tried to keep from her children. One day she had opened the door to a cluster of gruff German officers with alcohol on their breath. They pushed past her. Luise ordered Nelly and Franz to play downstairs.

Luise set about being the good hostess she was raised to be, making pleasant conversation in her cultivated Viennese, which they answered in homespun country German. Their conversation deteriorated into off-color jokes, conspiratorial guffaws, leering smiles. One reached for Luise, and his comrades roared with approval.

As Luise endured her drunken rapists, a young, pink-cheeked soldier hung back, clearly shocked by the animal carnality of the scene. He was goaded into taking his turn. When he finished, he looked ashamed. "Did you like me just a little bit?" he asked Luise hopefully.

Luise knew other women suffered terrifying fates. Roving soldiers locked women—Jews, Serbs, Gypsies—into military quarters where they conveniently ignored their doctrine of racial purity. When they finished with these women, they marched them into the woods and shot them.

As the alluring golden *Adele* was admired by strangers in Vienna, the niece of this glamorous daughter of Vienna was at the mercy of passing soldiers.

This was war, and women were the spoils.

The Immendorf Castle

It was a warm, blustery day in the spring of 1943 when the youngest baron of Schloss Immendorf, Johannes von Freudenthal, looked out of one of the castle's glorious towers and watched trucks pull into the courtyard.

At ten, Johannes, the inquisitive pet of the family, wasn't much of a baron yet. He still played hide-and-seek with his four brothers and sisters in the nooks and crannies of the castle turrets, imagining himself a dragon-slaying knight in one of the family's old suits of armor.

The eagle's-nest view of the castle took in the mountains northwest of Vienna, the Danubian river valley wine country, and one of Austria's oldest inhabited regions. By 1943, the Schloss Immendorf had long passed its days of feudal glory, though the little baron's father and his young wife had restored the gracefully turreted marvel. Outside were war, scarcity, and other terrible things, but Schloss Immendorf remained the family refuge.

On this cloudy day, Johannes had wandered upstairs, looking for his favorite kitten, when he heard motors outside.

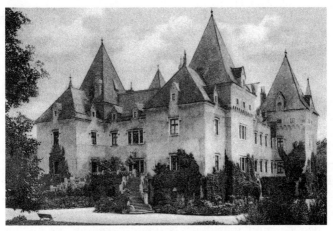

The lovely Schloss Immendorf, which had just been restored,
was commandeered to shelter the most important
single Klimt collection from Allied bombings. 1936.

Most strangers came in uniform. Castles were commandeered to house Nazi leaders or SS officers. His father, Baron Rudolf Freudenthal, was an officer in the Wehrmacht. A succession of German officers lived under his roof. Some were gruff and aloof. Others were kind to Johannes and played the piano with pleasure, filling the house with Schubert, Beethoven, and Mozart, while Johannes's mother set a place for them.

But the strangers downstairs that day wore dark suits, not uniforms. Their workmen brought enormous boxes and panels into the timber-beamed entry hall and carried them up the spiral stairs. Johannes watched them wrestle an enormous rolled-up tapestry into the attic. The men uncoiled a long rope and hoisted wooden crates up the stairs, and Johannes jumped out of the way as they struggled, balancing paintings and stacking them, one by one, against the wall in the tower.

They disappeared downstairs. Johannes examined the paintings. The one in front was as large as Johannes: an enormous tree in bloom, set against a riot of flowers. Nothing as exciting as his father's paintings of men on horses, raising their swords in battle with Napoleon.

Another painting had some naked women in it. Johannes began to pull the other canvases away from it so he could see. But they were heavy, and the whole stack began to slide. The little baron hung on, trying to prevent the paintings from falling down.

A big hand reached down from above and steadied the paintings. Johannes looked up. His father.

These are important paintings, not toys, his father told him sternly. They were painted by a great Austrian artist, Gustav Klimt. His father told Johannes to leave them alone.

The paintings were in the castle to protect them from air raids. The paintings had been in a big exhibition in Vienna. Baron Freudenthal had been given a choice: either store the paintings or house "war refugees," which could mean unruly SS officers pushed back at Stalingrad.

The baron chose the art.

There were other eyes watching the comings and goings at Immendorf. At nearby Hollabrunn, a large and infamous SS detachment imprisoned Jewish slave laborers. They sent the prisoners to Immendorf to grow food. One of them was Anna Lenji, from Hungary. To Anna, Baron Freudenthal "was very human and tried to do whatever he could, but of course he also was under the supervision of the Nazi superintendent," so "his power of help was very limited."

But he was not like the leaders of the two previous camps, who had

made her march naked in public with her husband and the other prisoners, "which I thought was horrible." At Schloss Immendorf, the baron sent books to the tiny unheated hut Lenji shared with twelve prisoners, which "meant so much to us because it was a testimony to the fact that we're still humans and not only beasts as we were treated there."

By the time Allied bombs rained down in Vienna in 1944, Austrian masterpieces, many of them stolen, would be tucked away in the cavernous onetime monastery of Gaming, or in the Schönborn Castle, not far from Schloss Immendorf. The Austrian Gallery's Fritz Novotny sent a typed memo reporting that a painting by Oskar Kokoschka was being held for safekeeping, along with Klimt's second portrait of Adele, in the stronghold of the massive twelfth-century Weinern Castle in the eastern Burgenland.

Degenerate or not, Kokoschka was still Austrian.

At Schloss Immendorf, Johannes and his brothers and sisters played near the paintings, shrieking with laughter as they ran past Klimt's *Golden Apple Tree,* avoiding crates that might contain statues. Their father had warned them of what would happen if they damaged the Klimts.

The Child in the Chapel

Croatian authorities sent the Gutmanns to the notorious Savska Cesta political prison in Zagreb. The prison was filled with anti-Nazi partisans. It had a small adjoining hospital, where partisans who had been tortured could be revived for further interrogation.

By 1943, Josip Broz Tito and the partisan guerrillas he commanded were strong enough to seriously threaten the Ustasha and the Nazis. They fought fearlessly, sustaining high casualties but taking a heavy toll on Axis forces. The woods near Belisce were a partisan stronghold.

For Nelly, now fourteen, the prison brought the close family life she had always wished for. She felt safe. Her father spent hours with her, reading and discussing Goethe's *Faust,* teaching her math and languages. Nelly finally had her parents' full attention.

One Croatian prisoner had been a guard at Jasenovac. The Croat said guards at Jasenovac were frightening and brutal. They killed prisoners with axes, sledgehammers, and a special knife they invented, shaped like the crescent moon of the Turks, called the *srbosjek*—"the Serb-cutter."

The Croat had been a provincial policeman. He was shocked by the stupid, illiterate guards and the ghastly slaughter. He fired off letters to the Ustasha government, telling what he saw. Surely they would share his outrage.

Instead, they had arrested him and sent him here.

Nelly learned that, for Jews, the prison was supposed to be a way station. Jewish families would appear overnight. They were locked behind the iron grillwork of the small hospital shrine, from which gilded saints had once gazed out mercifully.

One morning, as Nelly walked by the chapel, she saw that a new group of families had arrived. They were rail-thin. They had been stripped of their belongings and were dressed in rags. A father was hugging a small child. The child was only five or six, hollow-eyed and listless, with patchy hair and limbs hanging like matchsticks. This child was barely clinging to life. When anyone walked by, the father raised the dying child in his arms behind the grillwork, his imploring eyes begging each passerby to help. The father must have been starving too. He looked so weak that he seemed barely capable of raising the child. Yet he did.

The sight of the suffering child horrified Nelly. She would have liked to bring soup or water. It seemed incredible that prison guards could walk by, laughing and smoking, ignoring the desperate man and his feeble child. Nelly cringed as she walked by the chapel, and her breath quickened. But she was unable to stop herself from looking up into the pleading father's eyes.

When Nelly awoke the next morning, the man and his child had vanished, along with the rest of the Jewish prisoners.

The chapel was again the empty, silent sanctuary that had once held statues of Mother Mary and Jesus, their faces frozen with mercy.

The Castle of the First Reichsmarschall

By 1943, Baroness Elisabeth Bachofen-Echt, one of the dispossessed heirs of the Lederer Klimt collection, was living in desolate isolation. "Beautiful Lisl" spent her days in virtual solitary confinement. As the hours passed, did she sometimes wonder if she was losing her mind?

The Lederer Klimt collection had been seized and sent to Schloss Immendorf. Her mother was eking out a bleak existence in Budapest. Elisabeth was apparently still living at Jacquingasse, though the home was in the name of her "Aryan" ex-husband, Wolfgang. Rinesch said Wolfgang worried about her, even took her to see her mother in Budapest before Serena died there in March.

Wolfgang was also listed as the seller of two Lederer Klimts, the Faculty Paintings *Philosophy* and *Jurisprudence,* to the Belvedere. Thanks to the Nazis, Klimt's shocking modernism was finally making its way into the academy.

Loneliness was Elisabeth's first waking sensation. She flipped through her books at Jacquingasse, or watched the noisy construction crews that were excavating the garden of the Belvedere outside her window, pouring heavy concrete into an immense underground chamber under the pond.

Her neighbor, a little boy named Hans Hollein, watched the goings-on with interest: he would grow up to become one of Austria's finest architects. The composer Richard Strauss, living nearby with his Jewish daughter-in-law under the protection of Baldur von Schirach, had to walk around the construction site as he strolled the Belvedere gardens.

There would have been few other witnesses to the mysterious project at the Belvedere, except the leonine stone sphinxes, the guardians of secrets.

The brilliant former director of the Austrian Gallery, Franz Martin Haberditzl, was very ill in January 1944 from the complications of his degenerative disease. He spent the last hours of his life in a chilly apartment at the Belvedere, listening to his daughter Magdalene read the work of the Austrian poet Rainer Maria Rilke, a fellow soul-seeker whose lover had been a disciple of Freud. "Think, dear friend," Rilke had written, "reflect on the world you carry within yourself."

Haberditzl sifted through a lifetime of memories. He had attained the dream of Austrian art he shared with Adele, at least for a fleeting instant. Now, as a bitter winter wind blew across the snowdrifts outside, Magdalene read from *The Notebooks of Malte Laurids Brigge,* a story about the meaning of Time as Death draws near:

> You come and keep what is monstrous behind you. As if you had come far in advance of everything that may come, and had at your back only your hastening here, your eternal path, the flight of your love.

Magdalene's voice grew fainter as Haberditzl, the gentle visionary, closed his eyes and slipped away from his ravaged world forever.

The Austrian Gallery's paintings had been carted away to castles throughout Austria. Other works went to the ancient Celtic salt mines, deep in the bowels of the earth, at Alt Aussee, where they were packed like furniture next to art from all over Europe.

By September 1944, as Goebbels waged *Totaler Kriegseinsatz,* or total war, the museum was closed.

In reality, the Austrian Gallery had ceased to function solely as a museum. Now it was also occupied with the administration and protection of stolen art. There had been a Nazi plan for a museum of Prince Eugene's military exploits. But there was no time for that.

The massive fortified bunker under the Belvedere was completed, and a military team moved in. As Allied air raids began, a metal periscope emerged from the ground above the bunker and sounded an alarm.

Baldur von Schirach had alternate offices in the Belvedere, and as the bombing intensified, these elegant digs became much more attractive. Schirach had a deadly fear of bombings, and a love of bunkers—and this new refuge was designed to be impregnable.

A National Socialist daily called the Belvedere the "Castle of the First Reichsmarschall." Prince Eugene's Belvedere had become a true palace of war.

As the days grew shorter in the autumn of 1944, perhaps the comings and goings at the Belvedere relieved the endless monotony of Elisabeth's days at Jacquingasse.

What was left for her? Her mother had not lived to see the Jewish citi-

zens of Budapest deported to Auschwitz. Her mother's sister, Aranka Munk, had been expelled from her Austrian country villa at Bad Aussee, now just a few miles from the vacation homes of Nazi leaders at Alt Aussee.

Aranka had been arrested in October 1941. By then deportees were driven away in open-air trucks while Viennese on the streets yelled obscenities and catcalls. Onlookers laughed at old people who couldn't walk, who had to be lifted into the deportation trucks in chairs. Jeering crowds was their last sight of their beloved Vienna.

Aranka died a few weeks later in Lodz, Poland. Her daughter was murdered at the Chelmno camp in 1942. Someone carted away the painting Klimt had done of Aranka's daughter Ria after her death, in which the fading Klimt had struggled to infuse his subject with life. The man Ria had killed herself for, Hanns Heinz Ewers, the German writer of popular vampire novels, was by then penniless and dying of tuberculosis, following a Nazi flirtation that had not ended well. He earned the Führer's approval with a biography of a Nazi martyr, Horst Wessel, a young brownshirt who had been shot by the supposedly Communist pimp of his prostitute girlfriend and was nonsensically celebrated as a Nazi everyman. But the writer found himself banned when he created a valiant Jewish mistress in his novel *Vampyr*. Revelations of his support for a homosexual literary magazine sealed his exile.

Amalie Zuckerkandl, the white-shouldered model for the unfinished Klimt masterpiece, whose father had written a play with Mark Twain, had been deported in 1943 with her daughter Nora Stiasny. They were believed to have died in Belzec.

Authorities had also deported Samuel Morgenstern, the Jewish gentleman who had taken pity on the down-and-out young Hitler and bought his mediocre Vienna paintings. Morgenstern wrote Hitler a desperate letter. There was no reply.

Morgenstern, sixty-eight, died of exhaustion in the Lodz ghetto in August 1943. His widow probably died in Auschwitz.

In this bleak Vienna, there was almost no one left who had not betrayed the decency of Elisabeth Bachofen-Echt. She made a final foray to the Bachofen-Echt *schloss* in Nusdorf, the home of her brother-in-law Eberhard and the seat of the beer fortune Elisabeth's father had bailed out. She walked into the great house. The servants knew Elisabeth well. They were shocked to see her. They stared at her as if she were a ghost. But they made no effort to stop her as she made her way to the nursery of her nephew, Eberhard's son.

He was a little boy, his age close to that of Elisabeth's son, August, when

he died. Trying not to cry, Elisabeth told her small nephew that she loved him very much. But these were very hard times, and they would not see each other for a long while. She stooped down to hug him and kissed him goodbye.

Eberhard was furious when he found out. Relations like Elisabeth were hardly an asset for someone in the SS.

By October 1944 air raids were taking a toll on Vienna. As fierce battles raged, turning the tide of World War II, the forsaken Elisabeth succumbed to deep depression until finally, Gustav Rinesch wrote, she "died of a broken heart." Another piece of Klimt's painted mosaic had crumbled.

The Partisans

At the Zagreb prison, Nelly, at fifteen, was becoming a young woman. She angled for the chore of emptying the chamber bucket because it was the social event of the day, where prisoners chatted and got to know each other.

Some partisans befriended her, and asked her to help them. Nelly got permission to see a dentist. A prison guard had to accompany her, and since Nelly had promised him a mushroom omelette, he looked forward to it. The dentist belonged to the Communist Party. Once in his chair, Nelly took off her shoes and stockings and handed him the letters hidden there: important partisan mail, messages to prisoners' families, and letters from her parents to family members.

Nelly asked to stop down the street at a tiny store where an old lady sold buttons. There she delivered more letters while the guard smoked outside. Nelly returned to prison with correspondence passed along by the dentist and the button lady. Authorities eventually arrested the dentist and sent him to a concentration camp, but he never implicated Nelly or the button lady.

Nelly had reached the age when she wondered if boys found her pretty. Nelly did not possess Luise's soft baby face. The solitude of her childhood had not encouraged her to cultivate the teasing banter or the sultry gaze with which Luise had entranced young men in Vienna. Physically, Nelly

took after her father: her face lean, her cheekbones high. But she had none of his easy confidence. Nelly was reserved and wary, with watchful eyes.

Still, Nelly had admirers, among them the Croatian former policeman imprisoned for his letter of outrage at Jasenovac. One day at sunset, he led the prisoners in a courtyard serenade of Nelly. She smiled down from the window of her cell, thrilled.

Perhaps the Croatian policeman had learned Nelly was Jewish: Jewish women were fair game, lucky to be alive. The Croatian no longer felt obligated to court Nelly, or win her heart. One day, while cutting cooking greens on a table, throwing bits to the ducks that quacked noisily for scraps at her feet, Nelly heard footsteps. Before she could turn around, someone grabbed her in a tight embrace. It was the Croatian. He was strong. He shoved her against the table, running his hands over her body. Nelly, clutching her knife in her hand, warned him that if he didn't stop, she would cut him. He ignored her. Nelly raised the long knife and brought it down on his hand. Yelping in surprise and pain, the Croatian scurried away, clutching his bleeding hand.

Nelly proudly told her parents that she had defended her virginity. They exchanged worried glances. Jewish girls did not stab Gentiles with knives. But days went by, and nothing happened. The Croatian wore a thick bandage wrapped around his hand. He no longer met Nelly's eyes, but he had not told how he was injured.

If he had, he might have doomed Nelly's whole family.

Then, one day, the family was sent to live in a sanatorium and the restrictions on them eased. Luise sent Nelly to live with a woman who hid Jewish children, but then she brought her back and Nelly later heard the woman was deported to a concentration camp. Then the family was allowed to live in an apartment, under the supervision of police detectives who kept an eye on them when Nelly's father was ordered on trips.

Her father told her little about his trips to Hungary and Switzerland. Viktor knew what would happen to his family if he used the trips as a chance to escape.

In the woods, the partisans drew closer.

The Man Without Qualities

By the fall of 1944, the Allies were closing in. They had invaded France, liberating Paris. The Red Army was pushing into Yugoslavia, forcing German troops to withdraw. The Japanese were under pressure.

Astute observers in Vienna could see that it might be time to hedge their bets. That September, Erich Führer, Ferdinand's lawyer, rolled up Kokoschka's portrait of Ferdinand with lederhosen and a hunting rifle. He brought the painting to the Vienna offices of a state culture official he knew, and asked him to confirm that it was "degenerate." Führer didn't want to be accused of exporting patrimonial art from the Reich.

Nazi bureaucrats did not consider Kokoschka's works valuable. They had so much trouble auctioning confiscated Kokoschkas that Göring had tried to sell one to a foreign correspondent. The Vienna official obligingly stamped the back of the canvas "Degenerate Art" and handed it back to Führer.

Führer made his way to Zurich. Ferdinand met him in the lobby of his hotel. "Herr President, here is your painting," Führer said to Ferdinand, with a respect he did not feel.

"He was very content," Führer would tell a judge years later.

Ferdinand was prouder than ever to have been immortalized by Kokoschka. The artist, now in London, was a fervent and vocal critic of Nazism. The long-ago protégé of Klimt had not changed his principles to suit the times. Earlier that year, Kokoschka had complained publicly that schoolchildren asked him to show them his country on a European map, but the only maps that he could find showed Germany seamlessly encompassing the invisible borders of Austria. "Will it be of any interest for British readers to know the embarrassment I felt?" Kokoschka wrote in a letter to the *Forward*, a socialist newspaper. "Is it incidental that 'the first free country to fall a victim of Nazi aggression,' according to the statement of the Moscow conference, should be the only one not marked?

"How will future British tourists find their way to the country, traditional here for its '*Gemütlichkeit*,' if Austria has been wiped off the British globe?" Kokoschka wrote.

Ferdinand donated Kokoschka's portrait of him to Switzerland's national

gallery, the Zurich Kunsthaus. The work by Austria's best living painter would not return to the Vienna that had put a bounty on Ferdinand's head. Ferdinand made sure it would remain forever in the country that had given him refuge.

Führer would later testify that he had risked his life to bring the painting to Ferdinand. But archives that surfaced after the war suggest Führer actually made the trip to spy for the SS in Switzerland. And that Führer made as much as a million reichsmarks in 1938 alone—on an annual salary of 1,000 reichsmarks—profiteering at the expense of dispossessed Viennese like Ferdinand.

The Nero Decree

Hitler's last feverish thoughts were of art.

In the wee hours of April 29, 1945, Hitler, the failed artist, raved into the night about the great Führer Museum he planned in Linz to showcase his assemblage of stolen masterpieces.

By then, Hitler's army had stolen 20 percent of the artworks of Europe. The art was hidden in salt mines, monasteries, and convents across Europe, and hanging in the estates of Nazis who were now on the run. "My pictures, in the collections which I have bought in the course of years, have never been collected for private purposes, but only for the extension of a gallery in my home town of Linz," Hitler wrote in his will from his underground bunker in Berlin.

Two hours later, he and Eva Braun committed suicide.

The towers of the Schloss Immendorf still sheltered the greatest single collection of works by Gustav Klimt. But the German soldiers guarding the castle were nervous. Their leaders had surrendered. Russian forces were a day away. Even the Jewish slave laborers knew of the German defeat.

One by one, the German army soldiers abandoned their posts. They headed for rural hamlets where SS officers were burning their uniforms and Nazi identification cards, reinventing their pasts and even their names.

Upstairs, in a castle tower, stood the Klimt paintings. Men had come

and hastily picked up some of the Belvedere paintings. But, curiously, they left the Klimts behind.

Members of cashiered SS units began streaming in from the SS head-quarters at nearby Hollabrunn. The belligerence of defeat stared out from their ruddy faces. They barged into the castle, their alcohol-soaked breath reeking of failure. They helped themselves to the baron's liquor and emp-tied his wine cellar.

Then, according to a police report, the SS officers began an all-night "orgy." At some point during the bacchanalia, the terrified cook ran out of the castle. The military nurse was seen fleeing across the lawn and into the darkness. The police report said the baron himself finally "had to leave" his besieged castle, although according to other accounts he had fled with his children long before. Then it was just the drunken SS officers, fueled by the collapse of the Reich, the memories of the unspeakable things they had done for their Führer, and the price they might pay.

In the morning, the hungover SS men wandered out of the castle, leav-ing its great wooden door ajar. An hour later an SS officer returned on a bicycle. He ran into the castle. A few minutes later, he reappeared outside, mounted his bicycle, and sped away. The townspeople were startled by loud explosions in the castle towers. Smoke poured from the windows.

Flames began to lick through the turrets where little Baron Johannes had loved to linger. The townspeople saw the blaze against the sky and rushed to the castle with washtubs of water. But as they threw water on the flames, a terrible blast erupted inside, then another, blowing out the walls and making the ground tremble. Heavy stones rained down, and everyone fled. As the townspeople watched, the castle that had cradled the Lederer Klimts became a furnace.

The fire ate away the prized Faculty Paintings that had scandalized offi-cialdom with their images of nude pregnant women. This was the triptych that had gotten Klimt expelled from the academy and pushed him into the embrace of the enlightened Jewish elite.

Now his prescient vision of dystopia had arrived. The "dark powers" were incinerating his art. As the castle caved in, the heat consumed the delicate masterpiece depicting Schubert at the piano, with the apprehen-sive face of poor Mizzi Zimmermann, now a seraphim of flame and ash floating off in the wind.

The Klimt portrait of Valerie Neuzil, a teenage mistress of Egon Schiele who died of scarlet fever as a nurse in World War I, now turned red in the flames and blackened to ash. So did *Girl Friends,* Klimt's rendering of

two women who seemed languidly in love. The ethereal lute-strumming maiden with almond eyes of his *Music II* also ignited into searing flames.

This was believed to have been the fate of as many as fourteen spectacular Klimt paintings.

The Schloss Immendorf was not the only castle burned. Across Nazi Germany, a bizarre ritual was taking place. Retreating SS officers threw themselves into drunken binges. Concentration camp guards killed the exhausted skeletal prisoners who had witnessed their terrible crimes. The Countess Margit Batthyany, née Thyssen-Bornemisza, threw a lavish black-tie goodbye party for the SS officers in residence at her castle near the Hungarian border, where she had been reportedly cuckolding her husband with a Gestapo officer. At some point during the evening, the SS men reportedly marched out some Jewish slave laborers. They invited guests to shoot them for a while, and then returned to the dance.

In Klimt country—the magical, wildflower-carpeted Salzkammergut where the Bloch-Bauers had summered—"ordinary people bore witness to the random slaughter and mass murder of parents and children, clubbed or shot to death before their very eyes" by cashiered SS men who marched starving Jews out of the concentration camp at Mauthausen.

For four or five weeks, roving bands of Hitler Youth, demobilized Wehrmacht, and even firemen joined in the sporadic violence. In the pretty iron-mining mountain village of Eisenerz, two hundred exhausted Jewish slave laborers were machine-gunned by a randomly assembled mob. In Wiener Neudorf, on the outskirts of Vienna, a woman persuaded her SS boyfriend to hand over his gun so she could shoot some Jews.

A scorched-earth farewell was Hitler's idea. Just as the Roman emperor Nero had burned villages and farms, and seventeenth-century Vienna had burned palaces and houses outside the city walls as the Turks advanced. Hitler had issued his "Demolitions on Reich Territory" order in March. Its nickname, the "Nero Decree," betrayed its malice and final mendaciousness. Millions of people had died for the sins of the Reich. Now the SS was to mount a final orgy of destruction.

But Hitler was dead. Albert Speer, the Nazi architect Hitler had ordered to execute this order, began to lose his nerve.

Deep in the mountains of the Austrian village of Alt Aussee was the salt

mine that cradled a precious repository of stolen European art once des-tined for Hitler's planned grandiose Führermuseum in Linz. This hidden treasure trove of Western civilization held more than 6,577 paintings, from Van Eyck's *Ghent Altarpiece* to Vermeer's *The Artist in His Studio* and a Michelangelo sculpture, *Bruges Madonna*.

The conservator of this fragile patrimony was August Eigruber, the Nazi governor who had ruled the region like a king. As American troops approached, Eigruber had feverishly called for popular resistance to the last man, woman, and child. The contents of the Alt Aussee crypt were to be destroyed. Five-hundred-pound bombs were hauled into the cavern in wooden crates marked "Fragile." Eigruber's guards were to see that the bombs were detonated as the Nazis retreated. But others were aghast at the plan. By some accounts, an adjutant to Hitler's personal secretary, SS Hauptsturmführer Helmut von Hummel, began to contact mine officials and senior officers. It seemed terrible to smash the artistic treasures of an entire civilization to smithereens.

The day before Allied forces arrived, Ernst Kaltenbrunner, the SS intelligence chief, ordered the bombs removed. Then he kissed his young mistress goodbye and made his way up the steep terrain toward the snow-covered Alpine peaks that cradle Lake Attersee like a little blue cup. On May 5, the mines were safely sealed with explosives to protect the art.

At Schloss Immendorf, the damage was done. Red Army troops arrived the afternoon of May 8. They were greeted by blackened rubble. Flames roared from the depths of the old stone basement. The fire burned for days. Russian troops tried to extinguish the fire and salvage valuables. They ended up with two smoke-drenched Persian carpets. The Lederers' famous Klimt collection, the most important single collection of the artist's work, was reduced to wavy figures on charred canvases that crumbled when wind blew through the smoldering ruin.

Johannes, the little baron, came to survey the wreckage with his father. Baron Freudenthal was adjusting to life as a widower with five children. He had lost his wife to typhus in 1943. He said he had been purged from the officers' corps in the aftermath of the 1944 attempt to assassinate Hitler.

Johannes was twelve now. He watched his father's face carefully. His father didn't cry. But from then on he was a broken man.

In Vienna, the Nazi governor Baldur von Schirach had called on Vienna to take arms against the "latest horde of barbarians" to protect the "land of our ancestors," just as Vienna had fended off the Turks. He had posters put

up all over the city, proclaiming that Vienna was once again a fortress city to be defended to the last man. Then he too fled the Red Army.

The Secession building had endured the battering of Allied bombs in 1945, but "these damages could have been restored," according to the daily *Arbeiter Zeitung*. "Unfortunately," the last exhausted Wehrmacht soldiers were using the scarred Secession to store tires for automobiles and transport trucks, the newspaper said.

Two days before Red Army soldiers arrived, the German army troops set the tires on fire, "in order not to leave the victors a bundle of tires as a bounty of captured material," the *Arbeiter Zeitung* reported. The fire roared out of the basement, blackening the gold leaf and the famous cupola of golden laurels. The temple to new art collapsed into the inferno. Even the iron frame of the building melted in the heat. "A very precious building was destroyed, because the heat of this fire destroyed the architecture almost down to the foundation," the paper reported. The Secession was reduced to charred smoking rubble—a final cremation of Vienna's artistic belle époque.

In the coming days, Allied forces freed emaciated prisoners from concentration camps, fed exhausted refugees, and hunted notorious Nazis. One day, the U.S. soldiers opened a door in the mountainside at Alt Aussee. They trudged carefully into the dark cavern, in case it had been rigged with explosives.

To their amazement, their lanterns shone on seemingly endless paintings and statues, packed deep into the mountain passage.

Against the backdrop of so many lives destroyed, these fragments of creativity and brilliance paled. Yet the soldiers paused in awe.

When American soldiers caught up with Nazi Reichsmarschall Hermann Göring, he was fleeing with baggage stuffed with looted art.

Klimt's gold portrait of Adele Bloch-Bauer did make it through the war. She survived the Götterdämmerung deep in the former Carthusian monastery at Gaming, a mountain stronghold, founded in the 1330s and once known for the intellectual distinction of its holy men. Here, as bombs fell on Vienna, the pale, fragile face of Vienna's golden moment endured her stint in hell. Klimt's painted mosaic had been shattered. But his majestic empress had survived.

Her family and friends had been insulted, murdered, driven to suicide.

Her name had been erased. Now Adele emerged to join Europe's survivors, the glittering key to an undeniable past.

Restitution

Ferdinand, too, survived the war. But he had lost too much. Luise was trapped in Communist Yugoslavia. The rest of his family was either in Canada or dead. Berta Zuckerkandl had turned her Algiers home into a salon for American military commanders, but then a throat infection killed her, almost overnight. Ferdinand's friend turned Nazi acolyte, Carl Moll, had died in a suicide pact with his daughter and Nazi son-in-law.

Ferdinand's loss did not end with the defeat of the Nazis. His world had been betrayed. Another former friend, Karl Renner, who would now lead the postwar government, opined in April 1945 that "restitution of property stolen from Jews" should go "not to the individual victims, but to a collective restitution fund . . . to prevent a massive, sudden flow of returning exiles. "The entire nation should not be made liable for damages to Jews," Renner said.

So restitution would not be automatic? This was alarming. How would Ferdinand move back home? Elisabethstrasse was still functioning as a railway headquarters. Jews who returned to Vienna were telling of people living in their homes and refusing to leave.

Ferdinand's fellow exile Erich Lederer had lost his mother and sister. Erich was beside himself with grief and fury. Austrians had torched the family Klimt collection at Schloss Immendorf. Officials refused to give Erich an exit permit for the *Beethoven Frieze*. They had the delicate fresco stashed in the chapel of a damp, drafty castle. The Klimt portraits of Erich's sister Elisabeth and his mother, Serena, mysteriously resurfaced—for sale at the Dorotheum. The Klimt portrait of Serena's frail mother, Charlotte, had vanished.

The war was over. But there was little contrition.

In May 1945, the Nazi-era director of the Belvedere, Bruno Grimschitz, reported that the museum had gained "between 1938 and 1945 over two

hundred high-class works of art . . . by means of an uncommonly prolific acquisition policy"—a euphemism for the wartime ransacking of Jewish collections.

The Austrian Gallery had amassed an excellent Klimt collection during the war, and they did not intend to give it back.

In October 1945, Ferdinand wearily rewrote his will. He had few possessions to leave his heirs. Erich Führer was hanging on to the Klimt painting he had stolen from Ferdinand, *Houses in Unterach on Lake Attersee,* and even the books Adele had willed to the workers. Ferdinand could not move back to Elisabethstrasse. The administration of the onetime German railway that deported Jews was still housed in his home. Ferdinand knew the Belvedere had the Klimt gold portrait of his wife, and his *Apple Tree.* He didn't know it also had Adele's second portrait.

The war was over. But the people and the life that Ferdinand had treasured were gone, leaving him, at eighty-two, an old man alone in a hotel room. On October 22, 1945, Ferdinand signed his final will and testament. He left half of his estate to his niece Luise and a quarter each to Maria and her brother, Robert. In mid-November, as the darkening days signaled the approach of winter, a hotel maid came in to make up the room and discovered Ferdinand's body.

Liberation

In Yugoslavia, Tito's victorious partisans marched into Zagreb in May 1945. Nelly's father shot photo after photo of the troops marching down the streets, as crowds cheered. Free at last! Maria's brother Leopold begged Viktor and Luise to come to Canada, where their mother, Therese, had also found refuge. But Viktor wanted to be part of the reconstruction. His family had built railroads and been pioneers of industry. The Gutmanns belonged here. They would help build the new Yugoslavia. Leopold thought Viktor and Luise were mad.

The new Communist government praised Viktor's skills, promising

him a job as an engineer. Nelly and Franz returned to school. The Gutmanns breathed a sigh of relief.

They had survived.

Ferdinand never got to say goodbye to Luise. She would have told him they were finally safe.

Nelly, sixteen, now reveled in strolling in the open air, without fear. Nelly felt almost euphoric one November day after she walked home from school and opened the door to their apartment, a real home.

But her father wasn't there. A family friend was there to tell her that he was under arrest. Nelly panicked. Her mother was on vacation at Split.

No lawyer would take her father's case. The postwar show trials were just beginning. In the next few months, hundreds of Yugoslavs, guilty and innocent, would be condemned to death for collaboration, as members of the new Communist society jockeyed for position. Lawyers feared ending up like Viktor, facing the hasty revolutionary trials where former partisans proved their revolutionary zeal. Yet notorious Nazis like Ante Pavelic escaped.

Only one man dared to defend Nelly's father: a Serbian lawyer who, as a member of an ethnicity the Nazis had tried to exterminate, had some immunity. He had only a day to prepare for the November 20 trial, and only an hour to brief Viktor.

At Viktor's trial, the prosecutor opened with a rambling discourse on how since the days of the French Revolution, wealthy men like Baron Gutmann had been "parasites" who "exploited the working classes of their societies." He accused Viktor of helping "the German war economy" achieve the "industrial takeover of Croatia" with a major share transfer in 1941. Viktor said the transfer was arranged by relatives abroad, without his knowledge. The prosecutor also claimed that Viktor had orchestrated the deaths of several hundred partisans who battled Nazi forces near Belisce in 1943.

Viktor argued that as a Jew, jailed in Zagreb with political prisoners, he was not in a position to plot a fascist attack on partisans in Belisce.

"Gutmann is one of the worst war criminals and collaborators," the prosecuting attorney insisted. "Only the maximum punishment can be applied."

Viktor Gutmann had outlasted the Nazis. Now, the new self-appointed prophets of history hastily sentenced him to death.

His Serbian attorney had a desperate idea. Since the new Yugoslavia was

a proletarian workers' republic, Nelly should go to Belisce and collect signatures from the Gutmann workers. If the workers spoke, surely judicial authorities would listen. Alone, the shy, skinny teenager rode the train to Belisce.

The war-ravaged little town was much quieter than Nelly remembered it.

Nelly knocked on the doors of her father's former white-collar workers. At the first house, the father of one of her former playmates stared at her in alarm. Nelly blurted out the story, holding up her petition. The man had heard all about Viktor's problems. He shut the door in her face. Another woman opened her door a crack, recognized Nelly, and closed it. No one would let Nelly into the house.

In despair, Nelly trudged up the road to the lumber factory. The workers were getting off a shift. One of them, a big older man, recognized Nelly. He hugged her warmly, and proudly led her to his house. He set a plate of fresh sausage before her, then rushed to tell his neighbors that the baron's daughter was alive.

As the men filed in, Nelly's burly host drew up a petition declaring that the "workers of Belisce" supported Baron Gutmann. The old man was excited: Tito's Yugoslavia was now a Communist workers' state, and he had a say. The other workers weren't so sure. You sign it, one said. No, you sign it. Finally, the old man picked up a pen, and with the grandiose flourish of a man who felt his opinion finally counted, he signed his name. One after another, the other workers signed on the kitchen table.

Then the old man took Nelly by the arm and led her up the rutted dirt road to other workers' houses. It was pig-slaughtering time. Each family sat the baron's pretty daughter down and served her sausage as the workers washed their hands and signed the petition. Nelly gingerly ate platter after platter of greasy sausage, feeling increasingly sick to her stomach.

At the train station, Nelly was met by a demonstration of Communist youth militants who knew the daughter of the "Jewish collaborator" was coming. Her father's former manservant, Jozo, waited with Nelly behind some bushes near the train station. When the train passed, Jozo helped Nelly board the slowly moving train, with the signatures in her pocket.

She rode the train back to Zagreb and ran to the courthouse, holding her petition triumphantly in hand. It didn't matter: Nelly was told her father would be shot the next morning. She hurried over to the prison with her little brother, Franz. It was already late afternoon. Little Franz barely understood what was happening. The guards allowed Franz to say a brief goodbye to his father. Then a close friend of Viktor and Luise, Joseph Gattin, a Catholic schoolteacher, took Franz's hand and walked the boy home.

The prison guards told Nelly she could spend her father's last night with him. She followed them to her father's cell, stunned. She and Viktor lay on a blanket talking as the prisoners played chess by candlelight and smoked cigarettes. Viktor was peaceful. He spoke to Nelly as an adult, not a child.

He talked about how life would go on without him. During his months in prison, he had rehearsed his death in his mind, and he wasn't afraid.

In the next room was a dean of the university, who would also face the firing squad. The dean and his family were sobbing loudly. "Let's move," Viktor told Nelly. "It's getting on my nerves." They pulled their blanket to another corner of the floor. Viktor continued in the same detached tone. "So many people have been shot in the last few years," he mused. "What's one more?"

One more? Losing her father was unbearable. An ocean of exhaustion swept over Nelly. She closed her eyes for a moment, and her father's voice faded to a distant murmur.

When Nelly opened her eyes, her father was touching her shoulder and whispering her name. It was nearly dawn. Nelly was so ashamed. She had slept through her last night with her father. Her father had spent the night awake, reading Goethe's *Faust*. The guards walked in. "You can go home now," a guard told Nelly.

Her father stood up. He walked from guard to guard, shaking their hands with cordial formality. "Goodbye. Thank you very much," he told each guard, as if he had just dined at their house.

Viktor handed Nelly his copy of *Faust*. Then he hugged his daughter for the last time.

The guards walked Nelly to the door of the prison, and she stepped out into the cold air. The dark sky was beginning to turn pale blue, and the first birds were singing. Nelly walked slowly down the deserted streets, feeling like a ghost in a dream. The first early morning workers, men in worn work dungarees and women with scarves around their faces, brushed by Nelly in their winter coats, preoccupied with their own tragedies, in a country torn apart by war. Nelly searched their tired faces, but found no answering glance. She wanted to stop them and say, "Don't you know they are shooting my father?"

Viktor was shot that morning. The guards stole his clothes and shoes. They gave Luise one of Viktor's books, an anthology of the "worldly wisdom" of Goethe.

One of them handed Luise a letter from Viktor. It was dated January 30, 1946—two weeks before his execution.

Viktor knew he was doomed. He wrote:

Dearest Luise,

The Supreme Court has rejected my appeal.

I do not want to become sentimental and pathetic at this moment; that is not necessary between us.

I am completely calm. In the course of these difficult months, I have become so used to the thought of dying that I confront my fate under complete emotional control. God wanted it this way and therefore it will presumably be good and right.

I would now like to tell you a few things that concern me. There are two in particular. The first is, that you and the children should do your utmost to overcome these difficult events emotionally as soon and as completely as possible.

This will be more difficult for you than for them; the children have their whole lives before them; you have half your life before you.

You should make a particular effort to only look ahead and not back.

At first, your path will be a difficult one, and now comes the second thing that I have to say.

It is my wish that the man, who during these difficult times proved to be such a good, noble friend and such an honorable person, and who is so fond of you, should remain at your side as support and help in your future life.

Of course, I assume here that this is in agreement with the wishes of you both.

So Viktor had noticed. In the past few months, his good friend Joseph Gattin had been falling in love with Luise. Viktor wrote:

He was a Godsend to you. I am also sure that he will appreciate what a unique treasure he will have at his side.

I beg you to do everything in your power to achieve a future state where you have peace of mind and emotional calm and can think about yourself and your well-being . . . As far as the children are concerned, they have turned out so well that I don't worry about their future . . . They were the greatest joy of my life.

I do not wish to write you about the cursed shares. It disgusts me to mention a word about them in this letter . . .

I have one more wish: please do not feel too badly about me . . . In the course of my life, I experienced and saw so much that was beautiful. And how many millions of people have faced the same fate in recent years.

There is just one thing I regret: that I was never able to tell you and show you how very much I loved you.

I kiss you and the children a thousand times,

Your Viktor

P.S. It is my wish that the case of my trial should not rest. All possible evidence should be collected and efforts should be made so that the truth about the events that took place here become known in the widest possible circles.

Luise asked for Viktor's remains. The prison administrator bluntly refused. They kept his watch. As she left, Luise saw a guard walking through the prison yard, wearing Viktor's fine long black wool overcoat.

She trudged into the Interior Ministry, sat on a dirty bench, and waited her turn. Perhaps they could just tell her the location of the grave? An official glared at Luise across a desk. "If you don't stop pestering people," the official warned her, "you could end up like your husband."

Luise and her children were now pariahs, the ostracized family of an enemy of the people. Nelly retreated into shell-shocked silence. There would be no funeral, no memorial. That would only draw disdain, or worse. By now Nelly was familiar with suspicious stares and whispers. She kept her grief to herself. Alone, she pored over the picture of her father, alongside Uncle Erno, handsome in their Habsburg uniforms trimmed with gold braid and medals: the dashing Gutmann barons.

There was no trace now of Luise the baby-faced belle. Luise was desperate. There was no future for her in Yugoslavia, no future for her children.

She tried to escape. She was caught by a border guard with crazy eyes who seemed capable of anything. "Do you have any money?" he asked. "Jewelry?" Luise had almost nothing. "Can you get some?" the guard persisted, with his unfocused stare, pointing his gun at her. Luise began to cry. "My husband was murdered," she said. "I am all my children have."

"They burned my wife and children alive!" the guard retorted, with

his mad eyes. "They stuck them like pigs!" Luise looked into his unbalanced gaze with horror. He let her go.

Exodus

Then, improbably, a door opened. In 1948, the state of Israel was declared. The Tito government said Jews who could get visas to Israel were welcome to go. There were long lines of applicants. Now a Jewish grandmother was not such a liability.

Nelly loved her new home from the moment she saw the ancient stones of Jerusalem in the desert sun. She was not a Zionist, or a partisan. She was an orphan of a hostile world. Now she had a refuge. A place where people who had lived through hell were embracing life, joy, idealism, and love. Where intellectuals tilled the soil, smiling as they sweated in the sun. Nelly enrolled in a Jerusalem medical school, worked in a hospital, and helped relocate Jews from Yemen. Some of these men had six wives and thirty-five children. They tried to light cooking fires on the plane. One man amused Nelly by asking how much it would cost to make her his youngest wife. After years of fear and rejection, everyone here embraced Nelly. No one cared if she was born Jewish but celebrated Christmas and Easter. Here Marxists and Zionists mingled with refugees who wanted to be done with ideology and religion. Like Nelly, they were grateful just to be alive, surrounded by friendly faces and smiles as warm as sunlight.

After years as a pariah, Nelly felt she finally belonged.

The respite wouldn't last. Luise's family implored her to join them in Canada, and she finally listened. In 1950, the battle-scarred little family—Nelly and Franz, Luise and her new husband, the Jewish convert Joseph Gattin—arrived in Vancouver. The Bloch-Bauer brothers had changed their surname to Bentley and founded a timber company. Nelly applied to American medical schools, unaware that most accepted few or no women. She was admitted to only one, the University of Seattle. There, discrimination against the handful of female students was common, but this didn't

*What was to be a secret Nazi bunker under construction at the
Belvedere Palace, under the gardens, visible from the window of
Baroness Elisabeth Bachofen-Echt, 1943.*

discourage Nelly. After all, her old pediatrician, Dr. Bien, had stood up to
an entire profession to open the door for young women like her.

*Luise and her daughter, Nelly,
now a beautiful young woman
who aspired to be a doctor like
her childhood pediatrician,
Adele's good friend
Gertrud Bien, ca. 1949.*

Austrian refugees were crowding into Vancou-
ver. One of them asked Luise to help a fellow
émigré, a young man with a mysterious pedigree
who was washing dishes in the kitchen of the
Hotel Vancouver.

Johannes, twenty-one, was a tall, poised
youth, with black hair and blue eyes. Luise did a
double take as Johannes haltingly traced his
complicated journey. Johannes was an Auersperg
prince, from an eleventh-century lineage peo-
pled with statesmen, poets, and commanders. In
Tolstoy's *War and Peace,* even an enemy flattered
an Auersperg prince as "Dearest foe! Flower of
the Austrian army, hero of the Turkish wars."

Johannes had spent his childhood in the
Czech Sudetenland, a few miles from the Klimt
mural at Liberec. The region had been a bastion

of fervent Nazi support. At fifteen, Johannes had been marched to Austria on foot when Red Army troops expelled Germanic Czechs.

Luise listened carefully to the account of this penniless dishwashing prince. She got Johannes a job driving a sawdust truck for the family timber company, and invited him to dinner.

Nelly came in from Seattle, flushed with the excitement of medical school. Her mother's dinner guest kissed her hand with formal flourish. He was absurdly handsome, and immediately smitten with shy Nelly.

Before Nelly married Johannes, she confessed to a priest that after her father died, she had decided there was no God. How could the horror she had lived be part of a divine plan? "I don't believe in God," she said. "What can I do?" Never mind, the priest said thoughtfully. "There must be a God. You'll make a good wife." So Nelly, persecuted as a Jew and reinvented as a Catholic, became a princess of one of the oldest dynasties in Europe.

Maria had followed the Altmann clan to Los Angeles. She and Fritz had three boys and a girl. She sold some of Bernhard's knitwear to a few

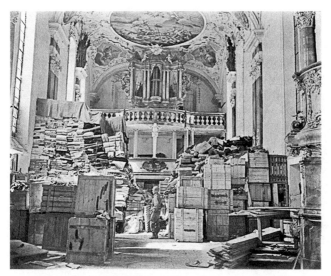

A depot of stolen art at Ellingen in Germany, ca. 1945. Allied forces sorted through millions of stolen artworks and returned many to their governments of origin—which often did not get them to their rightful owners.

stores and discovered that she loved to work. She opened a dress shop on Burton Way in Beverly Hills. Fritz became the West Coast salesman for Bernhard, and sang opera with his old friend, the composer Erich Zeisl. They joined the vast Los Angeles community of exiles from fascism: Bertolt Brecht, Thomas Mann, Alma Mahler, Arnold Schoenberg. Michael Curtiz was there, and Billy Wilder, whose parents had died in Auschwitz.

The only Bloch-Bauer work left in Vienna was the portrait of Adele, in the Belvedere Palace, the museum with the colorful history, bomb-scarred roof, and clandestine bunker.

Provenance

As Austria emerged from the war, Americans trucked Europe's orphan paintings from salt mines, castles, and convents in Austria and Germany. In many cases, the owners of the art could not pull their own paintings out of the stacks of assembled artworks. Often, the Allies turned the art over to their governments. In Austria, this practice left Jewish survivors at the mercy of government officials who had collaborated with the Reich.

The art historians who meticulously catalogued the art to be stolen after the Anschluss gave few clues about the fate of lost and missing works. Austrian officials remained silent about a huge cache of stolen art at the fourteenth-century former monastery at Mauerbach, outside Vienna. The art historians who could have provided answers remained silent, taking pains to cover their pasts.

Bruno Grimschitz, the dapper Nazi bureaucrat who ran the Belvedere under Hitler, wrote an elaborate history of the museum just after the war. But he ended it in the 1800s, revealing how the Viennese obsession with its glorious past could be used as a psychological refuge from the ugly history so close at hand.

Grimschitz concealed his role in the possession of the gold portrait of Adele as carefully as Belvedere directors sealed their Nazi bunker. When Erich Führer was arrested by French military police in western Austria in May 1945, Ferdinand Bloch-Bauer's Klimt painting *Houses in Unterach on Lake Attersee* was hanging on his wall. Führer had kept it for himself.

Führer was sentenced to three years of hard labor, though he managed to serve only two. He held on to Adele's books, insisting they were a "gift" from Ferdinand, and they trickled into the black market. Years later, a fine green leather Wiener Werkstatte art book, designed by Josef Hoffmann, turned up for sale bearing the ex libris of SS captain Erich Führer, "who liquidated the assets of Ferdinand Bloch-Bauer, including the painting of Adele Bloch-Bauer by Gustav Klimt," the bookseller noted.

Adele had been an icon of sophisticated, cosmopolitan turn-of-the-century Vienna, of the illustrious doomed empire, and of the duplicity and lies behind Nazi theories of racial superiority.

Now she began to acquire a new symbolism: of Austria's postwar refusal to make amends for its eager collaboration with Adolf Hitler.

Atonement

Historical Amnesia

It was difficult for the Bloch-Bauers to recover the remnants of their lives after the war.

Repentance was scarce. Austria was awash in self-pity. Vienna was a ruin. Allied bombings had reduced centuries of architecture to rubble. The city was divided into four zones controlled by the French, British, American, and Soviet armies. Amputees limped through the streets. A hundred thousand women in Vienna hid the trauma of rape. People sold valuables, or their bodies, to buy food.

More than 65,000 Austrian Jews had been murdered. An estimated 5,500 had survived in Austria. Exiles faced a thicket of unwelcoming laws. Some 130,000 Austrian Jews had fled, and many of the survivors had emigrated. They were required to give up their foreign citizenship if they wanted to recover their Austrian nationality, a slow process that could take years. For some forms of compensation, citizenship or residency was required. It was easier for many former SS officers to get benefits.

The 1946 Annulment Act declared Nazi-era legal transactions "null and void," but in practice, it was very difficult to get back occupied family homes and apartments that had been "Aryanized" during the war. Families that tried to reclaim art collections were told the most valuable pieces were "patrimony," and were asked to "donate" the works in exchange for exit permits to take lesser artworks out of the country.

Jewish survivors who returned in this bleak postwar period were tired and saddened. Friends and family had been murdered; strangers were living in their houses, using their silverware, selling their heirlooms on the black market. Austrian officials were often very unwelcoming.

Few Jews came home.

Austrians held on to their valuable art. Cultural institutions were led by veterans of the Nazi era. Officials who had played roles in the art theft during the war were now in the position to deny exiles their paintings, or the permits to take them to their new homes abroad.

At the concentration camp where Fritz was imprisoned, American soldiers had forced the well-dressed elite of the town of Dachau, holding handkerchiefs over their noses, to walk through the fetid barracks and look

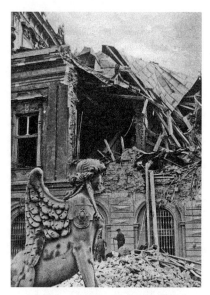

The Belvedere Palace, ravaged by Allied
bombings, December 1944. Many of the
roof statues were lost in the bombardment,
so orphaned statues were salvaged from
damaged buildings and reassembled on the
Belvedere parapet after the war.

at the smoking crematoriums they had lived alongside for years. But that was Germany.

Austrians were allowed to paper over their pasts and portray themselves as unwilling participants. They felt sorry for themselves, and for the proud family names sullied with the taint of Nazi collaboration.

The Cold War began in earnest, and the West was eager to hang on to Austria. A 1948 amnesty brought a premature end to Austrian de-Nazification. Austrians began to deny their jubilant welcome of Hitler and to claim that Austria had been "occupied" by Germany, like France or Poland. Thus was born the fictional alibi of Austria as the "first victim" of the Nazis. It was obvious Austrians themselves didn't truly believe this. Austrian men who had deserted the German army to join the Allies were not embraced as returning heroes who fought the Nazi "occupation"; instead, they were scorned as traitors. Austrians stubbornly remained in houses stolen from Jews, clinging to their furniture, books, and paintings.

Of some thirty-five thousand Jewish businesses, only a few thousand would ever be returned to their owners.

Nazi officials burned records and changed birth dates, even last names. A cloud of secrecy settled over Vienna, the city on the Danube once known for its love of beauty and pleasure. Austrians learned not to ask too many questions.

In this morally contaminated milieu, Austrian museum officials warily greeted U.S. Army major George Bryant, a friend of the Bloch-Bauer family who had walked into the Albertina Museum. Bryant needed an export permit for 175 Klimt drawings, many of Adele, and agreed to "donate" some of the drawings to the Albertina in exchange for exit papers for the rest. Otto Benesch, the director of the Albertina, slowly leafed through the elegant drawings, choosing sixteen of the finest. A young art historian with him, Alice Strobl, was aghast. "Why didn't you keep all of them?" she asked. It didn't occur to her that extorting "donations" from Jewish survivors was as morally corrupt as any Nazi-era robbery.

The postwar theft had begun.

Maria's brother Robert had contacted her old admirer, Gustav Rinesch. Rinesch was happily married to a woman from the Russian zone of partitioned Vienna whose former husband had vented his fury at Hitler's defeat by beating her. Rinesch was the first man who gave her food without trying to sleep with her.

Rinesch had begun making inquiries to culture officials in Vienna on behalf of the Bloch-Bauers about the property they left behind. The new postwar director of the Austrian Gallery, Karl Garzarolli, was apprehensive about the Bloch-Bauer Klimts. Garzarolli had reviewed the paperwork, and he realized there was trouble. The terms of Adele's bequest had been violated. The horse-trading by the Nazi lawyer Erich Führer was a mess. Ferdinand had donated Klimt's *Schloss Kammer am Attersee* to the Austrian Gallery in 1936, but the Belvedere had traded it away to Gustav Ucicky, as part of the complicated deal with Führer for the acquisition of the gold portrait of Adele. The will didn't allow paintings to be sold off. No one had tried to get Ferdinand to sign over the paintings. Now he was dead.

"In the documents in the possession of the Austrian Gallery, no mention is made of these facts," Garzarolli wrote his predecessor, Grimschitz, on March 8, 1948.

> In my view you should have definitely sorted this out.
>
> I am therefore in a particularly difficult situation.
>
> Since available files in the Austrian Gallery make no mention of these facts, either in the form of a court notice or a notarized or personal statement by President Ferdinand Bloch-Bauer—a statement I believe would have been your responsibility to obtain—I find myself in all the more difficult a situation.
>
> I cannot understand why, even during the Nazi era, an incontestable bequest in favor of a national institution was not taken into account . . .
>
> The situation is turning into a sea snake.
>
> It worries me enormously that so far all the circumstances surrounding the restitution issues are very unclear. It will be in your interest to stick closely to me through all this confusion. That will probably be the best way for us to emerge from this rather dangerous situation.

At no time did Garzarolli or any other Austrian officials suggest that conscience compelled them to consider giving back the Klimts. The paintings had been seized in furtherance of a great crime; returning them might have been a small act of atonement.

Instead, on April 2, 1948, Garzarolli wrote Otto Demus at the Federal Monument Office and instructed him to "delay for tactical reasons" Rinesch's requests for restitution to the Bloch-Bauers. He alerted the Austrian state attorney's office to prepare for a possible lawsuit.

Feeling far from confident, Austrian Gallery officials told Rinesch that Adele's 1923 will gave the gallery title to the Klimts. Rinesch tried to be pragmatic. The Austrians seemed willing to give up some less valuable paintings, along with a quarter of the antiques that had been extorted from the family—along with a hefty "exit tax"—in exchange for allowing Therese to leave Nazi Vienna. But first the Bloch-Bauers had to renounce any claim to Ferdinand and Adele's Klimts.

Rinesch thought the Bloch-Bauers should take what was being offered. He made a list of the paintings in Ferdinand's collection, and requested permits to take other works out of Austria, so long as the family relinquished claims to the Klimts. "I rely on your sense of justice," Rinesch wrote Austrian officials.

Then he reported back to Robert, in Vancouver with the other Bloch-Bauer brothers, who had changed their surname to Bentley. Rinesch wrote jauntily:

My ski holiday was wonderful. We don't have to go to Switzerland because it's already expensive enough here! The inspection by the Monument Office has taken place. As I predicted, the civil servants noticed some of the paintings were of the Bloch-Bauer collection. I was called by Dr. Demus. Demus told us that he and the Austrian Gallery attached great importance to those paintings, and their immediate export was hardly possible. We also touched on the matter of Klimt paintings, and the legacy of Adele Bloch-Bauer.

According to Adele's will of 1923, she left the paintings to the Austrian Gallery. Although this is not in the form of a legacy, there is a document where Uncle Ferdinand declares he will fulfill the request.

I have given Garzarolli a declaration that the heirs of Bloch-Bauer will fulfill her wish. Because of this deal, the museum is now very friendly to us, and I made a deal to export the remaining paintings.

As for the *Schloss Kammer,* Gustav Ucicky—now a Nazi-stained has-been whose wife had dumped him for an American soldier—"says he bought it in good faith and refuses to return it," Rinesch wrote.

Many such wartime deals had been declared void, but Austrian officials didn't plan to do that in this case. Instead, they enlisted Rinesch to help get a signed promise from Ucicky to donate his stolen Klimt paintings to the Austrian Gallery upon his death.

The Austrians didn't try to get signed authorization for the Klimt swap from Robert in Vancouver, or from Maria in Los Angeles, or from Luise, who was then trapped in Communist Yugoslavia. Instead, they cut a deal with Rinesch.

"I'm giving [Garzarolli] the authorization," Rinesch wrote Robert, "to receive the last Klimt paintings." With this agreement, the "museum is now very friendly to us," and promises to hang plaques identifying the Klimts as a "donation" of Adele Bloch-Bauer, Rinesch wrote.

But the museum simply identified the gold portrait as *Portrait of Adele Bloch-Bauer I,* with no information on its provenance—just as another museum had hung the portrait of Amalie Zuckerkandl, declining to mention that Amalie had died with her daughter in a concentration camp.

Other Vienna collectors struggled to get art returned. The Federal Mon-

ument Office was notoriously quick to designate art as patrimony and refuse exit permits for it.

Erich Lederer tried in vain to get an exit visa for Klimt's *Beethoven Frieze*. Austrian officials were now determined to acquire the work that had once been rejected by officialdom. They told Lederer he would have to pay for its storage, though the *Frieze* was sitting in the dank Altenburg Monastery, a puddle at its feet. Otto Demus had personally banned the export of the *Frieze* in 1950, and dismissed as "out of the question" Lederer's offer to "donate" the rest of his art collection in Austria in exchange for the *Frieze's* export. Austrian museums ended up extracting much of what was left of the Lederer collection anyway—a Bellini painting, a chance to buy a Jacobello del Fiore triptych—including forty-seven drawings and watercolors by Egon Schiele acquired by the Albertina in exchange for not standing in the way of the export permits of the Klimt portraits of Lederer's mother and sister. Demus duplicitously assured Lederer that he found this "horse-trading" of art for export permits distasteful and embarrassing. Lederer was beside himself. His mother, Serena, and his sister Elisabeth were dead. His aunt Aranka and her daughter had been murdered. Now he found himself begging, piece by piece, to get his family's art back from the defeated country that stole it.

Judgment was clouded by divided loyalties. Veterans of the Nazi era still controlled the fates of paintings.

In 1960, Fritz Novotny, who co-curated the 1943 Klimt exhibition for Baldur von Schirach, became director of the Austrian Gallery, where catalogues cosmetically erased the Nazi-era provenance of both portraits of Adele Bloch-Bauer, saying the gold portrait was acquired in 1936 and the second portrait in 1928, thereby sidestepping any question of acquisition during the Third Reich.

In 1965, Walter Frodl, a curator for Hitler's museum in Linz, was named president of the Federal Monument Office. He was now well positioned to block the return of art he had helped steal.

These Nazi-era holdovers would now decide whether to grant the exit permits that were the only way for exiles to regain their art.

Austria refused to give Emile Zuckerkandl an exit visa for his family's Klimt poppy field, *Mohnwiese,* which hung in the Zuckerkandls' sanatorium. Emile had tracked down the man who had it. The denial of the exit

permit noted that "interest in Klimt's paintings is increasing, particularly among the Austrian public, who have a right to see the landscape of their native painter, Gustav Klimt." The Austrian Gallery did offer to buy it, for 15,000 shillings, or about $576.

Emile was living in Paris. Someday he would be revered as a founder of the field of molecular biology. For now he was an impoverished student. His family was reeling from loss. His great-aunt Amalie Redlich had been deported to Lodz. His cousin Nora Stiasny had died at Belzec with her mother, Amalie Zuckerkandl. Her Klimt landscape, now hanging on Gustav Ucicky's wall, would end up at the Austrian Gallery when Ucicky died.

Emile said he got a call in 1956 from the collector Rudolf Leopold, who was strangely familiar with his problem. Leopold wrote Emile a cheery letter, offering him a low 20,000 shillings, or about $770. Emile refused. Leopold wrote again, offering 30,000 shillings, or about $1,150. This time Emile accepted, though he could have gotten far more for the painting—if only he could get it out of the country. But he couldn't, and he needed the money. Within a year, his *Mohnwiese* was at the Belvedere, traded by Leopold for Schiele's *Cardinal and Nun,* and his *Two Crouching Women,* considered somewhat risqué for exhibition at the Belvedere.

Emile was suspicious and angry.

Some of the paperwork for the swap was signed by a familiar hand, the Austrian Gallery's Fritz Novotny, the host of the 1943 Klimt exhibition that was a virtual showcase of stolen art.

The war was over. But the wartime theft was still enabling the Belvedere to consolidate its best Klimt collection ever.

In 1966, Maria's old friend Anton, now the Palo Alto, California, doctor Dr. Tony Felsovanyi, got a call from someone representing Ursula Ucicky, the widow of Klimt's Nazi filmmaker son. The emissary offered to sell back to Felsovanyi the stolen Klimt portrait of his mother, for $11,000. He declined. The Austrians would never give him an exit permit, and there was no way he would ever move back to Vienna. The last time he visited, a priest had asked a reunion of Theresianum alumni to bow their heads for two classmates hanged as war criminals.

Fritz Novotny had moved the *Beethoven Frieze* to the former stables of Prince Eugene at the Belvedere Palace. The "substance of the artwork is jeopardized and in need of extensive restoration soon, in order to save it from further decay," the Austrian chancellor, Bruno Kreisky, wrote Erich

Lederer in 1970. Though "the financial possibilities in our country are limited," Kreisky wrote, "I would like to appeal to you as a member of a family that fostered the path of Austrian art into modernity." He offered Lederer 6 million schillings for the *Beethoven Frieze*. Erich showed little interest. They raised the price. Finally, in 1973, Lederer, then an old man with no more hopes of getting the deteriorating *Frieze* out, reluctantly accepted 15 million schillings, or about $750,000.

The Bloch-Bauer Klimts made their way into the Belvedere. Führer sold *Birch Forest* to the Vienna city museum in 1941, but Belvedere officials wrestled it away in 1948, invoking Adele's will. *Houses in Unterach on Lake Attersee* was taken by the Belvedere in the 1948 negotiation with Rinesch. *Schloss Kammer am Attersee,* donated by Ferdinand in 1936, returned to the Belvedere when Vicky died in 1961. The portrait of Amalie Zuckerkandl, which once hung on Ferdinand's bedroom wall, would get to the Belvedere after the death of the art dealer who got it during the war.

Most elderly Jewish exiles who came to claim their art were dismissed by Austrian officials, who demanded that the exiles prove they owned the paintings. Many survivors had lost the proof when their homes were sacked, or had been assured that their families had "donated" the works. The officials had the truth locked away in secret files in closed archives. There was no point in advertising that the Austrian Gallery's Klimt collection had been raised to world-class stature by the "acquisition" of paintings stolen from its Jewish citizens during the war. Publicly, administrators who knew cynically papered over the histories of the paintings.

The paintings raised many questions. Austrians who knew the answers kept silent.

The Children of Tantalus

Then a new generation emerged, of Austrians who did not drink from the communal well of self-pity, denial, and deceit. Their questions provoked startled glances. Or glares.

An Austrian psychiatrist, Rudiger Opelt, would call his generation the "Children of Tantalus," after the son of Zeus who appalled the gods by inviting them to a banquet and serving the dismembered body of his son. Opelt lived in the village that gave the world the famous Christmas carol "Silent Night," a picturesque hamlet where his neighbor was a grandson of Arthur Seyss-Inquart, the former Nazi commissar of the Netherlands hanged at Nuremberg. Opelt believed secrecy and denial over the Nazi era was eating away at Austrian families and his entire society.

Opelt developed his observations firsthand. When he was a student in the 1970s, his neurology professor was Heinrich Gross, said to have directed the euthanasia of children and babies who had been the subject of experiments at a notorious clinic at Steinhof hospital. Some eight hundred deemed "unfit" by the Nazis—bed wetters, slow learners, children with harelips—died or were deported. Here children had brain surgery while still conscious, or were monitored while they froze to death. Attempts to prosecute Gross had been quashed since the 1950s. Gross continued to use the brains of the euthanized children, sealed in jars of formaldehyde—a collection he called "unique in the world"—for research that won him the Austrian Cross of Honour for Science and Art in 1975. The next year he attempted a follow-up exam on a survivor, who alerted the press. Opelt was appalled by the grisly revelations. It disturbed him that so many people kept Professor Gross's secrets. Some of these secret-keepers had been involved in the crimes. Others simply knew but were afraid of the greater questions they raised, of their own guilt as passive witnesses.

One of the heirs to this treacherous legacy was Hubertus Czernin, a young Vienna aristocrat turned crusading journalist.

Hubertus was a romantic. Tall and thin, he had large brown eyes, the elegant fingers of an artist, and a dry Viennese wit. He was also a class traitor.

Hubertus Alexander Felix Franz Maria Czernin von und zu Chudenitz was a count of a thousand-year Bohemian lineage. History flowed through his family like the Danube. The old Czernin Palace housed the Prague Foreign Ministry. His great-uncle Ottokar was the Austrian foreign minister during World War I. His uncle Jaromir sold Hitler a Vermeer, *The Art of Painting,* with a letter saying he hoped it "pleased the Führer"—which the family now claimed was done under duress.

Hubertus lived on the top floor of his grandfather's *palais* on the Mozart-

*Count Hubertus Czernin,
the intellectual and
investigative journalist, who
shocked Austria with the
Nazi-era secrets of Austrian
presidential candidate
Kurt Waldheim, 1999.*

gasse. The immense town house was a few minutes' walk from the Belvedere and the Secession. The *palais* too had a star-crossed history. Ludwig Wittgenstein's brother Konrad had lived there until his suicide in 1918, and Richard Strauss moved in when he co-directed the Vienna State Opera in 1919. Johann Strauss, Schubert, and Brahms once resided nearby.

The heavy wooden palace door opened onto the cobblestone Mozartplatz, with its bronze verdigris fountain of young Prince Tamino playing the "magic flute," entwined with his beloved Pamina.

Mozart had opened *The Magic Flute* after his fall from grace, at a hall at the Freihaus, or free workers' housing, which once stood near Czernin's *palais*. Mozart died not long after. He was buried in a pauper's grave with strangers. It was an ignominious end for Amadeus, once so "beloved by God."

Hubertus was ardently in love with his famous young wife, the petite blonde Baroness Valerie von Baratta-Dragona. Every morning, the newlywed Hubertus sat over his strong Viennese coffee and wrote his sleeping bride a love letter. He left it on their dresser, skipped down the palace's dizzying spiral of stairs, and rode off on his bicycle to report for the muckraking weekly *Profil*.

Aristocrats like Hubertus were not meant to be shoe-leather reporters. They were to be playboys, art collectors, at most diplomats. They were supposed to holiday in lederhosen in lakeside fairy-tale towns like Alt Aussee, where Hubertus's mother had a chalet.

Hubertus had spent his childhood in the Vienna Boys Choir and attended the tony Theresianum academy, where he seemed indistinguishable from the well-born young men who flaunted titles that had been legally abolished after the empire ended in 1918.

But Hubertus had a restless curiosity. In the early 1970s, he saw a television documentary that suggested Austria had played a more willing role in the Holocaust than he had been led to believe. In fact, the largest cache of stolen art in Europe had been found in the caves outside Alt Aussee, where he summered.

He discovered the Theresianum had been one of the Third Reich's elite

academies, a school of hand-picked cadets recruited as child soldiers in the last days of the war. He heard there were photographs somewhere, of Nazi leaders like Arthur Seyss-Inquart addressing the cadets. Hubertus suspected some of his teachers had been Nazis. He aimed his soft-spoken insolence at one old autocrat and was expelled.

Hubertus found a more appreciative audience in journalism. He was in the spotlight in 1985 for his biting coverage of the official welcoming reception for former SS major Walter Reder, returning from forty years in jail in Italy for involvement in the wartime killing of 1,830 Italian villagers. Italy was appalled when the Austrian defense minister shook Reder's hand.

Czernin heard a rumor in 1986 that presidential candidate Kurt Waldheim had covered up his war record. Czernin's editor at *Profil* insisted he pursue it. Hubertus began to sort through Austria's yellowed archives, and found answers to questions alluded to, whispered about, but never fully addressed, even in his own family.

Here, in the fading files, was the story of Austria's complicity in the Holocaust.

Waldheim had published an autobiography the year before, saying he had been drafted into the German army in 1941, wounded on the eastern front that December, and spent the rest of the war getting his law degree. He portrayed himself as an ardent opponent of National Socialism who had passed out anti-Nazi leaflets as a teenager.

In reality, Waldheim had joined the cavalry of the Sturmabteilung, or SA storm troopers, a week after the unit distinguished itself in the orgy of synagogue burning on Kristallnacht. Waldheim spent his army years serving as a translator in the Balkans under General Alexander Löhr, who oversaw deportations to places like the Jasenovac death camp, where Erno Gutmann had been murdered. His unit accompanied Nazi forces in Croatia, where Nazi puppet leader Ante Pavelic awarded Waldheim a medal.

A secret 1948 War Crimes Commission file recommended Waldheim be prosecuted for war crimes: "murder and putting hostages to death."

Hubertus's revelations dropped like a bomb. Waldheim denied "even his photos," Hubertus would say. Then Waldheim admitted his participation in the war, but said he hadn't known about the murder of civilians. Then he said he was aware, but was never a participant, and was powerless to stop it. When Waldheim finally sputtered that "I only did my duty," he exposed Austria's terrible historical conundrum. If Austria was "the first

victim" of the Nazis, how could serving in an occupation army led by Hitler be construed as a patriotic obligation? Wouldn't it be considered collaboration? Or treason?

Austria elected Waldheim president anyway a few months later, in 1986. The United States put him on a list of suspected war criminals and denied him entry.

The proceedings were carefully watched by the U.S. ambassador to Austria, Ronald Lauder. Lauder, an heir to the Estée Lauder cosmetics fortune, was a collector of Austrian art. He was just fourteen when he was awed by the portrait of Adele at the Belvedere, and he never forgot it.

Lauder did not attend Waldheim's inauguration. Austria blamed him for the blackballing of Waldheim, and soon Lauder was packing his bags, after just eighteen months in Vienna.

Hubertus moved on to other issues of Nazi-era provenance. In January 1998, New York district attorney Robert Morgenthau filed a subpoena for an Egon Schiele painting, *Portrait of Wally,* and another Schiele painting, *Dead City,* that had once belonged to comedian Fritz Grünbaum. They were on loan from Vienna's Leopold Museum and were hanging at an exhibition at the Museum of Modern Art in New York. Heirs of the prewar owners believed the paintings had been stolen after the Nazi takeover.

The paintings became a spectacle.

Rudolph Leopold, who had acquired Schiele's *Portrait of Wally* from the Belvedere in 1954, said he had no idea the paintings might be Nazi loot. This was a key point in Europe, where purchasers could say they bought the painting "in good faith." In the United States, it was not so simple. Buyers were under increasing pressure to prove they had diligently researched the paintings' wartime provenance. More and more, courts considered the paintings stolen property, and favored the true owners.

The fracas put the art world on notice. Culture Minister Elisabeth Gehrer said the government would examine the provenance of art works in museums. Hubertus decided to take a look for himself.

In the snowy winter of 1998 Hubertus spent hours at the Café Braunerhof, a literati hangout a few steps from the fictional apartment of Harry Lime, the black marketeer in *The Third Man,* the Hollywood classic of postwar Vienna intrigue. Hubertus pored over documentation from archives that officials at first would only allow to be copied by hand.

Hubertus published his first article that February, and it was damning. Locked up in secret files was proof that Austria had knowingly stolen vast art collections from the Rothschilds, the Lederers, and other Jewish fami-

lies. One of the world's most recognizable paintings, the gold portrait of Adele Bloch-Bauer, did not appear to have been "donated" at all. Apparently it had been stolen from her husband, a prominent industrialist— whose name Hubertus had never heard.

After the war, Austria had concealed the evidence and refused to return stolen art, Hubertus wrote—calling it the "double crime."

The revelations were devastating. Herbert Haupt, an archivist at Vienna's Art History Museum, declared that Austrian museums had engaged in a "veritable race for looted art."

Investigative journalists found not only that there was more loot, but that Austrian museum officials were in a position to know exactly where to find the damning evidence.

"Nobody wanted to open the box. But everyone knew where it was. People knew there was a scandalous past in it," said journalist Thomas Trenkler, who uncovered the sordid details of the theft of the Rothschild collection.

A new art restitution law was introduced to the Parliament. State-held art that had been obtained under duress or in exchange for export permits, or acquired in spite of the fact that it should have been restored to its rightful owners, was to be returned.

Now this Pandora's box would be pried open.

The Heirs of History

Maria was in her eighties. She and Fritz had reinvented their lives in America, raising four children in a modest West Side Los Angeles ranch house.

Groomed for idle luxury, Maria discovered she loved work. Fritz never lost either his dream of singing opera or his roving eye. He resigned himself to being his brother Bernhard's West Coast distributor, donning his top hat to sing at social events. He and Maria led a contented, uneventful life that ended when he died in 1994, after a stroke and then a fall. Maria wanted to play her only high-quality recording of Fritz at the funeral, singing "The Lord's Prayer." But the rabbi told her it was inappropriate for a Jewish service.

The great dramas of life seemed well behind her. A framed reproduction of Adele's portrait in her living room was a rare reminder of the stately, romantic Bloch-Bauers of Vienna.

In February 1998 she got a phone call from an old family friend in Vienna. An article had appeared in the newspaper suggesting that the Bloch-Bauer Klimt collection had been stolen by the Austrians. Of course, Maria thought. They had stolen everything else.

A few weeks later, Maria was called to her sister Luise's hospital bedside in Vancouver after Luise, ninety, suffered a fall. "I'm going to die," Luise had announced to her family, like an old warrior who knows she has seen her last battle. Maria told Luise that a journalist in Vienna had written a story suggesting that Ferdinand's art collection had been stolen, along with those of the Rothschilds and the Lederers. Should they try to get the Klimts back? Luise listened intently. "That," Luise replied thoughtfully, "would require an excellent lawyer."

A month later Luise was dead.

Randol Schoenberg was on the Internet at work in September 1998 when the phone rang. It was Maria Altmann, the best friend of his late grandmother Zeisl. Maria was looking for his mother, Barbara Zeisl Schoenberg.

At that moment, Randol was handling securities litigation at the Los Angeles office of a New York law firm, Fried Frank Harris Shriver & Jacobson. He was thirty-one years old. His work was lucrative, secure.

"My mother's in Vienna," he told Maria distractedly.

"I wanted to talk to her about a new law they have in Austria, about art stolen by the Nazis," Maria said, in the melodic Viennese Randol grew up on. "You know, my uncle had a Klimt collection."

At that moment, Randol was reading the new Austrian art restitution legislation on the Web. It would soon come before Austrian Parliament for approval.

Randol had strong ties to Vienna, Maria, and music. As a boy of eleven, he had stood before the gold portrait of Adele on his first trip to Vienna. "Do you see this picture?" his mother had said. "This is Adele Bloch-Bauer, the aunt of your grandmother's friend, Maria."

Randol's grandmother Gertrude Zeisl was the wife of Erich Zeisl, a promising young composer who had once played in a Vienna jazz band with Fritz Altmann. Erich Zeisl was thirty-three when he fled Vienna during the Anschluss, first to a spa town, Baden, where he correctly calculated that the Nazis would be less aggressive to avoid upsetting the tourists.

Then he and his wife escaped to Paris. When the Nazis approached Paris, Erich Zeisl found a Zeisl in the New York City phone book, a plumber who agreed to sponsor the couple. Zeisl's father and stepmother stayed and were deported to their deaths.

Randol's paternal grandfather, Arnold Schoenberg, was the brilliant experimental Austrian composer who fled the rise of Hitler and was on the Reich's list of "degenerate artists." Randol never forgot that he was alive because his grandparents had fled. He felt a keen identification with the extended family of Vienna, and the intertwined world to which he was a relation.

Randol Schoenberg, the grandson of composer Arnold Schoenberg, who fled the rise of Hitler and died in exile in Los Angeles, 2000.

His grandfathers never adapted to exile. Zeisl said two things he hated most were Hitler and the Los Angeles sun, which gave him a rash. As a teacher, Schoenberg inspired avant-garde composer John Cage, but he was turned down for a Guggenheim grant in 1945. He lived just six more years.

Randol looked uncannily like elder Schoenberg. Though he never knew his famous grandfather, he possessed his stubbornness and impatience. His privileged youth as a judge's son educated at the exclusive Harvard prep

Arnold Schoenberg in a quintet in Austria, 1900.
The composer was also a painter.

school in Los Angeles bore little resemblance to the self-made journey of his composer grandfather, the son of a shoemaker. Yet Randol was driven by the same insatiable curiosity. At Princeton, Randol wrote his under-graduate thesis on mathematic combinatorial set theory, while completing a second concentration in European cultural history. He went on to the University of Southern California law school.

Randol was a passionate advocate of Holocaust reparations. His grand-father Schoenberg had fled Berlin in 1933. In October 1938, Randol liked to remind people, the composer presciently warned of an approaching apocalypse. "Is there room in the world for almost 7,000,000 people?" Arnold Schoenberg wrote from Los Angeles. "Are they condemned to doom? Will they become extinct? Famished? Butchered?" As Randol pointed out, few had listened.

Like Austria's Children of Tantalus, Randol's most potent inheritance was history. If Austrians saw their murky past in shades of gray, Randol, like most Americans, saw the Nazi era in black-and-white. He believed there were still battles left to fight. Restitution law was one of his passions. He found it outrageous that Austria had largely evaded the return of stolen Jewish property. Maria's case had a strong narrative—a huge asset in the courtroom. It was also a narrative Randol believed in. He offered to take Maria's case on a contingency basis.

Randol's boss agreed that the Bloch-Bauer Klimt affair was compelling. But even if you spend years and years getting a U.S. court to recognize the claim, he asked, who will force Austria to honor the judgment? U.S. mar-shals? Randol was determined. If he had to, he would pursue the case on his own. Thus began an unlikely pairing: Randol and Maria, the untried young attorney and the aging Vienna belle, versus Austria.

The Library of Theft

Hubertus Czernin now had his own book publishing company, Czernin Verlag, above the Braunerhof Café. As carriage horses trotted over the cob-blestones between the Imperial Palace and the Spanish Riding School, Hubertus sat in the café, wearing horn-rimmed glasses and an air of bohe-

mian elegance, and plotting the books for his *Library of Theft,* a history of Nazi art theft in Vienna.

Hubertus sat beneath the portrait of his literary hero, the Viennese playwright Thomas Bernhard, who had sipped coffee at the Braunerhof with Paul Wittgenstein, a nephew of the philosopher. Like Hubertus, Bernhard devoted his career to exposing Austria's refusal to come to terms with its past. In his 1979 *Eve of Retirement,* Bernhard mocked a real-life Nazi judge who became a postwar politician. Bernhard's fictionalized judge dons an SS uniform on Himmler's birthday and has sex with his sister, declaring that "in a thousand years the Germans will hate the Jews, in a million years." In *The German Lunch Table,* a modern-day elderly housewife returns from the market and complains to her husband that "no matter what kind of noodle package you choose, out crawl nothing but Nazis." "Nazis in the soup," she keeps saying. "Always Nazis instead of noodles."

Bernhard inspired great prestige abroad—and furious opposition at home. Asked to write a play for the fiftieth anniversary of the Anschluss in 1988, Bernhard initially refused, saying Austria should instead mount plaques reading "*Judenfrei,*" or "free of Jews," on buildings stolen from Jews.

Bernhard called the play he eventually agreed to write *Heldenplatz,* Heroes' Square, after the plaza where Vienna welcomed Hitler. Word of the script leaked out. Former chancellor Bruno Kreisky called for the premiere to be canceled. President Kurt Waldheim—then the subject of a government investigation of whether he was a war criminal—said the play would be an insult to Austria. On November 4, 1988, as protesters milled outside, the play opened with a scene depicting the Schusters, a Jewish couple who returned to postwar Vienna. Frau Schuster is preparing for lunch in an apartment overlooking Heldenplatz. Her husband, an Oxford-trained mathematician, has persuaded her to move back to Austria. But she's a nervous wreck. She keeps imagining she can still hear the crowds chanting "Sieg Heil!" to Hitler. Frau Schuster collapses, dead. Her husband then jumps from the window.

The Burgtheater exploded with cheers, boos, catcalls, and chants of "Sieg Heil!" Bernhard had put the divided family of Austria onstage.

Bernhard was ostracized as a *Nestbeschmutzer,* or "nest soiler," someone who dared to dig up the dirt of the past. His fragile health collapsed. He died three months later in an assisted suicide, leaving a will that forbade the publication of his work in Austria. His martyrdom was not in vain. Like Freud and Klimt, Bernhard had publicly lifted the veil on the tor-

tured Austrian psyche, inspiring other truth seekers to come forward—but serving as a cautionary tale of the potential cost.

Like Bernhard, Hubertus got hate mail. But, with a happy marriage and three young daughters, Hubertus lacked Bernhard's caustic anger, though he shared his fragile constitution. Hubertus had been diagnosed with systemic mastocytosis, a rare, dangerously unpredictable disease.

Hubertus embraced his mission with mortal urgency. The Austrian files were a hidden trove of historical demons. It turned out that Vienna's eye-catching icon, the Prater Ferris Wheel, had belonged to a Jewish man who died in Auschwitz. The last surviving child of Theodor Herzl, the father of Zionism, had died at Theresienstadt. Even old tax records narrated the final desperate minutes of a lost world.

Perhaps stolen paintings weren't the worst tragedy of World War II. But to Hubertus Czernin, the art was a publicly visible symbol of Austria's failure to indemnify its murdered and wronged Jewish citizens. Lost lives could never be recovered. But paintings could be returned. Hubertus could do little about his compatriots' lack of repentance. But he could combat the historical amnesia that fueled it.

The Search for Provenance

As he scoured Vienna's dusty archives in search of the documents needed to prove the Bloch-Bauer case, Hubertus turned to Belvedere director Gerbert Frodl.

Frodl had a provenance as complicated as any Austrian painting. He had been born in 1940 to Walter Frodl, a curator for Hitler's final obsession, the Führermuseum in Linz. Belvedere staff claimed to have seen a wartime photograph of Walter Frodl raising his hand in the Nazi salute from the back of a truck loaded with Aryanized treasures stolen from the crates of fleeing Austrian Jews. In 1965, Walter Frodl became president of the Federal Monument Office. He was repeatedly accused of impeding attempts to recover art. But by the time he died in 1994, he had managed to sanitize his résumé of its Nazi past so well that reputable art historians co-authored books with him.

What about the reports that his father looted art? Vienna journalist

Barbara Petsch asked Gerbert Frodl. "I don't believe he would do something dishonorable, certainly not something involved with art theft," Frodl was quoted as replying.

Curiously, Frodl had published a Belvedere book in 1995 that said the Belvedere acquired the gold portrait of Adele in 1936 and the second portrait of Adele in 1928—well before the Anschluss—"through a bequest from Ferdinand Bloch-Bauer." It said the landscapes were acquired through separate "bequests." These were strange inaccuracies, since Frodl presumably had access to all the original documentation. Frodl told a reporter that in the past, if a painting was listed as a "donation," few questions were asked. "We knew a lot, but it wasn't really conscious knowledge," he said.

The Bloch-Bauer donation, Frodl insisted, was based on Adele's will. The museum was holding the paintings in accordance with Adele's wishes.

In Los Angeles, Randol was making overtures to Viennese officials, but he wasn't getting far. Someone pointed Randol toward Hubertus Czernin.

Hubertus was now seriously ill. Austria's dashing investigative reporter couldn't even struggle up the stone stairs of the Federal Monument Office to ask for archives. He worked with difficulty, in great pain.

He no longer found the stonewalling of Austrian officials amusing. Now he was as impatient as Randol. "Maybe you do understand, now, that from time to time I want to sue the whole republic! They play games—with you, with the heirs," Czernin wrote Randol in a furious e-mail on December 29, 1998. "I asked Frodl yesterday if he could fax to me Adele's last will. He didn't want to, because 'If I do, it will be sent around the world.' And that's the reason I'll send HIM around the world."

Hubertus had moles in the Vienna archives. Adele's will was key. Randol believed it was a nonbinding request and that Ferdinand had paid for the paintings, making him, in Austria's patriarchal society, their legal owner. After World War II, it was difficult to argue that Ferdinand would have given them to Austria. In January 1999, a fax from Czernin began to scroll into Randol's office. It was Adele's will. Czernin found more damning evidence: Erich Führer's letter transferring Adele's portrait to the Belvedere, signed "Heil Hitler."

That same month, a Vienna Advisory Council on art restitution, the Beirat, recommended that Austria return 241 pieces of the Rothschild collection, which it had long insisted were "donated," to the Rothschild heirs.

Things were changing.

That March, Maria's spirits soared as she flew over the Alps, her resolve strengthening with the sight of the massive peaks and luminous glaciers. She had been invited to speak at a restitution conference. Life was picking up for this octogenarian. She had a mission now—a score to settle with history.

When the taxi stopped at Karl-Lueger-Platz, Maria was overwhelmed with nostalgia. Here was the composers' park, where the young Maria had wandered disconsolately while Fritz dallied with a married woman. At the Stubenbastei, Maria stopped at the front door of her long-ago home, the peaceful haven where she had climbed into her father's arms and inhaled the smell of his leather chair. The concrete Roman legionnaire with wings on his helmet and snakes at his sternum still held vigil above her doorway. She thought of ringing her doorbell. But what was the point? There was nothing left. The names on the apartments belonged to strangers.

The Austrians had shamelessly stolen her family's life and offered no contrition. Even Maria's favorite actress, Paula Wessely, who had made her weep in *Liebelei,* had remained in Austria to entertain Nazis. Her Gestapo minder, Felix Landau, was barely punished, Maria would learn. He escaped American detention and lived for years in Bavaria as an interior designer. He finally got a life sentence in Germany, but was freed after ten years. Landau was a free man in Vienna the last decade of his life; he died in 1983. Former Nazi governor Baldur von Schirach had served only twenty years, and lived long enough to be interviewed by David Frost.

Maria hailed a cab. The Ringstrasse curved near Adele and Ferdinand's house, which still housed national railway offices now of Austria. The cab stopped at the Belvedere. Maria climbed the grand staircase until she came face-to-face with Klimt's golden Adele in the grand salon.

Maria remembered listening to Adele hold forth as famous men listened. So intimidating to a little girl. Now Maria looked at Adele's pale face with a lifetime of understanding, and saw the vulnerability and discontent. Maria saw her eagerness, the aspirations never realized. Now her aunt seemed poignant. Maria asked someone to photograph her in front of Adele. As the camera flashed, a young guard warned that photos were prohibited. "This is my aunt!" Maria retorted angrily. "This painting belongs to my family."

The young man regarded Maria with respectful curiosity. Museum

guides never explained this enigmatic woman. The guard asked: Who was she?

When Maria met Hubertus Czernin, he was terribly ill. Yet he was so intelligent and drily funny, so *charming.*

Hubertus arranged a meeting with the culture minister, Elisabeth Gehrer. Maria told Gehrer she would consider a negotiated solution.

Maria would later testify that she also met with Frodl.

She said he took her to a café near St. Stephansplatz. "Now that we are alone, let's say what's in our hearts," she quoted him as saying. Maria said she told Frodl they were not truly alone, she and other heirs had a lawyer—but he should speak frankly. She said Frodl told her: "Look, we have enough landscapes. We can spare landscapes, but just don't take the portraits away."

Frodl would later deny this exchange took place.

Randol got a free ticket to Europe that April by accepting an invitation to appear on a German game show, *I Carry a Big Name,* a sort of European *What's My Line* in which contestants guess a panelist's famous relative. Jet-lagged, Randol sat next to a great-grandson of opera singer Enrico Caruso and a grandson of German writer Heinrich Mann, who dressed like a rock star and said he wanted to found an "Island of Love" off Brazil.

Randol made it through the show with his college German, and took the next plane to Vienna. He carried an eighty-five-page argument for the return of the Bloch-Bauer Klimts to present to the Beirat council. But in June, the Austrian panel recommended against returning the Klimt paintings. It said only sixteen Klimt drawings of Adele and twenty pieces of Ferdinand's porcelain should be restituted. The decision was far from unanimous. One panelist resigned in protest.

The Belvedere "is not the legal owner of these paintings," Maria wrote to the Beirat. We "are keenly aware of the Gold Portrait's importance as a national treasure. Once the Beirat decides to recognize our legal right to the paintings, we would then be in a position to work out a way with you that leaves the portrait in Vienna."

Maria never got an answer to the letter, or any others she wrote to Austrian officials. "In the old Vienna, people kissed the hand, they answered letters," she would grumble.

Randol was furious. "The recommendation of the Beirat is based on lies," he wrote Hubertus in a scorching e-mail. "The world now knows that the Klimt paintings are Nazi-looted art. No amount of whitewashing, or legalistic argumentation can erase that fact."

Randol strafed Austria in the press. "To have argued that Ferdinand and Adele would have wanted this is to be a Holocaust denier," he told the *Los Angeles Times.* His outburst made headlines in Austria.

Czernin was delighted at his unfettered rage. Randol was barging into the fragile china shop that was Vienna and trashing the place.

Not everyone was happy with Randol's confrontational approach.

"Trottel," the skinny girl in Yugoslavia who had tried to save her father's life, was now Princess Nelly Auersperg, an internationally known cancer researcher at the University of British Columbia at Vancouver. She had spent her life searching for markers that could detect ovarian cancer in time to save women's lives. When Maria had asked her to join the legal claim in October 1998, she agreed to allow Randol to represent her. Now she had mixed feelings.

Nelly felt a deep kinship with her cerebral great-aunt Adele, and shared her passion for learning. Adele had loved Austria, and Nelly believed in her heart that the Klimt paintings belonged there. Most Austrians today hadn't even been born during this terrible history. Why should they be deprived of their paintings?

Nelly wanted to be left in peace. She had never really gotten over her father's death. She was trying to get his name cleared of the accusation that he collaborated with fascists in Yugoslavia. She had married into a conservative royal dynasty and made a good life. And she wasn't even sure the paintings belonged to her family. Nelly feared Randol was headed for a messy public showdown with the Austrians. "I am horrified," Nelly had written Randol, in a long, furious missive in November 1998. "It is clear to me that we have an irreconcilable difference of opinion as to how the case of the Bloch-Bauer estate should be handled. In the circumstances, it is better that you do not continue to represent my interest in this matter."

"I Can't Afford for You to Lose"

Randol now appealed directly to the Austrian culture minister, Elisabeth Gehrer, offering to settle the case through arbitration in Austria. Her response was simple: If you disagree with the Beirat, you can contest the decision in court. But the Austrians demanded $1.8 million as a deposit against court costs, based on a portion of the estimated value of the paintings. Randol got the sum reduced to the equally unaffordable $500,000. This was war. Randol and Maria would pursue the case in the United States.

After he returned from Vienna, Randol got a call from Stephen Lash, a top executive of Christie's auction house in New York. Lash was also making overtures to Maria and Nelly. Lash put Randol in touch with Ron Lauder, the chairman of the new Commission for Art Recovery. In August 1999, by Randol's account, Lauder's chauffeur picked him up at JFK Airport and drove him to the former diplomat's Long Island estate.

Lauder was in his robe, chatting with the author Louis Begley. Colin Powell was making phone calls in the next room. Randol chatted with Powell's wife, Alma, in the breakfast room.

Lauder and Begley finally summoned him. Randol explained his strategy to recover the Klimts. To his dismay, they only nodded politely. Randol had hoped he could get a job at the Commission for Art Recovery so he could leave his law firm and work on the Klimt case full-time.

Lauder told Randol he had seen the gold portrait of Adele for the first time when he was fourteen years old, on a trip to Vienna, and had thought about the painting ever since. He looked at Randol sternly. "Randy, I can't afford for you to lose," he said. But Lauder didn't seem confident Randol could win. Randol said Charles Goldstein, the legal counsel of the commission, had a colleague look over Randol's legal briefs and strategy. But no one offered Randol a job.

Randol was deeply disappointed. He had a baby girl, Dora, and a son on the way. With chronic Crohn's disease, Randol was tough to insure. He quit his job anyway, in April 2000. A friend, Mitch Stokes, sublet him a law office at Wilshire and Bundy for $1,200 a month. Randol's father and father-in-law lent him money. Randol was on his own.

But Randol and Maria had an ally of sorts. In February 2000, Lauder stood before the U.S. House of Representatives and declared that since the return of the notoriously extorted Rothschild collection, Austria had resolved few art theft claims. Lauder spoke as the founder and chairman of the Commission for Art Recovery of the World Jewish Congress. "I see this as part of the movement of the far right" of Austria, Lauder said. He told Congress that Minister Gehrer had "invited" Maria Altmann to sue for the return of the Bloch-Bauer Klimts in Vienna courts, but required a "bond of half a million dollars just to get started."

"Yes, you heard me correctly," Lauder said.

In August 2000, Randol and Maria filed the suit in U.S. federal court in Los Angeles. Austria asked that the suit be dismissed, saying U.S. courts were denied jurisdiction by the 1976 Foreign Sovereign Immunities Act, which shields foreign governments from most lawsuits in U.S. courts. At the time, many lawyers might have agreed with Austria.

How Do You Solve a Problem like Maria?

It might have surprised and disappointed Randol to discover he was not the worst fear of Gottfried Toman, the Vienna attorney defending Austria's claim to the Klimts.

Toman, a bald, bearded man with expressive eyes, dismissed Randol as a socially tone-deaf Los Angeles lawyer. Toman rolled his eyes when he heard that Randol called himself Viennese. To Toman, Randol was just a pushy American trial lawyer—the kind of assessment Randol chalked up to anti-Semitism.

In Toman's eyes, Randol's frankness and transparency would go nowhere in subtle, opaque Vienna. But Maria was a problem. Toman had seen Maria on television. She spoke the poetic, musical German he had not heard since he was a small boy. It was the Italianate German of the Habsburg empire, with flourishes, courtesies, and the instinctive impulse—even in open conflict—to be charming. It was like a magic spell, this lilting, delicate dialect, and it was all but extinct now. Toman was entranced as Maria conjured up the possibility of an affair between her aunt and Klimt,

then demurely waved it away with a smile and fluttering eyelashes that suggested the romance was indeed consummated.

Toman was charmed by Maria. This worried him. He didn't believe that either he or Randol had definitive proof that they were right. But Randol had Maria. Toman had only the Austrian state, and the liability of the terrible past that he called "the burden of history."

Klimt's Stolen Women

As Toman tried to anticipate Randol's next move, the burden of history reared its head in a manner no one could have predicted. In September 2000, Belvedere director Gerbert Frodl and curator Tobias Natter opened a long-awaited exhibition, *Klimt's Women.* It was to be a stunning triumph for Austria, a comprehensive showcase of Klimt's work surpassed only by the Nazi-sponsored 1943 show of Klimt works now unavailable to art lovers because they had been burned at Immendorf.

The poster of the 2000 show, Klimt's sultry *Lady with Hat and Feather Boa,* hung all over Vienna. But heirs stepped forward to claim the painting when the show opened. "The figure's bedroom eyes no longer seemed to signify an erotic gaze, but rather to convey something more akin to anxious anticipation, as if she were waiting to be picked up by her rightful owners," quipped historian Leo Lensing in the *Times Literary Supplement.*

As in the 1943 show under the Nazis, Adele was at center stage. But this time the inclusion of her portrait drew merciless barbs. Vienna culture reporter Joachim Riedl compared Austria to a "gangster's moll, parading around after a bloody robbery with jewelry that she insists the victims actually gave her as a present." The portrait of ill-starred Ria Munk, radiantly resurrected by Klimt, was also in dispute, claimed by the heirs of her murdered mother.

The book produced for *Klimt's Women* was a diary of tragedy. Here was a reproduction of the long-lost painting of Anton Felsovanyi's mother, Gertrud, in her diaphanous white dress, bought by the Nazi propagandist Gustav Ucicky and still at large. Amalie Zuckerkandl's bare white shoulders now evoked the vulnerability of an old woman who died at the hands

of brutes. Klimt's high-minded Elisabeth Bachofen-Echt seemed naïvely unprepared for the treachery that would darken her most intimate life.

These women were not just portrait subjects. They were martyrs.

The parade of stolen paintings could not have been more ill-timed. Some European leaders were already refusing to shake the hand of Austrian chancellor Wolfgang Schüssel. In early 2000, Schüssel had formed a coalition with the Freedom Party of infamous right-wing politician Jörg Haider, the son of a Nazi who called SS officers "men of honor." The European Union even briefly imposed sanctions.

Now Haider was using this strengthened political platform to attack U.S. attempts to win compensation for elderly Austrian former slave laborers and Holocaust survivors. "There must be an end at some point," Haider told a Vienna meeting. "Not a cent more," echoed the new Freedom Party finance minister, Karl-Heinz Grasser.

A month after the disastrous Klimt opening, Haider defended the SS to an annual gathering of SS veterans October 1 in a mountain town in Carinthia, where Haider was governor. He openly flouted the Nuremberg tribunal's definition of the SS as a criminal organization. "It is unacceptable that the past of our fathers and grandparents is reduced to that of criminals," said Haider. "They are not criminals." Chancellor Schüssel did little to improve Austria's tattered image in a November interview with the *Jerusalem Post* when he insisted Austria was "the first victim of the Nazi regime" and the Nazis "took Austria by force."

The *Klimt's Women* exhibition was scheduled to travel to Canada. But only a few paintings left Austria. Austria claimed that the gold portrait of Adele was too fragile. The art world, however, believed Austria feared that sympathetic foreign courts might pull the disputed paintings from museum walls.

Then, in May 2001, Austria got an ominous shot across the bow. Los Angeles federal judge Florence-Marie Cooper ruled Randol and Maria's case could go forward in U.S. courts.

Judge Cooper ruled that Maria had made a "substantial and non-frivolous claim that these works were taken in violation of international law." Austria was an inadequate forum for the claim because of its "unduly burdensome" court filing fees, she wrote.

Suddenly, the annoying Los Angeles attorney and his octogenarian plaintiff seemed a lot less easy to blow off.

A Lost Cause Célèbre

In the fall of 2001 there was a column in a *Los Angeles Times* community section, the *Westside Weekly*, by the columnist Robert Scheer, about an elderly woman trying to recover a painting of her aunt the Nazis had stolen from her family.

One often heard these stories in Los Angeles. A family painting seized by Nazis, on display at a European museum. This case probably had the proverbial chance of a snowball in hell.

I looked closer. *That* painting? I still recalled the first time I saw a reproduction, in my early teens, at a show of Germanic artists at the St. Louis Art Museum. I was now a reporter at the *Los Angeles Times*.

The plaintiff, an eighty-five-year-old woman named Maria Altmann, lived nearby, in Cheviot Hills. Her number was listed. I dialed it, and an elderly lady with an Old World accent answered. Of course, my darling, she said. Come over at once.

An elegant woman in a cream knit pantsuit opened the door. "Hello, my love!" Maria said warmly. "Can you wait just a moment while I finish with my client?"

Still working, at her age? But yes, her client, a stylish older woman in a flattering navy blue blazer was regarding herself with pleasure in a three-way mirror in the living room. Maria presided over the fitting with the gracious, ceremonial air of a diplomat.

With its orange sofa and tattered shag carpet, the place appeared to have been decorated in the seventies. Or the fifties. On the mantel was a large antique gilt clock with a cherub perched on it. A wall case held tiny pocket watches; one was shaped like a miniature skull, with diamonds for eyes. Macabre.

"Now I am all yours, my darling," Maria said cheerfully, taking a seat by a framed reproduction of the Klimt portrait of a woman surrounded by gold.

"My aunt Adele," she said, regarding the portrait thoughtfully.

"She and my mother were so different. My mother had teas for a lot of ladies who would not have interested Adele at all. Adele wanted to go to the university. She wanted an intellectual job. But it was not done when she was a girl."

Maria's voice rose and fell in a pleasant musical cadence as she spoke.

She smiled. "I was a timid little girl next to her," Maria said. "She seemed arrogant and not interested in a child. She blossomed when she was with people who were learned. All Adele cared about was knowledge, learning, improving your mind. She always smoked, which was not done at that time. She seemed elegant, and cold. But apparently Klimt saw a different woman."

Maria explained the twists and turns of the painting's history. Composers. Austrian artists and playwrights. Famous Nazis. It sounded like something out of *The Sound of Music*. Maria's eyebrows rose with disdain. "They say now Austria was a victim of the Nazis," Maria said scornfully. "Believe me, there were no victims. The women were throwing flowers, the church bells were ringing. They welcomed them with open arms. They were jubilant."

The case faced huge obstacles, not least of them Maria's age.

The Austrians "delay, delay, delay, hoping I will die," Maria was saying. "But I will do them the pleasure of staying alive." She smiled conspiratorially, as if she knew something the Austrians didn't.

But what legal Houdini could overcome sovereignty, long-dead witnesses, evidence destroyed by Nazis? "Randy is representing me," Maria said proudly. "I've known him since he was in diapers."

Randy?

"Randy is like a grandson to me," Maria said firmly. "His grandmother Trude, the wife of the composer Erich Zeisl, was my best friend. His mother, Barbara Zeisl Schoenberg, grew up with my children."

The next day I was in Randol Schoenberg's tiny legal atelier on Bundy and Wilshire. I didn't see a secretary or a receptionist. Finally a guy appeared who looked like he had just graduated from college. This was Randy?

His desk floated in a sea of books, stacked on the floor, crammed into bookshelves, piled on his blotter. He cleared books off a chair so I could sit down.

Randol didn't explain the case so much as rant about it: the Nazi lawyer, Nazi art historians, Nazi museum directors. He flung "Nazi" around rather liberally. Were all these Austrians Nazis?

Framed by the Santa Monica Mountains, Randol spread out a century of photographs, as if he were introducing the cast of a Russian novel. Here was Maria at the Opera Ball. Here was Ferdinand, standing regally over a

downed stag with a huge rack of antlers at his Czech castle; and Gustav Ucicky, the "crazy Nazi propagandist" and son of Klimt. My head swam. Was all this stuff in the lawsuit?

A FedEx man arrived. Randol signed for the package. Did the guy have any staff?

The delivery was the Austrian appeal. It was the size of a phone book. "It's all about jurisdiction," Randol said, flipping through it dismissively. "How sad." If cases like this could be won or lost on petty-sounding technicalities, he didn't want to hear it.

Alone in his office, twenty stories above Los Angeles, Randy was convinced he was absolutely right. I had met few people in my life so certain of this.

Diplomacy

A few weeks later, I was at a crowded diplomatic cocktail party when the new Austrian consul, Peter Launsky-Tieffenthal, arrived. "He's here to save the gold!" a popular European consul whispered. I stared blankly. "The *Nazi gold*!" the consul hissed loudly.

To the dismay of Austria, the Klimt case was becoming a cause célèbre, a romantic story winding its way around Los Angeles living rooms and cocktail parties. Austria had its own attorney, Scott Cooper, from a major national law firm, Proskauer Rose. But it was hard for a hired gun to possess the cachet of the grandson of an exiled composer.

The Austrian ambassador to the United States, Peter Moser, flew in from Washington. Moser was a portly man with a warm smile and a red-faced heartiness that made it easy to picture him tucking into a sausage and a mug of beer in the Vienna Woods. We were in more banal digs, a *Los Angeles Times* dining room, having tired roast beef.

"The Jewish residents brought lots of art and architecture to Vienna, and played a role in elevating it as a cultural capital," Moser was saying in the Austrian accent popularized by his compatriot Arnold Schwarzenegger.

"After the war, our government did not have the urge to invite these people back," he conceded delicately. "The deep wounds and humiliation

of this group of collectors—the Jews—the society has neglected, largely," Moser said in an empathetic tone. "The emotional wound has never been addressed properly. I realize restitution must take place before wounds can be healed. We focused on expanding pensions to deported Holocaust survivors."

But the Bloch-Bauer case, Moser was saying, "is not a Holocaust-related claim, though the claimants want to portray it like this. The ownership was with Adele Bloch-Bauer, who left a will saying that after her death her husband, Ferdinand, would leave the paintings to the Austrian Gallery."

I mused about what Adele might have decided, had she lived. If she had stayed in Austria, she would almost certainly have been deported to a concentration camp. Had she fled, would she still want her paintings in Vienna?

The Austrian ambassador was not unsympathetic. Ferdinand "was forced to sell his house in 1941 because he was a Jew," Ambassador Moser said. "He survived the war, but everything had been taken away. They didn't rob it. He was forced to sell his home at a discount, a fire-sale price, to the German railroad. The Nazis wanted to get rid of the Jews. The properties they had to leave behind or sell. The rest were confiscated. It was sheer looting and robbing.

"The Nazis took the paintings out of the home. They made use of the objects, they auctioned them off, whatever. What did the Nazis do with chinaware?" Moser asked in exasperation, evoking an image of Gestapo thugs holding up fine boneware like cavemen trying to make sense of a microwave oven. "They wanted money, money, money.

"He loved his wife, apparently very much," Moser said. "He put the Klimt paintings in her room. The paintings, by coincidence, ended up in the Belvedere, where the will said they should. The family lawyer stated after the war that the will was valid."

That would have been Gustav Rinesch, fresh from Stalag 17.

"It's very difficult to get victims' family members to deal with it in a strictly rational legal manner," Moser lamented. "You remember the atrocities, the brutality, and the humiliation, and it's hard to see it in a strictly legal way. It's sometimes difficult to separate this from a pure legal approach."

Moser sighed. "The Jews were some of the greatest minds of Vienna," he said. "Look at Freud. Gustav Mahler belonged to Adele's salon at a brilliant time when intermarriage was common between the Jewish and Christian bourgeoisie.

"What we object to is the situation is portrayed as condoning the Aryanizations and the looting and robbing of Jews in 1938. It has nothing to do with it! At a time of intensified restitution efforts, it's cast in a bad light. It's not fair!"

Ambassador Moser had a deeply pained expression. I didn't have the heart to point out that restitution efforts appeared to have intensified because Austrian reporters had discovered the outrageous cover-ups of art thefts.

Family History

To Maria, her case had everything to do with 1938.

"Oh, Peter Moser," Maria said over a plate of her homemade Hungarian goulash. "I was a friend of his wife. We used to have dinner. Now he says all this."

"*Tasteless,*" Maria said, as if the dispute were a grotesquely prolonged family feud. "Even the Nazis didn't believe it was a will," she said hotly. "Did they wait for Ferdinand to die, like Adele asked? No!

"Adele's wishes were a request, not an obligation, to share her love of the Klimts with her beloved Viennese. After she died it was up to my uncle. What love could my uncle have for Austria after they robbed him of everything? He had no intention of giving the Klimts to those people!"

Maria looked furious. Her memories of Vienna were often seductive, idyllic, like those of a long-ago love affair, conducted in waltz time in rustling silk dresses, against a backdrop of castles and mountainous clouds.

Now she spoke with the ire of betrayed love.

"This art was dragged out of the house by people who murdered their friends. Would Adele have wanted the things she treasured left there after that?"

One morning, Maria sat in her gently sunlit living room, turning the fragile pages of old leather books filled with black-and-white photographs. Here was one of Maria Bloch-Bauer, a girl becoming a woman, at the

opera, smiling behind the long red velvet curtains of a private balcony. In another, the year of her debutante ball, Maria is draped in an off-the-shoulder silk organza gown, with the provocative stare of a starlet. Like her mother, Maria was a bit of a flirt.

"I was so spoiled," Maria sighed, smiling.

Her eyes lingered on another photograph, of herself in an ivory wedding gown, kneeling before a white marble fireplace with gilded Corinthian ornamentation, surrounded by roses.

She had a photo of Fritz, a handsome man with bedroom eyes, taken when they returned from their honeymoon to the new apartment. They lived there as newlyweds for ten days, before Hitler arrived.

"And then," Maria said, "they took away my husband."

The darker images emerged from the shadows of Maria's memory reluctantly, as if the events could be revoked by silence.

One day she disappeared into the kitchen, emerging with a dish of little sausage links and a saucer of mustard. So sweet, yet so telling. No one ate this kind of food in Los Angeles.

"Where were we?" Maria said. "I was telling you about my sister, Luise. Luise was the beauty of the family. I was just pretty. Everyone was in love with Luise. She was a baroness."

Maria turned the pages of the album, stopping at a photo of a woman who looked like the leading lady of a 1940s movie. This was Luise.

Alongside Luise was a delicate-looking girl, about eleven or twelve, with long braids and enormous, wary eyes.

"That's Nelly," Maria said, Luise's daughter. "She married an Austrian prince. She's a cancer expert." Maybe I should speak to her? "Oh, *no,* don't call Nelly!" Maria said in an alarmed tone, closing the album with a thump.

She sighed. "Things were so terrible for them," Maria said. "In 1943, they lined up the family to deport them: Luise, Viktor, Nelly, Franz. One of Luise's friends ran to tell a Gestapo chief who was always in love with her.

"My sister had to sleep with that horrible Nazi, to save her family," Maria said. Her eyes grew distant. She picked up a glass paperweight of Adele's portrait and rubbed it like a talisman.

"So you see," she said, "I haven't lived through anything."

———

Maria and Randol didn't have endlessly deep pockets to pursue a speculative case. They did have allies. In February 2002, Randol said the Commission for Art Recovery, which was chaired by Lauder, contributed $21,750 toward a $35,000 independent legal opinion by Rudolf Welser, a distinguished Austrian expert on inheritance law. Welser concluded that Ferdinand was the true owner of the Klimts, making Adele's will irrelevant. "We [made the contribution] because Mr. Schoenberg correctly understood Austrian law and the Austrian government appeared not to understand," said Charles Goldstein, counsel for the commission, who declined to specify the amount.

But Randol had a family to think about. He told his wife, Pam, that if he lost a round, he would quit and go back to corporate law.

To give up would have been difficult for Randol, who said that a friend had told him that in every second generation from the Holocaust, there was a "torchbearer" of the family legacy. This is how Randol saw himself: as the torchbearer of his generation.

In 2000, he went to Washington, D.C., to be part of the negotiations for the creation of Austria's multimillion-dollar General Settlement Fund, to grant restitution awards to Jewish Holocaust survivors and their families. One day Randol stood and began to speak about the lost world that had shaped Freud and Mahler, the world of his grandparents, and he choked up with tears.

Like Czernin, Randol was a bit of a crusader.

But Pam had grown up in Ohio listening to the stories of her Ukrainian grandmother, Rose. Rose grew up in a shtetl in the Kiev region where Sholem Aleichem set the stories on which *Fiddler on the Roof* is based. As a little girl, she was swept up in the pogroms. Her handsome brother Herschel was murdered trying to save a girl from a rapacious mob. Her parents hid jewelry and money in Rose's thick red hair, and set off looking for a boat to America. Rose's disabled sister, Golda, was sent back from Ellis Island, to die in the Holocaust. Pam saw the Klimt case as a stark symbol of the unpunished and their ill-gotten gains. Keep going, Pam told him. I didn't grow up with a lot of privileges. Don't give this up for us.

And Randol kept winning. In December 2002, the Ninth Circuit Court of Appeals ruled that Maria could sue in U.S. courts under an exception to the Foreign Sovereign Immunities Act for property stolen in violation of international law. Randol had established jurisdiction by finding English-

language guidebooks of the Austrian Gallery for sale in a Los Angeles bookstore, demonstrating commercial activity. The *Los Angeles Times* called it "the first time in Holocaust reparations that a federal appeals court has ruled that a foreign government can be held accountable in a U.S. court."

"I want those paintings to be in American and Canadian museums," Maria told the *Los Angeles Times*. "That's my dream."

This ruling worried the Austrians. They had ignored Randol, but he hadn't gone away.

There was only one final place to appeal the decision: the U.S. Supreme Court.

Supreme Judgment

The Supreme Court case seemed a long shot.

The George W. Bush administration had warned the judges of the Ninth Circuit Court of the diplomatic consequences of allowing Maria's lawsuit to go forward. Now it filed a brief with the Supreme Court, supporting Austria's position. Leila Sadat, a Washington University expert on international criminal and human rights law, voiced a common view: "I think the plaintiffs are probably swimming upstream."

Randol and Maria figured they had nothing to lose.

But the stakes were much higher now.

Maria said Ron Lauder had told her that the Supreme Court argument should be made by a more experienced attorney, such as Robert Bork, a conservative warhorse whose embattled nomination as Supreme Court justice had gone down in defeat in 1987. "Lauder said, 'You can't just have Randy at the Supreme Court,' " Maria said. (A Lauder spokesman said he only wished to assist Randol.) Legendary Los Angeles trial lawyer Bert Fields told Maria she should add an "experienced litigator" to her Supreme Court team." "I would have been glad to help," Fields recalled later.

Maria mulled this over. Randol was living the case now. He didn't have time for a lot of distractions: His wife was at the end of another difficult

pregnancy. People who called him at home after hours would find him bathing his two youngest children, Dora and Nathan, or putting them to bed.

Randol drove to Los Angeles hearings singing along with the powerful soprano Jessye Norman to "The Love Death" from Richard Wagner's opera *Tristan und Isolde* to build his morale before preliminary hearings with the lawyer for Austria, Scott Cooper, of Proskauer Rose.

In Los Angeles, Randol and Maria were a familiar sight, appearing together at small luncheons of legal associations and stolen art registries, where Randol would stand up and explain the technical minutiae of laws governing stolen art, and the complicated twists and turns of their case.

Could anyone articulate their arguments better than Randol? To Maria, Randol and the case seemed inseparable.

In a pragmatic, drive-by world, Maria was loyal to the people she believed in. They would go to the Supreme Court together.

On the eve of the February 2004 hearing, Maria went to the Holocaust Museum in Washington and walked through the corridors. She studied the images of the concentration camps liberated by American soldiers, filled with dead prisoners and emaciated survivors. They could have been her. All of them. She was alive because she had escaped. If her father hadn't died, she would have stayed in Vienna. They would have been doomed.

When Randol walked into the vast court chamber the next morning, Maria was disconcerted. Randy looked so small, so incredibly young. She saw the judges look at him and exchange smiles. Would they take Randy seriously?

Justice David Souter's first question to Randol was long, unintelligible, incomprehensible. Randol froze. He had absolutely no idea what Souter was talking about.

"Can you repeat the question?" Randol said finally. There were gasps in the audience. Randol felt like an Olympic figure skater who had fallen on the ice at his first jump.

But the Supreme Court justices smiled. Randol would later hear that Souter sometimes threw out a convoluted first question.

Randol began again. He felt himself gain momentum. For the rest of his argument, he felt like he was soaring.

Scott Cooper, Austria's lawyer, was arguing that the exceptions to the

Foreign Sovereign Immunities Act, enacted in 1976, could not be applied retroactively to events that had occurred fifty years ago. Cooper said he felt international law shielded Austria from these kinds of lawsuits. "The question is one of the expectations of one sovereign that it would be treated fairly by another," he argued.

Justice Antonin Scalia, a conservative, cut in. "I don't know if we protect expectations of this sort," he shot back.

To Randol, this seemed a sign that things were going well for him.

But the next morning, David Pike, a veteran Supreme Court reporter in his sixties, predicted in the *Los Angeles Daily Journal* that Randol would lose. Randol hated the headline: "Court Likely Will Reverse Art Case." He called Pike. "Why did you write this?" he demanded tersely.

Pike sighed. "I've been reporting on the Supreme Court for thirty years," he said. "You don't have a chance. The body language was against you."

For the next three months, Randol woke up every morning and booted up his computer to check the Supreme Court website. One morning, as he made breakfast for his kids, the phone rang.

It was David Pike.

This was a very bad omen.

"Okay, give me the bad news," Randol said. He was still ticked off at Pike.

Pike paused.

"You won," he said.

A few hours later, Maria was surrounded by reporters.

"Because Mrs. Altmann is eighty-eight years old, we're trying to get a trial date very soon," Randol was telling a British journalist. "Slowly but surely, people are realizing paintings like these have to be returned."

"He spent six years on this!" Maria told another reporter, smiling at Randol with maternal affection.

Would you be willing to settle with the Austrian government? a reporter was asking. "Well—" Maria began.

Randol broke in. "You can't be too eager to settle with them!" he said. "You shouldn't even talk about it!

"It's up to Austria to decide how they will treat this issue," Randol said. "Right now, it's a big embarrassment to lose a case in a U.S. Supreme Court." A documentary crew was hovering over Maria. "You're famous," Randol said.

Maria looked fatigued. She headed for the kitchen.

Randol followed. "Just be careful," he told her. "Everybody wants to do a deal. Don't send the wrong message." Randol feared a settlement offer would give the Austrians an excuse to stall and hurt their effort to get a resolution on the case.

Maria sat down wearily at the kitchen table. The phone and doorbell kept ringing. She sighed, reaching out to touch the pink asters on the table. "I'm not a kid anymore," Maria said. "I get very tired.

"I'm concerned about Nelly," she said. "She has the idea that what we were doing was not correct."

She regarded a framed pen and ink drawing of her father, Gustav, playing his beloved Stradivarius.

"I didn't have any hope. Not this much," Maria said, holding up her little finger, her face a mirror of mixed emotions.

"The Austrians will still fight us tooth and nail."

In Vienna, Toman studied the U.S. Supreme Court decision with deep dismay. The ruling did not deal with the ownership of the paintings. It was highly technical. The Supreme Court concluded that the 1976 U.S. Foreign Sovereign Immunities Act could be retroactively applied. Justice John Paul Stevens said that while the act usually protects foreign governments from lawsuits in the United States, this case could proceed under the "expropriation exception."

The ruling did not deal with the merits of Maria's lawsuit—but the details were aired anyway, in the summary of the allegations.

"In 1946 Austria enacted a law declaring all transactions motivated by Nazi ideology null and void," wrote Justice Stevens in the majority opinion. "This did not result in the immediate return of looted artwork to exiled Austrians, however, because a different provision of Austrian law proscribed export of 'artworks . . . deemed to be important to the country's cultural heritage' and required anyone wishing to export art to obtain the permission of the Austrian Federal Monument agency. Seeking to profit from this requirement, the Gallery and the Federal Monument agency allegedly adopted a practice of 'forcing Jews to donate or trade valuable artworks to the [Gallery] in exchange for export permits for other works.' "

This ruling allowed the case to proceed in U.S. courts. The entire grievance had now been aired in a high-profile forum. This was a major setback for Austria. Now the country faced the daunting prospect of defending

itself against a prominent Holocaust case in a U.S. court. Even its appeals would publicize Maria's side of the case, all over the world.

Austria was cornered.

In April 2005, Maria and other heirs received a $21.8 million award from a Swiss restitution fund, for the surrender of Ferdinand's sugar factory by the Swiss bank that had illegally handed it over for Aryanization.

The tide was turning.

Arbitration

Randol, the seasoned chess player, thought long and hard. Then he proposed his next move.

Randol told Maria he thought they should accept an Austrian offer to submit the case to binding arbitration with a panel of Austrian legal experts. Maria was visibly startled. "Maria, if you want this case decided in your lifetime, we have to take this chance," Randol said.

Maria stared at him. Trust the Austrians? "You're crazy," she said. Czernin also had his doubts. "Are you sure?" he kept asking Randol.

Five Bloch-Bauer heirs agreed to take part in the arbitration in Austria. Four of them were represented by Randol: Maria; George Bentley, the son who had made the Yugoslavian escape aboard the Orient Express in the arms of Thea and Robert; Trevor Mantle, the nephew of Robert's second wife; and Francis, Nelly's younger brother Franz.

Nelly herself took part, though she had her own lawyer, William Berardino of Vancouver. Nelly said she didn't wish to stand in the way of her family. Randol wondered if she also doubted the Austrian arbitrators would ever give them the paintings.

Randol appeared before the Austrian arbitration panel in Vienna in September 2005 to present his case, in German and English. Under the terms of the arbitration, Randol had chosen one of the arbitrators, Andreas Noedl, a charismatic barrister whose intensity and rangy physicality were more suggestive of a symphony conductor than a lawyer. Noedl had met Randol in 2000, during Austrian negotiations over Aryanized property.

Noedl and his wife had invited Randol to dinner in Vienna, and Randol taught Noedl's kids to sing "Rudolph the Red-Nosed Reindeer." Austria chose its own expert, Walter Rechberger, the dean of the University of Vienna Law School.

Noedl and Rechberger elected the third panelist, Peter Rummel. Rummel, born in 1940, was a dark horse. He had an impeccable reputation. He was a distinguished law professor and had served as the dean of the faculty of law in Linz, Hitler's adopted hometown. He had written a highly influential two-volume work on Austrian civil law that was considered an obligatory reference. His son, Martin Rummel, was a concert cellist.

But little else was known about his background or his sympathies, except that he was German-born. He acquired Austrian citizenship as an adult.

Noedl told Randol they had selected Rummel. It was the same day Joseph Ratzinger was named the new pope.

"I hope he wasn't a member of Hitler Youth too," Randol said of the enigmatic Rummel, apocryphally. Rummel was born in 1940.

The panelists sat down and began a long walk through history. This was more than just law. This was a search for justice. Christmas came and still there was no decision.

Randol had also maintained that Ferdinand had owned the Klimt portrait of his friend Amalie Zuckerkandl, but since some of her heirs also claimed the painting, it was set aside for a separate arbitration.

Behind the scenes, the panelists had concluded that under the patriarchal property laws of Adele's era, the owner of the Klimts was presumably Ferdinand, and Adele's will was a "mere request." They discarded as "far-fetched" Toman's suggestion that Ferdinand might have claimed he owned the paintings to protect her from speculation about her relationship with Klimt.

The panelists wrestled for weeks over one of the key issues: whether Austria had extorted the paintings quid pro quo in exchange for exit permits for other property, a keystone of the 1998 restitution law.

The Austrian government had long said the case had nothing to do with the Holocaust and was a simple case of Adele's will. It was clear they had greatly miscalculated.

During the Third Reich, the panelists noted, "the parties involved in acts of seizure often did everything they could to at least give the appearance of legally valid transactions," leaving even acts of civil law open to

question. Erich Führer didn't seem to have adhered to Adele's will anyway: he had handed her paintings over to the Belvedere while Ferdinand was still very much alive, and he "simply extorted" Klimt's *Schloss Kammer am Attersee,* Ferdinand's sole donation, which Randol did not claim. After the war, it appeared that Gustav Rinesch "used the paintings as weapons" to recover what he could from Austria for his old friends who had fled.

Finally, on January 15, 2006, the three arbitrators made a decision. But instead of relief, they felt an even greater burden.

Noedl was drained. A few hours later, he took his family to the Belvedere Palace for a silent look at the gold portrait of Adele, whose destiny would be sealed by the judgment.

For Randol, the wait was agonizing. He nursed growing doubts about whether he should have trusted an Austrian panel. After all these years, had he finally made a fatal misstep?

He distractedly attended children's birthday parties one Sunday in mid-January with Pam and their three vivacious children.

There was still no word.

Randol second-guessed himself all day. Maybe he should have stuck with U.S. courts. Maybe Maria was right. Maybe he had been crazy to place his trust in an Austrian panel, after Austria had fought him every step of the way.

That afternoon he played chess. His friend won easily with a pawn. That evening, Randol lost hand after hand of poker, leaving $60 on the table. It seemed a bad omen.

It was well after midnight when Randol got home. His BlackBerry was on the table where he left it, its message light blinking as usual. Joey had a fever and Pam was asleep. Randol picked up the BlackBerry and scrolled through messages from family and work. He spotted one message from Austria, and with trepidation, he opened it.

He stared at the message in disbelief. He had won. Unbelievably, he had won!

He had to tell someone. He looked in on Pam, but she was sound asleep. It was too late to call anyone.

Except Hubertus Czernin. He picked up the phone.

The Viennese journalist was with his wife and three daughters, getting ready to celebrate his fiftieth birthday with the help of the morphine that kept his pain at bay. He and Randol laughed together at their unexpected shared victory.

The next day, the phone rang nonstop at Randol's office. He idly played his messages. "I let out a whopping yell in the bathroom when I heard this on NPR! I'm just bursting with pride! This will be with you for the rest of your life!" a friend of his, Art Gilbert, said euphorically.

"I have a possible buyer for some of the paintings," began another caller.

Randol laughed. "You don't know how many calls I get like that," he said.

At home, an aromatic smell filled the peaceful kitchen as the Schoenberg kids waited for Randol. "My daddy won a big case," announced Dora, a self-possessed little girl with long brown hair and bangs, wearing a multicolored skirt and blue-top tennis shoes.

Randol walked in with his bulging briefcase. The kids scrambled to greet him. Little Joey sang an Elmo song at the top of his lungs. Nathan tugged at his hand. "Daddy! My friends say they saw you on TV!" Nathan shouted.

Randol sat down in his everyday navy blue suit. He seemed shell-shocked. Had he really won? "Maria was afraid, until the last minute, that we would lose," Randol said.

Now, after fighting with Austrian officials for years, Randol had to open discussions with them on the logistics of the removal of the paintings.

"There's not going to be any donations or any loans" to Austria, Randol said adamantly. "If an Austrian museum wants to buy them, that's perfectly fine. I don't know if that's going to be possible. There's a lot of debate in Austria. There's a lot of recrimination at the government for letting it get this far. They're being criticized for a tactical blunder. They were acting on principle. The principle was wrong.

"I think they owe us an apology, but I'm not holding my breath," he said. "There's no honor in fighting to the death and holding out for a bad cause. It's like Hitler's soldiers fighting to the death. There's no honor in that.

"The options are open," Randol said. "Maybe we'll put them in a museum. It's like when you win the lottery: what do you do with the money? It's a great position to be in. We took a huge leap. Maria and I have an understanding. If money comes we'll both be doing well."

When Maria was asked about the future of the paintings, she said they belonged on public view. "I would not want any private person to buy these paintings," she told the *Los Angeles Times*. "It's very meaningful to me that they are seen by anybody who wants to see them, because that would have been the wish of my aunt."

At a celebratory dinner at Spago, Maria's son, Peter, delivered a toast for Randol and Maria's "David and Goliath battle."

"This is a fairy-tale story, because Maria did find her Prince," Peter read. "And her Prince is rescuing the Klimts, but as Randy cautions, the ship is not yet here."

But the art market already saw its ship coming in. Stephen Lash of Christie's flew to Los Angeles. "The availability of the Bloch-Bauer Klimts is the most significant event in the art market since the World War itself," Lash wrote Randol that February. "The objects are of such astonishing beauty and the story of the struggle for their restitution so compelling that their sale—privately or at public auction—will continue to capture the world's imagination."

The *Portrait of Adele Bloch-Bauer I* "will be the most expensive work of art ever sold," Lash predicted.

Ciao Adele

Now Austrians faced letting go of the treasured Klimts. Lines stretched around the block at the Belvedere as people crowded in for a last look at Adele. After a man threatened to deface the Klimts rather than see them go, the paintings were abruptly moved to the bunker.

Randol and I flew to Austria in a small, aging passenger plane. He focused studiously on the sheaf of documents on his lap, even as the dramatic peaks of the Alps, floating in the clouds like islands of snow, rose up to the Matterhorn. He was preoccupied. He had a biopsied lesion on his lip that would turn out to be basal cell carcinoma.

I idly mentioned that the new Austrian consul in Los Angeles, Martin Weiss, had said many Austrians had gone along with the Nazis because they feared for their families.

"They weren't afraid to be killed!" Randol scoffed. "Maybe they wouldn't get invited to parties or elected to the village council. But being ostracized

is not life threatening. They would have been like a Malibu kid who decides to stay home and study math, while the other kids are out surfing. So they think he's a nerd."

Vienna newspapers were filled with the legal travails of David Irving, the accused Holocaust denier, arrested in Austria in November.

The airport was a mall of Klimt reproductions. As we swept past tourist shops, Randol glared. Here was a postcard of *Lady with a Feather Boa,* now returned to its rightful owners. Here was a mouse pad with the sinuous, stolen *Water Snakes,* last seen in the dining room of Gustav Ucicky's widow. Here was the seductive Adele Bloch-Bauer—on a tea tin.

"This stuff is everywhere!" Randol said angrily. "Half of these paintings were stolen! It's disgusting!"

At the Belvedere, all that remained of Adele was an empty case of bulletproof glass. Magically, she was everywhere else in Vienna.

Posters of the gold portrait of Adele had appeared overnight, staring out from bus stops and kiosks, with bold black letters: "Ciao Adele."

Goodbye, Adele. As snowflakes fell, Adele gazed out, calm, self-possessed, sophisticated.

A group of intellectuals, including the head of the Schoenberg Center, were less happy to bid Adele farewell. They called for Austria to raise the money to buy the paintings. Austrian officials sputtered that they couldn't possibly afford such an expense.

When Randol reached the Schoenberg Center, there was a crush of Viennese reporters and television cameras. What would the heirs do with the paintings? Would they loan or donate any of them to Austria?

Just as Randol's spectacular victory disconcerted museums around the world, it also aroused hopes. After his interviews, we braved freezing wind and icy cobblestones to reach a former medieval tavern with glowing hardwood walls, inlaid with rustic Tyrolean intaglio and painted with floral folk art motifs.

Marina Mahler, a handsome older woman in black cashmere and elegant silver jewelry, rose from a little wooden table and smiled radiantly. Marina was the granddaughter of Alma and Gustav Mahler.

"You've been a *huge* inspiration," Marina told Randol.

The painting Marina claimed was an Edvard Munch painting, *Summer Night on the Beach,* that had belonged to Alma. It was now hanging in the Belvedere. Years ago, Alma had received the painting as a gift after the birth of her daughter, Manon, the beautiful girl who stole the show at Maria Altmann's debut. After Manon died of polio, Alma couldn't bear to look at it. She loaned the painting to the Belvedere, along with three paintings by her late father, Jakob Emil Schindler.

After the Anschluss, Alma fled, and Carl Moll asked the Belvedere to give him the Munch and the Schindlers.

"Ridiculous! How dare he? She *hated* her stepfather," Marina said, disdainfully. "He betrayed all his friends! Remember in Ferdinand's letter to Kokoschka, he said Moll had become an 'über-Nazi'?"

Moll had also helped himself to Alma's house, and sold the Munch painting back to the Belvedere.

When the Russians marched into Vienna, Moll's son-in-law—a Nazi named Richard Eberstaller—shot his wife, then Moll, and then himself in a suicide pact. Or at least this was the chronology Austrian officials had insisted upon years ago, when they ruled that since Moll died a few minutes sooner, Eberstaller had been his legitimate heir. Since Eberstaller had willed his art to the Belvedere, the Schindlers came to the Belvedere as an inheritance from Eberstaller.

Austria insisted the Belvedere bought the Munch painting in "good faith"—a viable shield in Europe, though not in U.S. courts. Even in Europe, this protection was being eroded by the morality plays of restitution.

The case seemed unpromising—until Randol's victory.

"I think the climate is extraordinary!" Marina said fervently. "I believe it is an opening, for many things. I believe I will get my painting back!"

A Friend from Old Vienna

The next morning, a gray sky glowered overhead. Randol announced he was heading off for a private lunch with Ron Lauder, who was apparently in Vienna. Randol offered no explanation.

"Why don't you look up Maria's friend Hans Mühlbacher?" Randol suggested. "He's her last childhood friend left alive in Vienna."

Ah yes, the legendary Hans, who had played his violin at the Stubenbastei the day of the Anschluss.

The clouds over the Schellinggasse were so low they seemed to touch the stone angels on the rooftops. Hans lived across the street from the grand old Coburg Palace, where well-endowed goddesses lounged on the roof in Grecian robes, creating the impression they were lingering in pajamas after a rough night.

The Bloch-Bauers' Stubenbastei apartment could be seen from Hans's doorstep. His building had a seashell staircase that climbed upward in a spiral. A heavy wooden door opened and Hans appeared, in a hand-tailored brown tweed suit with a rather twee pocket handkerchief.

Hans took both my hands. "How is my Maria?" he asked, in a tone that was a sigh of both joy and lament. He led me into a warm apartment that was like a museum of cozy Viennese *Gemütlichkeit*. The foyer was filled with mounted antlers, like a Tyrolean hunting lodge. There were blue-painted wardrobes with East European floral folk art designs. The herringbone geometry of the parquet floor contrasted with a tall chest carved with arabesques that might have been abducted from a sultan's seraglio. Above it was a painting of people around a bountiful kitchen table that looked like the work of a Flemish master, and a more run-of-the-mill portrait of Emperor Franz Joseph in his imperial uniform, radiating the confidence of the glorious empire. Gold silk curtains fell from long windows, and empire-style chairs were covered with crimson and gold silk upholstery. Sconces held leaded crystal shaped like grape arbors. I sat in a moss-green Hungarian chair with carved clamshells, and Hans settled into a Biedermeier settee.

How beautiful life was in Vienna, Hans was saying. It was another world! Friendships lasted a lifetime. Hans smiled with nostalgia.

Then came the Anschluss. His father died, very suddenly, a month later. His Jewish-born mother had to vacate the family chalet. His sister's Catholic fiancé jilted her. His cousin became an ardent Nazi.

"I was drafted, after Maria left," Hans continued. "I had to do it, to save the lives of my mother and sister. I wrote a memoir about this time," Hans said, pulling a book from the shelf.

The memoir didn't give much away. Hans spent the summer of 1940 occupying Villemeux-sur-Eure, France, with "many pretty girls we stared at and admired, without success," Hans wrote. Hans could not be pro-

moted because his mother was Jewish, "but I could, despite my lower rank, lead an interesting life in the still-quiet West, with all the comforts of the higher-ranked military staff."

Hans was stationed in Poland in 1941, in Rzeszow, a pretty Galician town where Jews were corralled into a ghetto. "Some of the soldiers were sorry there were Nuremberg racial laws, for the Jewish women were much better dressed than the rest of the people," Hans wrote. "Walking through the ghetto made me very depressed. I have never seen so much poverty."

Back in St. Wolfgang, his hometown, his mother's friends were deported, one by one. His mother and his sister, Lisl, once escaped deportation through intervention of his cousin, then a decorated Nazi.

At nearby Ebensee, the SS worked Jewish laborers to death building tunnels for armaments.

Hans flipped through the book and pointed to a photograph of himself, handsome and well-built, in his German army uniform.

No one should have had to make the choices he did.

Just then, a strong-faced matron in her sixties came into the room with sherry and apple strudel. She was Brigitte Wagner, and she seemed to be Hans's girlfriend. "Brigitte's husband saved my life," Hans said.

Brigitte regarded me warily.

"Dr. Wagner was the most famous German scientist in war technology," Brigitte said, in a guttural accent, entirely unlike the musical Viennese of Maria and Hans. "My husband invented missiles. He employed Hansl, so he was protected."

Her husband, Herbert Wagner, designed missiles. In 1943, Hans was kicked out of the German army for being a Jew, and Wagner hired him. Brigitte married Dr. Wagner after the war.

Hans flipped through his memoir and found a picture of Dr. Wagner at the height of Nazi Germany. The photo showed a heavily shadowed face and deep-set dark eyes, like a Hollywood version of a Nazi Dr. No.

Hans didn't work for just any Nazi scientist. Wagner had played a key role in the Nazi war machine, a serious charge at the Nuremberg trials. He was an SS officer. He surrendered to Americans hunting Nazi scientists in Bavaria. He and his two assistants were the first Nazi scientists to be secretly airlifted to the United States after the war.

"After the war, my husband was taken into prison," Brigitte was saying. "He was forced to work for the Americans. He worked on guided missiles for them."

It was a secret that Americans were working with former Nazis. Some of

the scientists had performed abominable experiments on Jewish victims at concentration camps. U.S. officials said they worried Nazi scientists would fall into the hands of the Russians in the Cold War arms race. They recruited Werner von Braun, another member of the SS, to help jump-start NASA, though he had overseen slave labor operations where thousands of Jews died. Dr. Wagner's FBI handlers helpfully repeated his contention that he only joined the SS for professional reasons and never went to the meetings.

"They needed my husband's invention to bomb Japan, late in the war," Brigitte was saying.

The clock ticked. The room was oppressively warm, the sherry sweet as syrup, the *Apfelstrudel* leaden. The wallpaper, a busy geometry of gold silk jacquard bouquets, made me claustrophobic. I must have had a bad poker face, because Brigitte was glaring at me. "You have no right to judge!" she said fiercely. "You can only judge when you yourself have survived such a conflict! It was life and death! Nobody knows what they would do in a similar situation!

"His mother made a big mistake," she said vehemently, pointing to Hans. "Many Jews did. She simply did not believe what was coming. She should have gone in time. But she didn't. She missed the boat. Many of those people were taken to concentration camps. If it wasn't for Hans, she would never have survived. An entire family Hans knew committed suicide."

"During the war my husband took Hansl to work at Henschel Aircraft," Brigitte said. "Otherwise, he would have been *dead.*"

Hans nodded.

"Dr. Wagner was my military protector," Hans said soberly. "Professor Wagner invented the guided missile. I was involved with the missile. The biggest was supposed to bomb New York."

Henschel had a slave labor factory at Dachau. Hans would have been forced to greet his colleagues with "Heil Hitler!" "Everyone did." Brigitte shrugged dismissively. "It was the polite salutation. Even schoolchildren had to greet 'Heil Hitler!' Everybody did so. Just as all the children joined Hitler Youth. *Everybody.*"

Hans began to speak, but Brigitte took over. "Things are not as simple as it might look to you in America," she said. "I believe, and Hansl agrees, that the majority of the Nazis, in the beginning at least, were very good, normal people. Many SS officers began as idealists. Black is not always black and white is not always white.

"There was, in Vienna, a very high percentage of Jews," Brigitte continued. "After World War I, the population was completely demoralized. Impoverished. Unemployed. The frustration was enormous.

"Because all the Jews of Eastern Europe came to Austria, especially Vienna, the aversion was very high. The Jews had a very close network of industry, of lawyers, of banking business. In the end it was very difficult for a non-Jew to make business in any of these fields. In my impression, it had nothing to do with religion. It had to do with commercial success."

"It" was a Vienna euphemism for the internments, the concentration camps, the Holocaust. It. Just as everyone said "National Socialist" instead of "Nazi."

After World War II, Brigitte said, "No one spoke of it, ever.

"The families were all involved in it, and to avoid questions, this has never been touched," she said. "People avoid details. Whenever you get into details, children will ask, 'What were you doing? What was Grandfather doing?' And there are unpleasant things to answer.

"If a society commits a crime, it's in the interests of society to close the files," Brigitte said vehemently. "It's in mutual interest to keep silent. It's like a family. In the end, they will stick together.

"Young people now know nothing about what happened in World War II," she said. They were finding out. Hans's storybook hometown, St. Wolfgang, was embroiled in a ferocious row over a proposal to rename its lakefront promenade, which honored a local Nazi who had turned in a Jewish woman.

Hans had spent a lot of the war in Vienna with his girlfriend, Maria Graf, a ballet dancer at the State Opera. He watched her dance there for Nazis. The State Opera had now been purged of talented Jews like Hans.

Then Allied bombs came crashing into the opera house. Hitler committed suicide. The British arrested Brigitte's father, the scientist Viktor Raschka. Dr. Wagner fled Vienna as the Red Army marched in, preceded by its reputation.

The SS ordered Hans and the other scientists to head to Nordhausen, home of the infamous Mittelbau V-2 rocket factory, where more than twenty thousand Jews had died. Instead Hans, terrified of the Red Army, fled into his building's cavernous basement.

Subterranean Vienna was a mecca. People who had seen air raid shelters collapse felt safer in ancient catacombs lined with skulls. Hans spent months in the dark rubble with Nazi collaborators trying to elude arrest and women trying to avoid rape. Maria Graf brought him food. If the Russians came to search, Hans ran through holes battered into the walls of the

burned-out basements that linked entire blocks into a vast labyrinth. Months later, Hans emerged, moved back into Maria's apartment, and married her. He was never arrested.

His mother and sister survived.

"Maria and Hans were very lucky to get this apartment during the war, in 1943," Brigitte was saying. "My husband's company rented this apartment for Hans. A German diplomat had been living here."

Who lived here before the diplomat?

Brigitte shrugged.

Hans showed me a joint Deutsches Museum–Smithsonian Institution tribute to Dr. Wagner. It said Wagner had moved to the Los Angeles suburb of Thousand Oaks and worked for Raytheon and Northrup, then researched guidance and control systems for reconnaissance drones for Fairchild aircraft. And that he engineered the stability system for Bay Area Rapid Transit, specifically the rail under the bay between San Francisco and Berkeley, the publication said.

Hans pointed to an illustration of a missile. "I was an engineer on this," he said. "This was designed to hit America. But America won the war."

Brigitte looked at me meaningfully. Not black or white.

On my way out, I stopped under a painting of pretty young nuns peering through the front gates of a convent, like Maria in *The Sound of Music*.

"What are they doing?" I asked.

"Don't you see the soldiers outside?" Brigitte asked pointedly.

Now I saw the spears above the door. What do the soldiers want?

"To rape them," Brigitte said sternly.

"It's a scary world," Brigitte said, in her deep German accent.

Patrimony

The next morning was frigid. Snow was piled in drifts as Randol walked briskly into the Belvedere. Gerbert Frodl seemed preoccupied. Randol listened as Frodl told him it injured his feelings when Maria called him a liar for denying that he had told her Austria might consider giving her the landscapes in exchange for the portraits of Adele. "I was a bit hurt, that she keeps saying I lied," Frodl said. "I didn't lie."

But he did lie, Randol thought.

But Randol remained silent. He was trying not to play the conqueror. Until the paintings were out of Austria, anything could happen. It's not like I waltzed in here like Napoleon, Randol kept reminding himself.

"Well, a lot of people said a lot of things," Randol demurred.

He didn't want to fight anymore. He just wanted the paintings.

Randol followed the administrator through the maze of underground passageways. He lost track of the twists and turns. He would never be able to retrace his steps and find it on his own. As they wound through the labyrinth, Randol's insatiable curiosity got the best of him. Why was this massive bunker built? For art? For arms? There had to be a reason.

Even fairy-tale palaces had dungeons.

Finally they came to a large room, about twice the size of a Vienna café. Randol was surrounded by some of the most valuable art in the world. The administrator pointed to a gurney.

Randol lifted up the first painting. It wasn't Adele. It was Mathilde Zemlinsky Schoenberg, his grandfather Schoenberg's first wife. She was holding a baby. The painting was by the brilliant early modernist Richard Gerstl, an artist who was passionately in love with the married Mathilde. Her composer husband ordered Mathilde to stop the affair. A few weeks later Gerstl finished his last portrait of himself, his mouth opened in mirthless laughter. Then Gerstl took off his clothes and hung himself in front of a mirror. Mathilde eventually followed Gerstl into the grave. The baby in the painting, Georg, would spend the last days of the war in an apartment lent to him by a fleeing Nazi leader, Benno Mattel, the son-in-law of Anton Webern, a former student of Arnold Schoenberg. When the bombs fell, Georg, by then an adult, hid in a cave in the Vienna Woods filled with women and children, running out to beg Russian soldiers not to throw grenades into the cavern.

In this perilous era, even the most personal painting became an accidental document of something much greater.

Randol idly wondered if the Belvedere had put the Gerstl painting of Mathilde here on purpose. He pushed it aside.

What he saw next amazed him.

It was Adele. Randol stared at her face for a long moment. He stared at the room filled with paintings, each with its own stories, many still untold.

———

If anyone didn't know who Adele was before, they did now.

Randol's attempt to get Adele out of Austria was the talk of the town as Austrian high society headed to that night's premiere of the Raúl Ruiz film about Gustav Klimt at the Konzerthaus. The American actor John Malkovich, who played Klimt, swept in wearing a luminous silk blazer emblazoned with a Klimtesque pattern of squares.

The Konzerthaus, built on the site of the Kunstschau exhibition grounds, where Adele's portrait had first been unveiled in Vienna, was a dazzling temple. Gold angels blew trumpets and gilded muses reclined under a golden ceiling patterned in an Italianate floral design whose radiance rivaled that of Heaven itself.

Andreas Mailath-Pokorny, the city councillor for cultural affairs, was onstage with the actress playing Serena Lederer. "The era has been so widely celebrated," he said. Klimt was the "pride of Austria," he went on. "Freud is not in the film, but his spirit is." It seemed strange to hear him extol these illustrious characters without mentioning why the whole party ended so suddenly. Though why advertise, on this happy evening, that Freud had barely made it out of Vienna alive, and four of his sisters died in concentration camps? Or that Serena Lederer lost everything and publicly disavowed her own husband to claim Klimt as the "Aryan" father of her daughter? That her sister died in a death camp, and her cherished Klimt collection was torched by Nazis?

When the lights came up, the writer and director of the film, Raúl Ruiz, began to explain his cinematic vision of this "mythical city, and its connection to the real Vienna.

"We have Ferdinand to the left and Hitler to the right," Randol whispered mockingly. "Will all the illegitimate children of Klimt please stand up?"

Randol made his way toward a group of Austrian officials, who seemed surprised and uncomfortable to see him. "I didn't tell anyone you were here tonight," one producer, a young Austrian named Suzanne Biro, told him apologetically. "I was afraid to.

"Austria is split in two," Biro explained. "One part is with Maria Altmann, and is ashamed, and happy that it is over. And a lot of people are not so ashamed—to the contrary. They are angry about the return of the paintings. I was ashamed. I think it is sad about the loss, of course. But it should have happened sixty years ago."

Andreas Mailath-Pokorny, a tall, dark man in a black suit, listened as Randol told an interviewer that "I thought there was no chance of it happening. Art cases always lose."

Mailath-Pokorny turned to a reporter. "There was a similar case in the city recently, with the estate of Johann Strauss," he began.

The family of the Waltz King, Johann Strauss II, was fleeced by the Nazis too. His third wife, Adele, was Jewish, a distant relation of Nelly. His stepdaughter and heir, Alice Meisner-Strauss, was forced to hand over the composer's Aryanized papers. The composer's great-grandfather had been born Jewish. But the Gestapo took great pains to destroy records of this inconvenient ethnic stain when Hitler adopted Strauss as a Germanic icon. After the war, Austria fought to hang on to the Strauss legacy, worth millions.

"In the end we gave it all back, and then we bought it," Mailath-Pokorny was saying. "It was very expensive. In the process, you realize you are not the owner, someone else is the owner. So we gave it back. It is still cultural patrimony."

"And within Austria, it's not even bad PR! That's the horrible thing!" Randol whispered loudly.

Mailath-Pokorny finally mentioned there was a VIP reception upstairs. The party overlooked Vienna, its city lights and its wintry cityscape. It was in full swing. Austrian officials swirled away from Randol, as if he were contagious. It was John Malkovich who mentioned the taboo. "Journalists keep asking me, 'Don't you think it's a shame that the portrait of Adele and the other Klimt paintings were going to leave Vienna?' " said Malkovich, towering over the party. "Bullshit! I think it's great!

"That's not a celebration of the loss of the Belvedere," Malkovich said. "It's a celebration of the owners of the art. *The paintings are theirs. They belong to them.* They might put them on the next plane out of here. Is it sad for the Belvedere? Yes! That's sad. But that's how life is. It's not clean! Martin Luther King said, 'The arc of life is long, but it tends towards justice.' Hopefully, these paintings will be able to be seen by a catholicity of people. I hope so. Where, I don't know."

The Austrian art world was distraught at the idea the paintings might be lost.

"It is something that is very painful," said Alice Strobl, the Austrian Klimt expert emerita, her eyes bright with tears as she sat under her tall black hussar hat at the Café Mozart, watching snow flurries fall outside.

Strobl, ninety, discovered her passion for Klimt during the war, when she was ordered to report to a state office of music and culture. "The Nazis

made everyone work," she said, shrugging. "I was lucky. I got peaceful work." It was the height of the Nazi obsession with so-called German culture, and "it was weird," Strobl said. In 1943, her co-workers suggested she go to the Klimt exhibition.

Strobl was stunned. Klimt's Faculty Paintings were like a spiritual awakening, a religious calling.

After the war, Strobl visited Gustav Ucicky's widow, Ursula, at the propagandist's apartment on Strudlhofgasse. Strobl gazed in awe at the stolen Klimts, mesmerized by *Water Snakes*. Ursula Ucicky "was very nervous," Strobl said. "She was afraid she would lose the paintings."

Now the paintings would be lost by Austria. When the Bloch-Bauers recovered the "donated" Klimt drawings from Austria and sold some, "it broke my heart," Strobl said. "It was only a matter of money for the family."

Austrian state art administrators insisted Adele would not be happy.

"It was so clear what she wanted," the intense young Stephan Koja, the Austrian Gallery Klimt expert, would lament later, at the museum café. "She did not want those paintings to go to her niece. She wanted them to go to the Belvedere Museum."

But to keep them, Austria would have to pay. When the case began, the paintings had been valued at $150 million. But that was before the panel ruled they did not belong to Austria.

Now Wolfgang Schüssel, the Austrian chancellor, was saying the government "will not continue to negotiate, because we don't think it will be possible to pay $300 million out of the government budget."

A well-connected group had taken out a full-page ad in *Die Presse* that week for a proposal to raise money to acquire the two portraits of Adele. Backers included architect Hans Hollein, Christian Mayer, the head of the Schoenberg Center, and the Belvedere's Gerbert Frodl.

"Basically, the government has been spoiling the whole thing," John Sailer, a leader of the movement, would say months later, when it was clear the effort would fail. Sailer, the owner of the Ulysses Gallery, loved his country. He lived high above the Ringstrasse in a light-filled atelier where his modern art collection competed with rooftop views of St. Stephen's Cathedral.

Sailer had lived his country's bittersweet history. He was four months old when Hitler marched into Vienna. His Jewish mother and Social

Democratic father were on a train at the time, and they fled without him. A woman smuggled him out eight months later by pretending he was her own son. Another mother in their circle stayed behind to pack the apartment, and her family never saw her again. Another large family was led away by the Gestapo, but as they walked down the spiral staircase, a non-Jewish neighbor pulled their littlest boy into their apartment; he was the only one to survive. Sailer's father testified against Nazi war criminals.

Sailer never tried to recover his family's confiscated home. He got on with his life. He was hired to help redesign the Belvedere in the 1960s. There, a guard whispered the way to the mysterious hidden concrete bunker. People told him it had been designed to be the last SS command station in Vienna. Sailer helped transform it into an art storage depot.

"My gut feeling is that there is some vague sentiment that 'If the rich Jews want to take away the paintings, let them. We're not going to give them any money,' " Sailer would say, when the effort failed. "It was, 'There are the rich Jews in America, taking over our paintings.' Or 'Adele was a Jew, so why do we want to keep her? Why don't we send her off?' "

Yet as long as the Klimts were in Austria, there was hope.

"Maybe you can change [Randol's] mind," said Elisabeth Sturm-Bednarczyk, a fashionably thin, well-groomed businesswoman, as she sipped pungent black coffee at her art and antiques store on the Dorotheegasse. Elisabeth, an old friend of Maria's sister Luise, was the dealer for Ferdinand's porcelain, and she had informally advised Austria in the negotiations.

Change his mind? Once Randol made a decision, you couldn't change his mind if you put a gun to his head.

"He's demanding such a high price that the government felt they were being mocked," she said. "Randol said, 'Oh, you have to offer a price.' But we can't offer a price, really.

"Perhaps you can also help. The situation is horrible," Elisabeth continued. "Austria didn't give them back, all those years, not for anti-Semitic reasons. The impression that Austria is anti-Semitic is mistaken. It was really a misunderstanding. People say, 'Oh, they were stealing them.' Gerbert Frodl, the director of the Belvedere, felt they really belonged to Austria. Frodl is a very good friend of mine, of many years."

Elisabeth sighed. "It is said an Arab wants to buy them. They will not know how they can be preserved. If they don't take care the paintings will be ruined in thirty years' time," she said, with a pained expression.

"It's extremely important that the paintings stay in the Belvedere," Elisabeth said. "Otherwise the Bloch-Bauer name will be forgotten in Austria, and all that it meant. It was a time when Vienna had not just cultural influence, but with Freud, the subconscious itself was being analyzed, and the origin of all of this was Vienna."

The gold portrait of Adele, she said, "stands here like a symbol of time, painted by the most well-known painter of Austria. Everything becomes one in this painting. The time, the social standing of the Bloch-Bauer family, all that was made possible by the Jewish haute bourgeoisie. This was a very special time, and Adele played a great role here. If you don't have a symbol to remind you, everyone forgets.

"Everyone says, what is the most famous work of Klimt? *The Kiss* and the *Portrait of Adele Bloch-Bauer.* The portrait is a symbol of the history of the nation. This is the prestige of Vienna."

Elisabeth sipped her thick black coffee. "The family is very divided, and now Maria has the say in everything," she said. "I think Randol put her up to this. The Canadian family isn't happy about this. They've gotten a lawyer. Nelly wanted these paintings to stay in Austria.

"There is very important family history behind these paintings," Elisabeth continued. "As Luise always said, it must have been a big love affair. A grand passion. But it was taboo to speak about it. Those were her words. And I'm sure that's why Adele wanted the museum to have it, so they are connected. So what they didn't have in their lifetime was always in the viewers' minds. So they always saw her and Klimt together, forever."

Elisabeth walked me to the door. "There's still a chance," she said. "Perhaps these paintings can still be saved."

Elisabeth opened the door. It was bitter cold outside. "Where will all this restitution end?" she said exasperatedly. "Are we going to go back to Napoleon?"

I stepped out of her shop, which was just down the block from the Dorotheum, the five-hundred-year-old auction house where the possessions of Jews had been auctioned off. The Dorotheegasse was the marketplace of the treasures that make museums of Vienna apartments: antique guns, jeweled golden swords, portraits of long-dead ancestors, and tiny porcelain statues of demure ladies with parasols. It was difficult to imagine how all this bric-a-brac survived World War II, much less Napoleon.

I walked across the cobblestones to the Jewish museum to see an exhibit on Erich Zeisl, Randol's grandfather. Randol was off in a concert hall, listening to a symphony record a recital of Zeisl's *Requiem Hebraico,*

the composer's homage to his murdered father and the many who shared his fate.

The Klimts did leave Austria. A few days later, they were carefully crated. False itineraries were circulated by e-mail, to throw off would-be thieves. The gold portrait of Adele left the Belvedere on a chilly morning before dawn, to avoid protesters. It was loaded on an unmarked truck. Adele would fly along the wintry Danube and over the Salzkammergut, with its snowy mountain peaks. The painting would climb higher, over the Alps, to the grand Duchy of Luxembourg and, finally, Los Angeles.

Ciao Adele!

Adele's Final Destiny

As the five Klimt paintings drew record-breaking crowds at a hastily arranged special exhibit at the Los Angeles County Museum of Art (LACMA), potential buyers intensified their courtship, hoping to close a deal.

Developer turned billionaire philanthropist Eli Broad was leading a bid by LACMA donors to acquire all five paintings for $150 million, the art writer Tyler Green reported in *Fortune* magazine. "It was a very significant offer," a LACMA curator said. "Our goal was to keep them all together."

But valuations seemed to rise by the day, as the LACMA show told the world the saga of loss and redemption. One afternoon Maria sat on her burnt-orange sofa, looking over monographs on the paintings sent by Christie's and Sotheby's. "The most significant event in the art world since the World War itself," Maria read aloud. "Shameless," she said, shaking her head, with an amused smile.

There was truth to the flattery. Restitution was putting on sale artistic masterpieces that otherwise would have been locked up as tight as *Mona Lisa* in the Louvre. The belated correction of Nazi dirty deals was spilling into a voracious art market willing to pay $100 million for a silly diamond-encrusted skull by Damien Hirst.

These paintings were legends. They had a history. Hungry auction houses saw it coming.

Ron Lauder had coveted the gold portrait of Adele for years. Now he needed it. He needed a destination painting, a reason for people to go to the Neue Galerie.

One morning, as I sat in her kitchen, Maria looked at her watch. "Oh my darling, I have to go to the hairdresser," she said. "I'm seeing Ron Lauder. We're going to the Peninsula." Lauder was also meeting with Steve Thomas, the art law specialist representing the heirs of the Klimts.

In Vienna, the catalyst for this drama, Hubertus Czernin was failing.

"I've lost so much weight," he mused. "People say that I already look like Death." He chuckled, as if in sad wonder at the progressing evidence of his own mortality. His body ached so much he felt he no longer fit in it. He took so much morphine he was useless after 1 p.m. His physical decline felt surreal. "I keep feeling as if someday I'll wake up, and this will all turn out to be a strange dream," Czernin said. "But now I'm sleeping twenty hours a day. When I wake up, it's still here."

When his wife, Valerie, came home from her errands, Hubertus called her to his bedside to describe everything he could no longer see: the streetcars, the blooming chestnut trees, the children playing outside by the fountain in the square where Tamino played Mozart's magic flute, his Pamina wrapped around him. Hubertus imagined it all: life.

On the eve of a dinner in his honor, Hubertus closed his eyes and let go. Austria had lost another fragile, eloquent troublemaker.

A week later, Lauder announced that he had bought the gold portrait of Adele Bloch-Bauer for a record $135 million. It was a sum greater than that year's funding for the National Endowment for the Arts. Klimt, once branded as a pornographer, then dismissed as too decorative, was now the creator of the world's most expensive painting.

The LACMA effort to buy the rest of the paintings had collapsed. "It became clear that they were looking to get the greatest number of dollars they could," Eli Broad told *Fortune*.

"It's pretty hard to be resolutely philanthropic with a large group of

people when there's that much money on the table," the LACMA curator said of the five heirs.

Nelly had agreed to the sale of the gold portrait of Adele, but she still had mixed feelings. She told Maria that taking Adele out of Vienna was like taking *David* out of Florence, or the *Mona Lisa* out of Paris. She argued that both portraits of Adele should hang in a museum, together.

Days before the gold portrait was to be delivered to the Neue Galerie in New York, Nelly balked at paying Randol his 40 percent contingency fee.

Randol filed a $40 million lawsuit against Nelly in U.S. Court of the Central District of California in Los Angeles for refusing to compensate him for his investment of eight years in a highly speculative endeavor that had resulted in the "most successful Nazi-looted art recovery litigation in the history of the United States," according to his court filing.

Randol accused Nelly of unjust enrichment, saying she planned to collect a 25 percent share that could total more than $86 million from the sale of the Klimts—which Randol valued at more than $300 million—without paying his fee.

The other heirs—Maria Altmann and Nelly's brother Francis Gutmann, who would also get 25 percent, and George Bentley and Trevor Mantle, who would split the remaining 25 percent—were paying his fee, Randol said.

But Nelly, he argued, was refusing to compensate his "hard work and efforts" in "extremely high-risk" litigation that was now going to put money in her pocket.

He said Nelly's attorney, Bill Berardino, had said that since Nelly did not sign the 40 percent contingency fee agreement, she was not bound by it, yet she was prepared to pay a "fair fee."

Nevertheless, "Auersperg has refused to pay a fair fee, or any fee," Randol charged.

Nelly caved. She agreed to pay Randol in full.

"I refused to pay because he was not my lawyer. My lawyer advised me to pay," Nelly would say later, offering no further explanation.

Steve Thomas, the lawyer for the sale, said that "the misunderstanding was resolved amicably between them outside any courtroom and put behind them, and they quickly moved on."

Adele was on the move again. The gold portrait was carefully packed in a crate that was bolted to an eighteen-wheel truck. A special high-security

team drove for three days and three nights from Los Angeles, updating its position and stopping only to refuel. East Eighty-sixth Street was sealed off by a special police cordon. Ron Lauder was anxiously pacing the pavement when the rig pulled in at midnight July 5.

"In many ways, this is what I believe Adele Bloch-Bauer wanted for herself, had she lived to see this," Lauder said at the unveiling of the painting at the Neue Galerie a week later.

Nelly sat in the audience. Randol's lawsuit had been formally dismissed just the day before.

Now she silently watched as Lauder introduced Adele, a woman "who believed in the value of art.

"Klimt realized this was a very, very special woman and you can see how beautiful she looks, surrounded by gold," said Lauder. "This is a painting of an obviously very emotional feeling toward Adele Bloch-Bauer."

Lauder recalled his awe when he first saw the painting as a teenager. "It's not just a portrait," he said. "It captures all the emotions, all of the spirit that was embodied in turn-of-the-century Vienna. It represents everything that was Vienna at that time. You cannot find a more important piece of Austrian art than this painting."

Now it had the cachet of history.

Adele Bloch-Bauer was "one of the last prisoners of World War II," Lauder said. "$135 million? You can't put a value on great works of art. This painting is priceless."

When the press had gone, Nelly studied the gold portrait, hung as *Adele Bloch-Bauer I.*

At the Belvedere, *Adele* had been one of many. Here *Adele* dominated the room, the entire museum.

To see all the paintings on public view was Nelly's wish. As the auction loomed, there was no guarantee.

Nelly said she and Maria called Steve Thomas to suggest that they donate the second portrait of Adele to Ron Lauder, and ask Lauder to pay Randol only what he might lose from his 40 percent fee on the proceeds of the sale of the painting. The proposal went nowhere.

Nelly said she sent a message to the rest of the heirs about the possibility of an auction in which only museum directors would bid, keeping the paintings affordable enough for an acquisition and ensuring they would remain in public view. She said she got no reply. (The other heirs declined

to comment, or said they had no recollection of this. Thomas said all decisions on the painting were made unanimously.)

Nelly said her only remaining option was to stridently oppose the other heirs, and she was not prepared for an unpleasant family fracas.

The Burden of History

Nelly mulled this over in Canada, at a house perched above Vancouver Bay, with a sweeping view of mountains, tidal pools, and seabirds.

A tiny woman, Nelly was as watchful and wary as a deer—yet also direct. "I don't like the inference that my mother was raped," she said bluntly, five minutes after we met. "We were saved from Auschwitz by a Croatian friend of hers. I still have the egg warmers she knitted."

Her husband, Prince Johannes (John) Weikhart Auersperg, had the elegant, dark good looks of a much younger man. He was describing the Auersperg family dynasty, which traced its roots to the eleventh-century Knights of Auersperg, of the Turjak castle of Slovenia. His maternal great-grandfather, General Eduard Clam-Gallas, served with the legendary Field Marshal Josef Radetzky, immortalized in the elder Johann Strauss's *Radetzky March*. His maternal grandfather, Franz Clam-Gallas, was a member of the entourage of Empress Elisabeth in England. The prince was describing the Czech family castle he visited as a child, a turreted twelfth-century marvel called Friedland—a magical castle where Goethe wrote legends and Schiller wrote poetry, and where Beethoven carried on with a Clam-Gallas belle.

The prince was dwelling on the past, the romantic distant past his generation loved to live in. Not the recent past they hated to even visit.

The Friedland Castle was in Germanic Czech Sudetenland, where Hitler had enjoyed his greatest support in all of the Reich—especially among some Germanic nobles whose Czech estates diminished by the land reform of Ferdinand's friend, President Masaryk. The Auersperg name also appears among the nobles who joined the Nazi Party in the wartime membership files in Berlin.

John came of age nearby in tiny Haindorf on the Polish border, a

thirteenth-century pilgrimage site with an onion-domed basilica, where some members of his generation recalled Hitler Youth as a kind of summer camp, hiking in the mountains and learning to sing harmony. He was fifteen when his family was expelled from Czechoslovakia at the end of the war with the rest of the Sudeten Germans. The family was reportedly declared "enemies of the people" by the new Communist local authorities.

He left on foot.

John didn't mention this era at all.

Here in this idyllic setting, relatives joked, Nelly and Prince Auersperg had created a studiously serene, picture-perfect life "inside the golden frame," a peaceful vision that shut out disturbing memories of the past.

Nelly was soft-spoken and articulate, with the intellectual range of a well-read woman with a classical education. She was discussing the evolution of gender roles and suggesting that the sexualized Klimt portrayals of women could be viewed as disrespectfully one-dimensional.

"I have a feeling Klimt was interested in Adele because she was a very fascinating person," Nelly was saying, as she opened a collection of family letters and photographs. "I see Adele as a very serious woman, trapped in wealth."

"She was a drawing-room socialist, and bothered by her wealth," John remarked impassively.

"I would prefer Adele's portrait to be somewhere in the Belvedere," Nelly said vehemently. "To this day I don't know if we should have gotten the paintings. I couldn't make up my mind who is right. I didn't like Randy's way of going after it. He didn't seem to care about my opinion."

"He's going to make ninety-six million dollars," John interjected blandly. "If Randol gets ninety-six million dollars, over eight years he was paid one million dollars a month." He raised his eyebrows. "He took a huge chance. Still—a forty percent fee."

John believed the Klimt paintings belonged in Austria. He held up the letter from Gustav Rinesch, written just after the war to Maria's brother Robert. " 'My ski holiday was wonderful,' " John read from Rinesch's jaunty introduction. " 'According to Adele's will of 1923, she left the paintings to the Austrian Galerie,' " he read. " 'I have given them a declaration that the heirs of Bloch-Bauer will fulfill her wish—' "

"Luise loved Klimt paintings," Nelly said. "If you ask, 'Did she agree?' I don't know. Luise always said, 'I wish Adele had deeded the other paintings, and not the Klimts. My mother hated the Biedermeiers, and sold them all.'"

The Biedermeiers were campy pastorals of bosomy maidens and men in lederhosen. Hitler viewed them as exemplary "Germanic" culture.

"The fact that Luise said 'Adele gave the Klimts' shows she agreed," the prince said.

" 'I'm giving [Garzarolli] the authorization,' " John read, " 'to receive the last Klimt paintings, and instructions to please go and retrieve them . . .' "

John looked up. "With this, one cannot say it is looted!" he said adamantly.

" 'There will be plaques—' " he read from the letter.

"No! There were no plaques!" Nelly broke in hotly. "People were very upset!"

Nelly sighed and shook her head. "I never knew what was in Rinesch's mind when he wrote this letter," she said. "The story was, he was trying to soften up the authorities. But I didn't feel, with all this, I could sue."

"It was tit for tat," her husband said.

But wasn't this "tit for tat"—the quid pro quo deal of granting export permits for minor paintings, to extract permission to hang on to the good ones—proof of Randol's contention that the deal violated the laws against using the lure of export permits to extort paintings? That was what the Austrian panel had concluded when they said Austria should give the paintings back.

Nelly changed the subject. She opened her photo album to a picture of Ferdinand. "I was the last one to see Ferdinand," she said. "In January 1941, at the most expensive hotel in Zurich, the Bellerive au Lac. I went down to look at the swans swimming in the lake . . ."

Her husband broke her reverie with a direct stare.

"The mistake was not that Luise stayed," he said carefully. "The mistake was that she didn't leave in 1941."

Nelly turned back to her album.

Here was a sepia photo of handsome Viktor in a World War I uniform, the heir to a Jewish dynasty of barons who threw New Year's Eve parties with Gypsy musicians and sleigh rides in the snow. Viktor and Luise were children of privilege. Nelly was a child of war. Nelly wanted to clear her father's name of the long-ago charge of collaboration.

She pulled out a lock of her father's hair. "We thought the Nazis were gone and life would be great," Nelly said, shaking her head. "He was charged on a Thursday. The trial was Tuesday. The trial was ridiculous. We thought, 'This is a sham.' They wanted to steal the lumber business, again."

In the courtroom "they said, 'Since the French revolution, types like you have exploited the working classes. You are a parasite to society.'

"The main 'sin' for which he was sentenced to death was he had caused the death of several hundred partisans," she said. "He explained that since he was a Jew under Nazi government, he was unlikely to be able to arrange Nazi maneuvers. He was in jail in Zagreb with us at this time.

"The charges were irrelevant," Nelly said disdainfully. "He was the kind of person you get rid of in a Communist country. So Baron Gutmann, who barely escaped the Nazis, was shot by Tito's henchmen.

"People are weak!" Nelly said angrily. "There are few heroes around!"

Her husband looked concerned. But soon the conversation returned to the paintings. She had proposed donating the second portrait of Adele to Lauder, or making it easy for him to buy it. The landscapes could be donated to museums. But all five heirs would have to agree.

John started to say something else about Randol's fee. Nelly shot him a look.

Nelly had other reasons for not wishing to dredge up the past, and they had nothing to do with paintings or porcelain. After a dinner, she led me to a tiny alcove off the stairs. One wall was covered by a portrait of Maria's mother, Therese, in lush greens and blues. Who was the artist? Nelly shrugged. "No one remembers."

What Nelly wanted to show me were framed pencil sketches of men in a big room, some playing checkers or reading. Others slept on the floor. The men were condemned to death. Nelly's father made these drawings in the prison cell where Nelly spent her last night with him in 1946. "They weren't supposed to shoot him yet. The appeals were not exhausted," she said.

Nelly paused, studying the drawings. "It was a very weird evening. I can't put it any other way," she said. "That's the only way to describe it. Weird. It wasn't sad. It was very confusing. Something you couldn't grasp. We talked about life and death. My father said, 'So many people have been shot in the last few years. What's one more? It's not that important.' They came and woke me up. My father said goodbye to me. He was very peaceful.

"I walked out into the street, but it was like in a dream. I thought, 'Oh my God, the world is carrying on as if nothing was happening. I wanted to stop people in the street and say, 'Don't you know they are shooting my father?'

"I don't think I will ever get over it," she said, her eyes shining with tears. "It's just part of me."

On the way downstairs, Nelly paused before Klimt's languid drawings of Adele, and a backlit cabinet of Ferdinand's eighteenth-century teacups, with cobalt-and-gold geometric designs that looked as contemporary as porcelain by Gianni Versace.

"I'm the only one who didn't sell them," Nelly said.

Art History

In Vienna, the impact of the Bloch-Bauer restitution rippled out of ministries and courtrooms and into cafés and dinner parties. Austrian officials were forced to confront the fact that the world saw the restitution cases differently, and they had paid a price for this.

They might pay even more. Long-lost heirs with illustrious family names were submitting new claims for paintings stolen during the war.

One of the clouds on Austria's horizon was Baroness Marianne Kirstein-Jacobs, an elegant, willowy older woman who was an heir to the Lederer collection. The baroness was trying to recover Klimt's portrait of Ria Munk, which had been commissioned by Ria's mother, Aranka Munk, the baroness's great-aunt. The portrait had disappeared from Aranka's sacked villa at Bad Aussee. At that moment, the painting was at the Landesmuseum in Linz. When the Nazis came, "the museums helped themselves, like self-service at Wal-Mart," the baroness said angrily.

The baroness took a seat on a buttery yellow leather sofa in front of a Lederer collection of cast bronze statues of Bacchus, the lusty god of wine and pleasure, dating from the 1600s. She opened a box of photographs of Gustav Ucicky, presented in a Nazi court to argue that Elisabeth Bachofen-Echt, her great-aunt, was his half sister.

She lifted up Elisabeth's typewritten memoir. "She wrote how he took her on his knee like a father. I'm sure he did, but it had nothing to do with that! She wrote it to save her life!

"She succeeded, but she didn't live very long after that," the baroness said, raising her eyebrows meaningfully. "Her brother Erich was a good

friend of the Bachofens, but they tried to take everything that belonged to Elisabeth, even after Wolfgang divorced her. There was a long lawsuit after the war."

The baroness was not convinced that the entire Lederer Klimt collection had been destroyed. "The Belvedere took many paintings away from Schloss Immendorf before it was burned," the baroness said. "Are some of them sitting in someone's castle right now, somewhere in Austria?"

After the war, Erich Lederer, Elisabeth's brother, went back to Austria. But Austria held on to his family's property. Officials neglected the Lederer mansion until it caved in. Erich found the Klimt *Beethoven Frieze* in a dank monastery, surrounded by rubble.

"My uncle Erich took the photographs to the Belvedere and said, 'Are you completely crazy? It's sitting in water!' " she said. "He couldn't take it out of the country. So he finally sold it to the Belvedere. If they loved Klimt so much, would they do this? They just want to hang on to everything."

The baroness was born in 1943, into the Protestant family of Erich's wife, Baroness Elisabeth von Jacobs. Erich hid art above her family's ceiling when he fled. After the war, the childless Erich paid to fix their bombed-out roof and sent the baroness to a French *lycée*. When he died, she inherited his restitution claims.

The baroness pulled out a letter from Felix Hurdes, a postwar culture minister. "Look. He says, 'We would love to give you back your art, but if we give it to you, we have to give all the art back to everyone,' " the baroness said.

"Does anyone really believe Adele would have given her paintings to these people if she had lived through the war?" the baroness said irately. "They returned *Adele* only because they had to! The whole world was watching the case!

"Don't you think that if they really regretted everything that happened with the Nazis, they would stop finding excuses not to return people's paintings?"

The senior legal counsel for the Austrian State, Gottfried Toman, clung to his conviction that Adele's wishes had been violated. "She wanted a monument to herself in Austria. Now she's hanging in a museum in New York. I seriously doubt it was the intention of Adele Bloch-Bauer for her paintings to be spread all over the world," Toman said on a warm, golden afternoon

in October under the arched spires of the Café Central. His cheeks were pink from the sun, contrasting with his navy blue barrister's suit, set off by a gold silk tie and a tiny gold pinky ring. He had a deferential, courtly demeanor.

"Adele was an extraordinary person in her lifetime," Toman mused, sipping his cappuccino. "You know, if you compare the portraits of Adele, it is quite fascinating. The first portrait is very erotic, full of love and understanding. The second one is a pale, ghostly face, with tobacco-stained teeth. I think it is quite clear that at the time of the second painting, the affair was definitely over."

Toman, too, had succumbed to the cult of Adele.

"I think Maria was Randol's greatest asset," he said. "I'm not sure he would have won without her. She had a certain elegance, a sense of humor, a way of speaking German that people remember hearing when they were children."

Toman still believed that someday a document or letter would surface to prove that he was right, that the paintings belonged to Austria. "The only problem we had with this case is we never found the so-called smoking gun. We both had no hard evidence," Toman said. "He was so totally convinced that he was the only one who knew what justice was. I've never met someone so absolutely convinced he was right. It was more of a crusade than a legal battle.

"And of course, from a financial standpoint, it was the case of a lifetime," Toman added drily.

"I had no Maria." Toman sighed. "I had the burden of history. This was extraordinary. The position of Maria Altmann, fleeing the Nazis, was of course terrible. But it was not relevant, from a strictly legal point of view. This is a case based on a will of 1923. This has nothing to do with the Holocaust. Of course it was easier to argue this case behind the windshield of the terrible events of the Holocaust."

The fact that the chairman of the panel was German-born "affected his decision-making enormously," Toman said. "If an Austrian had been sitting in the driver's seat, it would have been different," he said. "Many Austrians have personal guilt. But it's not like the collective guilt that Germans share.

"This was not a legal decision," Toman mused. "It was a referendum on the events of World War II." And even that era was not so black-and-white, Toman said, repeating an Austrian refrain that was by now familiar. Toman's own father had faced a simple choice, "to be in the German army

or be unemployed." His uncle had joined too. "Personally, I have the feeling that Austria felt the Nazi approach was a new approach for a new time," Toman said. "They didn't know the evil of this regime, or they didn't want to see it. After World War I they had lost their world. And here comes this guy who says 'I will show you a new dawn.' Of course, he said some ugly things about the Jews. But people didn't know it would lead to the Holocaust. Many, many people were involved with this regime, and thought it could be an advantage to the economy, and then realized, in wartime, what it meant.

"Personally, I'm glad I didn't live in this time. I don't know which way my life would have gone. Standing in line, unemployed with my kids, I don't know what I would have done.

"Do you know fifteen- or sixteen-year-old boys were pressed into the SS? Not everyone who was in the Waffen SS has personal guilt. Is every one of those fifteen- or sixteen-year-old boys guilty? Were they really able to make their choice? It is sometimes easy to make decisions after World War II. I don't know what my personal fate would have been. Who knows?"

Who could have guessed the history of Vienna would be told by its paintings?

Adele was no longer a beautiful enigma. Vienna, too, was being stripped of mystery, as Adele and Klimt's other stolen women changed the city's relationship with its past. Each stolen painting had a story, and each story raised pressing moral questions. Regardless of whether one believed the Bloch-Bauer Klimts should be returned, it was impossible to look at the paintings the same way again. It had been possible to avoid history. But not the talismanic images of these blameless, insulted daughters of Vienna.

The restitutions gave the paintings a potent unspoken psychological dimension, like the dream symbols of Freud. "It stirs up a lot of things for the old people. Things they don't want to deal with," observed Felicitas Kunth, the new provenance director of the Dorotheum. "There's too much personal guilt."

Artistic provenance was no longer just an investigation into the authenticity of Vienna's artistic treasures—it was a rediscovery of its past. One expert, Sophie Lillie, wrote a Bible-sized catalogue of stolen art for Czernin's *Library of Theft,* called "What Once Was"; it revealed a ghost town in Vienna of lost families, lost salons, lost love affairs, lost paintings, and lost lives. The high-profile restitutions led to other questions, such as,

What did my grandfather do during the war? One Belvedere provenance researcher discovered that his father had attended an elite Nazi military academy and his grandfather had commanded a slave labor camp where he shot a man. "My oldest friend was from a hard-core Nazi family," Lillie said, over goulash, at an outdoor table at the Café Korb.

"It really pained him. He didn't know for certain," she said. "Then a magazine published a list of high-ranking Nazis, and his grandfather was one of them. He said, 'Sophie, you're in the archives a lot, can you pick up his file?' Almost everybody had Nazis in their family here. It's your father and grandfather. People you love, and want to protect. All those people had a past."

The provenance cases shed light on other mysteries familiar to the Viennese. Ruth Pleyer, a researcher on the Bloch-Bauer case, played as a child at a neighbor's house that was filled with books that none of them read, and paintings they knew nothing about. Eventually Pleyer learned the entire house had been Aryanized. The family lived there like extras on a film set. "You grew up not knowing," Pleyer said. "Now people are finding out." In Vienna's complex recent past, "everyone in Vienna is related to persecutors, or the persecuted," Pleyer said. "In some cases, they are related to both."

This mixed inheritance was the uneasy birthright of Stanislaus Bachofen-Echt, a hip young heir with the fine good looks and antiquated air of a Romantic poet. His apartment on Graf Starhemberg Gasse was a museum of alabaster vases and dynastic oil paintings. On his mantel was the coat of arms of the Bachofen-Echts, who were made barons in 1906. Like many Viennese, they continued to use the title after titles were abolished in 1919.

Just back from India, Stanislaus poured jasmine tea and explained how this Viennese desire to be on the inside track might have been among the reasons his father, Werner, joined Austria's illegal Nazi Party in 1933. "He realized he could do good business," Stanislaus said, among the well-connected fraternity in this small party.

His father's brother, Eberhard, was "a real Nazi," and joined the SS. "My family always said Eberhard joined the SS because he looked handsome in the uniform," Stanislaus said, looking skeptical.

His father's other brother, Wolfgang, joined the Austrian Nazi Party with them in 1933, but his flirtation was more complicated. Wolfgang was the husband of Elisabeth Bachofen-Echt.

Like the rest of his generation, Stanislaus was left to puzzle through this era, and his family's role in it.

Stanislaus had heard the family legend of the marriage since he was a child. During the downturn in the family fortunes, the Bachofen-Echt brothers had convened a card game at the Hotel Sacher to decide which of them would propose to the conspicuously eligible Elisabeth Lederer. The punch line was that no one knew whether Wolfgang had won or lost.

The stories Stanislaus was told cast the Bachofen-Echt brothers in a typically benign light: Wolfgang divorced Elisabeth and took control of her property to protect her interests from seizure. Wolfgang took Elisabeth to join her mother in Budapest. Elisabeth was allowed to stay with Wolfgang in the Nusdorf great house of Eberhard. Eberhard sent SS officers to guard Elisabeth at Jacquingasse.

"During the war, two SS people were stationed in front of the Jacquingasse *palais* so she wouldn't be arrested. Uncle Eberhard arranged this," Stanislaus said. "I don't know how badly Wolfgang behaved, but I know Uncle Eberhard helped, stationing SS outside the *palais*. At least that was the story."

On the other hand, "my grandfather said when he saw Eberhard, he would hide, because Eberhard was dangerous," Stanislaus said.

"Eberhard was arrested after the war. I never found out why. As far as I know, he was not involved in the killings," Stanislaus said. "There is a place in the State Archive to find out. Someday I will."

A yellowing U.S. military form in the archive said Eberhard was released in 1946 with a disability: "Psychosis."

The apartment was crowded with enormous portraits of illustrious ancestors in heavy gilt frames, and photographs, many of the late Hubertus Czernin.

"That's my cousin Hubertus," Stanislaus said. "His mother and my mother were sisters. Our grandfather, Franz Joseph Mayer-Gunthof, was part Jewish, and he was active in another fascist organization, the Heimwehr. He got a Nazi medal during the war for factory production. But then he had to give it back, because they found out he was Jewish." Stanislaus laughed.

It took a moment to adjust to the news that Czernin was closely related to Elisabeth Bachofen-Echt. Hubertus had mentioned some Bachofen-Echts in the family, calling them "pure SS" and saying Elisabeth's marriage to a Bachofen-Echt was "like a bad joke."

"Our other cousins were the Jewish Schey barons who built the Schey Palace on the Ringstrasse," Stanislaus was saying. "Our Schey cousins stayed for a long time after the Anschluss. Finally my grandfather Mayer-

Gunthof went to them and said, 'You *have* to leave! *Now!*' They couldn't believe they had to go."

"Hubertus's father was a Nazi too," Stanislaus said matter-of-factly. Hubertus had mentioned that his father had been a Nazi sympathizer, but said he was jailed at the end of the war for belonging to the resistance. "I'm positive of it," Stanislaus continued. "Hubertus was completely aware of it. Did you ever ask him?"

A few days later Hubertus's older brother, Franz Joseph, slid into a red leather booth at the Café Braunerhof in faded black jeans, horn-rimmed glasses, and a tattered green tweed blazer. He looked a bit like Elvis Costello. Franz Josef was a poet.

Like Hubertus, he didn't mind staring history in the face. "We had some Nazis in the family," Franz Josef said, under the now-familiar gaze of Thomas Bernhard, the theatrical conscience of Austria. "Some family members had Jewish ancestors, and they would have liked to have been Nazis, but they weren't allowed to be Nazis because they were Jewish," Franz Josef said.

"And our father? They said in 1935 he left the Nazis. But I don't think so. This was a myth. He worked in a German bank that occupied Belgium during the war, a bank that was involved in Aryanization. I believe they were involved in art Aryanization."

Growing up, he explained, "the story was, he didn't become a Nazi, or was for a short time, and then left the party. But then I found out my father was a Nazi Party member in good standing, on a research database. A study came out, on the Aryanization of Jewish banks. My father was working for a bank that did that, and his name came up as someone involved. Hubertus was curious."

Franz Josef took a sip of his espresso. "Most people were not heroes," he said. "My father was very kind. It doesn't take anything away."

"My mother's father, Franz Josef Mayer-Gunthof, a leader of the Heim-wehr, was half Jewish," he said. "He was sent to Mauthausen for two years. But not for being Jewish. It was because he made an anti-Nazi joke in his salon. A woman told the Gestapo. He was sentenced to death for treason. Then, at the end of the war, he was sent to Vienna, and freed.

"My father told me that at the end he was in the resistance. A lot of people said that. He said he spent the last weeks of the war jailed by the Nazis, and when the jail was bombed, he escaped. Who knows?" Franz Josef shrugged.

"In any case, I believe in collective guilt," Franz Josef said. "There must have been a sort of consensus, so they all have some guilt. If someone actually kills, they have more guilt. There are different levels. But it's a shared guilt. Someone might not have been a murderer, but they mingled with murderers. People say an SS officer was lucky he never killed someone. What difference does it make? He was part of it.

"I was almost sixteen when our father died; Hubertus was only eleven. Hubertus started to realize, on his own, how many lies were under the layers of secrecy. Hubertus discovered the whole psychology of Austrian amnesia."

At the height of the Waldheim affair, some of their relatives stopped speaking to Hubertus. "They said, 'One doesn't do that to one's president. One lets the past rest in peace,' " Franz Josef said.

"Adele was a symbol of Austria too. When Austria lost *Adele*, a lot of people were sad and shocked. 'Our paintings! Leaving Austria!' They were saying goodbye to *Adele*. And to another illusion.

"Paintings are not as important as a president," Franz Josef said. "But Hubertus saw in *Adele* the same layers of half-truths, lies, and amnesia he grew up with, even in his own family."

There turned out to be plenty of information implicating their banker father, Count Felix Czernin. Documents of the American Office of Military Government for Germany called Count Czernin a "German espionage agent." The files said Czernin—"alias Burger, Agent No. A-306"—joined the German Nazi Party in 1939. He was said to be deeply involved in the Aryanization of Jewish property, and to have reported on his progress to a top Aryanizer for Reichsmarschall Hermann Göring.

In 1945, in the dregs of the war, Felix was reportedly arrested for treason somewhere, but managed to escape. Another Czernin count was an adjutant to Odilo Globocnik, the "Butcher of Lublin," and did something to deserve Himmler's SS death's head ring.

There were also whispers in the family about another relative, the late Igor Caruso. Caruso, an Italian aristocrat, came to Vienna to work at the pediatric clinic of the Steinhof Hospital in 1942, when it was an infamous Nazi euthanasia center. Caruso had said he was horrified when he discovered this and quit to work for Prince Alfred Auersperg, a neurologist and SS man. Caruso died in 1981. But new Nazi-era archives were emerging on his boss, the unpunished Heinrich Gross, who still had a flat at the hospital as late as 1996. The last preserved brains of euthanized children were

finally buried in 2002, after scores of children's remains were "discovered" in the clinic's cellar and laboratories. The press would report that Igor Caruso had personally evaluated fourteen children who were later euthanized. One magazine headline would call Caruso "a perpetrator who called himself a victim."

For Hubertus, the search for his country's conscience began at home.

The once-impenetrable Belvedere had itself become a center of intrigue. Its director, Gerbert Frodl, was now linked to Austria's failed effort to keep the Bloch-Bauer Klimts. Behind his back, Belvedere staff sniped that the museum archives contained a photograph of Frodl's father giving the "Heil" salute from the back of an open truck filled with stolen art. Frodl was born in 1940 and so was only a toddler when his father became one of Hitler's art collectors. It was a dark inheritance indeed.

The Belvedere's secrets were spilling out. Staff whispered that the museum's bunker had been a last resort for Hitler, its construction ordered by the Nazi foreign minister, Joachim von Ribbentrop. One curator said it had been a vast underground military center that was walled off after the war to outfit a small portion with the necessary climatic conditions to store paintings. "This wasn't for art," another museum official said. "It was in case Berlin fell. It would be one of the possible structures of command for a government-in-exile."

It sounded far-fetched. But Hitler built a number of secret underground headquarters. Perhaps Nazi governor Schirach had hoped a special contingency bunker would restore his lost favor with Hitler.

Officials at the Belvedere and the Federal Monument Office maintained for years they had no idea why the bunker was built. Yet Hans Aurenhammer, a highly respected postwar Belvedere director, wrote in detail of the Belvedere during wartime in his 1971 history, *Das Belvedere in Wien*. His book shows Hitler presiding over a 1940 reception in the Belvedere's Marble Hall, in one of the many period photographs that are now locked out of sight somewhere.

In those days, Aurenhammer wrote ruefully, the Belvedere was rechristened the Castle of the First Reichsmarschall by the National Socialist daily, the *Völkischer Beobachter*. By 1943, Aurenhammer wrote, "Vienna was no longer far from the combat zone. Under the pond of the Upper Belvedere a large bunker was built that Hitler was to move into in case of the transfer of the headquarters to Vienna. Of course, this did not happen."

The fortified refuge was completed in 1944. The Central Air Raid Police Command Post of the Vienna district moved in. There was a monitoring tower on the roof. In the park, there were floodlights and a flak battery with heavy antiaircraft guns. "The protest of the Gallery's management against this exceptional threat to the Belvedere was in vain," Aurenhammer wrote.

It was too late. The Belvedere was a military target. Allied bombs thundered down. Prince Eugene's roof, modeled on the billowing tents of the Turks he had conquered, caved in.

Long after the war, the Austrian architect Hans Hollein wrote about the "Führer Headquarters" in the bowels of the Belvedere, comparing the museum to a volcano with an incendiary "subterranean secret."

Were Austria's paintings hidden in an old refuge for the Führer? Frodl had no comment. He swept past reporters and strode briskly out of the Belvedere gates, then down toward the Theresianum, where, in another era, Nazis trained child cadets to shoot.

Three years after the initial query, a new administration provided a brief explanation for the "subterranean secret."

"Please note what the Belvedere has to say about the bunker," spokeswoman Lena Maurer wrote in a November 2009 e-mail. "The collections of the Belvedere were sent out in 1942/43. In June 1943, the construction of the bunker for the protection of Adolf Hitler began, between the palace and the pond. From October 1944 onwards it was used by the Central Air Raid Police Command Post for the Vienna district. On November 18, 1944, bombs of the Allied forces hit the palace and destroyed part of the western wing. On February 21, 1945, massive air raids led to severe damages to the main building.

"Please do not hesitate to contact me in case you need any other information."

Cultural Property

What was left of Adele Bloch-Bauer in the Austria that clung to her as indispensable cultural property?

There was little trace at the drafty old *palais* on the Elisabethstrasse. The

cubicle partitions of the Austrian train headquarters had cut her elegant salon to pieces. Plaster moldings and ornamentation had been ripped out in what struck Randol's Vienna partner, Stefan Gulner, as a Freudian desire to ravage the *palais*: to strip this Jewish mansion to its bones. An underground parking garage marred a view of the pretty Schillerplatz. Rusty bullet holes pocked the metal door into the attic, a relic, perhaps, of Red Army troops searching for fugitive Nazis and Wehrmacht soldiers. When the mansion was marked for restitution, Ron Lauder was advised not to buy it. It had lost too much integrity.

The gutted old place posed another question. What would have become of an aging Adele had she stayed? Would she have been driven to exile, despair, and death, like other Jewish models of Klimt?

Whatever her conceivable fate, there was nothing left of her here.

But in this country of the "beautiful corpse," the relationship to the dead, like the past, was intimate. So I set out to visit Adele Bloch-Bauer's grave on the chilly gray morning of All Saints' Day. A miserable drizzle was falling on Vienna's peaked mansard roofs when I reached Vienna's Central Cemetery, a who's who where the graves of "Handsome Karl" Lueger, Karl Renner, and Kurt Waldheim mingled with those of Beethoven, Brahms, Schoenberg, and Johann Strauss, father and son. Here angels beckoned from elaborate family mausoleums, their ceilings painted, like the Sistine Chapel, with mortals reaching for the divine.

Adele was not in the celebrity directory. At the administration office, a stout matron wearing a cap of short gray hair and a severe expression frowned at the name of Adele Bloch-Bauer. "*Jüdische? Jüdische? Nein!* Not here," she announced loudly, shaking her head. "It is a Jewish grave. She's in Döbling." I insisted. She sighed with exasperation. A younger, bespectacled gentleman went to a computer and came back with a printout for an Adele Bauer at the Döbling cemetery across town. The matron plopped the paper down triumphantly. "The model of Klimt?" I asked.

"She's not here," the young man insisted.

Was it possible the subject of the most expensive painting in the world had passed unnoticed? Perhaps in Vienna, so frozen in time, yet with such a complicated relationship with its past. I said I would walk to the crematorium and have a look. The matron threw up her hands. I walked toward the white Art Deco gates of the cemetery for the cremated. Chestnuts and potatoes roasted on open fires in the parking lot, giving off their tantalizing garlic-and-salt aroma. The complex was a maze, as thickly wooded as the Black Forest. There was a narrow dirt path along a mock castle wall. Above, a black raven cried loudly as it flew from treetop to treetop.

I was about to turn back when I came upon the stark black-gray granite plaque lettered in gold: ADELE BLOCH-BAUER. Beneath it were dry brown stems of long-dead flowers, mercifully upstaged by a lush green wild fern, as if nature itself had stepped in to celebrate this forgotten grave. The ledge held a rusted votive. Here, unadorned and obscure, lay the remains of Adele.

Someone in Vienna honored Adele's memory.

The cemetery in Hietzing, the district where Klimt had his last studio, was a stroll through the century. Bronze angels and roses decorated the grave of Katharina Schratt, Emperor Franz Josef's mistress, near the remains of Karl Renner, the fickle opportunist. Klimt's good friend Egon Schiele rested with his wife nearby. The remains of Elisabeth Bachofen-Echt and her handicapped son lay not far from those of Gustav Ucicky, her alleged half brother, close by where her brother Erich Lederer was likely turning in his grave.

Between two weeping birch trees there was a small arched brown marble headstone, with Art Nouveau lettering: GUSTAV KLIMT. At its center was the face of Adele, from the gold portrait, no larger than a playing card, laminated against rain and snow. Adele seemed to stare up from Klimt's grave with pleading eyes, like a holy card of Mary Magdalene, between two burning candles. An older man appeared in a worn suede jacket, with a ruddy, unlined face, and began clipping the tiny hedge with blue berries that cradled the grave. I asked him about Adele's picture. "It's not from me!" he retorted vehemently.

Was he related to Klimt? He looked up with piercing blue eyes. His glance was fierce and unsmiling. "My grandmother was one of his models," he said finally. "She is the girl in the Schubert painting. The painting was burned. Many were burned. It was terrible." The painting of Mizzi Zimmermann, torched at Schloss Immendorf.

"My father was the son of Klimt," he said finally.

His name was Gustav Zimmermann. Gustav didn't get much out of being the grandson of Austria's most famous artist. His father was serving in World War I when Klimt died, and was a sergeant in the German army when Gustav was born, in 1939. Gustav had spent his life selling used cars. No one invited him to the Belvedere, or to Klimt film premieres with John Malkovich.

But for years Gustav had been a lone guardian of the Klimt myth. Klimt's Josefstädterstrasse studio had been torn down years before. Gustav

was a member of a small community group that had saved Klimt's last studio, not far from the cemetery, from being razed to make way for a shopping mall. His grandmother told him she was already pregnant at the time of the Schubert painting. "She was very young. He liked young girls," he said ruefully. "He was surely not a bad man. But a really good man? I don't know."

Gustav was helping organize an exhibition of Klimt's letters to Mizzi. He invited Gustav Ucicky's widow, Ursula. But she blew him off. "Probably she's afraid of being asked about the Nazi period and her husband. And she has all those paintings. People are asking questions about paintings like that nowadays," he said, raising his eyebrows meaningfully.

He looked at the picture of Adele, yellowed by rain and sun. A warm foehn wind was blowing in from the southern Alps, pushing away the clouds and melting the snow. Suddenly the cemetery glowed with sunlight.

Later, over dinner at a restaurant overlooking a cobblestone street near St. Stephen's Cathedral, Gustav spoke of the difficulties of Mizzi's life as a single mother. She had another son with Klimt, Otto. When little Otto died, Klimt blamed her for not taking him to the doctor soon enough. Gustav studied a picture of Mizzi in the Schubert painting, reproduced in a book on the table, alongside his collection of her letters from Klimt.

"It was painful for Austria to lose those paintings," Gustav said. "But it was just. I think Adele's will was finally interpreted in the right way. Because it was clear that Ferdinand Bloch-Bauer bought the paintings of his wife. He paid for them, and it was clear they were his. If Adele had lived longer, she would have changed her will a thousand times, had she known what was to come."

His bright blue eyes were thoughtful. "The funny thing is, the Belvedere didn't even want most of those paintings in 1938," Gustav said. "They made the deal with Ucicky where they sold the paintings to pay for the ones they wanted. It's like a crime story.

"The truth is, if it weren't for the restitutions, Austrians would have never known anything about Adele Bloch-Bauer."

For Gustav the only mystery left was the nature of the relationship between Adele and his grandfather. "There's no way of knowing," he said. He smiled and cocked an eyebrow. "I'm certain he tried."

A Reckoning

For Maria, the family rift with Nelly over the paintings was another of the unwelcome novelties she had taken to calling "the curse of the Klimts." Things like her inability to get around her house without a cane. Or people who wanted her to give them money. Maria was ninety-one. She no longer embraced change. She waved away suggestions she give her house a makeover, and still left the front door unlocked, even when she napped.

"Nelly and I used to be so close," Maria said sadly. "I remember when she was born, I cried. We were like this," she said, holding up two intertwined fingers. "Now that's all gone."

Nelly wanted to donate the second Adele portrait to the Neue Galerie to hang alongside the gold portrait. But Maria's son Chuck said it couldn't be done. There were five heirs: George Bentley—the newborn carried by Robert and Thea when they escaped Vienna—shared Robert's stake with Trevor Mantle, a nephew of Robert's second wife. The heir who wanted a donation would have to come up with enough money to cover Randol's 40 percent contingency fee for the value of the second portrait of Adele.

The Altmanns were not sophisticated Rockefellers. They were a middle-class émigré family with bitter memories. None of them were ever certain they would get the paintings back. But they did. And this was the math. A life-changing sum was on the table. If it wasn't about the money before, now the money was an unavoidable reality. It seemed ever more unlikely that they would make the grand gesture of a donation.

In fact, few heirs of Vienna restitutions did make donations. They usually sold the paintings.

Some insiders were disappointed. "How sad—if unsurprising—to hear that the heirs of Ferdinand and Adele Bloch-Bauer are indeed cashing in, as planned, and selling four Klimts at Christie's in November," wrote the *New York Times* art critic Michael Kimmelman. "A story about art and redemption after the Holocaust has devolved into yet another tale of the crazy, intoxicating art market." Had the family left a painting in public hands, Kimmelman wrote, "they would have underscored the righteousness of their battle for restitution and in the process made clear that art, even in these money-mad days, isn't only about the money."

In Vienna, even the most diplomatic Austrian officials were openly dismayed.

"This was our Austrian *Mona Lisa*," lamented Werner Fürnsinn, the director of the Culture Ministry's Commission for Provenance Research. Fürnsinn was a genteel, old-fashioned man. His office was at the Imperial Hofburg, with a window overlooking a cobblestone courtyard where an enormous stone Hercules was clubbing what seemed to be a lion. Fürnsinn had impeccable manners, but the auction of the Bloch-Bauer Klimts had clearly punctured his Old World reserve.

"The auction houses are waiting for important pieces of art to come on the market. There is a market being made by the claims of the victims of the Nazi regime. It's not only in Austria. It's Germany. It's the Netherlands. It's Poland. It's everywhere," he said. "There are too many people making money from it!"

"As soon as a work of art is restituted, the new heirs can do as they like. It's money. They do not have the same sentimental approach as their grandparents," Fürnsinn said. "These paintings were loved here. The public should see these paintings. Not put one in some basement in Tokyo. It's crazy."

Maria said she didn't care if the Austrians were upset. "We lent them those paintings for sixty-eight years!" she said hotly. "They had a chance to buy them."

The deepening rift with Nelly was another story. It saddened Maria, and sometimes made her angry. "How dare you accuse me of only caring about money," Maria wrote Nelly one day. "I told you I offered to donate the portraits of Adele, but the Austrians did not respond. Nelly, you've lost perspective on what happened. Austria was not a victim." When Maria told the Austrians that the Nazis had stolen the paintings, "Austria insisted it was a gift," Maria wrote. If it wasn't for Randol, the paintings would still be in the Belvedere, with no proper explanation.

Nelly was furious. She found it insulting to be told she was on the wrong side of history. She was uncomfortable even visiting Vienna because of her World War II ordeal. She felt her Los Angeles family disregarded her feelings. She refused to take a share in the restitution of the Elisabethstrasse house of Adele. "My mother never wanted to dig up all of this, but having

dug it up she wants to do right by Adele," Nelly's daughter Maria Harris said. "She would never have chosen to dig it up because she lived it most deeply."

"It" was the past that robbed Nelly of her childhood. As with Maria, "it" swept away her world, took her father, nearly cost her life.

For Nelly, this past was a dark well of psychic pain. For Maria, it was an unaddressed injustice. Nelly wanted peace. Maria wanted atonement—recognition of a world swept away, an act of contrition.

How was Adele best honored? If Maria and Randol had not fought for the paintings, no one would ever know Adele's story.

But the paintings were slipping away.

For Maria, her long-awaited reckoning would end at the Christie's auction in New York. In a way, the auction was Maria's divorce—the final splashy denouement of her betrayed love for Austria.

Maria was a celebrity in the art world. When her long limousine pulled up to Christie's in Manhattan on the afternoon of the auction, photographers lined up like paparazzi, speaking in French, German, British accents. A doorman held red roses. Blowing kisses and sporting a movie-star smile, Maria swept past a king's ransom of art. A corpulent nude woman gazed down from a Botero, a Mexican peasant labored in a Diego Rivera, and translucent fish and crabs swam on iridescent purple and green Lalique vases.

The Bloch-Bauer Klimts hung in a room decorated like Josef Hoffmann's Secession chamber. "Mrs. Altmann, congratulations on the final chapter of this story," a young reporter said. But why, he asked, are you not making a single donation to a museum? "That's a difficult question," Maria began carefully, as Randol stood behind her, thumbing his BlackBerry. "I'm one of several heirs. We decided to go ahead with the sale."

Ronald Lauder showed Maria to his private auction box. He was going to try to get the second portrait of Adele tonight, Maria's family was told.

Below her were wealthy buyers: A man with spiky bleached hair and a Warhol Campbell's Soup T-shirt. A handsome brunet with black leather pants and a white T-shirt had his hair piled up Amadeus-style above theatrically haunted eyes, looking as rumpled as if he just rolled out of someone's bed. A fragile-looking elderly gentleman in cowboy getup walked by a woman garbed in what appeared to be Tibetan robes. A lady at least sixty

years old wore black leather pants and a fuchsia T-shirt. A man wandered by in an antique monocle, and a woman hid behind enormous dark sunglasses, like Jean-Luc Godard. A gamine barely out of her teens settled into a prime bidding spot in jeans, Keds, and a sweater tied around her waist. This was a spectator sport for rich people. There were waves, air kisses, hellos mouthed across the room. "Absolutely! They're going to take no prisoners!" a florid white-haired man in navy pinstripes shouted into a cell phone.

Into this rather unseemly orgy of art and commerce stepped the auction world's equivalent of heavy artillery: Christopher Burge, an honorary chairman of Christie's, sipping three fingers of scotch. Behind him, as in a stock market, was a monitor to translate prices into euros, Swiss francs, Japanese yen, and British and Hong Kong pounds.

The jaunty Burge and his crisp British accent went a long way toward dignifying this Costco-like jumbo sale. One of the first items up was a Picasso "tomahto plahnt." The eager bidders quickly eclipsed the presale estimate of up to $7 million. "Do I hear $12 million?" Burge chirped brightly, just before the painting sold for $13.4 million. This seemed to set the high-flying tone. A tiny sliver of hammered green metal on a wooden base was presented as *La Jambe,* or "The Leg," by Alberto Giacometti. It had a presale estimate of up to $2.5 million. But in a few giddy seconds, the tiny leg went for $7.9 million.

Finally, the Klimts. Maria leaned forward as they offered *Birch Forest,* which she said was coveted by Microsoft founder Paul Allen. In less than a minute bidding climbed to $28 million, $30 million; "all yours at $36 million!" Murmurs rippled through the crowd. Klimt's painting of the Attersee shot up to $28 million. His *Apple Tree,* "like a cupcake of delight!" Burge trilled, "selling to you, Thomas, at $29.5 million!" Now the second portrait of the mortal Adele with smoke-stained teeth. Feverish bidding pushed up the price in seconds. "Yusi, $60 million," Burge baited "Yusi," a handsome blond with sculpted cheekbones who looked like a sane, well-groomed Klaus Kinski. "$69 million Yusi! Pedro $70 million! Yusi $70.5 million . . ."

Lauder stopped bidding.

A dark horse pulled ahead of the pack. "It goes to the bidder at $78.5 million!" Burge said with surprise, as the two bidders, an older man and woman, hurried out.

In six minutes, Ferdinand and Adele's Klimts were gone.

Everyone jumped to their feet for a standing ovation. The auction total "is a record $491 million," Burge told reporters, "the most extraordinary

auction I've been involved with in my career." It was "a return to the extraordinary period of the 1980s. It's $200 million more than the highest sale ever held!" A Christie's press agent read Maria's statement: "My aunt Adele and uncle Ferdinand enjoyed living with these paintings and sharing them and we trust the new owners will continue this tradition."

The fairy tale had ended.

"We were lucky to have the works of art because of restitution, so we have to be sensitive to the issue," Christie's Stephen Lash was saying to an older woman he introduced to Maria's grandson, Philip Altmann, and his wife, Tanya.

"Your paintings are really lovely," Lash told them.

"We hope to get to see them again," Tanya said.

Lash raised his hands. "Who knows?" he said. "Who knows?"

Maria said she turned to Lash and was surprised to see his eyes filled with tears.

The gavel prices for the four Klimts sold at the auction totaled $192.7 million. The proceeds, combined with the $135 million sale of the gold portrait, would be divided among Randol and the five heirs.

Life had changed for the heirs of Adele and Ferdinand, and for the lawyer who had found jurisdiction in a museum guide.

Weeks later, back in Los Angeles, the phone rang. It was Maria. "Did Adele's portrait go to that man who put the hole in the Picasso?" Maria asked. It took a moment to realize Maria meant Steve Wynn, the Vegas hotel baron who accidentally poked his elbow through a $139 million painting of Picasso's twenty-one-year-old mistress, *Le Rêve*, while showing it off to celebrities. "I wonder if Paul Allen got *Birch Forest*," she mused. Maria had promised Nelly she would find out who bought the paintings and persuade the buyer to loan them for public exhibition. But she said Lash wouldn't reveal their names.

The paintings had disappeared, confirming Nelly's worst fears. No one knew who had bought *Adele Bloch-Bauer II, Apple Tree, Birch Forest,* or *Houses in Unterach on Lake Attersee.* If Adele knew "the fate of the Klimt paintings," Nelly said, "she would be heartbroken."

A couple of months later, it was clear that Maria, too, might never find peace on the issue. "I don't want to ask Nelly for forgiveness," Maria said,

Art Nouveau master Koloman Moser created an ex libris of Adele as a nude princess who is courted by a frog—not a particularly flattering image of Ferdinand.

over dinner at her favorite Italian restaurant, near her old Burton Way dress shop. "If she was so against this, then why did she take the money? I did nothing to forgive."

Maria was pensive. "What would Adele think?" she asked. "She loved Austria." But which Austria? The Austria of music, art, and philosophy? Or the murderous, greedy Austria, eager to hang on to palaces, paintings, books—even knives and forks—stolen from families that were exiled and murdered?

Maria sighed, with a century of weariness. "I don't know," she said finally.

In the end, many things led to the restitution of the Bloch-Bauer Klimts. There was the coming-of-age of a younger generation of Austrians, who felt more curiosity than shame. Austria was assuming presidency of the European Union in 2006, casting a spotlight on its perpetually unfinished business. There was "the burden of history."

There was the higher moral standard, demanded by the living victims of an unprecedented historic crime. In the days of Napoleon, war meant booty. It was accepted: to the victor went the spoils. Now people were disturbed by art taken by force and kept by deception.

Restitution cases were now judged in the court of public opinion. The world of today was shocked to discover that even one of the women painted by Klimt was sent at gunpoint to a place where families burned in ovens.

The rarefied art world seemed an unlikely stage for the reenactment of a drama steeped in love and blood.

Once again, the *Lady in Gold* was reborn. The portrait had been created, stolen, renamed, consigned to a shadowy underworld. It had miraculously eluded the inferno of war. A man who had seen Adele and never forgotten her paid $135 million to buy her, legally, for the first time. Adele was now legend.

Restitution had reintroduced Gustav Klimt to the world. The com-

pulsive reproduction of *The Kiss* had made him blandly ubiquitous. The artist was now revealed not as a purveyor of easy beauty, but as a deeply flawed man who nevertheless faced the biggest ethnic question of his day and emerged righteous. Long after his death, his art had opened eyes and minds. He had finally changed the world. Maybe this was Klimt's true "kiss to the whole world."

Perhaps no one would ever agree whether the "Austrian *Mona Lisa*" belonged to Vienna or to the exiled creators of the insulted culture that produced her; whether *Adele* represented the glittering aspirations of turn-of-the-century Vienna—or the sacking of everything that made Vienna shine. Adele's life was a triumph of Jewish assimilation, but her portrait was a relic of assimilation's tragic failure. *Adele* symbolized one of the most brilliant moments in time, but also one of the world's greatest thefts: of all that was lost when one woman and an entire people were stripped of their identity, their dignity, and their lives.

What is the meaning of justice when law is used to legalize thievery and murder? What is the meaning of cultural property when patrimony is an arm of genocide? What is the value of a painting that has come to evoke the theft of six million lives?

The public wrangle seemed a strange fate for a work of art so intimate. The portrait of Adele is not a field of lilies or a starry night. Here, in her naked eyes, lies a story that is more diary than novel. A painting comes from a time and place. Those who have heard the story of the portrait of Adele Bloch-Bauer can never again see her as a "lady in gold." Frozen in Vienna's golden moment, Adele achieved her dream of immortality, far more than she ever could have imagined.

And that is the power of art.

Acknowledgments

I am deeply indebted to Maria Altmann, who graciously re-created people and events in the lost world of Vienna in conversations that began in 2001. Maria opened a trove of letters, photos, opera programs, and even notes she scribbled to herself on scraps of paper while under Nazi house arrest. I regret that Maria did not live to see this book. She died, surrounded by her family, in February 2011. I owe much to Maria's niece, Dr. Nelly Auersperg. Nelly shared her father's poignant journal and memoir, and her own harrowing memories. These two courageous women truly belong to the greatest generation.

I was aided by Maria's contemporaries, who helped re-create the Austria of yesterday: Dr. Anthony Felsovanyi; the late Hans Mühlbacher; Dr. Emile Zuckerkandl, the former president of the Linus Pauling Institute; Maria's sister-in-law Thea Bentley; Nelly's cousin Rudy Gelse; and the centenarian Dr. David Lehr.

I am grateful to Randol Schoenberg for encouraging me to write a book on his remarkable case and for sharing relevant source material and expertise. The distinguished journalist Hubertus Czernin generously shared contacts and advice in the final days of his life.

In Vienna, the historian Elisabeth Penz was an invaluable researcher. Gustav Klimt's remarkable grandson Gustav Zimmermann generously opened letters from Klimt to his grandmother Mizzi Zimmermann, and recounted her bittersweet stories of their relationship. Daniela Skrein and her mother, Marianne Kirstein-Jacobs, graciously shared the tragic memoir of Elisabeth Bachofen-Echt. Stanislaus Bachofen-Echt provided wartime accounts drawn partly from family journals. Alexander Rinesch kindly copied the memoir by his father, Gustav Rinesch, of the prewar belle époque of the Bloch-Bauer clan, and his struggle to save them. Dr. Gottfried Toman, the senior legal counsel for Austria in the case, was a professional and helpful source for the government point of view. At the Belvedere museum, Monika Mayer provided valuable historical documents. Klimt expert Alice Strobl shared her voluminous Klimt research and recollections of the art world of Nazi Vienna. At the National Library in Vienna, Brigitte Mersich located Bloch-Bauer family letters. Dr. Brigitte Wallinger-Schorn, of the National Socialism history project at the University of Salzburg, clarified such cultural details as the Nazi position on *Bambi*. Information and documents regarding postwar legal conditions were provided by Ingo Zechner, then head of the IKG, Vienna's Holocaust Victims' Information and Support Center; Professor Brigitte Bailer, of the Documentation Centre of Austrian Resistance; and Dr. Robert Holzbauer, director of provenance at the Leopold Museum.

I benefited from the work of provenance experts Sophie Lillie and Ruth Pleyer, and many others: the Austrian arbitrator Andreas Noedl; Stefan Gulner, Randol's Vienna partner; researcher Ilse Kopke; poet Franz Josef Czernin; psychiatrist Rüdiger Opelt; John Sailer, owner of the Galerie Ulysses; Otto Kapfinger; Christian Witt-Döring, curator of decorative arts at the Neue Galerie in New York; Sylvie Liska, the president of Friends of the Vienna Secession; Pritzker-winning architect Hans Hollein; Gerhard Botz; and Elisabeth Sturm-Bednarczyk, of the Vienna art firm C. Bednarczyk.

Dr. Salomon Grimberg—the early proponent of the theory that Adele and Klimt had a love affair—shared stories and photos from his years as a confidant of Maria's sister, Luise.

Amy Schmidt, staff archivist at the National Archives, provided wartime records from the Berlin Archives. Neda Salem of the Mark Twain Papers and Project at the University of California at Berkeley shared the writer's Vienna notebooks. I am grateful to Alice Short for publishing the Klimt story in the *Los Angeles Times Magazine* in 2001 and to *Times* researcher Robin Mayper for her work on this book. I thank my colleagues: Dean Baquet, Rick Meyer, John Montorio, Lennie LaGuire, Leo Wolinsky, Tim Rutten, and Steve Padilla. At Knopf, my editor, Victoria Wilson, lent wisdom, guidance, and erudition. Carmen Johnson fielded vital details. Fabled Knopf editor Ash Green offered enthusiasm and encouragement. I thank my agent, Steve Wasserman, for finding such a wonderful home for the book.

Peter Altmann, Maria's son, found the love-letter exchange between Maria and Fritz; his brother, Charles Altmann, lent invaluable support. Nelly's children, Maria Harris and Eddie Auersperg, provided emotional context. Their cousin Michael Bentley shared a draft of a family memoir. The late Cecil Altmann shared memories of the formidable Bernhard Altmann. Nelly's husband, John Auersperg, shared letters and papers. Tom Trudeau combed Maria Altmann's photo archives. Jeremy Bigwood mined the National Archives. Mexico City–based art historian Esther Janowitz, Chilean journalist Pia Diaz Parada, Marlies Abreu, Ursula Mayer, Elisabeth Penz, and Jakob Veit provided excellent translations. Araceli Garcia, Esteban Juarez, and Gabriela Martinez provided logistical support.

I would also like to thank Gerhard Botz, professor of Austrian history at the University of Salzburg; Oliver Rathkolb, professor of contemporary history at the University of Vienna; Greg Bradsher, director of the Holocaust-era Assets Records Project of the National Archives and Records Administration; Peter Prokop of the photo archives of the Austrian National Library; Doris Schneider-Wagenbichler, a researcher at the National Library; Stephan Koja and Alfred Weidinger, Klimt experts at the Austrian Gallery; Agnes Husslein, director of the Austrian Gallery; Georg Lechner, its curator of the Baroque; and its spokeswoman, Lena Maurer. Also Thomas Geldmacher, a former Belvedere provenance expert; Professor Franz Gschwandtner of the Theresianische Akademie Wien; Günter J. Bischof of the Center Austria at the University of New Orleans; and special thanks to Lynn Nicholas, author of *The Rape of Europa,* for early advice.

Finally, I would like to thank my husband, William Booth, for reading drafts of the book and offering advice, support, and hours of delightful conversation.

Notes

ADELE'S VIENNA: *Poems and Privilege*

3 SO WHEN THE CURTAINS OPENED: William M. Johnston, *The Austrian Mind: An Intellectual and Social History, 1848–1938* (Berkeley: University of California Press, 1983), p. 44.

3 "THE PRINCIPAL NOURISHMENT": Ilsa Barea, *Vienna* (New York: Knopf, 1967), p. 27.

4 "THE SACRED CITY OF MUSICIANS": Ibid., p. 33.

4 HIGHEST SUICIDE RATE IN EUROPE: George E. Berkley, *Vienna and Its Jews: The Tragedy of Success, 1880–1980s* (Cambridge, MA: Abt Books, 1988), p. 21.

4 THE HALLOWED HOUSE OF HABSBURG: Andrew Wheatcroft, *The Habsburgs: Embodying Empire* (New York: Penguin, 1996), p. 3.

4 GUSTAV MAHLER—WHO CONVERTED TO CATHOLICISM: Michael P. Steinberg, *Austria as Theater and Ideology: The Meaning of the Salzburg Festival* (Ithaca, NY: Cornell University Press, 2000), p. 170.

4 "AFRICAN AND HOT-BLOODED": Johnston, *Austrian Mind,* p. 128.

4 "GAY APOCALYPSE": Ibid., p. 402.

5 "DO YOU RECOGNIZE ME?": Prolog zum Hochzeitsfeste von Thedy Bauer mit Dr. Gustav Bloch am 22. Marz 1898 verfaßt von Eugene und gesprochen von Adele Bauer (Wien) 1898; courtesy of Nelly Auersperg (also in the holdings of the Austrian National Library). Subsequent quotations from the poem are from this source.

THE KING

7 "WHIPPED CREAM PLAYED A MAJOR ROLE": Stephan Koja, ed., *Gustav Klimt: Landscapes* (Munich: Prestel Verlag, 2006), p. 124.

8 KLIMT'S FRIENDS CALLED HIM KÖNIG: Emil Pirchan, *Gustav Klimt: Ein Künstler aus Wien* (Vienna: Wallishauser, 1942), p. 35; Peter Vergo, *Art in Vienna, 1898–1918: Klimt, Kokoschka, Schiele, and Their Contemporaries* (London: Phaidon, 1994), p. 224.

8 "PRINCE OF PAINTERS": Sophie Lillie, "Hans Makart Malerfurst," *Was einmal war: Handbuch der enteigneten Kunstsammlungen Wiens* (Vienna: Czernin, 2003), p. 143.

8 RAVAGED BY SYPHILIS: Martin Pippal, *A Short History of Art in Vienna* (Munich: Beck, 2001), p. 156.

9 THEY REDISCOVERED A NEGLECTED PORTRAIT: Ted Byfield, *The Renaissance: God in Man (A.D. 1300 to 1500),* vol. 8 of *The Christians: Their First Two Thousand Years* (Edmonton: The Society to Explore and Record Christian History, 2010), p. 236.

9 "THE EROTIC NEURASTHENIA": Susana Partsch, *Gustav Klimt: Painter of Women* (Munich: Prestel, 1999), p. 14.

10 SIGMUND FREUD SIFTED THROUGH: Lynn Gamwell and Richard Wells, eds., *Sigmund Freud and Art: His Personal Collection of Antiquities* (Binghamton and London:

State University of New York and the Freud Museum in association with Harry N. Abrams, 1989).

EMANCIPATED IMMIGRANTS

10 THE AURIGNACIANS: David W. Anthony, *The Horse, the Wheel, and Language: How Bronze-Age Riders from the Eurasian Steppes Shaped the Modern World* (Princeton, NJ: Princeton University Press, 2007), p. 329.

10 THE WARRIOR EMPEROR MARCUS AURELIUS: Nicholas Parsons, *Vienna: A Cultural History* (New York: Oxford University Press, 2009), pp. 94–99.

11 THE DISCOVERY OF A GOLDEN SCROLL: University of Vienna press release, Mar. 13, 2008, on the discovery of the scroll at a burial site in the Austrian town of Halbturn.

11 JEWISH ARISTOCRAT FANNY VON ARNSTEIN: Hilda Spiel, *Vienna's Golden Autumn: From the Watershed Year 1866 to Hitler's Anschluss, 1938* (New York: Weidenfeld & Nicolson, 1987), pp. 39–41. Also, for Vienna in 1814, see David King, *Vienna, 1814: How the Conquerors of Napoleon Made Love, War, and Peace at the Congress of Vienna* (New York: Harmony Books, 2008), pp. 206–7.

11 A SALACIOUS MOUNTAIN COURTSHIP DANCE: Barea, *Vienna*, p. 21.

11 WHEN THE EARLIEST REFORMS: William O. McCagg, *A History of Habsburg Jews, 1670–1918* (Bloomington: Indiana University Press, 1989), p. 86. See also p. 96: "They succeeded . . . because as well-connected, modernist members of the Jewish community, they acted in the most 'Viennese' manner of which they were capable . . . The Jewish emancipation of 1848 was achieved at Vienna because leading figures of the Jewish community were indigenized . . . The Vienna Jews adopted a 'Viennese' style of behavior because they had to."

12 "BLOOD-RED FEZZES"; "TINY BONFIRES LIT BY ISLAM": Joseph Roth, *The Radetzky March* (Woodstock, NY: Overlook Press, 2002), p. 192.

12 "IF YOU WANT PEACE, PREPARE FOR WAR": For details, see Roland Hill, *A Time Out of Joint: A Journey from Nazi German to Post-war Britain* (London: Tauris, 2007), p. 43.

12 HONORING THEM WITH ARISTOCRATIC TITLES: Frank Whitford, *Klimt* (London: Thames & Hudson, 1990), p. 29.

12 BETWEEN 1860 AND 1900, THE JEWISH POPULATION: Berkley, *Vienna and Its Jews*, p. 35.

12 LUDWIG WITTGENSTEIN, WHOSE FAMILY HAD CONVERTED: Alexander Waugh, *The House of Wittgenstein: A Family at War* (New York: Doubleday, 2008), p. 208.

12 "WHOEVER WISHED TO PUT THROUGH": Stefan Zweig, *The World of Yesterday: An Autobiography* (Lincoln: University of Nebraska Press, 1964), p. 22.

12 "INTELLECTUAL CEMENT": Ruth Ellen Gruber, *Virtually Jewish: Reinventing Jewish Culture in Europe* (Berkeley: University of California Press, 2002), p. 42.

13 "MATZOH ISLAND": Harriet Pass Freidenreich, *Jewish Politics in Vienna, 1918–1938* (Bloomington: Indiana University Press, 1991), p. 13.

13 GEORG VON SCHÖNERER, AN ANTI-SEMITIC POLITICIAN: Frederic Morton, *A Nervous Splendor* (New York: Penguin, 1980), pp. 73–74.

13 "I DECIDE WHO IS A JEW": Steven Beller, *Vienna and the Jews, 1867–1938: A Cultural History* (Cambridge, UK: Cambridge University Press, 1991), p. 195.

THE WOUNDED CREATOR

14 KLIMT'S VIENNESE MOTHER, ANNA: Pirchan, *Gustav Klimt*, p. 13.

14 "THERE WASN'T EVEN ANY BREAD": Whitford, *Klimt*, p. 24.

14 "RELIGIOUS MADNESS": Pirchan, *Gustav Klimt*, p. 44.

14 AN IMPORTANT MENTOR, PROFESSOR FERDINAND LAUFBERGER: Gilles Neret and Charity Scott-Stokes, *Gustav Klimt: 1862–1918* (Cologne: Taschen, 2002), p. 9.

15 "HE WAS NOT NATURALLY": Alfred Weidinger, *Gustav Klimt* (Munich: Prestel, 2007), p. 211.

15 "GUSTL, WHY DON'T YOU KNOW HOW": Pirchan, *Gustav Klimt,* p. 19.

15 "WHAT SEDUCERS YOU ARE!" Ibid., p. 25.

16 SERENA PULITZER: Tobias Natter and Gerbert Frodl, *Klimt's Women* (Vienna: Österreichische Galerie Belvedere, 2000), p. 90.

16 WHEN THE OMISSION WAS NOTICED: Morton, *A Nervous Splendor,* p. 169.

16 BUT AS SOMEONE WOULD REMARK: Ibid.

16 IN A DAZE OF ASTONISHMENT AND RELIEF: Ibid., p. 168.

16 "IS IT WE WHO ARE STUPID": Pirchan, *Gustav Klimt,* p. 24.

17 "PUT THEIR FATE": Gustav Klimt, letter to Mizzi Zimmermann. Courtesy of Gustav Zimmermann.

ARRANGED MARRIAGE

18 "AS IF THEY WERE SLIGHTLY TIPSY": Zweig, *World of Yesterday,* p. 69.

18 "LACED INTO A WASP'S SHAPE": Ibid., p. 64.

18 THE BAUERS LIVED IN AN APARTMENT: Sophie Lillie and Georg Gaugusch, *Portrait of Adele Bloch-Bauer* (New York: Neue Galerie Museum for German and Austrian Art, 2007), p. 20.

18 OWNED BY HERMINE WITTGENSTEIN: Allan Janik and Stephen Toulmin, *Wittgenstein's Vienna* (New York: Simon & Schuster, 1973), p. 172.

18 "YOU DON'T HAVE TO BECOME AN ART EXPERT": Adele Bloch-Bauer, letter to her nephew Robert for his eighteenth birthday, ca. Aug. 1921.

18 "YOU HAVE TO DEVELOP": Adele Bloch-Bauer, letter, ca. Aug. 1921.

20 "TODAY, I TRIED TO REACH YOU": Moritz Bauer letter, July 1901, Historical Association of Deutsche Bank, *Bank and History Historical Review,* Mar. 2007, no. 13, p. 1.

20 JEWISH MODERNIZERS: Austrian National Library, *Hof- und Staats-handbuch der össterreichisch-ungarischen Monarche;* also Vienna State Archive, List of Orders.

20 GUSTAV BLOCH, AN ATTORNEY: Gustav Rinesch, 191-page unpublished memoir, written after World War II. Courtesy of Alexander Rinesch, private archive.

20 "IN ORDER TO PROTECT YOUNG GIRLS": Zweig, *World of Yesterday,* p. 68.

22 "AND WHEN IT IS TIME": Brigitte Hamann, *The Reluctant Empress* (New York: Knopf, 1986), p. 370.

22 "HOW CAN YOU KILL": Ibid.

23 "HAND-IN-HAND TO THE ALTAR": Family poem, probably by Julius Bauer, Auersperg Family Archive.

THE SECESSION

23 "ART OF THE SOUL": Christian Brandstätter, ed., *Vienna 1900: Art, Life and Culture* (New York: Vendome Press, 2006), p. 91.

23 "DICTATORSHIP OF EXHIBITIONS": Koja, *Gustav Klimt: Landscapes,* p. 145.

24 "PAINTINGS THAT GO WITH THE FURNITURE": Siegfried Matt and Werner Michael Schwarz, *Felix Salten: Schriftsteller—Journalist—Exilant* (Vienna: Holzhausen Verlag, 2006), p. 82.

24 "BUSINESS OR ART": Koja, *Gustav Klimt: Landscapes,* p. 147.

24 "LET THE ARTIST SHOW HIS WORLD": Brandstätter, *Vienna 1900,* p. 111.

24 AS THE NOTORIETY GREW: Koja, *Gustav Klimt: Landscapes,* p. 149.
24 "HOW SURPRISED THE GENERAL PUBLIC WAS": Whitford, *Klimt,* p. 19.
25 "IF YOU CANNOT PLEASE ALL": Maria Constantino, *Gustav Klimt* (London: PRC Publishing, 2001), p. 10.
26 "TRUTH IS FIRE": Koja, *Gustav Klimt: Landscapes,* p. 148.

KLIMT THE SEDUCER

26 "HIDEOUS FIANCÉ": Natter and Frodl, *Klimt's Women,* p. 116.
26 "AT LEAST THREE AFFAIRS": Anthony Beaumont, ed., *Alma Mahler Werfel Diaries* (London: Faber & Faber, 2005), p. 120.
26 "SHEER PHYSICAL EXCITEMENT": Ibid., p. 124.
26 "HE WOULD HAVE LOST CONTROL": Ibid., p. 141.
26 "MY HEART MISSED A BEAT": Ibid., p. 144.
26 "AND BEFORE I REALIZED IT": Ibid., p. 124.
26 "WE WERE BOTH TERRIBLY AGITATED": Ibid., p. 125.
26 "WITH SUCH FORCE": Ibid., p. 139.
27 "ANIMAL LUST": Ibid., p. 140.
27 HER STEPFATHER WAS A STERN, LOW-PAID OFFICER: Gustav Zimmermann, interviews, Vienna, Nov. 1, 2006.
27 KLIMT OPENED THE GARDEN DOOR: Weidinger, *Gustav Klimt,* p. 213.
27 A WEALTHY KLIMT PATRON: Natter and Frodl, *Klimt's Women,* p. 88.
27 KLIMT ASKED HER TO MODEL NUDE: Weidinger, *Gustav Klimt,* p. 213.
27 KLIMT WANGLED MIZZI A ROLE: Gustav Zimmermann, interviews.
28 "THE MOST BEAUTIFUL PAINTING": Christian Nebehay, *Gustav Klimt: From Drawing to Painting* (New York: Harry N. Abrams, 1994), pp. 46–47.
28 "IS IT POSSIBLE": Gustav Klimt, letter to Mizzi Zimmermann, undated. Courtesy Gustav Zimmermann.
29 MIZZI TOOK KLIMT'S ADVICE: Gustav Zimmermann, interview, Vienna, May 2007.

AN INNOCENT ABROAD

30 FREUD DONNED LEDERHOSEN: Beller, *Vienna and the Jews,* p. 179.
30 "THE MELANCHOLY OF THE SYNAGOGUE": Ibid.
30 THE VIENNESE *FIAKERLIED:* Ibid., p. 180.
30 "THE DIFFERENCE BETWEEN THE BRAIN": Carl Dolmetsch, *Our Famous Guest: Mark Twain in Vienna* (Athens: University of Georgia Press, 1992), p. 164.
31 THE VIENNA LITERATI INVITED TWAIN: Ibid., p. 43.
31 THEN TWAIN STOOD UP: Ibid., p. 44.
31 "THWARTED MY DESIRE": Ibid., p. 315.
32 "SO THAT WHEN YOU NEED IT FOR PRAYER": Ibid.
32 TWAIN BEGAN HIS VIENNA SOJOURN: Ibid., p. 170.
32 "THE UNAVOIDABLE MARK TWAIN": Ibid., p. 174.
32 "THE JEW IS NOT A BURDEN": Mark Twain, "Concerning the Jews," written Jul. 1898, published in *Harper's Monthly* Sept. 1899.
32 "OUR OLD FRIEND MARK TWAIN": Jerome Loving, *Mark Twain: The Adventures of Samuel L. Clemens* (Berkeley: University of California Press, 2010), p. 385.
32 FREUD CONFESSED TO SKIPPING: Dolmetsch, *Our Famous Guest,* p. 136.
32 HISTORIANS BELIEVE FREUD WAS ALSO INFLUENCED: Ibid., p. 161.

33 "THE JEWS HAVE THUS EVER BEEN": Twain, "Concerning the Jews."

33 "WILL IT EVER COME": Ibid.

33 "LONG LIVE LUEGER!": Dolmetsch, *Our Famous Guest,* p. 65.

33 "TALLOW-CHANDLER": Mark Twain, *Vienna Notebook,* Nov. 3, 1897, p. 44. Courtesy the Mark Twain Project, Bancroft Library, University of California, Berkeley.

33 "INVENTED A NEW NAME TONIGHT": Ibid., p. 47. This notebook is filled with humorous jibes at anti-Semites.

33 "UGLY AS A RUSSIAN JEW": Alma Mahler and E. B. Ashton, *And the Bridge Is Love* (London: Hutchinson, 1959), p. 38.

33 "INNOCENT WILD AMERICANS": Twain, *Vienna Notebook,* no. 40, Feb. 14, 1898, p. 10.

34 "THE JEW MARK TWAIN": Dolmetsch, *Our Famous Guest,* p. 166.

34 "IT WAS PAST MIDNIGHT": Ibid., p. 28.

34 IT TOOK SIX WEEKS: Alessandra Comini, *Gustav Klimt* (New York: George Braziller, 1975), p. 13.

34 "ISOLATION CELL": Ibid.

"I WANT TO GET OUT"

35 "PETIT-BOURGEOIS": Elisabeth Bachofen-Echt, *Memoir,* dated April 1939. Courtesy of Marianne Kirstein-Jacobs and Daniela Skrein.

35 "IF ONLY PEOPLE WOULD ANALYZE LESS": Ibid.

35 ONE OF THE OLDEST UNIVERSITIES: The University of Prague, opened in 1348, was the first in central Europe.

35 "LIKED IT THIS WAY": Bachofen-Echt, *Memoir.*

36 THE SUICIDE, IN JANUARY 1899, OF CROWN PRINCE RUDOLF: Wheatcroft, *The Habsburgs,* p. 283.

36 "A DULL, SPINELESS MASS": Koja, *Klimt: Landscapes,* p. 151.

36 "PORTRAYED IN A PUZZLING PAINTING": Weidinger, *Gustav Klimt,* p. 215.

36 "WHO IS REALLY INTERESTED": Karl Kraus, *Die Fackel,* no. 36 (Mar. 1900), quoted in Nebehay, *Gustav Klimt,* p. 69.

36 "HE MUST ALLEGORIZE HER": Ibid.

36 "NOT ONLY PROVOKED A FIERCE DEBATE": Bachofen-Echt, *Memoir.*

36 "YOU MUST NOT BECOME": Ibid.

36 "WHILE THE WAR OF THE PENS": Ibid.

37 "HERR KLIMT INITIATES FRAU LEDERER": Agatha Schwartz, *Gender and Modernity in Central Europe: The Austro-Hungarian Monarchy and Its Legacy* (Ottawa: University of Ottawa Press, 2010), p. 132.

37 "THIS RAPPORT BETWEEN MODERN ART AND IDLE-RICH JEWRY": Ibid.

38 "I WOULD PREFER TO BYPASS": Nebehay, *Gustav Klimt,* p. 70.

38 "HIDEOUS!": Ibid., p. 106.

38 "HIS EYES WERE SHINING": Ibid.

38 "FEELING OF A TEMPLE": Koja, *Klimt: Landscapes,* p. 150.

38 KLIMT'S *KISS TO THE WHOLE WORLD:* Carl E. Schorske, *Fin de Siècle Vienna* (Cambridge, UK: Cambridge University Press, 1981), p. 258.

38 "INTO THE IDEAL REALM": Ibid.

38 "SLIM AND LOVELY": Berta Szeps, *My Life and History* (New York: Knopf, 1939), p. 181.

38 "I HAVE NEVER BEFORE EXPERIENCED": Ibid.

39 "ORGIES OF THE NUDE," "OBSCENE ART," "PAINTED PORNOGRAPHY," "PATHOLOGICAL FANTASIES": Pirchan, *Gustav Klimt,* p. 57.

39 "AMONG THE MOST EXTREME EXAMPLES": Gerbert Frodl, *Secession, Gustav Klimt, Beethovenfries* (Vienna: Secession, 2002), pp. 14, 15.

39 "ALL POSSIBLE MEASURES": Ibid.

39 "THOSE OF US WHO ARE MODERN": Karl Kraus, *Die Fackel,* Nov. 21, 1903, quoted in Nebehay, *Gustav Klimt,* p. 75.

39 WHY SUCH "HATRED"?: Weidinger, *Gustav Klimt,* p. 215.

39 *AGAINST KLIMT:* Frodl, *Secession,* p. 14.

39 "ONE CAN TELL KLIMT IS A VIENNESE": Colin Bailey and John Collins, *Modernism in the Making* (New York: Harry N. Abrams in association with National Gallery of Canada, 2001), p. 42.

39 "FORGET THE CENSORSHIP": Schorske, *Fin de Siècle Vienna,* p. 266.

39 "GUSTAV IS FOLLOWING": Weidinger, *Gustav Klimt,* p. 208.

40 PEOPLE SAID THAT UNDERNEATH: Whitford, *Gustav Klimt,* p. 19.

40 HE TOOK HOME *PHILOSOPHY:* Schorske, *Fin de Siècle Vienna,* p. 267.

40 "UNDOUBTEDLY ONLY OF AESTHETIC INTEREST": Rainer Metzger, *Gustav Klimt: Drawings and Watercolors* (London: Thames & Hudson, 2005), p. 46.

41 "A NASTY THING": Weidinger, *Gustav Klimt,* p. 206.

41 "A GUY CAN HIDE A BELLY": Bachofen-Echt, *Memoir.*

ADELE'S "BOHEMIAN HOME"

41 "DREADED DRAMATIC CRITIC": *New Music Review and Church Music Review* 13 (1906): 12.

41 ONE VICTIM WAS: Jacques Kornberg, *Theodor Herzl: From Assimilation to Zionism* (Bloomington: Indiana University Press, 1993), pp. 169–70.

42 "AS TRULY AS AN ITCHING OF THE HEAD": Wilma Abeles Iggers, *Karl Kraus: A Viennese Critic of the Twentieth Century* (The Hague: Martinus Nijhoff, 1967), p. 43.

42 "I AM SURE YOU THOUGHT": Adele Bauer, letter to Julius Bauer, Aug. 22, 1903, in the holdings of the Austrian National Library.

42 "IT WAS SOMETIMES NOT 'SAFE'": Weidinger, *Gustav Klimt,* p. 212.

43 "THE MOST SWEET-SCENTED POETRY": Natter and Frodl, *Klimt's Women,* p. 98.

43 "THE STILL HALF-CLOSED BUD": Ibid.

43 "BEAUTIFUL JEWISH *JOURDAME*": Brandstätter, *Vienna 1900,* p. 30.

THE EMPRESS

45 "SURPASSING IN INTELLIGENCE": Helen Gardner, *Gardner's Art Through the Ages: The Western Perspective* (Australia; Florence, KY: Wadsworth/Cengage Learning, 2010), p. 240.

45 THEODORA HAD ALREADY BEEN: James Allen and Stewart Evans, *The Empress Theodora, Partner of Justinian* (Austin: University of Texas Press, 2004), p. 114.

46 "NEITHER DID ANYTHING": Richard Atwater, *The Sacred History of Procopius* (Ann Arbor: University of Michigan Press, 1961), p. 47.

46 "MOSAICS OF UNBELIEVABLE SPLENDOR": Natter and Frodl, *Klimt's Women,* p. 115.

"DEGENERATE WOMEN"

47 "YOU CANNOT RECEIVE KNOWLEDGE": Letter from Adele Bloch-Bauer to her nephew Robert Bentley (then Bloch-Bauer), ca. Aug. 1921. Translated by Barbara Zaisl Schoenberg.

47 "BY A SMALL GROUP OF MODERNS"; "GREAT MAN"; "THE TRUTH OF HIS OWN SOUL": Szeps, *My Life,* p. 179.

47 "AS AN ANATOMIST": Ibid., p. 166.

47 SHE WAS ORDERED TO SIT: Berkley, *Vienna and Its Jews,* p. 20.

47 EMIL HAD TO CALL SECURITY: Szeps, *My Life,* p. 167.

48 EMIL MADE FRÄULEIN BIEN: Weidinger, *Gustav Klimt,* p. 228.

48 "THE MOST MARVELOUS AND WITTY WOMAN": Szeps, *My Life,* p. 163.

48 "A HUSBAND AND WIFE": Henry-Louis de La Grange, *Gustav Mahler: Letters to His Wife* (Ithaca, NY: Cornell University Press, 2004), p. 82.

49 "CULTURAL CHATTERBOX": Edward Timms, *Karl Kraus, Apocalyptic Satirist: The Post-War Crisis and the Rise of the Swastika* (New Haven, CT: Yale University Press, 2005), p. 115.

49 "DEGENERATE WOMEN'S EMANCIPATION FIT": Brigitte Hamann, *Hitler's Vienna: A Portrait of the Tyrant as a Young Man* (New York: Oxford University Press, 2000), p. 82.

49 "THE SEXUAL IMPULSE DESTROYS": Otto Weininger, *Sex and Character* (New York: Howard Fertig, 2003), p. 249.

49 "NOT ONLY OF THE LOGICAL RULES": Ibid., p. 195.

49 "THERE IS NO FEMALE GENIUS": Ibid., p. 131.

49 "THE DEGENERATES BABBLE": Hamann, *Hitler's Vienna,* p. 83.

EYES WIDE SHUT

52 "IN HIS JUDITH": Partsch, *Gustav Klimt: Painter of Women,* p. 81.

53 "I BECOME THE PERSON": Arthur Schnitzler, *The Seduction Comedy,* in *Three Late Plays,* trans. G. J. Weinberger (Riverside, CA: Ariadne Press, 1992), p. 128.

53 "DID I EVER HAVE TO BEG?": Ibid.

53 "MY HOUSE STANDS ALONE": Ibid.

53 "THE POLICE WILL COME": Ibid., p. 138.

53 "JUST AS CORREGIO PAINTED": Ibid.

53 "DON'T REFUSE ME": Ibid., p. 136.

54 "TO EMBRACE HIM OR KILL HIM?" Ibid., p. 209.

54 "ALIVE WITH THE LAMENTATION": Ibid.

54 "SMOTHERED IN FLOWERS": Ibid., pp. 209–10.

54 "AND THEN I EXPERIENCED IT": Ibid., p. 209.

54 AN EROTIC KLIMT DRAWING: Klimt, *Standing Nude,* copy provided by Salomon Grimberg from the 1973 Klimt show at the Piccadilly Gallery in London.

THE OUTSIDER

55 HIS SURNAME WAS CHOSEN: Hamann, *Hitler's Vienna,* pp. 43–44.

55 IN LINZ, HITLER STUDIED: Ibid., p. 15.

55 "THE LIMITS OF MY LANGUAGE": J. Mark Lazenby, *The Early Wittgenstein on Religion* (London: Continuum, 2006), p. 47.

55 "FOR HOURS AND HOURS": Adolf Hitler, *Mein Kampf* (Mumbai: Jaico Publishing House, 2003), p. 30.

55 "CHILD'S PLAY": Hamann, *Hitler's Vienna,* p. 32.

55 "I WAS SO CONVINCED": Hitler, *Mein Kampf,* p. 30.

56 "FOR THE FIRST TIME": Ibid., p. 31.

56 AS HE BECAME AN INCREASINGLY DOWN-AND-OUT ARTIST: Hamann, *Hitler's Vienna,* p. 159.

56 LUEGER RAILED AGAINST: Robert A. Michael, *A Concise History of American Anti-Semitism* (Lanham, MD: Rowman & Littlefield, 2005), p. 112.

56 "JEWISH YOUTH IS REPRESENTED EVERYWHERE": Hamann, *Hitler's Vienna*, p. 80.

57 "NOTHING BUT CRIPPLED DAUBING": Ibid.

57 "ART REVIEWS IN WHICH ONE JEW SCRIBBLED": Ibid., p. 81.

57 "THIS RACE SIMPLY HAS A TENDENCY": Ibid.

57 "ODOUR OF THOSE PEOPLE": Hitler, *Mein Kampf*, p. 63.

57 "THE HOUR OF FREEDOM": Hamann, *Hitler's Vienna*, p. 129.

57 "TURNED INTO THE GREATEST BLESSING": Ibid., p. 135.

57 "DEPRIVED OF THE RIGHT": Ibid., p. 404.

THE PAINTED MOSAIC

58 IT MADE ADELE, AT TWENTY-SIX: Natter and Frodl, *Klimt's Women*, p. 115.

58 "THE EXPRESSION 'VAMP'": Szeps, *My Life*, p. 180.

58 "A RAPTUROUS FEELING": Weidinger, *Gustav Klimt*, p. 285.

59 "PAINTED MOSAIC": Ludwig Hevesi, "Gustav Klimt und die Malmosaik," printed in *Kunstchronik*, 1906–1907, no. 33 (Sept. 27).

59 "SECOND SOCIETY": Schorske, *Fin de Siècle Vienna*, p. 45 ("that 'second society,' sometimes called 'the mezzanine,' where the bourgeois on the way up met the aristocrats willing to accommodate new forms of social and economic power").

59 "THEY HAVE A GREAT LONGING": Natter and Frodl, *Klimt's Women*, p. 63.

60 "WHETHER HER NAME IS HYGIEIA OR JUDITH": Spiel, *Vienna's Golden Autumn*, p. 68.

60 "*LA BELLE JUIVE*": Natter and Frodl, *Klimt's Women*, pp. 68, 69.

60 "THE NEW VIENNESE WOMAN": Metzger, *Gustav Klimt: Drawings and Watercolors*, p. 239.

61 AS WAS DONE IN RELIGIOUS ART: Koja, *Gustav Klimt: Landscapes*, p. 153.

KLIMT'S WOMEN

61 "THE YOUNG NO LONGER": Neret and Scott-Stokes, *Gustav Klimt*, p. 65.

62 "MUCH TOO MUCH": Alessandra Comini, *In Passionate Pursuit: A Memoir* (New York: George Braziller, 2004), p. 29.

62 "RESULTS GOOD": Weidinger, *Gustav Klimt*, p. 227.

62 "A VERY BEAUTIFUL EXISTENCE": Postcard to Emilie Flöge, Sept. 27, 1911, quoted in Hubertus Czernin, *Die Falschung, der Fall Bloch-Bauer und das Werk Gustav Klimts* (Vienna: Czernin Verlag, 1999), p. 65.

62 "A MIXTURE OF RAIN AND SUN": Postcard to Emilie Flöge, Sept. 28, 1911, quoted ibid.

62 "ARRIVED WELL": Postcard to Emilie Flöge, Nov. 15, 1912, quoted ibid.

63 "AN ALMOST PATHOLOGICAL SENSITIVITY": Koja, *Gustav Klimt: Landscapes*, p. 37.

63 "I AM LESS INTERESTED": Whitford, *Klimt*, p. 18.

63 "LITTLE PLEASURE FOR WORK": Koja, *Gustav Klimt: Landscapes*, p. 142.

64 "I'LL PAINT MY GIRL": Bachofen-Echt, *Memoir*.

64 "SLAVING AWAY": Weidinger, *Gustav Klimt*, p. 225.

64 "WORK PROCEEDING SLOWLY": Ibid., p. 227.

64 "ARTISTICALLY SUPER ROTTEN": Ibid.

64 "REALLY GETTING ON MY NERVES": Ibid.

64 "WEARINESS AND SUFFERING": Ibid.

64 "I DID NOT KNOW": Ibid., p. 210.

64 "WHY IS KLIMT": Ibid., p. 227.

64 "A. BAUER": Renée Price, ed., *Gustav Klimt: The Ronald S. Lauder and Serge Sabarsky Collections* (New York: Neue Galerie/Prestel, 2007), p. 217.

65 "ART HAS LOST SOMETHING": Weidinger, *Gustav Klimt*, p. 227.

65 "HE DIED OF SYPHILIS": Ibid., p. 210.

65 "TO THINE OWN SELF": Datebook of Adele Bloch-Bauer, Auersperg family archives.

65 "I WAS PARALYZED": Bachofen-Echt, *Memoir*.

65 "HE HAS ENTERED INTO THE CENTRE": Natter and Frodl, *Klimt's Women*, p. 56.

"HUGS FROM YOUR BUDDHA"

66 SHE TOLD PEOPLE SHE WAS A SOCIALIST: Jonathan Petropolous, "Report of Professor Jonathan Petropolous, Claremont McKenna College," July 14, 2005, http://www.adele.at/Report_Prof_Jonathan_Petropou/Petropoulos.pdf, p. 2.

66 "A SPECULATOR, AN EXPLOITER": Mahler and Ashton, *And the Bridge Is Love*, p. 30.

66 "IF FATE HAS GIVEN ME FRIENDS": Letter from Adele to her nephew Robert Bentley for his eighteenth birthday, ca. Aug. 1921.

66 "I THINK THAT IN MEMORY": Adele Bloch-Bauer, letter to Franz Martin Haberditzl, Nov. 9, 1919. Courtesy of Gottfried Toman.

67 LIKE MANY VENERABLE VIENNESE INSTITUTIONS: Stephen Brook, *Vanished Empire: Vienna, Budapest, Prague* (New York: William Morrow, 1990), p. 1.

68 "I ASK MY HUSBAND AFTER HIS DEATH": District Court, Vienna Inner City Court Section II, Jan. 31, 1925.

68 "GOETHE WRITES IN *TORQUATO TASSO*": Adele Bloch-Bauer to her nephew Robert Bentley, ca. Aug. 1921.

69 THE "TENDER" AND THE "SENSUAL": Peter Gay, *Schnitzler's Century: The Making of Middle-Class Culture, 1815–1914* (New York: W. W. Norton, 2002), p. 59.

THE GOOD SPIRIT

70 "BEWARE OF CRITICIZING": Adele Bloch-Bauer to her nephew Robert Bentley, ca. Aug. 1921.

70 WITH REGARDS TO OTHERS": Ibid.

71 "I'M STILL DAZED": Letter from Alma Mahler to Alban Berg, quoted in Martina Steiger, *"Immer wieder werden mich Thatige Geister verlocken": Alma Mahler-Werfels Briefe an Alban Berg und seine Frau* (Vienna: Siefert, 2008), p. 126.

DEGENERATE ART

75 "CULTURED AND EDUCATED": Gloria Sultano and Patrick Werkner, *Oskar Kokoschka: Kunst und Politik, 1937–1950* (Vienna: Böhlau Verlag, 2003), p. 53.

75 BY THEN HE HAD SERVED: Czernin, *Die Falschung*, p. 23.

76 "WELCOMED ANYTHING NEW": Ibid., p. 49.

76 "THE OLD MOSES OF REMBRANDT": Sultano and Werkner, *Oskar Kokoschka*, p. 123.

76 "VERY DIFFERENTLY FROM HOW": Ibid.

76 "HE FOUND IT VERY TRUE": Ibid.

76 "OUR UNCLE FERDINAND": Ibid., p. 51.

76 THE SHOW'S NOTORIETY: Jonathan Petropoulos, *Art as Politics in the Third Reich* (Chapel Hill: University of North Carolina Press, 1996), pp. 55–56.

76 "PERVERSE JEWISH SPIRIT": Peter Adam, *Art of the Third Reich* (New York: Harry N. Abrams, 1992), p. 123.

76 KOKOSCHKA WAS ALREADY THREATENING: Klaus Albrecht Schroeder, Johann Winkler, and Christopher Asandorf, *Oskar Kokoschka*, part 2 (Munich: Prestel, 1991), p. 223.

76 ERNST ASKED FERDINAND: Sultano and Werkner, *Oskar Kokoschka*, p. 68.

"YOU ARE PEACE"

78 "YOU ARE PEACE": Friedrich Rückert, "Du bist die Ruh," translation by Maria Altmann.

79 "I'D LIKE TO GO": Maria Altmann, interviews, 2006.

80 *MEPHISTO* WAS BASED: Maya Roth, *International Dramaturgy: Translation and Transformations in the Theater of Timberlake Wertenbaker* (Brussels: Lang, 2008), p. 94. For the lingering impact of the explosive novel *Mephisto*, see Dieter Sevin, *Die Resonanz des Exils: gelungene und misslungene Rezeption deutschsprachiger Exilautoren* (Amsterdam: Rodopi, 1992), p. 203.

80 "I WOULDN'T GET MY HOPES UP": Maria Altmann, interviews, 2006.

80 "HE'S A HOMOSEXUAL": Maria Altmann, interviews, 2006. On Aslan's sexual orientation, see Lucian O. Meysels, *Die Welt der Lotte Tobisch* (Vienna and Klosterneuburg: Edition Va Bene, 2002), p. 30, and Reinhold Nagele, *Gemälde, Galerie der Stuttgart* (Stuttgart: K. Theiss, 1984), p. 114.

UNREQUITED LOVE

81 MARIA, TWENTY-ONE, WAS DEEPLY LOVESICK: Maria Altmann, interviews, 2006.

81 THERESE BLOCH-BAUER WAS A STOLIDLY CONVENTIONAL: Maria Altmann, interviews, 2006.

82 THE ONLY THING WORSE: Maria Altmann, interviews, 2006.

82 NEVER MIND THAT IN HER OFFICIAL WEDDING PHOTO: This photo is in the family archive of Nelly Auersperg.

82 IN MARIA'S EYES: Maria Altmann, interviews, 2001.

83 ASIDE FROM WEDDINGS AND FUNERALS: Maria Altmann, interviews, 2001.

83 AS EVERYONE KNEW: Maria Altmann, Cecile Altmann, interviews, 2001.

84 HE HAD AMASSED: Petropolous, "Report of Professor Jonathan Petropoulos."

84 HE LOCKED HEDY: Stephen Michael Shearer, *Beautiful: The Life of Hedy Lamarr* (New York: St. Martin's Press, 2010), p. 45.

84 MANDL FORCED HEDY: Ibid., p. 41; Hedy Lamarr, *Ecstasy and Me: My Life as a Woman* (New York: Bartholomew House, 1966), p. 21.

MARIA VIKTORIA

84 HER MIDDLE NAME REPRESENTED: Maria Altmann, interviews, 2001–2008.

84 THERESE, FORTY-TWO, INITIALLY MISINTERPRETED: Maria Altmann, interviews, 2001. A later poem by Julius Bauer jokingly characterizes Maria as an "unwelcome belated addition to the house."

85 SHE AND GUSTAV COLLECTED "FANTASY WATCHES": Elisabeth Sturm-Bednarczyck, *Phantasie-Uhren* [Fantasy Watches]: *Kostbarkeiten des Kunsthandwerks aus der Sammlung Therese Bloch-Bauer* (Vienna: Christian Brandstätter Verlag, 2002), p. 8.

85 VIENNA WAS IN THRALL TO: Ibid.

85 "A CRAZE FOR TOTALLY MEANINGLESS ARTICLES": Janik and Toulmin, *Wittgenstein's Vienna*, p. 97.

86 "THE WOLF AND THE SEVEN LITTLE KIDS": Thomas L. Johnson and Eberhard Michael Iba, *Germanic Fairy Tale Landscape: The Storied World of the Brothers Grimm* (Gottingen: Klartext GmbH, 2006), p. 21. The book's version of the tale was told by Maria Altmann.

87 FREUD BELIEVED FAIRY TALES: Elrud Ibsch, Dick Schram, and Gerard Steen, *The Psychology and Sociology of Literature: In Honor of Elrud Ibsch* (Philadelphia: Benjamins, 2001), p. 187.

87 HE THOUGHT THAT: Herman Westerink, *A Dark Trace: Sigmund Freud on the Sense of Guilt* (Leuven, Belgium: Leuven University Press, 2009), p. 165.

87 "FINALLY, HE'S WRITTEN SOMETHING": Maria Altmann, interviews, June 2007.

88 *JOSEPHINE MUTZENBACHER:* Hamann, *Hitler's Vienna,* pp. 76–77, states authoritatively that Salten authored this "pornographic bestseller"; this was a widespread view.

88 "THE OLD SWINE DO YOU INJUSTICE": Maria Altmann, interviews, Sept. 2001.

88 SHE ENROLLED MARIA: Maria Altmann, interviews. See also Gustav Rinesch's unpublished 191-page memoir, which was written after the war.

MARIA AND LUISE

89 MEALS WERE SERVED AT PRECISE HOURS: Thea Bentley, interviews, Aug. 2006.

93 "*TROTTEL*—IDIOT! WALK FASTER!": Maria Altmann, interviews, 2006.

93 LUISE'S WEDDING BANQUET: Nelly Auersperg, archive.

93 FOR HER WEDDING PHOTO, LUISE STARED: Nelly Auersperg, archive.

93 EVEN AS A MARRIED WOMAN: Rinesch, unpublished memoir.

94 CHRISTL WAS ALREADY HAVING: Tony Felsovanyi and Maria Altmann, interviews.

94 "FLAMING SOCIALIST": Tony Felsovanyi, interviews, Menlo Park, June 23, 2006.

94 ANTON FELSOVANYI CONQUERED CHRISTL: Tony Felsovanyi, interviews, Menlo Park, June 23, 2006.

94 "A BIG NAZI": Tony Felsovanyi, interviews, Menlo Park, June 23, 2006.

95 SHE QUIETLY EXPLAINED THAT CHRISTL'S RELATIONSHIP: Tony Felsovanyi, interviews, Menlo Park, June 23, 2006, and by telephone, 2006–2011.

STUBENBASTEI

95 JEWS, JUST 2.8 PERCENT: Evan Burr Bukey, *Hitler's Austria: Popular Sentiment in the Nazi Era, 1938–1945* (Chapel Hill: University of North Carolina Press, 2000), p. 131.

96 "THE SPIRIT OF THE TOWN"; "VERY HUMANISTIC"; "JEWISH HUMOR": Rinesch, memoir.

96 "AN ASPIRING OPERA SINGER": Rinesch, memoir.

96 BERNHARD ALTMANN SWEPT INTO: Maria Altmann, interview, June 2006.

97 "IF I WERE A PRINCE": Maria Altmann, interview, June 2006.

THE HOUSEPAINTER FROM AUSTRIA

99 "REVELATION OF THE JEWISH RACIAL SOUL": R. J. Overy, *The Dictators: Hitler's Germany and Stalin's Russia* (London: Allen Lane, 2004), p. 360; Sultano and Werkner, *Oskar Kokoschka,* p. 80.

99 "AN INSULT TO GERMAN WOMANHOOD": Barbara McCloskey, *Artists of World War II* (Westport, CT: Greenwood Press, 2005), p. 50.

99 "THE JEWISH LONGING FOR WILDNESS": Alan Milchman and Alan Rosenberg, *Postmodernism and the Holocaust* (Amsterdam: Rodopi, 1998), p. 93.

99 "NATURE AS SEEN BY SICK MINDS": Overy, *The Dictators*, p. 360.

99 "AS FOR THE DEGENERATE ARTISTS": Text of Hitler's 1937 Munich speech, "Die Kunst ist in den Volkern begrundet," in E. M. Forster and Philip Gardner, *Commonplace Book* (Stanford, CA: Stanford University Press, 1987), p. 110.

99 "HOUSEPAINTER FROM AUSTRIA": Sultano and Werkner, *Oskar Kokoschka*, p. 12.

99 "WE CALL UPON OUR ARTISTS": Robert M. Edsel, *Rescuing Da Vinci: Hitler and the Nazis Stole Europe's Great Art, America and Her Allies Recovered It* (Dallas: Laurel Publishing, 2006), p. 9.

99 HITLER KNEW HE WAS WIELDING: Max Knight, trans., *A Confidential Matter: The Letters of Richard Strauss and Stefan Zweig* (Berkeley: University of California Press, 1977), p. 115.

100 "TO STRAUSS THE COMPOSER": Norman Del Mar, *Richard Strauss: A Critical Commentary on His Life and Works*, vol. 3 (London: Barrie & Jenkins, 1978), p. 47.

100 THE NAZIS BANNED FELIX SALTEN'S 1923 *BAMBI:* Siegried Mattl and Werner Michael Schwarz, *Felix Salten* (Vienna: Holzhauren Verlag, 2006), p. 63, say *Bambi* was declared verboten in Germany in 1935, and in 1936 the Gestapo ordered copies seized. See also Angela Lambert, *The Lost Life of Eva Braun* (New York: St. Martin's Press, 2006), p. 32.

100 MORE THAN SIXTEEN THOUSAND "DEGENERATE" ARTWORKS: Lynn H. Nicholas, *The Rape of Europa* (New York: Vintage, 1995), p. 23.

100 "TO MAKE SOME MONEY": Ibid.

100 "EXHIBITION OF JEWISH COMMUNIST ART": Sultano and Werkner, *Oskar Kokoschka*, p. 68.

WITH OR WITHOUT YOU

101 FRITZ'S COLLECTION INCLUDED: Maria Altmann, interviews, June 16, 2006.

101 MARIA PANICKED: Maria Altmann, interviews, June 16, 2006.

102 "IF YOU MARRY HIM": Maria Altmann, interviews, June 2006.

102 MARIA'S MOTHER MADE THE BEST OF IT: In the private family memoir, one contributor said some in the family were "horrified" that Maria was marrying Fritz. In some cases, the accounts given in my interviews were supported by interviews in an early 248-page draft of a privately published family memoir, undertaken by the Prentice and Bentley branch of the family, with interviews with Maria Altmann, Nelly Auersperg, and others. Michael Bentley allowed me to read an early draft in Vancouver in August 2006.

102 "NO. WE ARE GALICIAN": Maria Altmann, interviews, 2001.

102 "WE DON'T BELIEVE IN DOWRIES": Maria Altmann, interviews, 2001. According to the private family memoir, Fritz also brushed off the idea of a dowry in a separate appointment with Gustav.

103 "BACK IN THE DAY": Poem by Julius Bauer, Maria Altmann, archive. "Tisch-Rede zur Feier des Hochzeitpaares, Fritz und Maria, am December 1937, Gesprochen von Julius Bauer."

103 MARIA WAS STUNG: Maria Altmann, interviews, 2007.

103 "THE SILENCE OF THE BRIDAL BED": Edgar Alfred Bowring, ed., *The Poems of Goethe* (Whitefish, MT: Kessinger, 2004), p. 61.

104 "STUPID IRON VIRGIN": Maria Altmann, interviews, June 16, 2006.

105 "LENE!": Maria Altmann, interviews, June 16, 2006.

105 "WELL, AT LEAST NOW I KNOW": Maria Altmann, interviews, June 16, 2006.

THE RETURN OF THE NATIVE

106 WHEN THEY RETURNED, BERNHARD HANDED THEM THE KEYS: Maria Altmann, interviews, 2001.

106 "WELL, WE EASTERN JEWS": Maria Altmann, interviews, 2001.

106 "THE BLOCH-BAUERS ARE NOT *OSTJUDEN*": Maria Altmann, interviews, 2001.

107 A FEW DAYS LATER, A MESSENGER ARRIVED: Maria Altmann, interviews, 2001.

107 "GERMAN BLOOD:" Peter Utgaard, *Remembering and Forgetting Nazism: Education, National Identity and the Victim Myth in Postwar Austria* (New York: Berghahn Books, 2003), p. 75.

108 BUT ROBERT WOULDN'T HEAR OF: Thea Bentley, interview, Vancouver, Aug. 2006.

108 "HEIL HITLER!" AND "JEWS, KICK THE BUCKET!": Hans Mühlbacher, interviews, Mar. 2006.

108 "AUSTRIA WILL LIVE AGAIN": Hans Mühlbacher, interviews, Mar. 2006.

108 "IT'S JUST NONSENSE": Hans Mühlbacher, interviews, 2007.

108 A FEW MORNINGS LATER, MARIA AWOKE: Maria Altmann, interviews, 2001.

109 "ARE YOU SURE?": Maria Altmann, interviews, 2007.

110 GET US TO THE HUNGARIAN BORDER: Interviews with Maria Altmann and Bernhard's son, Cecil Altmann, 2001.

111 "DO YOU KNOW YOUR HUSBAND": Maria Altmann, interview, 2001.

111 "WOULD YOU MIND": Maria Altmann, interview.

111 CHRISTL COULDN'T TALK LONG: Maria Altmann, interviews, 2006–2007.

111 HE FOUND HIS OLD WORLD WAR I PISTOL: Tony Felsovanyi, Maria Altmann, interviews.

112 "HE WAS SO HAPPY": Maria Altmann, interviews.

112 SOMETIMES THE WATER WAS MIXED WITH ACID: Berkley, *Vienna and Its Jews*, p. 259.

112 THEY GRABBED A WOMAN: Thomas Weyr, *The Setting of the Pearl: Vienna Under Hitler* (New York: Oxford University Press, 2005), p. 77.

113 JEERING CROWDS WERE PLUNDERING: Mark Mazower, *Hitler's Empire* (New York: Penguin, 2008), p. 49.

113 DAPPER LOUIS ROTHSCHILD: Petropoulos, *Art as Politics in the Third Reich*, p. 84.

113 THE GESTAPO AGENTS WHO "SEARCHED" THE HOME: Saul Friedlander, *Nazi Germany and the Jews,* vol. 1: *The Years of Persecution, 1939–1945* (New York: HarperCollins, 1997), p. 243.

113 "BUT THE ANSCHLUSS HAS NONETHELESS": Gordon Brook-Shepherd, *Anschluss* (London: Macmillan, 1963), p. 203.

114 "I HAVE BEEN INFORMED": David Lehr, *Austria Before and After the Anschluss* (Pittsburgh: Dorrance, 2000), p. 113.

114 HUNDREDS OF VIENNESE JEWS: Mazower, *Hitler's Empire*, p. 50.

114 "IN THE PAST, GERMANS": Jonathan Goldstein, *The Jews of China,* vol. 2 (Armonk, NY, and London: M. E. Sharpe, 1999), p. 114.

LOVE LETTERS FROM A BRIDE

114 "MY BELOVED FRITZL": Letter, Maria Altmann, Apr. 29, 1938. The 1938 correspondence between Maria Altmann and Fritz Altmann is courtesy of Maria Altmann.

115 "MY BELOVED DUCKLING!": Letter from Fritz Altmann to Maria Altmann, Apr. 28, 1938.

115 "FROM AN OLD AUSTRIAN": Maria Altmann, interviews; also private family memoir.
116 "MY BELOVED FRITZL": Letter from Maria Altmann to Fritz Altmann, Apr. 30, 1938.
116 "HAS PROBLEMS WITH HIS NERVES": Letter from Maria Altmann to Fritz, May 5, 1938.
116 "THE DUCKLING RUFFLES HER FEATHERS": Letter from Thea Bentley to Fritz Altmann, May 6, 1938.
116 SEVEN CLOSE FAMILY FRIENDS: Maria Altmann, interviews.
117 "WE'RE THINKING OF YOU": Postcard, Therese Bloch-Bauer, Gustav Bloch-Bauer, and Maria Altmann to Fritz Altmann, undated.
117 "MY DEAREST FRITZL": Letter, undated, from Maria Altmann to Fritz Altmann, May 11, 1938.
117 BERNHARD HAD TRAMPED THROUGH: Cecil Altmann, interview.
118 "I WENT AWAY QUITE DEPRESSED": Letter from Maria Altmann to Fritz Altmann, May 13, 1938.
118 "MY BELOVED WIFE": Letter from Fritz Altmann to Maria Altmann, May 15, 1938.
119 "WE BOTH HAVE TO BE PATIENT": Letter from Maria Altmann to Fritz Altmann, May 16, 1938.
119 "MY LOVE, TODAY": Letter from Maria Altmann to Fritz Altmann, May 18, 1938.
119 HE WAS BORN IN 1910: Jerzy Ficowski, *Regions of the Great Heresy: Bruno Schulz, a Biographic Portrait* (New York: W. W. Norton, 2003), p. 164.
119 WHEN HITLER ROSE TO POWER: Ibid.
120 RELEASED IN 1937, LANDAU HEADED: Ibid.
120 LANDAU WAS PLAYING A STEALTHY GAME: Petropoulos, "Report of Professor Jonathan Petropoulos."
120 "FROM THE POST I GET": Letter from Fritz Altmann to Maria Altmann, May 22, 1938.
120 THE NUREMBERG LAWS: Bukey, *Hitler's Austria*, p. 135.
121 THERE WERE 170,000 JEWS IN VIENNA: Ibid., p. 131.
121 "I CAN HEARTILY RECOMMEND": Ernest Jones, *The Life and Work of Sigmund Freud* (Garden City, NY: Doubleday, 1963), p. 506. Freud was rephrasing the slogan of a Vienna ad.
121 "DEAREST WIFE": Letter from Fritz Altmann to Maria Altmann, May 22, 1938.
121 "DESPERATELY BEGGING FOR INFORMATION": Letter from Maria Altmann to the Dachau administration, May 24, 1938.

WORK MAKES FREEDOM

123 "THE GANGSTER'S METHOD": Fritz Altmann, *My Adventures and Escape from Nazi Germany,* undated. Courtesy of Maria Altmann.
123 THEY SET UP A MEETING IN PARIS: Ibid.
124 AS THE AFTERNOON WORE ON: Dirk Riedel, research associate, Dachau Concentration Camp Memorial.
124 "EVERYTHING IN DACHAU IS PROHIBITED": Paul Cummins, *Dachau Song: The Twentieth-Century Odyssey of Herbert Zipper* (New York: Peter Lang, 1992), p. 77.
124 SOME OF THE FIVE HUNDRED MEN: Ibid., p. 76.
124 THE DEPOSED MAYOR OF VIENNA: Giles MacDonogh, *1938: Hitler's Gamble* (London: Constable, 2009), p. 109.
124 ALSO IN DACHAU, UNBELIEVABLY, WERE ERNST AND MAXIMILIAN HOHENBERG: Ibid. See also Cummins, *Dachau Song,* pp. 86–87.
125 "JEWS AND JEW LACKEYS": Marie-Therese Arnbom and Christoph Wagner-Trenkwitz, *Grüss mich Gott! Fritz Grünbaum 1880–1941: Eine Biographie* (Vienna: Christian Brandstätter Verlag, 2005), p. 78.

125 "YOUR MOTHER CROAKED": Cummins, *Dachau Song,* p. 81.

125 "MY BELOVED GOOD WIFE": Letter from Fritz Altmann to Maria Altmann, June 1, 1938.

126 "I'M FIT AS A FIDDLE": Letter from Fritz Altmann to Maria Altmann, June 6, 1938.

126 ON THIS LEVEL PLAYING FIELD: Cummins, *Dachau Song,* p. 87.

126 "THAT I WAS THE PERSON": Altmann, *My Adventures and Escape.*

126 "MY BELOVED HUSBAND": Letter from Maria Altmann to Fritz Altmann, June 17, 1938.

127 "AFTER YOUR LAST LETTER": Letter from Fritz Altmann to Maria Altmann, July 3, 1938.

127 HE HELD UP A NEWSPAPER OBITUARY: Maria Altmann, interviews, 2001.

127 AS HE WORKED, HE BEGAN TO SING: Maria Altmann, private family memoir.

127 "WHEN YOUR HEART WITHIN YOU BREAKS": Franz Liszt, *The Schubert Song Transcriptions for Solo Piano/Series II: The Complete* Winterreise *and Seven Other Great Songs* (New York: Dover, 1996).

THUNDER AT TWILIGHT

128 "THINGS WILL BE DIFFERENT NOW": Maria Altmann, interviews, 2006.

128 "WHERE IS FRITZL?": Maria Altmann, interviews, 2006.

129 ONE OF THE RICHTHOFEN BARONS: Rinesch, memoir.

130 "I'M IN LOVE WITH MY HUSBAND": Maria Altmann, notes to herself while under house arrest, Sept. 29, 1938. Courtesy of Maria Altmann.

130 "YOU DON'T LOOK LIKE A JEW": Rinesch, memoir.

130 "I HAVE FOUND A WAY": Maria Altmann, interviews, 2006.

131 "GO WITH GOD": Maria Altmann, interviews, 2006.

132 "I WAS ADMIRING YOUR RAINCOAT": Maria Altmann, interviews.

134 THEY ARRESTED JAN HONNEF: Letter from Jules Huf to Maria Altmann, June 6, 1999.

DECENT HONORABLE PEOPLE

134 "ALL THE JEWISH STUDENTS": Thea Bentley, interview, Aug. 9, 2006.

135 "YOU DON'T LIKE ME": Thea Bentley, interview, Aug. 9, 2006.

135 "WE HAVE TO GET OUT": Thea Bentley, interview, Aug. 9, 2006.

135 "TODAY GERMANY BELONGS TO US": Thea Bentley, interview, Aug. 9, 2006.

135 "WE'RE NOT GOING ANYWHERE": Thea Bentley, interview, Aug. 9, 2006.

135 ONE DAY THERE WAS A KNOCK: Thea Bentley, interview, Aug. 9, 2006.

136 GUSTAV RINESCH HAD WARNED THE FAMILY: Thea Bentley, private family memoir.

136 THE OBSTETRICIAN CAREFULLY EXAMINED: Thea Bentley, interview, Aug. 9, 2006.

GAY MARRIAGE

137 SOME GAY MEN MARRIED JEWISH WOMEN: Thea Bentley, interview, Aug. 9, 2006. Thea Bentley also had an account in a draft of the collective family memoir, as does the Rinesch memoir.

137 ADA FOUND A DUTCH "FIANCÉ": Rinesch, memoir.

137 "NATURALLY," GUSTAV RINESCH OBSERVED: Rinesch, memoir.

137 ADA BOUGHT A SOLITAIRE: Rinesch, memoir.

137 "NOT A WORD ABOUT SENTIMENT": Rinesch, memoir.

137 "VERY DECENT": Thea Bentley, interview, Aug. 9, 2006.

THE ORIENT EXPRESS

137 RINESCH HELPED THEA AND ROBERT: Rinesch, memoir.

138 LUISE SENT SERVANTS: Thea Bentley, interview, Aug. 9, 2006; Rinesch, memoir.

138 THEN THE TRAIN SLOWED: Thea Bentley, interview, Aug. 9, 2006.

138 SOON THE CARABINIERE WAS GALLANTLY FETCHING: Thea Bentley, interview, Aug. 9, 2006.

139 MEN ROUNDED UP JEWS: Alan E. Steinweis, *Kristallnacht 1938* (Cambridge, MA: Belknap Press of Harvard University Press, 2009), p. 94.

139 THREE DAYS BEFORE CHRISTMAS, THERESE BEGAN: Claims Resolution Tribunal, Timeline of Events Re: Account of Österreichische Zuckerindustries AG Syndicate, Exhibit C, p. 4 ("December 22: Therese Bloch-Bauer renounces her late husband's legacy in an effort to gain permission to leave Austria").

THE AUTOGRAPH HUNTER

139 "WE'RE GOING TO HAVE TO LEAVE": Emile Zuckerkandl, interview, June 24, 2006, and subsequent telephone interviews.

139 FERDINAND PROVIDED FINANCIAL HELP: Petropoulos, "Report of Professor Jonathan Petropoulos," p. 43, citing Ruth Pleyer.

139 AMALIE'S ARRESTING UNFINISHED KLIMT PORTRAIT: Ibid., pp. 24, 42.

140 "ANY NONSENSE CAN ATTAIN IMPORTANCE": Albert Einstein, inscription in the autograph book of Emile Zuckerkandl, 1937–38, trans. Emile Zuckerkandl. Courtesy of Emile Zuckerkandl.

140 "IF HUMANS, NOW THAT AT LONG LAST": Zuckerkandl autograph book.

140 "FOR EMILE ZUCKERKANDL": Zuckerkandl autograph book.

140 "SO, YOU ARE AN AUTOGRAPH HUNTER": Zuckerkandl autograph book.

140 "A DESCENDANT OF NOBLE LINEAGE": Zuckerkandl autograph book.

140 "ONE WILL ALWAYS FORGET": Zuckerkandl autograph book.

140 "HAS NOT EVERYTHING": Zuckerkandl autograph book.

141 "FOR KIND REMEMBRANCE": Zuckerkandl autograph book.

141 IF I HAD A GUN: Emile Zuckerkandl, interviews.

141 "BURN YOUR DIARY": Emile Zuckerkandl, interviews.

141 HE PULLED IT OFF THE WALL: Emile Zuckerkandl, interviews.

141 FRIEDELL HAD ONCE SUGGESTED: Szeps, *My Life,* p. 318.

141 "A DICTATORSHIP WITHOUT A GOSPEL OF HATRED": Ibid.

142 HE WALKED TO HIS OPEN WINDOW: Mahler and Ashton, *And the Bridge Is Love,* p. 220.

STEALING BEAUTY

143 "THOUSANDS OF JEWS WERE FLEEING": Czernin, *Die Falschung,* pp. 166–67.

143 NOW HE COULD GET HIS HANDS ON: Petropoulos, "Report of Professor Jonathan Petropoulos," p. 12.

143 LEOPOLD RUPPRECHT REPRESENTED: Ibid.

143 "DEGENERATE ARTISTS": Magdalene Magnin-Haberditzl, *Familien-Chronik aus dem europaweiten Österreich, 1678–1982* (Vienna: Christian Brandstätter Verlag, 2008), p. 435. Also see Stephan Koja, interview, Oct. 2006.

143 HIS WIFE'S JEWISH HERITAGE: Magnin-Haberditzl, *Familien-Chronik,* p. 17.

144 "RELIEVED OF HIS DUTIES": Anselm Wagner, "Integrating Photography into History of Art: Remarks on the Life and Scientific Estate of Heinrich Schwarz," *Photoresearcher,* no. 11 (April 2008): 15 (publication of the European Society for the History of Photography, Danube University Krems).

144 HE CLOSED THE MODERNE GALERIE: Magnin-Haberditzl, *Familien-Chronik,* pp. 17, 435. The Moderne Galerie opened July 15, 1929, and closed Mar. 22, 1938.

144 KAJETAN MÜHLMANN, A NAZI AESTHETE: Jonathan Petropoulos, *The Faustian Bargain: The Art World in Nazi Germany* (London: Penguin, 2001), p. 182.

144 "HE HAS NO CONSCIENCE": Ibid., p. 198.

144 FOR NOW, ONE OF HIS FIRST TASKS: Petropoulos, "Report of Professor Jonathan Petropoulos," pp. 11, 12.

144 "NEGOTIATION BETWEEN AGENCIES": Ibid., p. 13.

145 "ALT AKTION": Lillie and Gaugusch, *Portrait,* pp. 68–70.

145 HERMANN GÖRING: Ibid., p. 70.

145 "MOMENTARILY LORD OF THE WORLD": Sultano and Werkner, *Oskar Kokoschka,* p. 12.

145 "I WOULD LIKE TO DO SOMETHING": Letter from Carl Moll to Oskar Kokoschka, undated, early 1938, quoted in Sultano and Werkner, *Oskar Kokoschka,* p. 51.

145 "THERE ARE 75 MILLION PEOPLE": Ibid.

146 "UNCLE FERDINAND HAS LEFT VIENNA": Ibid.

THE LAST OF THE BLOCH-BAUERS

146 DOCTORS HAD "EUTHANIZED" SUSI: Rinesch, memoir.

146 ADA SAT ON A TRUNK: Rinesch, memoir.

146 "SO THE WHOLE BLOCH-BAUER FAMILY": Rinesch, memoir.

HOMECOMING

148 BUT FORST THREATENED TO QUIT: Charles Higham, *Marlene: The Life of Marlene Dietrich* (New York: W. W. Norton, 1977), p. 68.

148 UCICKY'S BOSS, COUNT SASCHA, BECAME OBSESSED: Ibid.

148 "SPONSORING MEMBER OF THE SS": Czernin, *Die Falschung,* p. 210.

148 IN 1934, UCICKY'S *REFUGEES* WAS AWARDED: David Welch, *Propaganda and the German Cinema, 1933–1945* (London: Tauris, 2001), p. 108.

148 HIS NEXT FILM, *MORGENROT*: Brigid Haines, Stephen Parker, and Colin Riordan, *Aesthetics and Politics in Modern German Culture* (Oxford and New York: Peter Lang, 2010), p. 80.

149 "FOR ME, THE AIR STINKS": Andreas Hutter and Klaus Kamolz, *Billy Wilder: Eine europäische Karriere* (Vienna: Bohlau, 1998). "Die Luft stinkt fur mich mit einmen Nazi im Zimmer" (p. 199).

149 RICHARD STRAUSS'S OPERA *FRIEDENSTAG*: *Time* magazine, June 19, 1939.

149 "DO YOU SUPPOSE MOZART": Bryan Randolph Gilliam, *The Life of Richard Strauss* (Cambridge, UK: Cambridge University Press, 1999), p. 149.

149 HE WAVED OVER OPERA SINGER HANS HOTTER: Hans Hotter, Dietrich Fischer-Dieskau, Zubin Mehta, and Donald Arthur, *Hans Hotter: Memoirs* (Lebanon, NH: University Press of New England, 2006), p. 101.

149 "A HANDFUL OF GERMAN PEOPLE": Welch, *Propaganda,* p. 110.

149 "THE WORST PROPAGANDA FEATURE": Heidi M. Schlipphacke, *Nostalgia After*

Nazism: History, Home, and Affect in German and Austrian Literature and Film (Lewisburg, PA: Bucknell University Press, 2010), p. 83.

FÜHRER

150 THE FATE OF THE BLOCH-BAUER KLIMTS: Czernin, *Die Falschung*, p. 153.
150 FÜHRER WOULD COMPILE A DISTINGUISHED ROSTER: Ibid., p. 143. See also Lillie and Gaugusch, *Portrait*, p. 76; Lillie reports that Führer's clients included the banker Louis Rothschild, Sigmund Freud's brother Alexander Freud, and four sisters of Freud who were deported and murdered.
150 THEY MAY NOT HAVE BEEN AWARE: Czernin, *Die Falschung*, pp. 153, 154; Lillie and Gaugusch, *Portrait*, p. 72.
150 "UGLY JEW": Czernin, *Die Falschung*, p. 185.
150 FERDINAND HAD DONATED: Petropoulos, "Report of Professor Jonathan Petropoulos," p. 10.
151 NAZI-APPOINTED "REPRESENTATIVE": Austria arbitration decision, January 2006, p. 41.
151 "AWE-INSPIRING PORTRAIT": Pirchan, *Gustav Klimt*, pp. 65, 66. Belvedere provenance researcher Monika Mayer and Klimt expert Alice Strobl confirm that this passage celebrates the acquisition of the gold portrait of Adele Bloch-Bauer.
152 *DAME IN GOLD:* Ibid., illustration 105.
152 "*HEIL* KLIMT THE HERO!": Ibid., p. 99.

NAZIS IN THE FAMILY

153 THE BACHOFEN-ECHT BROTHERS: Marianne Kirstein-Jacobs, interviews with Stanislaus Bachofen-Echt.
153 ELISABETH LEFT THE ISRAELITE COMMUNITY: Natter and Frodl, *Klimt's Women*, p. 134.
153 "WOLFGANG DID NOT MARRY": Rinesch, memoir.
154 "INSANE FEAR": Rinesch, memoir.
154 IT COULD HARDLY HAVE BEEN REASSURING: SS file of Eberhard Bachofen-Echt, the National Archives, College Park, MD. Bachofen-Echt applied in March 1938. His qualifications included membership in the Nazi Party in 1933, joining the SA brownshirts in 1934, and a lengthy investigation of his Aryan pedigree, completed Dec. 1, 1938. On Feb. 23, 1939, his file declared that there were "no obstacles" to his membership.
154 "THE STRICKEN MOTHER REFUSED": Rinesch, memoir.
154 ON AUGUST 17, HE UNILATERALLY DIVORCED: Lillie, *Was einmal*, p. 145; Natter and Frodl, *Klimt's Women*, p. 134.
154 WOLFGANG MAY HAVE KEPT A SECRET: Lillie, *Was einmal*, p. 145.

"ABOVE THE MOB"

155 "MY MEMORIES OF GUSTAV KLIMT": All quotations from Elisabeth Bachofen-Echt in this chapter come from her memoir, dated April 1939.
158 ACCORDING TO A PERHAPS APOCRYPHAL ACCOUNT: Rinesch, memoir.
159 "JEWISH CHARACTERISTICS": Report of the Reichstelle for Genealogical Research, signed by Paul Schultze-Naumburg, Mar. 18, 1940.
159 HER JEWELRY WAS TAKEN AND SOLD: Lillie, *Was einmal*, p. 145.

159 "WHY MUST IT BE THE PAINTINGS?": Ibid., p. 662.

159 IN MARCH 1940, ELISABETH FINALLY OBTAINED: Certificate signed by Schultze-Naumburg for the Reichsstelle for Genealogical Research.

159 ELISABETH WAS DECLARED A *MISCHLING:* Schultze-Naumburg, certificate. Copy provided courtesy of Marianne Kirstein-Jacobs.

THE VIENNESE CASSANDRA

160 IN JUNE 1940, AS THE GERMAN ARMY APPROACHED PARIS: Firsthand account of Emile Zuckerkandl, June 24, 2006, and subsequent telephone interviews.

161 "WHY DON'T YOU GIVE UP": Emile Zuckerkandl, interviews.

161 THE CAPTAIN WAS: Emile Zuckerkandl, interviews. Similar accounts appear in Arnold Geier, *Heroes of the Holocaust* (New York: Berkley Books, 1998), p. 257.

161 THERE WAS A SMALL CANNON: Emile Zuckerkandl, interviews.

162 THE REFUGEES BEGAN TO SING THE "MARSEILLAISE": Emile Zuckerkandl, interviews, 2006–2011.

162 THE ELEGANT FRENCH WRITER ARRIVED: Emile Zuckerkandl, interviews.

FERDINAND IN EXILE

163 "DEAR FRIEND AND PROFESSOR": Letter from Ferdinand Bloch-Bauer to Oskar Kokoschka, Apr. 2, 1941, in the holdings of the Zentralbibliotek Zürich Nachlass O. Kokoschka (English translation from Randol Schoenberg's lawsuit, p. 13).

THE GUTMANNS

164 A BRITISH INTELLIGENCE OFFICER: Interviews with Rudy Gelse, a cousin of Nelly Auersperg, whose family shared the Gutmann manor in Belisce from Feb. 22, 2007, to 2011, by telephone.

167 IN MAY, AN USTASHA GOVERNMENT OFFICIAL: *Baron Viktor Gutmann: His Trial and Death* (a "translation of a paper written by Baron Gutmann in a Zagreb prison after he had been condemned to death"), family archives. Courtesy of Nelly Auersperg.

167 "TO SETTLE THE MATTER OF THE SHARES": Ibid.

167 THEY SUMMONED VIKTOR AND ERNO: Ibid.

167 A FEW HOURS LATER: Ibid. Also, interviews with Maria Altmann and Dr. Edward Auersperg.

THE "BLONDE BEAST"

168 HEYDRICH MARRIED LINA VON OSTEN: Gerald Reitlinger, *The Alibi of a Nation, 1922–1945* (New York: Da Capo Press, 1989), p. 34.

168 LINA AND HER BROTHER HAD BEEN: Callum MacDonald, *The Killing of Reinhard Heydrich: The SS "Butcher of Prague"* (New York: Da Capo Press, 1998), p. 14.

169 HEYDRICH, A CAROUSING PHILANDERER: Joachim Fest, *The Face of the Third Reich* (London: Weidenfeld & Nicolson, 1970), p. 337.

169 HE WAS EXPELLED BY THE NAVY: Ibid. See also Anthony Read, *The Devil's Disciples: Hitler's Inner Circle* (New York: W. W. Norton, 2004), p. 310.

169 IN JUNE 1931, HEYDRICH FOUND HIMSELF: MacDonald, *The Killing of Reinhard Heydrich*, p. 18.

169 HIS RIVALS BELIEVED: Reitlinger, *The Alibi*, p. 33.

169 THEY BADLY BOTCHED: Ibid., p. 32.

169 PEOPLE WHISPERED ABOUT: Ibid., p. 33.

169 EVEN HEYDRICH'S FELLOW OFFICERS: Steven Lehrer, *Wannsee House and the Holocaust* (Jefferson, NC: McFarland, 2000), p. 55.

170 ON MAY 27, HEYDRICH OPENED: MacDonald, *The Killing of Reinhard Heydrich*, p. 170.

171 "GET THAT BASTARD!" Ibid., p. 172.

171 HEYDRICH DIED OF INFECTION: Ibid., p. 178.

171 REVENGE WAS SWIFT: Callum MacDonald and Jan Kaplan, *Prague in the Shadow of the Swastika* (Prague: Melantich, 1995), p. 132.

171 THE SURVIVING WOULD-BE ASSASSINS: William L. Shirer, *The Rise and Fall of the Third Reich* (New York: Simon & Schuster, 1960), p. 196.

171 THE NAZIS ROUNDED UP: Richard J. Evans, *The Third Reich at War* (New York: Penguin, 2009), p. 278.

171 FERDINAND CONTACTED AN OLD FRIEND: Ruth Pleyer, interviews, April 2007.

172 THE DEAL SOURED SOMEWHAT: MacDonald, *The Killing of Reinhard Heydrich*, p. 198.

LOVE LETTERS FROM A MURDERER

173 "AFTER A SLEEPLESS NIGHT": Omer Bartov, *Holocaust: Origins, Implementation, Aftermath* (London: Routledge, 2000), p. 187.

173 "SHOOTING EXERCISES": Ibid., p. 202.

173 HE WOULD IDLY LOOK OUT: Ficowski, *Regions of the Great Heresy*, p. 164.

173 "FINE, SO I'LL JUST PLAY": Irena Steinfeldt, *How Was It Humanly Possible?: A Study of Perpetrators and Bystanders During the Holocaust*, vol. 1 (Jerusalem: International School for Holocaust Studies at Yad Vashem; Laxton, Newark, Nottinghamshire, UK: Beth Shalom Holocaust Memorial Centre, 2002), p. 63.

174 "THERE WERE ROWS OF JEWS": Bartov, *Holocaust*, p. 189.

174 "THE THOUGHT OF YOU": Ficowski, *Regions of the Great Heresy*, p. 135.

174 BUT ANNA AND HER HUSBAND WERE SEIZED: Ibid.

174 HE TOLD AN ACQUAINTANCE: Ibid., pp. 136–37.

174 IN NOVEMBER 1942: Ibid., p. 137.

174 "YOU KILLED MY JEW": Ibid., p. 138.

FERDINAND'S LEGACY

175 "IT USED TO BE CALLED PLUNDERING": Petropoulos, *Art as Politics in the Third Reich*, p. 195.

175 FERDINAND BEGAN TO REWRITE: Petropoulos, "Report of Professor Jonathan Petropoulos," p. 20.

175 "IN AN ILLEGAL MANNER": Claims Resolution Tribunal, Certified Award Re: Account of Österreichische Zuckerindustry AG Syndicate, Apr. 13, 2005, p. 23.

175 "THE SITUATION HAS CHANGED": Melissa Müller and Monika Tatzkow, *Lost Lives, Lost Art: Jewish Collectors, Nazi Art Theft, and the Quest for Justice* (New York: Vendome, 2010).

175 IN FEBRUARY, ZWEIG HAD LEFT: Leo Spitzer, *Lives In Between: Assimilation and Mar-*

ginality in Austria, Brazil, and West Africa, 1780–1945 (Cambridge, UK: Cambridge University Press, 1990), p. 171.

175 "THE WORLD OF MY OWN LANGUAGE": Zweig, *World of Yesterday*, p. 437.

176 THEN ZWEIG AND HIS WIFE: Ibid.

THE USES OF ART

176 "THIS GENIUS GRAZING THE STARS": Shirer, *The Rise and Fall of the Third Reich*, p. 253.

176 SCHIRACH HAD SPONSORED AN EXHIBITION: Petropoulos, *Faustian Bargain*, p. 126.

177 LIKE OTHER TOP NAZIS: Ibid.

177 SCHIRACH BOUGHT WORKS DIRECTLY: Ibid., p. 195.

177 AS THE SHOW OPENED, CARL MOLL: Alice Strobl, interviews, Nov. 3, 2006.

178 "VERY SAD, THAT YOU STAYED": Czernin, *Die Falschung*, p. 405. The titles of the paintings are listed in the guide to the show: *Gustav Klimt, Ausstellung 7. Februar bis 7 Marz 1943, at the Ausstellungshaus Friedrichstrasse Ehemalige Secession, by the Veranstalter: Der Reichsstatthalter in Wien*. The text of the catalogue was written by Fritz Novotny. A copy of the exhibition catalogue provided courtesy of the Belvedere.

178 "OWNERS OF THE KLIMT WORKS": Exhibition catalogue.

178 "MY FÜHRER, I REPORT TO YOU": Ivar Oxaal, Michael Pollak, and Gerhard Botz, *Jews, Antisemitism, and Culture in Vienna* (London: Routledge & Kegan Paul, 1987), p. 238.

178 IT HUNG NEAR: Petropoulos, "Report of Professor Jonathan Petropoulos," p. 10.

NELLY

179 IN MAY 1942, CROATIAN JEWS: Slavcho Zagorov, *The Agricultural Economy of the Danubian Countries, 1935–45* (Stanford, CA: Stanford University Press, 1955), p. 337.

179 AMONG THE FEW EXCEPTIONS: Ibid.; Hannah Arendt, *Eichmann in Jerusalem: A Report on the Banality of Evil* (New York: Penguin, 2006), pp. 183–84.

179 SOME WERE FORCED TO PLEDGE: Philip J. Cohen, *Serbia's Secret War: Propaganda and the Deceit of History* (College Station: Texas A&M University Press, 1996), p. 91.

179 AUTHORITIES WERE GROWING IMPATIENT: Viktor Gutmann, memoir.

180 TENJE: *The Third Reich and Yugoslavia, 1933–1945*, vol. 1973 (Institute for Contemporary History, 1977), p. 668.

180 AT THE GYPSY VILLAGE: Nelly Auersperg, interviews, Aug. 2006.

181 ONE NIGHT IN EARLY MAY 1943: Gutmann, *His Trial and Death*.

181 THEY WERE TOLD TO KEEP: Nelly Auersperg, interview, Aug. 2006.

182 A FRIEND OF LUISE'S: Maria Altmann, interviews, 2006.

182 "I WILL HELP YOUR FRIEND": Maria Altmann, interviews; "Whose Art Is It, Anyway?" *Los Angeles Times Magazine*, Dec. 16, 2011.

182 HERE LUISE WAS EXPECTED TO WAIT: Maria Altmann, interviews, 2001–2011.

182 ONE DAY SHE HAD OPENED: Telephone interviews with Eddy Auersperg, Jan. 24, 2007, and Maria Altmann, 2001–2008.

THE IMMENDORF CASTLE

183 IT WAS A WARM, BLUSTERY DAY: Document for Storage of the "Sammlung S. Lederer," or Serena Lederer collection, listing the Klimt paintings transferred from the Belve-

dere to the Schloss Immendorf; signed by Baron Freudenthal, dated Mar. 3, 1943. A copy of the document provided courtesy of the Belvedere.

184 "WAS VERY HUMAN": Anna Lenji, "The Testimony of Anna Lenji on Labour in an Estate," Shoah Resource Center, Yad Vashem, p. 1.

185 "WHICH I THOUGHT WAS HORRIBLE": Ibid.

185 THE AUSTRIAN GALLERY'S FRITZ NOVOTNY SENT: The Belvedere inventory of important paintings signed by Fritz Novotny on Aug. 1, 1944, included works by Kokoschka. A copy of original document provided courtesy of the Belvedere.

185 THEIR FATHER HAD WARNED THEM: Johannes Freudenthal, telephone interview, Jan. 20, 2007.

THE CHILD IN THE CHAPEL

185 FOR NELLY, NOW FOURTEEN: Nelly Auersperg, interviews Vancouver, Aug. 2006.

186 INSTEAD, THEY ARRESTED HIM: Nelly Auersperg, interviews Aug. 2006.

186 THE SIGHT OF THE SUFFERING CHILD: Nelly Auersperg, interviews Aug. 2006.

THE CASTLE OF THE FIRST REICHSMARSCHALL

187 WOLFGANG WAS ALSO LISTED: Lillie, *Was einmal,* p. 662.

187 CONSTRUCTION CREWS THAT WERE EXCAVATING: Hans and Gertrude Aurenhammer, *Das Belvedere in Wien* (Vienna: Verlag Anton Schroll, 1971), p. 36.

187 HER NEIGHBOR, A LITTLE BOY NAMED HANS HOLLEIN: Hans Hollein, interview.

187 THE COMPOSER RICHARD STRAUSS: Kennedy, *Richard Strauss,* pp. 101, 108. See also Mark-Daniel Schmid, *The Richard Strauss Companion* (Westport, CT: Praeger, 2003), p. 53; and Del Mar, *Richard Strauss,* vol. 3, p. 400.

187 HE SPENT THE LAST HOURS: Magnin-Haberditzl, *Familien-Chronik,* p. 17.

187 "THINK, DEAR FRIEND": Rainer Maria Rilke, *Letters to a Young Poet,* trans. Joan M. Burnham (Novato, CA: New World Library, 2000), p. 51.

188 "YOU COME AND KEEP": Rainer Maria Rilke, *The Notebooks of Malte Laurids Brigge,* trans. Burton Pike (Champaign, IL: Dalkey Archive Press, 2008), p. 56.

188 THE MASSIVE FORTIFIED BUNKER: Aurenhammer and Aurenhammer, *Das Belvedere,* p. 36.

188 "CASTLE OF THE FIRST REICHSMARSCHALL": Ibid.

189 BY THEN DEPORTEES WERE DRIVEN AWAY: Bukey, *Hitler's Austria,* p. 164.

189 THE MAN RIA HAD KILLED HERSELF FOR: Christie's press release, May 28, 2010. See also Comini, *Gustav Klimt,* p. 29, citing a 1975 letter from Erich Lederer identifying Munk as the fiancée of Hans Heinz Ewers.

189 HE EARNED THE FÜHRER'S APPROVAL: Max Beloff, *On the Track of Tyranny* (Freeport, NY: Books for Libraries Press, 1971), pp. 58–59.

189 MORGENSTERN WROTE HITLER: Hamann, *Hitler's Vienna,* pp. 357–59.

189 SHE MADE A FINAL FORAY: Stanislaus Bachofen-Echt, interviews.

190 "DIED OF A BROKEN HEART": Rinesch, memoir.

THE PARTISANS

190 SOME PARTISANS BEFRIENDED: Nelly Auersperg, interviews.

191 THE CROATIAN NO LONGER FELT OBLIGATED: Nelly Auersperg, interviews. Nelly also tells this story in a private family memoir.

191 THEN, ONE DAY, THE FAMILY: Nelly Auersperg, interviews.

THE MAN WITHOUT QUALITIES

192 THAT SEPTEMBER, ERICH FÜHRER: Sultano and Werkner, *Oskar Kokoschka,* p. 56.

192 "DEGENERATE ART": Ibid.

192 "HERR PRESIDENT, HERE IS YOUR PAINTING": Ibid.

192 "WILL IT BE OF ANY INTEREST": Ibid., p. 155.

193 BUT ARCHIVES THAT SURFACED: Czernin, *Die Falschung,* p. 154.

193 AND THAT FÜHRER MADE: Ibid., p. 141.

THE NERO DECREE

193 BY THEN, HITLER'S ARMY HAD STOLEN: Greg Bradsher, National Archive and Records Assistant Chief Administration, "Documenting Nazi Plunder of European Art."

193 "MY PICTURES": The Private and Political Testaments of Hitler, Apr. 29, 1945, Office of United States Chief of Counsel for Prosecution of Axis Criminality.

194 THEN, ACCORDING TO A POLICE REPORT: A belated police report on the incident, dated May 20, 1946, was provided and translated at the Leopold Museum. In a Mar. 28, 2011, article titled "Burned to the Ground," grandson Rudolf Freudenthal told the *Niederösterreichische Nachrichten* newspaper that the SS used timed fuses to ignite the fire.

195 THIS WAS BELIEVED TO HAVE BEEN: The precise number of paintings burned at Schloss Immendorf is unknown. An inventory signed by Baron Rudolf Freudenthal lists ten paintings from the Lederer collection. Belvedere researchers add an eleventh, *Medicine,* which Ferdinand Bloch-Bauer helped the Belvedere to acquire. But in the book *Gustav Klimt, Egon Schiele und die Familie Lederer,* by Klimt expert Christian Nebehay (Vienna: Verlag Galerie Kornfeld Bern, 1987), p. 17, there is a list of thirteen Lederer Klimts sent to the Immendorf. With *Medicine,* that would bring the total to fourteen.

195 THE COUNTESS MARGIT BATTHYANY, NÉE THYSSEN-BORNEMISZA: David R. L. Litchfield, *The Thyssen Art Macabre: The History of the Thyssens* (London: Quartet Books, 2006), p. 181.

195 "ORDINARY PEOPLE BORE WITNESS": Bukey, *Hitler's Austria,* p. 224.

195 IN THE PRETTY IRON-MINING MOUNTAIN VILLAGE: Ibid., p. 225.

195 IN WIENER NEUDORF: Ibid.

196 FIVE-HUNDRED-POUND BOMBS: Nicholas, *Rape of Europa,* pp. 316–17.

196 ON MAY 5, THE MINES: Ibid., p. 317.

196 "LATEST HORDE OF BARBARIANS": Marie Vassiltchikov, *Berlin Diaries, 1940–1945* (New York: Vintage, 1988), p. 270.

196 HE HAD POSTERS PUT UP: Ibid., p. 266.

197 "THESE DAMAGES COULD HAVE BEEN": "Der Zeit ihre Kunst, der Kunst ihre Freiheit: Wiederaufbau und Neugestaltung der Secession," *Arbeiter-Zeitung,* July 20, 1951, provided and translated by the architect, author, and Secession historian Otto Kapfinger.

197 "IN ORDER NOT TO LEAVE": Ibid.

197 "A VERY PRECIOUS BUILDING": Ibid.

197 SHE SURVIVED THE GÖTTERDÄMMERUNG: Monika Mayer, Provenance Researcher at the Belvedere. A Belvedere inventory lists the second portrait of Adele in wartime storage at the Weinern Castle: July 31, 1944, memo from Fritz Novotny, on Direktion der Österreichen Galerie stationery. The second portrait of Adele was listed as "Frau Bl. Bauer." In addition to the account of the Secession fire in the *Arbeiter-Zeitung,* see also Andreas Lehne, "Die Katastrophe von Immendorf, nach dem Archivmaterial

des Bundesdenkalamtes," in *Belvedere: Zeitschrift für bildende Kunst* (Vienna: Sonderband Gustav Klimt, 2007), p. 54.

RESTITUTION

198 "RESTITUTION OF PROPERTY": Czernin, *Die Falschung,* p. 262.
198 "THE ENTIRE NATION": Ibid. See also Petropoulos, "Report of Professor Jonathan Petropoulos."
198 THE KLIMT PORTRAITS OF ERICH'S SISTER: Natter and Frodl, *Klimt's Women,* p. 91.
198 "BETWEEN 1938 AND 1945": Monika Mayer, "Provenance Research at the Österreichische Galerie Belvedere," unpublished essay, presented at Sotheby's London, Oct. 2006, p. 3.
199 ON OCTOBER 22, 1945, FERDINAND SIGNED: Petropoulos, "Report of Professor Jonathan Petropoulos," p. 23.

LIBERATION

199 THE NEW COMMUNIST GOVERNMENT: Gutmann, *His Trial and Death,* p. 15.
200 BUT HER FATHER WASN'T THERE: Nelly Auersperg, interviews, 2006–2011.
200 THE POSTWAR SHOW TRIALS: Pamela Ballinger, *History in Exile: Memory and Identity at the Borders of the Balkans* (Princeton, NJ: Princeton University Press, 2003), p. 108; John Borneman, *Death of the Father: An Anthropology of the End in Political Authority* (New York: Berghahn Books, 2005), p. 150; MacDonald, *Balkan Holocaust?: Serbian and Croatian Victim-Centered Propaganda and the War in Yugoslavia* (Manchester, UK: Manchester University Press, 2002), p. 191; Ivo Banac, *With Stalin Against Tito: Cominformist Splits in Yugoslav Communism* (Ithaca, NY: Cornell University Press, 1998), p. 110.
200 "PARASITES" WHO "EXPLOITED THE WORKING CLASSES": Nelly Auersperg, interviews.
200 "THE GERMAN WAR ECONOMY": Viktor Gutmann, memoir.
200 THE PROSECUTOR ALSO CLAIMED: Gutmann, *His Trial and Death,* p. 17.
200 VIKTOR ARGUED: Ibid.
200 "GUTMANN IS ONE OF THE WORST": Nelly Auersperg, interviews, Aug. 2006.
201 "WORKERS OF BELISCE": Nelly Auersperg, interviews, e-mail, May 3, 2011.
201 AT THE TRAIN STATION: Nelly Auersperg, interviews, e-mail, May 3, 2011.
202 "LET'S MOVE": Nelly Auersperg, interviews, Aug. 2006.
202 "YOU CAN GO HOME NOW": Nelly Auersperg, interviews, Aug. 2006.
202 "GOODBYE. THANK YOU": Nelly Auersperg, interviews, Aug. 2006.
202 VIKTOR HANDED NELLY: Nelly Auersperg, interviews, Aug. 2006.
202 "DON'T YOU KNOW": Nelly Auersperg, interviews, Aug. 2006.
203 "DEAREST LUISE": "To Luise, Written in the cell No. 29, on January 1, 1946, at 7 p.m., Zagreb. Baron Viktor Gutmann." Family archives. Courtesy of Nelly Auersperg.
204 "IF YOU DON'T STOP PESTERING PEOPLE": Gutmann, *His Trial and Death,* p. 19: "Don't ask too many questions or you will find yourself in the same situation."
204 SHE WAS CAUGHT BY A BORDER GUARD: Salomon Grimberg, interviews, May 1, 2007.
204 "THEY BURNED MY WIFE": Ibid. Luise was arrested trying to leave the country several times. This account was given in Dallas on May 1, 2007, by her friend and confidant Dr. Salomon Grimberg, a Dallas psychiatrist and art historian who has published widely on subjects from Klimt to Frida Kahlo.

REFUGEE

205 NELLY LOVED HER NEW HOME: Nelly Auersperg, interviews.
206 "DEAREST FOE!": Leo Tolstoy, *War and Peace* (New York: W. W. Norton, 1966), p. 173.
206 JOHANNES HAD SPENT HIS CHILDHOOD: Johannes Auersperg, interview.

PROVENANCE

208 AS AUSTRIA EMERGED FROM THE WAR: Petropoulos, "Report of Professor Jonathan Petropoulos," p. 24.
208 AUSTRIAN OFFICIALS REMAINED SILENT: Andrew Decker, "A Legacy of Shame," *Art-News,* December 1984.
208 BRUNO GRIMSCHITZ: Bruno Grimschitz, *Das Belvedere in Wien* (Vienna: Kunstverlag Wolfrum, 1946).
209 FÜHRER WAS SENTENCED: Lillie and Gaugusch, *Portrait,* p. 76. By 1965 Führer was defending convicted Belgian war criminal Robert Jan Verbelen from charges in Austria.
209 "WHO LIQUIDATED THE ASSETS": This book, with Führer's ex libris, was for sale at a Vienna antiquarian bookstore in 2009.

HISTORICAL AMNESIA

213 A HUNDRED THOUSAND WOMEN: Steven Beller, *A Concise History of Austria* (Cambridge, UK: Cambridge University Press, 2006), p. 252.
213 AN ESTIMATED 5,500: Evan Burr Bukey, *Jews and Intermarriage in Nazi Austria.* (New York: Cambridge University Press, 2011), p. 190.
214 A 1948 AMNESTY: See Richard Breitman and Norman J. W. Goda, *Hitler's Shadow: Nazi War Criminals, U.S. Intelligence, and the Cold War* (Washington, DC: National Archives and Records Administration, 2010), p. 60: "Austria had roughly 700,000 Nazis when the war ended. In May 1945 Austria's new government legally banned the Nazi organizations, prohibited former Nazis from voting and state employment, and required Nazis to register (about 524,000 did so). A War Criminals Law of June 1945 established People's Courts throughout Austria that heard some 136,000 cases and pronounced 13,607 guilty verdicts over the next decade. The National Socialist Law of February 1947 established categories of Nazis including war criminals (including illegal Nazis from the 1933 to 1938 period), 'incriminated' Nazis (SS and Gestapo members for instance), and 'less incriminated' Nazis (about 550,000 persons), allowing them to vote. With only 2.5 million voters in Austria, this group and their families were an important voting bloc."
215 OF SOME THIRTY-FIVE THOUSAND JEWISH BUSINESSES: Ingo Zechner, interview, Oct. 2000.
215 "WHY DIDN'T YOU KEEP": Alice Strobl, interview, Mar. 1, 2006.
216 "IN THE DOCUMENTS IN THE POSSESSION": Letter from Karl Garzarolli to Bruno Grimschitz, Schoenberg July 2004 Amended Complaint, *Maria Altmann v. Republic of Austria and the Austrian Gallery,* U.S. District Court for the Central District of California, p. 19.
216 "DELAY FOR TACTICAL REASONS": Schoenberg July 2004 Amended Complaint, p. 19.
217 "MY SKI HOLIDAY": Gustav Rinesch, letter to Robert Bentley, Apr. 11, 1948.
218 THEY TOLD LEDERER HE WOULD HAVE TO PAY: Frodl, *Secession,* p. 57.

218 OTTO DEMUS HAD PERSONALLY BANNED: Lillie, *Was einmal,* p. 664.

218 AUSTRIAN MUSEUMS ENDED UP EXTRACTING: Frodl, *Secession,* p. 56.

218 DEMUS DUPLICITOUSLY ASSURED LEDERER: Lillie, *Was einmal,* p. 664.

218 IN 1960, FRITZ NOVOTNY: Petropoulos, "Report of Professor Jonathan Petropoulos," p. 67.

218 IN 1965, WALTER FRODL: Ibid., p. 29.

219 "INTEREST IN KLIMT'S PAINTINGS": Thomas Trenkler, "Hunting for a Bargain," *Der Standard,* Feb. 4, 2010.

219 EMILE SAID HE GOT A CALL: Emile Zuckerkandl, interviews, 2006–2011.

219 LEOPOLD WROTE EMILE A CHEERY LETTER: Correspondence between Rudolf Leopold and Emile Zuckerkandl, 1955–56. Courtesy of Robert Holzbauer, the Leopold Museum.

219 FRITZ NOVOTNY HAD MOVED THE *BEETHOVEN FRIEZE:* Frodl, *Secession,* p. 57.

220 "THE FINANCIAL POSSIBILITIES": Ibid., p. 66.

220 HE OFFERED LEDERER: Gustav Klimt, *Beethovenfrieze,* ed. Susanne Koppensteiner (Vienna: Secession, 2002), p. 57. The dollar figure is based on an exchange rate of 20.6 schillings to the dollar in March 1973, the month of purchase, provided by the National Bank of Austria.

THE CHILDREN OF TANTALUS

221 WHEN HE WAS A STUDENT: Kate Connolly, "Unquiet Grave for Nazi Victims," *The Guardian,* Apr. 29, 2002.

221 GROSS CONTINUED TO USE THE BRAINS: Ibid.

222 LUDWIG WITTGENSTEIN'S BROTHER KONRAD: Allan S. Janik and Hans Veigl, *Wittgenstein in Vienna: A Biographical Excursion Through the City and Its History* (Vienna and New York: Springer Verlag, 1998), p. 155.

222 EVERY MORNING, THE NEWLYWED HUBERTUS: Valerie and Hubertus Czernin, interviews, 2006.

222 HUBERTUS HAD SPENT HIS CHILDHOOD: Ibid.

222 IN THE EARLY 1970S, HE SAW: Ibid.

222 HE DISCOVERED THE THERESIANUM HAD BEEN: Ibid.

223 HIS UNIT ACCOMPANIED NAZI FORCES: Stanley Meisler, *United Nations: The First Fifty Years* (New York: Atlantic Monthly Press, 1995), p. 190.

223 A SECRET 1948 WAR CRIMES COMMISSION FILE: Ibid., p. 186. On p. 193 a Yugoslav commission calls him a "war criminal."

223 "I ONLY DID MY DUTY": "Former U.N. Secretary-General Elected President of Austria Despite Criticism of His Wartime Activities," *The Independent,* June 15, 2007.

225 "DOUBLE CRIME": Elizabeth Neuffer and Walter V. Robinson, "Austria Confronts Dark Past by Combing for Nazi Links," *Boston Globe,* Mar. 5, 1998.

225 "VERITABLE RACE FOR LOOTED ART": Associated Press, "Austria Willing to Part with Misappropriated Jewish Art," *Augusta Chronicle,* Mar. 12, 1998.

225 "NOBODY WANTED TO OPEN THE BOX": Thomas Trenkler, interview, Apr. 2007.

THE HEIRS OF HISTORY

225 FRITZ NEVER LOST: Maria Altmann, interviews, 2001.

226 IN FEBRUARY 1998: Maria Altmann, interviews, 2001.

226 "I'M GOING TO DIE": Maria Harris, interview, 2006.

226 "THAT," LUISE REPLIED THOUGHTFULLY: Maria Altmann, interviews, 2001.

226 "I WANTED TO TALK TO HER": Maria Altmann, interviews, 2001.

226 "DO YOU SEE THIS PICTURE?": Randol Schoenberg, interview, Jan. 2006.

227 WHEN THE NAZIS APPROACHED PARIS: Malcolm S. Cole and Barbara M. Barclay, *Armseelchen: The Life and Music of Eric Zeisl* (Westport, CT: Greenwood Press, 1984), pp. 38–39.

227 ZEISL'S FATHER AND STEPMOTHER: Randol Schoenberg, interview, Sept. 14, 2011.

227 REICH'S LIST OF "DEGENERATE ARTISTS": Milchman and Rosenberg, *Postmodernism and the Holocaust*, p. 93.

227 ZEISL SAID TWO THINGS HE HATED MOST: Cole and Barclay, *Armseelchen*, p. 5.

227 AS A TEACHER, SCHOENBERG: Allen Shawn, *Arnold Schoenberg's Journey* (New York: Farrar, Straus & Giroux, 2002), p. 272.

228 "IS THERE ROOM IN THE WORLD": Michael J. Bazyler and Roger P. Alford, *Holocaust Restitution: Perspectives on the Litigation and Its Legacy* (New York: New York University Press, 2005), p. 293; previously unpublished 1938 Schoenberg essay, published by the Arnold Schoenberg Institute of Southern California, vol. 10, no. 149, 1987.

THE LIBRARY OF THEFT

229 "NAZIS IN THE SOUP": Dr. Jeannette R. Malkin, "Nazis in the Bernhard Soup: The Political Bernhard Revisited," Theatre Studies Department, Hebrew University, Jerusalem.

229 "*JUDENFREI*": Ruth Franklin, "The Art of Extinction: The Bleak Laughter of Thomas Bernhard," *The New Yorker*, Dec. 25, 2006.

229 FORMER CHANCELLOR BRUNO KREISKY: Malkin, "Nazis in the Soup."

229 PRESIDENT KURT WALDHEIM: *Die Presse*, Sept. 9, 2010, *Heldenplatz: Bernhards Skandalstück wieder in Wien.*

229 THE BURGTHEATER EXPLODED WITH CHEERS: Franklin, "The Art of Extinction." See also Serge Schmeman, "Along with Strudel, Demons That Don't Die," *New York Times*, Dec. 2, 1988.

229 HIS FRAGILE HEALTH COLLAPSED: His friends believe the stress may have accelerated his death three months later, by assisted suicide. Franklin, "The Art of Extinction."

230 HUBERTUS HAD BEEN DIAGNOSED: Dr. Johannes Czernin, e-mails, May–Oct. 2011.

230 IT TURNED OUT THAT: Steven Erlanger, "Vienna Skewered as a Nazi-Era Pillager of Its Jews," *New York Times*, Mar. 7, 2002.

THE SEARCH FOR PROVENANCE

230 BELVEDERE STAFF CLAIMED TO HAVE SEEN: Interviews with Belvedere staff who wish to remain anonymous, Oct. 2006.

231 "I DON'T BELIEVE HE WOULD DO SOMETHING": Barbara Petsch, "Tug of War for Six of Consequence," *Die Presse*, Mar. 11, 1998.

231 CURIOUSLY, FRODL HAD PUBLISHED: Petropoulos, "Report of Professor Jonathan Petropoulos," p. 29; Gerbert Frodl, *Gustav Klimt in der Österreichischen Galerie Belvedere in Wien*, 2nd ed. (Salzburg: Verlag Galerie Salzburg, 1995), pp. 54, 56, 74, 80, 92.

231 "THROUGH A BEQUEST": Petropoulos, "Report of Professor Jonathan Petropoulos"; Frodl, *Gustav Klimt*, pp. 54, 56.

231 "WE KNEW A LOT": Associated Press, "Austria Willing to Part with Misappropriated Art," Mar. 11, 1998.

231 "MAYBE YOU DO UNDERSTAND": E-mail from Hubertus Czernin to Randol Schoenberg, Dec. 29, 1998.

232 WHEN THE TAXI STOPPED: Maria Altmann, interview, 2001.

232 HER GESTAPO MINDER, FELIX LANDAU: Petropoulos, "Report of Professor Jonathan Petropoulos," p. 14.

232 "THIS IS MY AUNT!": Maria Altmann, interviews, 2001.

233 MARIA WOULD LATER TESTIFY: Deposition of Maria Altmann, May 29, 2002; *Maria Altmann v. the Republic of Austria and the Austrian Gallery,* an agency of the republic of Austria; United States District Court for the Central District of California.

233 "IN THE OLD VIENNA": Maria Altmann, interviews, 2001.

234 "TO HAVE ARGUED THAT FERDINAND": *Los Angeles Times,* June 30, 1999.

234 "I AM HORRIFIED": E-mail from Nelly Auersperg to Randol Schoenberg, copy sent to Maria Altmann.

"I CAN'T AFFORD FOR YOU TO LOSE"

235 BUT THE AUSTRIANS DEMANDED $1.8 MILLION: Petropoulos, "Report of Professor Jonathan Petropoulos."

235 "RANDY, I CAN'T AFFORD FOR YOU TO LOSE": Randol Schoenberg, interviews.

235 RANDOL WAS DEEPLY DISAPPOINTED: Randol Schoenberg, interviews.

236 "I SEE THIS AS PART": Testimony of Ronald S. Lauder, then chairman of the Commission for Art Recovery of the World Jewish Congress, before the U.S. House Committee on Banking and Financial Services, Feb. 10, 2000.

236 "BOND OF HALF A MILLION DOLLARS": Ibid.

HOW DO YOU SOLVE A PROBLEM LIKE MARIA?

236 TOMAN, A BALD, BEARDED MAN: Gottfried Toman, interviews Oct. 31, 2006.

236 TOMAN WAS ENTRANCED: Gottfried Toman, interviews Oct. 31, 2006.

237 TOMAN WAS CHARMED BY MARIA: Gottfried Toman, interviews, May 2007.

KLIMT'S STOLEN WOMEN

237 "THE FIGURE'S BEDROOM EYES": Leo A. Lensing, "Letter from Vienna," *Times Literary Supplement,* Jan. 19, 2001.

237 "GANGSTER'S MOLL, PARADING AROUND": Ibid.

238 "MEN OF HONOR": Andrew Purvis and Angela Leuker, "Jörg Haider's New Clothes," *Time,* Apr. 10, 2005.

238 "THERE MUST BE AN END": John Authers and Richard Wolffe, *The Victim's Fortune* (New York: HarperCollins, 2002), p. 319.

238 "NOT A CENT MORE": Ibid., p. 312.

238 "IT IS UNACCEPTABLE": Kate Connolly, "Haider Embraces SS Veterans," *The Guardian,* Oct. 2, 2000.

238 "THE FIRST VICTIM OF THE NAZI REGIME": Jeff Barak, interview with Wolfgang Schüssel, *Jerusalem Post,* Nov. 10, 2000.

238 "SUBSTANTIAL AND NON-FRIVOLOUS CLAIM": "Order Denying Defendants' Motion to Dismiss," United States District Court, Central District of California, CV 008913, filed May 4, 2001.

A LOST CAUSE CÉLÈBRE

239 "HELLO, MY LOVE!": Maria Altmann, interviews, 2001.

239 "SHE AND MY MOTHER WERE SO DIFFERENT": Maria Altmann, interviews, 2001.

240 "I WAS A TIMID LITTLE GIRL": Maria Altmann, interviews, 2001.

240 "THEY SAY NOW AUSTRIA WAS A VICTIM": Maria Altmann, interviews, 2001.

241 "CRAZY NAZI PROPAGANDIST": Randol Schoenberg, interview, 2001.

DIPLOMACY

241 "HE'S HERE TO SAVE THE GOLD!": Heard at a reception of consuls of Los Angeles at the home of Swedish consuls Andreas and Anita Ekman, 2001.

241 "THE JEWISH RESIDENTS BROUGHT": Interview with Ambassador Peter Moser. All subsequent quotations from Moser in this chapter come from this interview, 2001.

FAMILY HISTORY

243 "OH, PETER MOSER": Maria Altmann, interviews. All subsequent quotations from Maria Altmann in this chapter come from these interviews, 2001.

245 "WE [MADE THE CONTRIBUTION]": Charles Goldstein, e-mail, June 17, 2010.

245 KEEP GOING, PAM TOLD HIM: Pamela Schoenberg, interview, Sept. 2007.

246 "THE FIRST TIME IN HOLOCAUST REPARATIONS": Henry Weinstein, "Klimt Art Suit May Proceed," *Los Angeles Times,* Dec. 13, 2002.

246 "I WANT THOSE PAINTINGS": Ibid.

SUPREME JUDGMENT

246 "I THINK THE PLAINTIFFS": Anne-Marie O'Connor, "A Portrait of Perseverance," *Los Angeles Times,* Feb. 5, 2004.

246 "YOU CAN'T JUST HAVE RANDY": Maria Altmann, interviews, 2004.

246 "EXPERIENCED LITIGATOR": Bert Fields, phone interview, May 11, 2010.

248 "THE QUESTION IS ONE": David Pike, "Court Likely Will Reverse Art Case," *Los Angeles Daily Journal,* Feb. 26, 2004.

248 "I DON'T KNOW IF WE PROTECT": Ibid.

248 "WHY DID YOU WRITE THIS?": Randol Schoenberg, interviews.

248 "I'VE BEEN REPORTING ON THE SUPREME COURT": Randol Schoenberg, interviews.

249 "EXPROPRIATION EXCEPTION": Henry Weinstein, "Austria Can Be Tried in U.S. Courts over Nazi-Seized Paintings," *Los Angeles Times,* June 8, 2004.

249 "IN 1946 AUSTRIA ENACTED": *Republic of Austria et al. v. Altmann,* Certiori to the United States Court of Appeals for the Ninth Circuit, Argued Feb. 24, 2004, Decided June 7, 2004.

ARBITRATION

250 "YOU'RE CRAZY": Randol Schoenberg and Maria Altmann, interviews, 2006.

251 "I HOPE HE WASN'T A MEMBER": Randol Schoenberg, interview, e-mail, Jan. 29, 2009.

251 THE PANELISTS HAD CONCLUDED: Austria arbitration decision, Jan. 2006, p. 20.

251 "MERE REQUEST": Ibid., p. 21.
251 THEY DISCARDED AS "FAR-FETCHED": Ibid., p. 19.
251 "THE PARTIES INVOLVED IN ACTS OF SEIZURE": Ibid., p. 25.
252 "SIMPLY EXTORTED": Ibid., p. 24.
252 "USED THE PAINTINGS AS WEAPONS": Ibid., pp. 43–44.
252 RANDOL SECOND-GUESSED HIMSELF: Randol Schoenberg, interview, Jan. 2006.
253 "I LET OUT A WHOPPING YELL": On-site reporting, Los Angeles, Jan. 2006.
253 "I HAVE A POSSIBLE BUYER": On-site reporting, Los Angeles, Jan. 2006.
253 "YOU DON'T KNOW HOW MANY CALLS": On-site reporting, Los Angeles, Jan. 2006.
253 "MY DADDY WON": On-site reporting, Los Angeles, Jan. 2006.
253 "DADDY! MY FRIENDS SAY": On-site reporting, Los Angeles, Jan. 2006.
253 "THERE'S NOT GOING TO": Randol Schoenberg, interview, Los Angeles, Jan. 2006.
253 "I WOULD NOT WANT": Diane Haithman and Christopher Reynolds, "Court Awards Nazi-Looted Artworks to L.A. Woman," *Los Angeles Times,* Jan. 17, 2006.
254 "THIS IS A FAIRY-TALE STORY": Speech delivered by Peter Altmann at celebratory dinner at Spago, Jan. 9, 2006.
254 "THE AVAILABILITY OF THE BLOCH-BAUER KLIMTS": Letter from Christie's chairman Stephen S. Lash to Randol Schoenberg, Feb. 9, 2006.

CIAO ADELE

254 AFTER A MAN THREATENED TO DEFACE: Diane Haithman, "Threat Spurs Removal of Painting," *Los Angeles Times,* Jan. 21, 2006.
254 "THEY WEREN'T AFRAID": Randol Schoenberg, reporting, Feb. 26, 2006.
255 "THIS STUFF IS EVERYWHERE!": Randol Schoenberg, reporting, Feb. 26, 2006.
255 THEY CALLED FOR AUSTRIA: "Austria Won't Buy Art Awarded to LA Heir," Associated Press, Feb. 3, 2006.
255 "YOU'VE BEEN A *HUGE* INSPIRATION": On-site reporting, Feb. 26, 2006.
256 "RIDICULOUS!": On-site reporting, Feb. 26, 2006.
256 "I THINK THE CLIMATE": On-site reporting, Feb. 26, 2006.

A FRIEND FROM OLD VIENNA

256 RANDOL ANNOUNCED HE WAS HEADING OFF: Randol Schoenberg, interview, Vienna, Feb., 2006.
257 "I WAS DRAFTED": Hans Mühlbacher, *Zwischen Technik und Musik* (Vienna: Edicion Atelier, 2003).
257 "MANY PRETTY GIRLS": Ibid., p. 126.
258 "SOME OF THE SOLDIERS WERE SORRY": Ibid., p. 142.
258 HE WAS AN SS OFFICER: Herbert Alois Wagner FBI File 105-10525. FBI HQ: Investigative Reports; Classified Subject Files. Released under the Nazi and Japanese War Crimes Disclosure Acts. Classification 105: Foreign Counterintelligence. U.S. National Archives and Records Administration, College Park, Maryland.
258 HE AND HIS TWO ASSISTANTS: Linda Hunt, *Secret Agenda* (New York: St. Martin's Press, 1991), pp. 6–7.
260 HANS'S STORYBOOK HOMETOWN: "Von Juden und Nationalsozialisten in St. Wolfgang im Salzkammergut," *One Journal,* June 12, 2010, www.salai.at/article/lokales/stwolfgang/17274.
260 THE SS ORDERED HANS: Guy B. Adams and Danny L. Balfour, *Unmasking Administrative Evil* (Armonk, NY: M. E. Sharpe, 2009).

260 PEOPLE WHO HAD SEEN AIR RAID SHELTERS COLLAPSE: Graziella Hlawaty and Pamela S. Sauer, *Broken Songs: An Adolescent in War-Torn Vienna* (Riverside, CA: Ariadne Press, 2005), p. 180.

261 HANS SHOWED ME: *Herbert Wagner, His Work and Life, Documents* (Bonn: Deutsche Gesellschaft fur Luft- und Raumfahrt e. V.; Deutsches Museum, Smithsonian Institution, 1990), p. 10.

PATRIMONY

261 "I WAS A BIT HURT": Randol Schoenberg, interview, Jan. 8, 2007.

262 RANDOL FOLLOWED THE ADMINISTRATOR: Randol Schoenberg, interview, Jan. 8, 2007.

262 RANDOL LIFTED UP: Randol Schoenberg, interview Jan. 8, 2007.

262 THE BABY IN THE PAINTING, GEORG: Arnold Greissle-Schönberg and Nancy Bogen, *Arnold Schönberg's European Family,* e-book, www.schoenbergseuropeanfamily.org, chap. 4.

263 "THE ERA HAS BEEN SO WIDELY CELEBRATED": Andreas Mailath-Pokorny, speech at premiere of Raul Ruiz's film *Klimt,* Mar. 1, 2006.

263 "MYTHICAL CITY": Ibid.

263 "WE HAVE FERDINAND TO THE LEFT": Randol Schoenberg, reporting at the scene, Mar. 1, 2006.

263 "I DIDN'T TELL ANYONE": Suzanne Biro, author reporting at the scene, Mar. 1, 2006.

263 "I THOUGHT THERE WAS NO CHANCE": Randol Schoenberg, author reporting at the scene, Mar. 1, 2006.

264 THE FAMILY OF THE WALTZ KING: Elaine Dutka, "Vienna Buys Back Strauss Memorabilia," *Los Angeles Times,* Feb. 2, 2002. See also Michael J. Bazyler, *Holocaust Justice: The Battle for Restitution in America's Courts* (New York: New York University Press, 2003), p. 244.

264 "IN THE END WE GAVE IT ALL BACK": Andreas Mailath-Pokorny, author reporting at the scene, Mar. 1, 2006. Mailath-Pokorny was then City Councillor for Cultural Affairs and Science of the City of Vienna.

264 "AND WITHIN AUSTRIA": Author reporting at the scene, Mar. 1, 2006.

264 "JOURNALISTS KEEP ASKING ME": John Malkovich, interview, Mar. 1, 2006.

264 "IT IS SOMETHING": Alice Strobl, interview, Mar. 1, 2006.

264 "THE NAZIS MADE EVERYONE WORK": Alice Strobl, interview, Mar. 1, 2006.

265 "BASICALLY, THE GOVERNMENT": John Sailer, interview, Nov. 2, 2006.

266 "MY GUT FEELING": John Sailer, interview, Nov. 2, 2006.

266 "MAYBE YOU CAN CHANGE [RANDOL'S] MIND": Elisabeth Sturm-Bednarczyk, interview, Mar. 2, 2006. Subsequent quotations are also from this interview.

ADELE'S FINAL DESTINY

268 "IT WAS A VERY SIGNIFICANT OFFER": Tyler Green, "'This Is Our Mona Lisa,'" *Fortune,* Sept. 28, 2006.

268 "THE MOST SIGNIFICANT EVENT": Christie's letter, Feb. 9, 2006.

269 "OH MY DARLING": Maria Altmann, interview, Spring 2006.

269 "I'VE LOST SO MUCH WEIGHT": Hubertus Czernin, telephone interview, May 20, 2006.

269 "IT BECAME CLEAR": Green, "'This Is Our Mona Lisa.'"

269 "IT'S PRETTY HARD TO BE": Ibid.

270 DAYS BEFORE THE GOLD PORTRAIT: Lawsuit, Randol Schoenberg, filed June 30, 2006, in the U.S. Court of the Central District of California. It was docketed July 10, 2006.
270 "I REFUSED TO PAY": Nelly Auersperg, telephone interview, May 18, 2011.
270 "THE MISUNDERSTANDING WAS RESOLVED": Steve Thomas, e-mail, May 17, 2011.
270 THE GOLD PORTRAIT WAS CAREFULLY PACKED: Green, "'This Is Our Mona Lisa.'"
271 RON LAUDER WAS ANXIOUSLY PACING: Ibid.
271 "IN MANY WAYS": Ron Lauder, press preview, July 12, 2006. Subsequent quotations from Lauder also from the press preview.

THE BURDEN OF HISTORY

273 "ENEMIES OF THE PEOPLE": Malteser Kreuz Zeitung des Soveranem Ritter-Ordens Member Chapter of the Grand Priory of Austria Franz Karl Auersperg; Franz Karl von Auersperg biography on website www.malteserkreuz.org.
273 "INSIDE THE GOLDEN FRAME": Marisa Harris, interview, Vancouver, Aug. 2006.
273 "I HAVE A FEELING KLIMT WAS INTERESTED": Nelly Auersperg, interview, Vancouver, Aug. 3, 2006.
273 "SHE WAS A DRAWING-ROOM SOCIALIST": Johannes Auersperg, interview, Vancouver, Aug. 3, 2006.
273 "I WOULD PREFER": Nelly Auersperg, interview, Vancouver, Aug. 3, 2006.
273 "HE'S GOING TO MAKE NINETY-SIX MILLION DOLLARS": Johannes Auersperg, interview, Vancouver, Aug. 3, 2006.
273 "'MY SKI HOLIDAY'": Johannes Auersperg, interview, Vancouver, Aug. 3, 2006.
273 "LUISE LOVED KLIMT PAINTINGS": Nelly Auersperg, interview, Vancouver, Aug. 3, 2006.
274 "IT WAS TIT FOR TAT": Johannes Auersperg, interview, Vancouver, Aug. 3, 2006.
274 "WE THOUGHT THE NAZIS WERE GONE": Nelly Auersperg, interview, Vancouver, Aug. 3, 2006.
275 JOHN STARTED TO SAY SOMETHING: Johannes Auersperg, interview, Vancouver, Aug. 3, 2006.
275 "THEY WEREN'T SUPPOSED TO SHOOT HIM YET": Nelly Auersperg, interview, Vancouver, Aug. 3, 2006.

ART HISTORY

276 "THE MUSEUMS HELPED THEMSELVES": Baroness Marianne Kirstein-Jacobs, interview, Vienna, May 7, 2007. Subsequent quotes are from this interview.
278 "ADELE WAS AN EXTRAORDINARY PERSON": Gottfried Toman, interview, Oct. 2007. Subsequent quotes from Toman are from this interview.
279 "IT STIRS UP A LOT OF THINGS": Felicitas Kunth, provenance director of the Dorotheum, interview, Oct. 2006.
280 "MY OLDEST FRIEND": Sophie Lillie, interview, Apr. 2006.
280 "YOU GREW UP NOT KNOWING": Ruth Pleyer, interview, Apr. 16, 2007.
280 "HE REALIZED HE COULD": Stanislaus Bachofen-Echt, interview, Vienna Nov. 5, 2006. Subsequent quotations are also from interviews in Apr. 2007.
281 A YELLOWING U.S. MILITARY FORM: Certificate of Discharge, Aug. 29, 1946, signed by Dr. Lardschneider and approved by an Allied Discharging Officer (name illegible), Vienna State Archives.
282 "WE HAD SOME NAZIS IN THE FAMILY": Franz Josef Czernin, interview, Vienna. Subsequent quotations are from this interview, May 2007.

283 THERE TURNED OUT TO BE PLENTY: Christopher Simpson, ed., *War Crimes of the Deutsche Bank and the Dresdner Bank: Office of Military Government (U.S) Reports* (New York: Holmes & Meier, 2002), pp. 308, 342, 351. Also: Johannes Bahr, *Die Dresdner Bank in der Wirtschaft des Dritten Reichs* (Munich: Oldenbourg, 2006), p. 602.

283 STEINHOF HOSPITAL: Francis Nicosia and Jonathan Huener, *Medical Ethics in Nazi Germany: Origins, Practices, Legacies* (New York: Berghahn Books, 2002), pp. 101–4. Also: Marius Turda and Paul Weindling, *"Blood and Homeland": Eugenics and Racial Nationalism in Central and Southeast Europe, 1900–1940* (New York: Central European University Press, 2006), p. 329; Debra Martens, "Unfit to Live," *Canadian Medical Association Journal,* Sept. 14, 2004, pp. 619–20.

283 BUT NEW NAZI-ERA ARCHIVES: Kate Connolly, "Unquiet Grave for Nazi Victims," *The Guardian,* Apr. 29, 2002.

284 "A PERPETRATOR WHO CALLED HIMSELF": Renate Göllner, "Ich war gar nicht eingeheit," *Konkret,* Oct. 2008. Additional sources on scrutiny of Caruso: Bettina Reiter, "Es waren doch Gutachten," *Die Presse,* May 9, 2008; Eveline List, "'Warum nicht in Kischniew?' Zu einem autobiographischen Tondokument Igor Caruso," *Zeitschrift für Psychoanalytische Theorie und Praxis* 33, no. 1 (2008): 117–41.

284 ONE CURATOR SAID IT HAD BEEN: Telephone interview with Dr. Georg Lechner, the curator of the Baroque, Belvedere Museum, July 20, 2010. On the Belvedere bunker as a potential refuge for Hitler and Nazi leadership, see also Simone Fässler, *Von Wien her, auf Wien hin: Ilse Aichingers "Geographie der eigenen Existenz"* (Vienna: Böhlau, 2011).

284 BUT HITLER BUILT: Franz Wilhelm Seidler and Dieter Ziegert, *Hitler's Secret Headquarters: The Führer's Wartime Bases from the Invasion of France to the Berlin Bunker* (Bamsley, UK: Greenhill Books, 2006).

284 HIS BOOK SHOWS HITLER PRESIDING OVER: Aurenhammer and Aurenhammer, *Das Belvedere,* p. 126, photo.

284 IN THOSE DAYS: Ibid., p. 36.

284 "VIENNA WAS NO LONGER FAR FROM THE COMBAT ZONE": Ibid.

285 "THE PROTEST OF THE GALLERY'S MANAGEMENT": Ibid.

285 "FÜHRER HEADQUARTERS": *Das Museum. Spiegel und Motor kulturalpolitischer Visionen* (The Museum: Mirror and Motivator of Cultural-Political Visions 1903–2003), ed. Hadwig Krautler and Gerbert Frodl (Vienna: Österreichische Galerie Belvedere, 2003), p. 72.

285 "PLEASE NOTE WHAT THE BELVEDERE": E-mail from Lena Maurer, Belvedere press spokeswoman, Nov. 9, 2009.

CULTURAL PROPERTY

286 PLASTER MOLDINGS AND ORNAMENTATION: Stefan Gulner, interviews, Apr. 2007.

286 *"JÜDISCHE?":* Interview at the Zentral Friedhof, Nov. 1, 2006.

287 "MY GRANDMOTHER WAS ONE OF HIS MODELS": Gustav Zimmermann, interview at the Hietzing Friedhof, Nov. 1, 2006; subsequent quotations from interviews Apr.–May 2007.

A RECKONING

289 "THE CURSE OF THE KLIMTS": Maria Altmann, interview, 2006.

289 "NELLY AND I USED TO BE": Maria Altmann, interview, 2006.

289 NELLY WANTED TO DONATE: Maria Harris, Maria Altmann, interviews, 2006; multiple e-mail exchanges with Nelly Auersperg.

289 "HOW SAD—IF UNSURPRISING": Michael Kimmelman, "Klimts Go to Market; Museums Hold Their Breath," *New York Times,* Sept. 19, 2006.

290 "THIS WAS OUR AUSTRIAN *MONA LISA*": Werner Fürnsinn, interview, Vienna, Sept. 2006.

290 "WE LENT THEM THOSE PAINTINGS": Maria Altmann, interview, Sept. 2006.

290 "HOW DARE YOU ACCUSE ME": Letter from Maria Altmann to Nelly Auersperg, read to author, Sept. 7, 2007.

290 "MY MOTHER NEVER WANTED TO DIG UP": Maria Harris, interview.

291 "MRS. ALTMANN, CONGRATULATIONS": Press conference prior to the Christie's auction, Nov. 8, 2006.

291 RONALD LAUDER SHOWED MARIA: Maria Altmann, interview, Dec. 2006.

292 "DO I HEAR $12 MILLION?": On-site reporting at the Christie's auction, Nov. 8, 2006.

293 "MY AUNT ADELE AND UNCLE FERDINAND": Christie's press statement, Nov. 8, 2006.

293 "WE WERE LUCKY": Reporting at the event, Nov. 8, 2006.

293 "DID ADELE'S PORTRAIT GO TO THAT MAN": Maria Altmann, interview, Dec. 2006.

293 "THE FATE OF THE KLIMT PAINTINGS": Nelly Auersperg, correspondence with the author, Jan. 31, 2009.

293 "I DON'T WANT TO ASK NELLY": Maria Altmann, interview.

294 RESTITUTION CASES WERE NOW JUDGED: Stuart Eizenstat, *Imperfect Justice* (New York: Public Affairs, 2004), p. 352.

Selected Bibliography

Adam, Peter. *Art of the Third Reich.* New York: Harry N. Abrams, 1992.

Adams, Guy B., and Danny L. Balfour. *Unmasking Administrative Evil.* Armonk, NY: M. E. Sharpe, 2009.

Allen, James, and Stewart Evans. *The Empress Theodora, Partner of Justinian.* Austin: University of Texas Press, 2004.

Anthony, David W. *The Horse, the Wheel, and Language: How Bronze-Age Riders from the Eurasian Steppes Shaped the Modern World.* Princeton, NJ: Princeton University Press, 2007.

Arendt, Hannah. *Eichmann in Jerusalem: A Report on the Banality of Evil.* New York: Penguin, 2006.

Arnbom, Marie-Therese, and Christoph Wagner-Trenkwitz. *Grüss mich Gott! Fritz Grünbaum 1880–1941: Eine Biographie.* Vienna: Christian Brandstätter Verlag, 2005.

Atwater, Richard. *The Sacred History of Procopius.* Ann Arbor: University of Michigan Press, 1961.

Aurenhammer, Hans and Gertrude. *Das Belvedere in Wien.* Vienna: Verlag Anton Schroll, 1971.

Authers, John, and Richard Wolffe. *The Victim's Fortune.* New York: HarperCollins, 2002.

Bahr, Johannes. *Die Dresdner Bank in der Wirtschaft des Dritten Reichs.* Munich: Oldenbourg, 2006.

Ballinger, Pamela. *History in Exile: Memory and Identity at the Borders of the Balkans.* Princeton, NJ: Princeton University Press, 2003.

Banac, Ivo. *With Stalin Against Tito: Cominformist Splits in Yugoslav Communism.* Ithaca, NY: Cornell University Press, 1998.

Barea, Ilsa. *Vienna.* New York: Knopf, 1967.

Bartov, Omer. *Holocaust: Origins, Implementation, Aftermath.* London: Routledge, 2000.

Bazyler, Michael J. *Holocaust Justice: The Battle for Restitution in America's Courts.* New York: New York University Press, 2003.

Bazyler, Michael J., and Roger P. Alford. *Holocaust Restitution: Perspectives on the Litigation and Its Legacy.* New York: New York University Press, 2005.

Beaumont, Anthony, ed. *Alma Mahler Werfel Diaries.* London: Faber & Faber, 2005.

Beller, Steven. *A Concise History of Austria.* Cambridge, UK: Cambridge University Press, 2006.

———. *Vienna and the Jews, 1867–1938: A Cultural History.* Cambridge, UK: Cambridge University Press, 1991.

Beloff, Max. *On the Track of Tyranny.* Freeport, NY: Books for Libraries Press, 1971.

Berger, John. *Ways of Seeing.* New York: Penguin, 1972.

Berkley, George E. *Vienna and Its Jews: The Tragedy of Success, 1880–1980s.* Cambridge, MA: Abt Books, 1988.

Borneman, John. *Death of the Father: An Anthropology of the End in Political Authority.* New York: Berghahn Books, 2005.

Botstein, Leon, and Linda Weintraub. *Pre-Modern Art of Vienna*. Annandale-on-Hudson, NY: Edith C. Blum Art Institute, 1987.

Brandstätter, Christian, ed. *Vienna 1900: Art, Life and Culture*. New York: Vendome Press, 2006.

———. *Wiener Werkstätte, Design in Vienna 1903–1932*. New York: Harry N. Abrams, 2003.

Brook, Stephen. *Vanished Empire: Vienna, Budapest, Prague*. New York: William Morrow, 1990.

Brook-Shepherd, Gordon. *Anschluss*. London: Macmillan, 1963.

Bukey, Evan Burr. *Hitler's Austria: Popular Sentiment in the Nazi Era, 1938–1945*. Chapel Hill: University of North Carolina Press, 2000.

Clare, George. *Last Waltz in Vienna: The Rise and Destruction of a Family, 1842–1942*. New York: Holt, Rinehart and Winston, 1982.

Cohen, Philip J. *Serbia's Secret War: Propaganda and the Deceit of History*. College Station: Texas A&M University Press, 1996.

Cole, Malcolm S., and Barbara M. Barclay. *Armseelchen: The Life and Music of Eric Zeisl*. Westport, CT: Greenwood Press, 1984.

Comini, Alessandra. *Gustav Klimt*. New York: George Braziller, 1975.

———. *In Passionate Pursuit: A Memoir*. New York: George Braziller, 2004.

Constantino, Maria. *Gustav Klimt*. London: PRC Publishing, 2001.

Cummins, Paul. *Dachau Song: The Twentieth-Century Odyssey of Herbert Zipper*. New York: Peter Lang Publishing, 1992.

Czernin, Hubertus. *Die Falschung, der Fall Bloch-Bauer und das Werk Gustav Klimts*. Vienna: Czernin Verlag, 1999.

Del Mar, Norman. *Richard Strauss: A Critical Commentary of His Life and Works*. Vol. 3. London: Barrie & Jenkins, 1978.

Djilas, Milovan. *Wartime*. New York: Harcourt Brace Jovanovich, 1977.

Dolmetsch, Carl. *Our Famous Guest: Mark Twain in Vienna*. Athens: University of Georgia Press, 1992.

Dolnick, Edward. *The Forger's Spell*. New York: Harper, 2008.

Domarus, Max. *Hitler: Speeches and Proclamations, 1932–1945: The Chronicle of a Dictatorship*. Wauconda, IL: Bolchazy-Carducci, 2004.

Edsel, Robert M. *Rescuing Da Vinci: Hitler and the Nazis Stole Europe's Great Art, America and Her Allies Recovered It*. Dallas: Laurel Publishing, 2006.

Eizenstat, Stuart. *Imperfect Justice*. New York: Public Affairs, 2004.

Evans, Richard J. *The Third Reich at War*. New York: Penguin, 2009.

Feliciano, Hector. *The Lost Museum*. New York: Basic Books, 1998.

Ferguson, Niall. *The House of Rothschild*. Vol. 1. New York: Penguin Books, 1999.

Fest, Joachim. *The Face of the Third Reich*. London: Weidenfeld & Nicolson, 1970.

Ficowski, Jerzy. *Regions of the Great Heresy: Bruno Schulz, a Biographic Portrait*. New York: W. W. Norton, 2003.

Freidenreich, Harriet Pass. *Jewish Politics in Vienna, 1918–1938*. Bloomington: Indiana University Press, 1991.

Friedlander, Saul. *Nazi Germany and the Jews*. Vol. 1, *The Years of Persecution, 1933–1939*. New York: HarperCollins, 1997.

———. *Nazi Germany and the Jews*. Vol. 2, *The Years of Extermination, 1939–1945*. New York: HarperCollins, 2007.

Frodl, Gerbert. *Secession, Gustav Klimt, Beethovenfries*. Vienna: Secession, 2002.

Gamwell, Lynn, and Richard Wells, eds. *Sigmund Freud and Art: His Personal Collection of Antiquities*. Binghamton and London: State University of New York and the Freud Museum in association with Harry N. Abrams, 1989.

Gardner, Helen. *Gardner's Art Through the Ages: The Western Perspective.* Australia; Florence, KY: Wadsworth/Cengage Learning, 2010.

Gay, Peter. *Schnitzler's Century: The Making of Middle-Class Culture, 1815–1914.* New York: W. W. Norton, 2002.

Gedye, G. E. R. *Betrayal in Central Europe.* New York: Harper & Bros., 1939.

Geier, Arnold. *Heroes of the Holocaust.* New York: Berkley Books, 1998.

Grimschitz, Bruno. *Das Belvedere in Wien.* Vienna: Kunstverlag Wolfrum, 1946.

Gruber, Ruth Ellen. *Virtually Jewish: Reinventing Jewish Culture in Europe.* Berkeley: University of California Press, 2002.

Hagen, Rose-Marie and Rainer. *What Great Paintings Say.* Vol. 1. New York: Taschen, 2003.

Hamann, Brigitte. *Hitler's Vienna: A Portrait of the Tyrant as a Young Man.* New York: Oxford University Press, 2000.

———. *The Reluctant Empress.* New York: Knopf, 1986.

Heyworth, Peter. *Otto Klemperer: His Life and Times.* Vol. 1, *1885–1933.* Cambridge, UK: Cambridge University Press, 1983.

Hickey, Eric W. *Serial Murderers and Their Victims.* Florence, KY: Wadsworth, Cengage Learning, 2010.

Higham, Charles. *Marlene: The Life of Marlene Dietrich.* New York: W. W. Norton, 1977.

Hilberg, Raul. *The Destruction of the European Jews.* New York: Holmes & Meier, 1985.

Hill, Roland. *A Time Out of Joint: A Journey from Nazi Germany to Post-war Britain.* London: Tauris, 2007.

Hitler, Adolf. *Mein Kampf.* Mumbai: Jaico Publishing House, 2003.

Hitler's Degenerate Art: The Exhibition Catalogue. Ed. Joachim von Halasz. London: World Propaganda Classics, Foxley Books Ltd., 2008.

Hlawaty, Graziella, and Pamela S. Sauer. *Broken Songs: An Adolescent in War-Torn Vienna.* Riverside, CA: Ariadne Press, 2005.

Hotter, Hans, Dietrich Fischer-Dieskau, Zubin Mehta, and Donald Arthur. *Hans Hotter: Memoirs.* Lebanon, NH: University Press of New England, 2006.

Hunt, Linda. *Secret Agenda.* New York: St. Martin's Press, 1991.

Hutter, Andreas, and Klaus Kamolz. *Billy Wilder: Eine europäische Karriere.* Vienna: Bohlau, 1998.

Ibsch, Elrud, Dick Schram, and Gerard Steen. *The Psychology and Sociology of Literature: In Honor of Elrud Ibsch.* Philadelphia: Benjamins, 2001.

Iggers, Wilma Abeles. *Karl Kraus: A Viennese Critic of the Twentieth Century.* The Hague: Martinus Nijhoff, 1967.

Janik, Allan, and Stephen Toulmin. *Wittgenstein's Vienna.* New York: Simon & Schuster, 1973.

Janik, Allan S., and Hans Veigl. *Wittgenstein in Vienna: A Biographical Excursion Through the City and Its History.* Vienna and New York: Springer Verlag, 1998.

Johnson, Thomas L., and Eberhard Michael Iba. *Germanic Fairy Tale Landscape: The Storied World of the Brothers Grimm.* Gottingen: Klartext GmbH, 2006.

Johnston, William M. *The Austrian Mind: An Intellectual and Social History, 1848–1938.* Berkeley: University of California Press, 1983.

Jones, Ernest. *The Life and Work of Sigmund Freud.* Garden City, NY: Doubleday, 1963.

Kater, Michael H. *The Twisted Muse: Musicians and Their Music in the Third Reich.* New York: Oxford University Press, 1999.

Kennedy, Michael. *Richard Strauss.* New York: Oxford University Press, 1995.

King, David. *Vienna 1814: How the Conquerors of Napoleon Made Love, War and Peace at the Congress of Vienna.* New York: Harmony Books, 2007.

Knight, Max, trans. *A Confidential Matter: The Letters of Richard Strauss and Stefan Zweig.* Berkeley: University of California Press, 1977.

Koja, Stephan, ed. *La destrucción creadora: Gustavo Klimt, el friso de Beethoven, y la lucha por la libertad del arte.* Madrid: Fundación Juan March, 2006.

———, ed. *Gustav Klimt: Landscapes.* Munich: Prestel Verlag, 2006.

Kokoschka, Oskar. *Letters, 1905–1976.* Selected by Olda Kokoschka and Alfred Marnau. London: Thames & Hudson, 1992.

Kornberg, Jacques. *Theodor Herzl: From Assimilation to Zionism.* Bloomington: Indiana University Press, 1993.

La Grange, Henry-Louise de, ed. *Gustav Mahler: Letters to His Wife.* Ithaca, NY: Cornell University Press, 2004.

———. *Mahler.* Vol. 1. Garden City, NY: Doubleday, 1973.

Lamarr, Hedy. *Ecstasy and Me: My Life as a Woman.* New York: Bartholomew House, 1966.

Lambert, Angela. *The Lost Life of Eva Braun.* New York: St. Martin's Press, 2006.

Lazenby, J. Mark. *The Early Wittgenstein on Religion.* London: Continuum, 2006.

Lehr, David. *Austria Before and After the Anschluss.* Pittsburgh, PA: Dorrance, 2000.

Ligne, Charles Joseph. *The Life of Prince Eugene, of Savoy: From His Own Original Manuscript.* Charleston, SC: Nabu Press, 2010.

Lillie, Sophie. *Was einmal war: Handbuch der enteigneten Kunstsammlungen Wiens.* Vienna: Czernin, 2003.

Lillie, Sophie, and Georg Gaugusch. *Portrait of Adele Bloch-Bauer.* New York: Neue Galerie Museum for German and Austrian Art, 2007.

Litchfield, David R. L. *The Thyssen Art Macabre: The History of the Thyssens.* London: Quartet Books, 2006.

Loving, Jerome. *Mark Twain: The Adventures of Samuel L. Clemens.* Berkeley: University of California Press, 2010.

MacDonald, Callum. *The Killing of Reinhard Heydrich: The SS "Butcher of Prague."* New York: Da Capo Press, 1998.

MacDonald, David Bruce. *Balkan Holocaust?: Serbian and Croatian Victim-Centred Propaganda and the War in Yugoslavia.* Manchester, UK: Manchester University Press, 2002.

MacDonogh, Giles. *1938: Hitler's Gamble.* London: Constable, 2009.

Magnin-Haberditzl, Magdalena. *Familien-Chronik aus dem europaweiten Österreich, 1678–1982.* Vienna: Christian Brandstätter Verlag, 2008.

Mahler, Alma, and E. B. Ashton. *And the Bridge Is Love.* London: Hutchinson, 1959.

Matt, Siegfried, and Werner Michael Schwarz. *Felix Salten: Schriftsteller—Journalist—Exilant.* Vienna: Holzhausen Verlag, 2006.

Mazower, Mark. *Hitler's Empire.* New York: Penguin, 2008.

McCagg, William O. *A History of Habsburg Jews, 1670–1918.* Bloomington: Indiana University Press, 1989.

McCloskey, Barbara. *Artists of World War II.* Westport, CT: Greenwood Press, 2005.

Meisler, Stanley. *United Nations: The First Fifty Years.* New York: Atlantic Monthly Press, 1995.

Metzger, Rainer. *Gustav Klimt: Drawings and Watercolors.* London: Thames & Hudson, 2005.

Meysels, Lucian O. *Die Welt der Lotte Tobisch.* Vienna and Klosterneuburg: Edition Va Bene, 2002.

Michael, Robert A. *A Concise History of American Anti-Semitism.* Lanham, MD: Rowman & Littlefield, 2005.

Milchman, Alan, and Alan Rosenberg. *Postmodernism and the Holocaust.* Amsterdam: Rodopi, 1998.

Morton, Frederic. *A Nervous Splendor.* New York: Penguin, 1980.

———. *Thunder at Twilight.* New York: Da Capo Press, 2001.

Mühlbacher, Hans. *Zwischen Technik und Musik.* Vienna: Edicion Atelier, 2003.

Müller, Melissa, and Monika Tatzkow. *Lost Lives, Lost Art: Jewish Collectors, Nazi Art Theft, and the Quest for Justice.* New York: Vendome, 2010.

Natter, Tobias. *The Naked Truth: Klimt, Schiele, Kokoschka and Other Scandals.* Munich: Prestel, 2005.

Natter, Tobias, and Gerbert Frodl. *Klimt's Women.* Vienna: Österreichische Galerie Belvedere, 2000.

Nebehay, Christian. *Gustav Klimt: From Drawing to Painting.* New York: Harry N. Abrams, 1994.

Neret, Gilles, and Charity Scott-Stokes. *Gustav Klimt: 1862–1918.* Cologne: Taschen, 2002.

Nicholas, Lynn H. *The Rape of Europa.* New York: Vintage, 1995.

Oechsner, Frederich Cable, Joseph Williams Grigg, and Jack Martin Fleischner. *This Is the Enemy.* Boston: Little, Brown, 1942.

Opelt, Rüdiger. *Die Kinder des Tantalus.* Vienna: Czernin Verlag, 2002.

Overy, R. J. *The Dictators: Hitler's Germany and Stalin's Russia.* London: Allen Lane, 2004.

Oxaal, Ivar, Michael Pollak, and Gerhard Botz. *Jews, Antisemitism, and Culture in Vienna.* London: Routledge & Kegan Paul, 1987.

Palmer, Alan Warwick. *The Lands Between: A History of East-Central Europe Since the Congress of Vienna.* New York: Macmillan, 1970.

Parsons, Nicholas. *Vienna: A Cultural History.* New York: Oxford University Press, 2009.

Partsch, Susanna. *Gustav Klimt: Life and Work.* Germering, Germany: Grange Books, 2004.

———. *Gustav Klimt: Painter of Women.* Munich: Prestel, 1999.

Petropoulos, Jonathan. *Art as Politics in the Third Reich.* Chapel Hill: University of North Carolina Press, 1996.

———. *The Faustian Bargain: The Art World in Nazi Germany.* London: Penguin, 2001.

———. *Royals and the Reich: The Princes von Hessen in Nazi Germany.* New York: Oxford University Press, 2006.

Pippal, Martin. *A Short History of Art in Vienna.* Munich: Beck, 2001.

Pirchan, Emil. *Gustav Klimt: Ein Kunstler in Wien.* Vienna: Verlag Wallishauser, 1942.

Price, Renée, ed. *Gustav Klimt: The Ronald S. Lauder and Serge Sabarsky Collections.* New York: Neue Galerie/Prestel, 2007.

Read, Anthony. *The Devil's Disciples: Hitler's Inner Circle.* New York: W. W. Norton, 2004.

Reitlinger, Gerald. *The Alibi of a Nation, 1922–1945.* New York: Da Capo Press, 1989.

Roth, Joseph. *The Radetzky March.* Woodstock, NY: Overlook Press, 2002.

Sachar, Abram Leon. *A History of the Jews.* New York: Knopf, 1965.

Schneider, Gertrude. *Exile and Destruction: The Fate of Austrian Jews, 1938–1945.* Westport, CT: Praeger, 1995.

Schnitzler, Arthur. *My Youth in Vienna.* New York: Holt, Rinehart & Winston, 1970.

———. *Three Late Plays.* Trans. G. J. Weinberger. Riverside, CA: Ariadne Press, 1992.

Schorske, Carl E. *Fin de Siècle Vienna.* Cambridge, UK: Cambridge University Press, 1981

Schwartz, Agatha. *Gender and Modernity in Central Europe: The Austro-Hungarian Monarchy and Its Legacy.* Ottawa: University of Ottawa Press, 2010.

Shawn, Allen. *Arnold Schoenberg's Journey.* New York: Farrar, Straus & Giroux, 2002.

Shearer, Stephen Michael. *Beautiful: The Life of Hedy Lamarr.* New York: St. Martin's Press, 2010.

Shirer, William L. *The Rise and Fall of the Third Reich.* New York: Simon & Schuster, 1960.

Simpson, Christopher, ed. *War Crimes of the Deutsche Bank and the Dresdner Bank: Office of Military Government (U.S.) Reports.* New York: Holmes & Meier, 2001.

Somerset, Anne. *The Affair of the Poisons: Murder, Infanticide, and Satanism at the Court of Louis XIV.* New York: St. Martin's Press, 2004.

Spiel, Hilda. *Vienna's Golden Autumn: From the Watershed Year 1866 to Hitler's Anschluss, 1938.* New York: Weidenfeld & Nicolson, 1987.

Spitzer, Leo. *Lives In Between: Assimilation and Marginality in Austria, Brazil, and West Africa, 1780–1945.* Cambridge, UK: Cambridge University Press, 1990.

Spotts, Frederic. *Hitler and the Power of Aesthetics.* London: Overlook Press, 2002.

Steiger, Martina. *"Immer wieder werden mich Thatige Geister verlocken": Alma Mahler-Werfels Briefe an Alban Berg und seine Frau.* Vienna: Siefert, 2008.

Steinberg, Michael P. *Austria as Theater and Ideology: The Meaning of the Salzburg Festival.* Ithaca, NY: Cornell University Press, 2000.

Sturm-Bednarczyk, Elisabeth. *Phantasie-Uhren* [Fantasy Watches]: *Kostbarkeiten des Kunsthandwerks aus der Sammlung Therese Bloch-Bauer.* Vienna: Christian Brandstätter Verlag, 2002.

Sultano, Gloria, and Patrick Werkner. *Oskar Kokoschka: Kunst und Politik, 1937–1950.* Vienna: Bohlau Verlag, 2003.

Szeps, Berta. *My Life and History.* New York: Knopf, 1939.

Timms, Edward. *Karl Kraus, Apocalyptic Satyrist: The Post-War Crisis and the Rise of the Swastika.* New Haven, CT: Yale University Press, 2005.

Turda, Marius, and Paul Weindling. *"Blood and Homeland": Eugenics and Racial Nationalism in Central and Southeast Europe, 1900–1940.* New York: Central European University Press, 2006.

Utgaard, Peter. *Remembering and Forgetting Nazism: Education, National Identity and the Victim Myth in Postwar Austria.* New York: Berghahn Books, 2003.

Vassiltchikov, Marie. *Berlin Diaries, 1940–1945.* New York: Vintage, 1988.

Vergo, Peter. *Art in Vienna, 1898–1918: Klimt, Kokoschka, Schiele, and Their Contemporaries.* London: Phaidon, 1994.

Waugh, Alexander. *The House of Wittgenstein: A Family at War.* New York: Doubleday, 2008.

Weidinger, Alfred. *Gustav Klimt.* Munich: Prestel, 2007.

Weininger, Otto. *Sex and Character.* New York: Howard Fertig, 2003.

Welch, David. *Propaganda and the German Cinema, 1933–1945.* London: Tauris, 2001.

West, Rebecca. *Black Lamb and Grey Falcon: A Journey Through Yugoslavia.* New York: Penguin, 1994.

Weyr, Thomas. *The Setting of the Pearl: Vienna Under Hitler.* New York: Oxford University Press, 2005.

Wheatcroft, Andrew. *The Habsburgs: Embodying Empire.* New York: Penguin, 1996.

Whitford, Frank. *Klimt.* London: Thames & Hudson, 1998.

Zagorov, Slavcho. *The Agricultural Economy of the Danubian Countries, 1935–45.* Stanford, CA: Stanford University Press, 1955.

Zamecnik, Stanislav. *That Was Dachau, 1933–1945.* Paris: Fondation Internationale de Dachau, le Cherche Midi, 2004.

Zweig, Stefan. *The World of Yesterday: An Autobiography.* Lincoln: University of Nebraska Press, 1964.

Index

Page numbers in *italics* refer to illustrations.